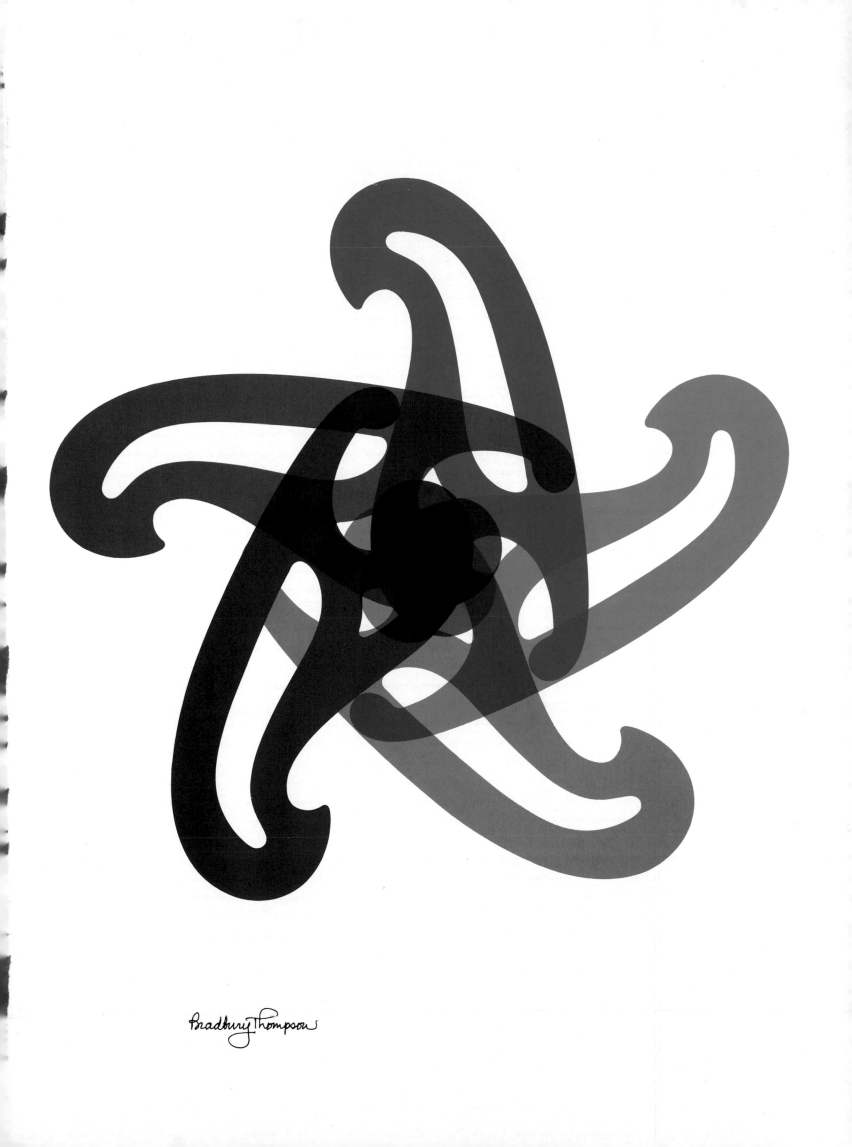

Bradbury Thompson

The American Institute of Graphic Arts

Watson-Guptill Publications
New York

The Annual of The American Institute of Graphic Arts

Written by David R. Brown and Steven Heller

Designed by Miho

The American Institute
of Graphic Arts
First published 1984 in
New York by The
American Institute of
Graphic Arts,
1059 Third Avenue,
New York, N.Y. 10021
and Watson-Guptill
Publications, Inc.,
a division of Billboard
Publications, Inc., 1515
Broadway, New York,
N.Y. 10036

ISBN 0-8230-2140-8

Printed in Japan by Dai
Nippon Printing Co., Inc.

Set in Bodoni by
U.S. Lithograph Inc.,
New York, New York

Exhibition photographs
by John Egana

First Printing, 1984

Distributed outside the
U.S.A. and Canada by
Fleetbooks, S.A.
c/o Feffer & Simons,
Inc., 100 Park Avenue,
New York, New York
10017

Contents

Acknowledgments

The publication of this volume is the culmination of a year's activities of The American Institute of Graphic Arts. It celebrates not only the work selected for exhibition, but also the vitality of the Institute itself. We are indebted to our exhibition chairmen and juries, to the men and women who participated in our competitions, and also to the increasing number of energetic individuals across the United States whose efforts on behalf of the graphic design community have enriched our program. Their contribution is reflected in the success of our continuing commitment to chapter development, publishing, professional practice, travelling exhibitions, research assistance, and awards programs, which depend on the active participation of our members.

Our current vitality is due, in large part, to the leadership, foresight, and eloquence of David R. Brown, our outgoing president, who, with the aid of our Board of Directors, has achieved the Institute's goal of becoming truly national.

For the publication of this book, we are indebted to James Miho, who assembled myriad images with insight and care; to the authors, Steven Heller and David R. Brown, for their analytical expertise; and to Bradbury Thompson, whose jacket design elegantly represents the field to which he has made such a profound contribution. The photographs of John Egana provide continuity and clarity. We are also indebted to Kaoru Shinzaki, Ellen McNeilly, and Paul Gottlieb for their counsel and advice.

I would like to thank the staff of the AIGA: Sophie McConnell, Associate Director; Nathan Gluck, Competitions Coordinator; Shelley Bance, Managing Editor; Allison Schacter, Membership Coordinator; and Glenngo King, Exhibitions Coordinator. Their management of our programs makes the Institute's current strength and growth an achievement in which they all share.

Caroline Hightower
Director

The American Institute of Graphic Arts

The American Institute of Graphic Arts is a national nonprofit organization of graphic design and graphic arts professionals. Founded in 1914, AIGA conducts an interrelated program of competitions, exhibitions, publications, educational and professional practice activities, and public service efforts to promote excellence in, and the advancement of, graphic design.

Members of the Institute are involved in the design and production of books, magazines, and periodicals, as well as corporate, environmental, and promotional graphics. Their contribution of specialized skills and expertise provides the foundation for the Institute's program. Through the Institute, members form an effective, informal network of professional assistance that is a resource to the profession and to the public. This has been increased with the formation of seven national chapters over the past two years. As a member of the Joint Ethics Committee, AIGA is part of a cooperative effort to uphold ethical standards in the field.

The exhibition schedule at the Institute's gallery includes our annual competitive exhibitions. Of these, the Book Show and a Communication Graphics exhibition, which incorporates Advertising, are held each year. Other exhibitions may include Illustration, Photography, Covers (bookjackets, magazines, periodicals, record albums), Insides (design of the printed page), Signage, and Packaging. The exhibitions travel nationally and internationally. Each year, the Book Show is donated to the Rare Book and Manuscript Library of Columbia University, which houses the AIGA collection of award-winning books dating back to the 1920's. Other exhibitions are sent to the Popular and Applied Graphic Arts Department of the Library of Congress.

AIGA publications include: a quarterly *Journal of Graphic Design*; a voluntary *Code of Ethics and Professional Conduct* for AIGA members; *Symbol Signs Repro Art*, a portfolio containing 50 passenger/pedestrian symbols and guidelines for their use; the guide *Graphic Design for Non-Profit Organizations*; and a *Graphic Design Education Directory*.

This year, we have undertaken a major renovation of our gallery, office space, and library. In addition, "AIGA Conference 1985 —Toward a Graphic Design Community" will be held at Massachusetts Institute of Technology in September 1985.

Contributors	Corporate Sponsors
Neale Albert	American Broadcasting Co., Inc.
Roger Black	Atlantic Richfield Co.
Diana Bryan	Avon Books
Case-Hoyt Corp.	N.W. Ayer, Inc.
Champion International Corp., Paper Division	Baldwin Paper Co.
Crafton Graphic Co., Inc.	Burson-Marsteller
Eastern Type	Carnegie-Mellon University
Milton Glaser	CBS Inc.
Peter Good	Champion International Corp.
Heritage Press	Chermayeff & Geismar Assoc., Inc.
Innovative Graphics International	Container Corporation of America
International Paper Company	Crafton Graphic Co., Inc.
Karastan Rug Division	Danne & Blackburn, Inc.
Knoll International	Digital Equipment Corporation
Mead Paper	Doubleday & Co.
Eugene Mihaesco	Dow Jones & Co.
Miho	General Foods, Inc.
Jim Myers	Group 243 Design, Inc.
The Penney & Bernstein Corp.	Herman Miller, Inc.
Rapoport Printing Co.	Holt Rinehart Winston, Inc.
Frank Riccio	Houghton Mifflin Co.
Sam Flax, Inc.	IBM Corporation
Saxon Graphics	Integrated Software Systems Corp.
Simpson Paper Company	International Typeface Corporation
Charles Slackman	Knoll International
Jeff Smith	Lehigh Press, Inc.
Southwestern Typographics	Lubalin, Burns & Co.
Jack Summerford	McGraw-Hill Book Co.
Bradbury Thompson	Mead Paper
Toppan Printing Company America, Inc.	Metropolitan Museum of Art

Mohawk Paper Mills, Inc.
Monadnock Paper Mills, Inc.
Parsons School of Design
J.C. Penney Co., Inc.
Polaroid Corporation
Random House, Inc.
Raychem Corporation
Arnold Saks, Inc.
Siegel & Gale
Simon & Schuster
Simpson Paper Company
St. Martin's Press
Takeo Co., Ltd.
Town & Country
Time, Inc.
TRW Inc.
Vignelli Associates
Western Publishing Company
Westvaco

Patrons
Cook and Shanosky Associates
Exxon Corporation

For most people outside the field, graphic design is an enigma—for some on the inside, it is a conundrum. It is an art or a craft, a profession or a trade? And does the answer ultimately matter?

The term *graphic designer* was purportedly coined in the 1920's by W.A. Dwiggins to clarify, define and elicit respect for *his* growing, new profession. That the term has become a puzzle for the semanticist proves that, in over half a century, the forms, techniques and styles, as well as the universe of graphic design, have become varied and multitudinous. Regardless, the Internal Revenue Service continues to categorize the field in an antiquated, yet humorous manner—as a "printing service"— while on the other extreme, some tempestuous young practitioners, anxious to rise above the mundane classifications, have dubbed themselves "visual communicators." Both catch-phrases are equally vague. Paul Rand is more succinct when he refers to himself as a "commercial artist," and the late Alan Hurlburt said it best when he defined graphic design as "an umbrella phrase that covers a broad range of printed and projected images [whose] three principal functions are to *persuade*, to *identify*, and to *inform*.

As major concerns of the AIGA, these functions are echoed as criteria in selecting material for the four exhibitions herein: to inform the graphic arts community of notable work and talented practitioners; to identify trends, directions and innovations where possible; and to persuade those in and out of the field that imaginative design is endemic to clear, effective communication. That this goal has been accomplished cannot be determined fully at present, since this Annual, like those published by other organizations, has both immediate and long-term ramifications. How the decisions of the juries will influence what others produce over the next year is left to be seen, and how this year's endeavor will contribute to the entire schema of design history is too distant to consider.

In the short run, no sweeping pronouncements can be drawn from these shows. In none of the categories did one particular designer or a specific style, movement or school take center stage. In fact, the only common denominator to all four is that in contrast—or probably in reaction—to the previous two years, the New Wave and Post-Modernist esthethics are less prominent, despite the many submissions representing this approach.

Rather than evoking clearcut statements about graphic design, these competitions instead raise questions about its present and future: Is there, as many jurors complained, a high level of competency that mitigates against unprofessionalism, but somehow hampers risk-taking and innovation? Is innovation, in fact, the best measure of success? Are the wants of the client supplanting the creative needs of the designer more than in the past? Is graphic design in stylistic transition? Is traditionalism returning with a vengeance?

It would be helpful if someone could handily answer these questions, someone who should, doubtless, be on the agendas of design conferences. Unlike the *fine* arts where pundits are ubiquitous, the applied graphic arts do not have similar commentators. While the history of graphic art and the legacies of those corporations and individuals who contribute to the richness of the field are intelligently documented, scholarly analysis based on a year's worth of design is not as valuable. The work itself is what matters.

Growth—in both the vocabulary and technique —is essentially the lifeblood of this field, but, unlike the youngster who returns to school noticeably matured after three months of summer vacation, development in graphic design is cumulative and takes longer to discern. While this year's exhibitions are somewhat different from last year's, it is not surprising that ever since the AIGA began issuing inclusive Annuals five years ago, only minor changes are visible in any of the continually scrutinized areas.

For now, this Annual is important as an indication of how the language of graphic design is best employed today. In the future, it will doubtless be a signpost. But most significantly, it continues to reinforce a statement about methodology, written by Leon Friend and Joseph Hefter in their 1936 edition of *Graphic Design*: "The essential factors in successful graphic expression are a knowledge of *tradition* of the craft (though not a slavish nor an academic one), a consideration of the *purpose* for which the design is intended, *imagination*, and a control of the requisite skill which will leave the artist free for self-expression."

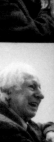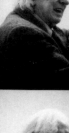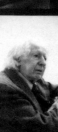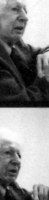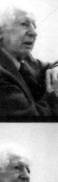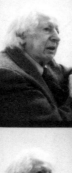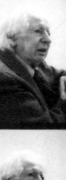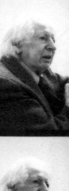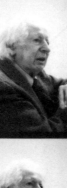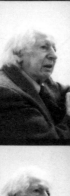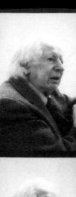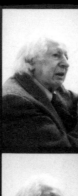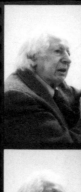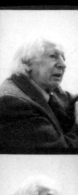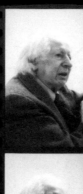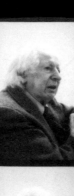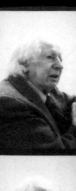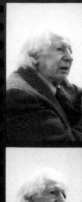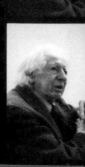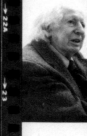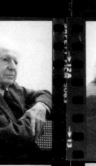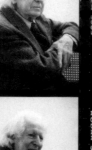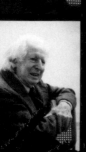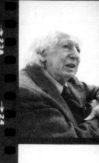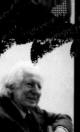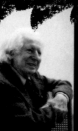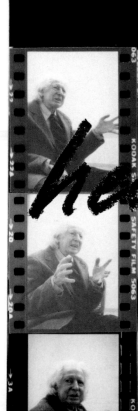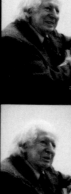

For sixty-three years, the Medal of The American Institute of Graphic Arts has been awarded to individuals in recognition of their distinguished achievements, services, or other contributions within the field of the graphic arts. Medalists are chosen by a committee, subject to approval by the Board of Directors. Past recipients have been:

Norman T.A. Munder, 1920
Daniel Berkeley Updike, 1922
John C. Agar, 1924
Stephen H. Horgan, 1924
Bruce Rogers, 1925
Burton Emmett, 1926
Timothy Cole, 1927
Frederic W. Goudy, 1927
William A. Dwiggins, 1929
Henry Watson Kent, 1930
Dard Hunter, 1931
Porter Garnett, 1932
Henry Lewis Bullen, 1934
J. Thompson Willing, 1935
Rudolph Ruzicka, 1936
William A. Kittredge, 1939
Thomas M. Cleland, 1940
Carl Purington Rollins, 1941
Edwin and Robert Grabhorn, 1942
Edward Epstean, 1944
Frederic G. Melcher, 1945
Stanley Morison, 1946
Elmer Adler, 1947
Lawrence C. Wroth, 1948
Earnest Elmo Calkins, 1950
Alfred A. Knopf, 1950
Harry L. Gage, 1951
Joseph Blumenthal, 1952
George Macy, 1953
Will Bradley, 1954
Jan Tschichold, 1954
P.J. Conkwright, 1955
Ray Nash, 1956
Dr. M.F. Agha, 1957
Ben Shahn, 1958
May Massee, 1959
Walter Paepcke, 1960
Paul A. Bennett, 1961
Willem Sandberg, 1962
Saul Steinberg, 1963
Josef Albers, 1964
Leonard Baskin, 1965
Paul Rand, 1966
Romana Javitz, 1967
Dr. Giovanni Mardersteig, 1968
Dr. Robert L. Leslie, 1969

Herbert Bayer, 1970
Will Burtin, 1971
Milton Glaser, 1972
Richard Avedon, 1973
Allen Hurlburt, 1973
Philip Johnson, 1973
Robert Rauschenberg, 1974
Bradbury Thompson, 1975
Henry Wolf, 1976
Jerome Snyder, 1976
Charles and Ray Eames, 1977
Lou Dorfsman, 1978
Ivan Chermayeff and Thomas Geismar, 1979
Herb Lubalin, 1980
Saul Bass, 1981
Massimo and Lella Vignelli, 1982
Herbert Matter, 1983

The AIGA Medalist 1983:

Herbert Matter

Chairman
Lou Dorfsman
Vice President/Creative Director
Advertising and Design
CBS, Inc.

Committee
Peter Bradford
Designer
Peter Bradford & Associates
James Cross
President/Creative Director
Cross Associates Designers
Miho
Designer
Stan Richards
Principal
The Richards Group

These photographs of Herbert Matter were taken by James Miho on March 12, 1984, the day Matter selected the illustrations for this section.

Herbert Matter

The growing archive of modern graphic design includes works by formidable practitioners who influenced styles, epitomized epochs, and left indelible marks on common perception. Such imagery as Herbert Bayer's *Bauhaus* magazine cover, E. McKnight Kauffer's poster for the *Daily Herald*, and Alexander Rodchenko's constructivist paperback covers are signposts of innovation. Due to their functional nature, however, these and other works are usually viewed as artifacts. Many should be seen and appreciated as art.

One series of examples: Herbert Matter's emblematic posters for the Swiss Tourist Office (1935–36) fit squarely into both categories. While the posters successfully communicate their immediate messages through a skillful application of photomontage, on a more lasting note, they transcend what is momentary through the integration of strong, personal expression. This expression found in all significant design is essential to Matter's work.

Herbert Matter's prodigious contribution to the development of photography and design, his lifelong prolificacy, and his teaching make it appropriate that he has been named the 1983 Medalist of The American Institute of Graphic Arts (awarded to him before he died this past May).

Most of us are aware of Matter's work, though less familiar with the photographer/designer himself. This lack of notoriety is not surprising, since Matter was exceedingly modest and unassuming. "The absence of pomposity was characteristic of this guy," says Paul Rand, a friend for three decades. While his creative life was devoted to narrowing the gap between so-called fine and applied arts, the deed is often best stated through works rather than through speech.

Matter was born in 1907 in Engelberg, a Swiss mountain village, where exposure to the treasures of one of the two finest medieval graphic art collections in Europe was unavoidable. In 1925, he attended the Ecole des Beaux-Arts in Genf, but after two years, the allure of modernism beckoned him to Paris. There, the artist attended the Academie Moderne under the tutelage of Fernand Leger and Amédée Ozenfant. While the former became a close lifelong friend, both

encouraged Matter to expand his artistic horizons.

In Europe during the late Twenties and early Thirties, the creative scope of graphic design was boundless. Journalistic, imaginative and manipulative photography were revolutionary influences, and Matter, long-enamored with the camera, began to experiment with the Rollei as both a design tool and an expressive form—a relationship that never ended. Inspired by the work of El Lissitzky and Man Ray, Matter was intrigued by photograms, as well as the magic of collage and montage —both were favored modes. In 1929, his entry into graphic design was completed when he was hired as a designer and photographer for the legendary Deberny and Piegnot concern. There he learned the nuances of fine typography, while he assisted A.M. Cassandre and Le Corbusier. In 1932, abruptly expelled from France for not having the proper papers, he returned to Switzerland to follow his own destiny.

"Herbert's background is fascinating and enviable," says Rand. "He was surrounded by good graphics and learned from the best." Therefore, it is no wonder that the famed posters designed for the Swiss Tourist Office soon after his return had the beauty and intensity of Cassandre and the geometric perfection of Corbu, wed to a very distinctive personal vision.

In 1936, Matter was offered roundtrip passage to the United States as payment for his work with a Swiss ballet troupe. He spoke no English, yet travelled across the United States. When the tour was over, he decided to remain in New York. At the urging of a friend who worked at the Museum of Modern Art, Matter went to see Alexey Brodovitch, who had been collecting the Swiss travel posters (two of which were hanging on Brodovitch's studio wall). Matter soon began taking photographs for *Harper's Bazaar* and Saks Fifth Avenue. Later, he affiliated himself with a photographic studio, "Studio Associates," located near the Conde Nast offices, where he produced covers and inside spreads for *Vogue*.

During World War II, Matter made striking posters for Container Corporation of America. In 1944, he became the design consultant at Knoll, molding its graphic identity for over 12 years. As Alvin Eisenman, head of the Design Department at Yale and long-time

friend, points out: "Herbert had a strong feeling for minute details, and this was exemplified by the distinguished typography he did for the Knoll catalogues."

In 1952, he was asked by Eisenman to join the Yale faculty as professor of photography and graphic design. "He was a marvelous teacher," says Eisenman. "His roster of students included some of the most important names in the field today." At Yale, he tried his hand at architecture, designing studio space in buildings designed by Louis Kahn and Paul Rudolf. "He was good at everything he tried to do," continues Eisenman. In 1954, he was commissioned to create the corporate identity for the New Haven Railroad. The ubiquitous "NH" logo, with its elongated serifs, was one of the most identifiable symbols in America.

Affinity for modern, avant-garde and nonobjective art was always evident, not only in Matter's own work, but in his closest friendships. In 1944, he was asked by the Museum of Modern Art to direct a movie on the sculpture of his intimate friend and neighbor, Alexander Calder. It was his first cinematic attempt, yet because of the sympathetic and deep understanding that only one kindred artist can have for another, the completed film was one of the finest in its genre. From 1958 to 1968, he was the design consultant for the Guggenheim Museum, applying his elegant typographic style to its posters and catalogues—many of which are still in print. He worked in Gertrude Vanderbilt Whitney's former studio in McDougal Alley with his wife, Mercedes Matter, who founded the famed Studio School just around the corner. During the late Fifties and early Sixties, he was an intimate participant in the New York art scene, counting Jackson Pollock, Willem de Kooning, Franz Kline, and Philip Guston as friends and confidants. In 1960, he started photographing the sculpture of Alberto Giacometti, another spiritual intimate, for a comprehensive, as yet unpublished book, a project on which Matter worked for 25 years. In 1978, he had a major exhibition of photographs at the Kunsthaus in Zurich; he received a Guggenheim Foundation Fellowship for photography in 1980. The Marlborough Gallery continues to handle Matter's photographic work.

In many ways and for many years, Matter's friends and students have praised his aims and motives, his work and career, but it was Paul Rand, in his introductory "Poem" for a 1977 Yale exhibition catalogue, who best describes the AIGA Medalist—with the same clarity, brevity and strength as a Matter poster:

Herbert Matter is a magician.
To satisfy the needs of industry, that's what you have to be.
Industry is a tough taskmaster.
Art is tougher.
Industry plus Art, almost impossible.
Some artists have done the impossible.
Herbert Matter, for example.
His work of '32 could have been done in '72, or even '82.
It has that timeless, unerring quality one recognizes instinctively.
It speaks to all tongues, with one tongue.
It is uncomplicated, to the point, familiar, and yet unexpected.
Something brought to light, an image, a surprise, an analogy.
It is believable, as it is unbelievable.
It always has an idea, the one you almost thought of.
It may be formal or anecdotal, full of sentiment, but not sentimental,
It is commercial; it is contemplative.
It enhances the quality of life.
It is Art.

The illustrations in this section were selected by Herbert Matter before his death in May, 1984. We are grateful to those individuals who helped research the titles for this section, and regret that some works remain untitled.

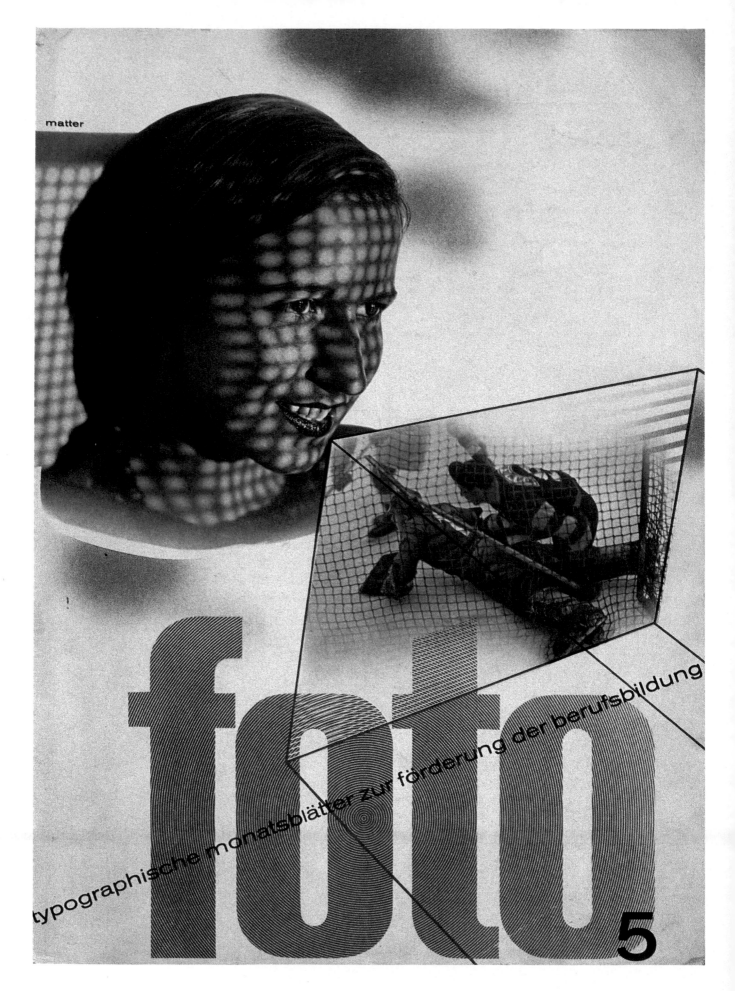

Die Farbigkeit in der Zeichnung ist die Parallele zur Tonart in der Musik.
Das Spielerische in Linie und Kolorit ist Improvisation des Graphikers und Druckers.
Alles Neue wirkt anfänglich befremdend und alles Gewöhnliche überhaupt nicht mehr.
Drucker, die nicht den Mut aufbringen, neue Wege zu gehen, sind schlechte Berater.

Brochure:
Swiss National
Tourist Office
1935

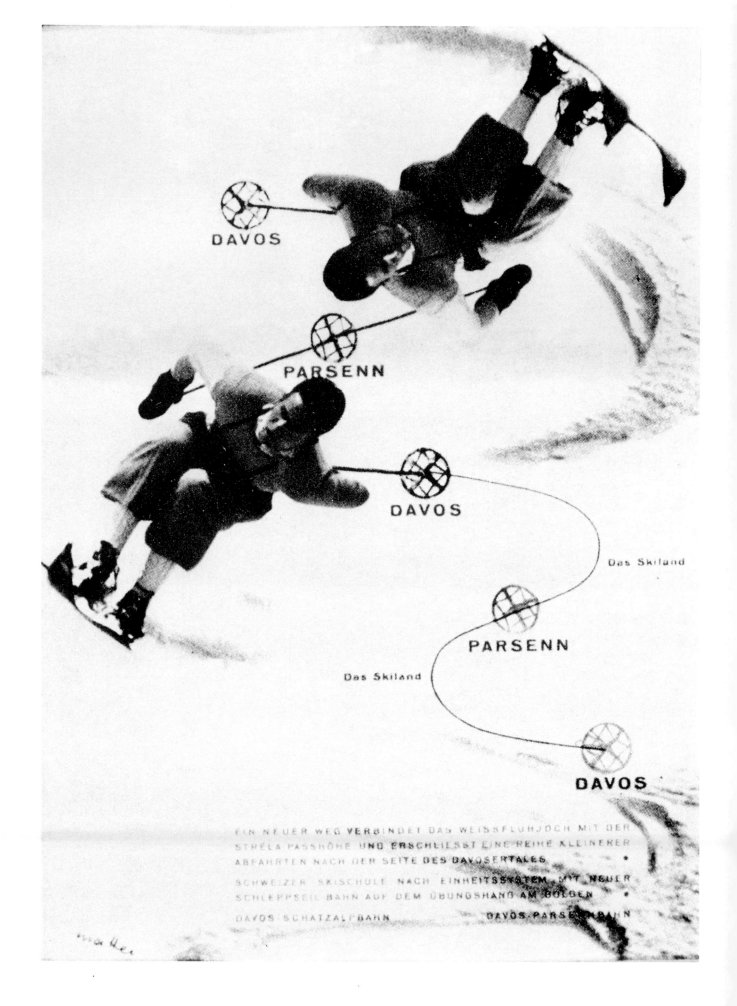

DAVOS

PARSENN

DAVOS

Das Skiland

PARSENN

Das Skiland

DAVOS

EIN NEUER WEG VERBINDET DAS WEISSFLUHJOCH MIT DER
STRELA PASSHÖHE UND ERSCHLIESST EINE REIHE KLEINERER
ABFAHRTEN NACH DER SEITE DES DAVOSERTALES

SCHWEIZER SKISCHULE NACH EINHEITSSYSTEM MIT NEUER
SCHLEPPSEILBAHN AUF DEM ÜBUNGSHANG AM BOLGEN

DAVOS SCHATZALPBAHN DAVOS PARSENNBAHN

Schweizer Skischule

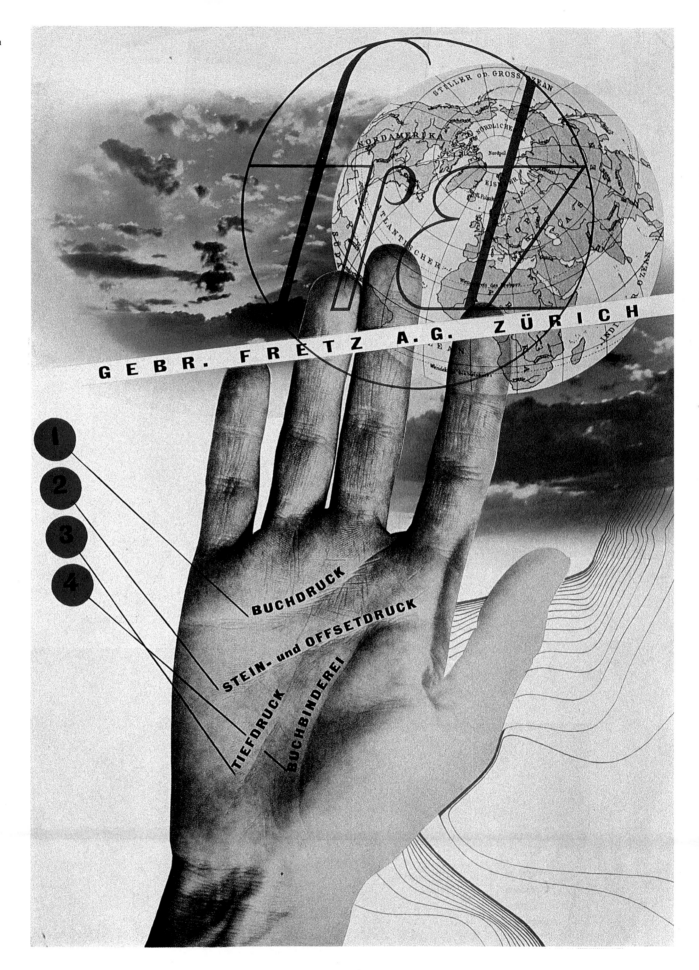

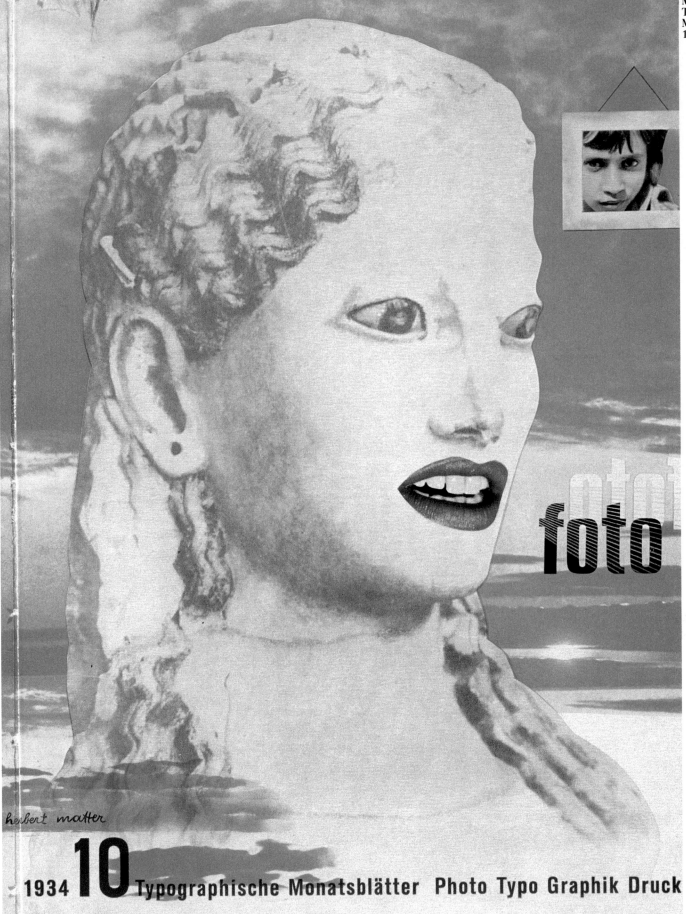

herbert matter

1934 10 Typographische Monatsblätter Photo Typo Graphik Druck

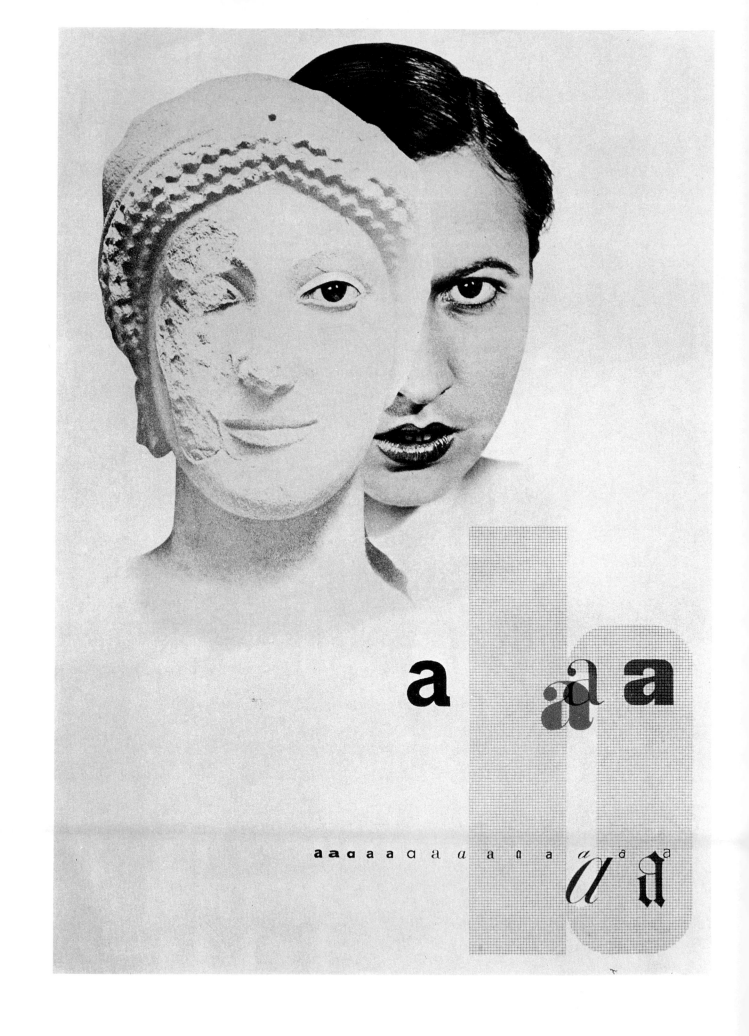

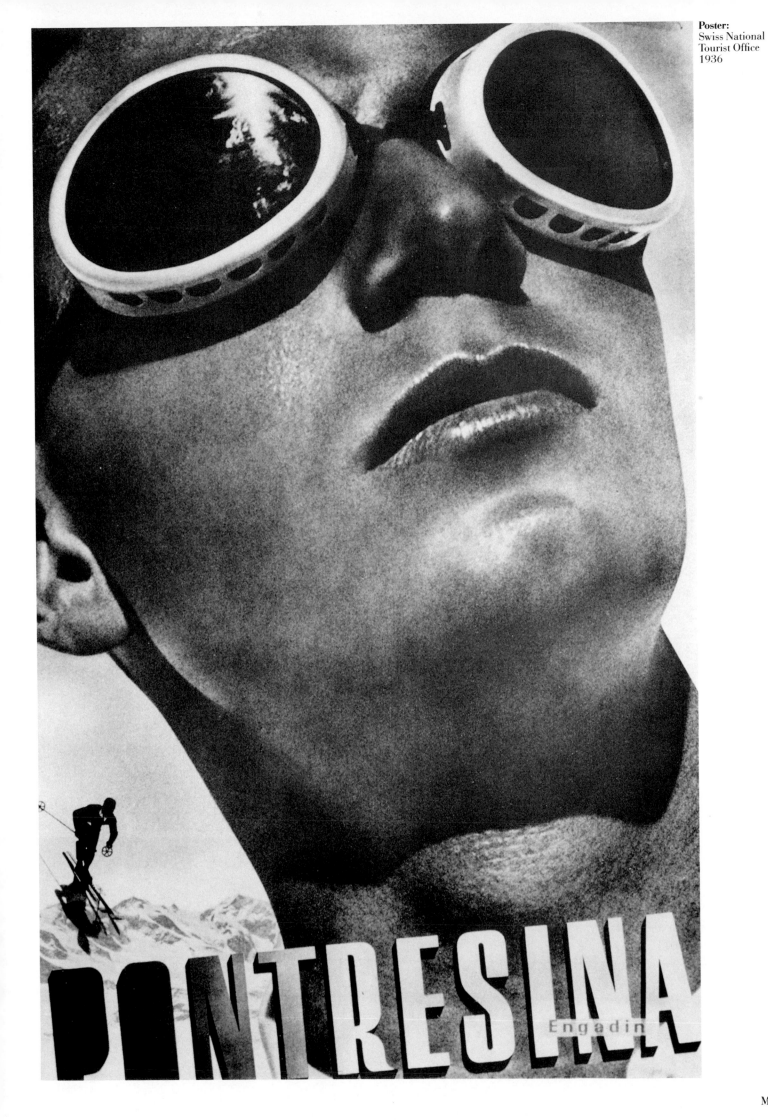

Poster:
Swiss National
Tourist Office
1936

PONTRESINA

Engadin

Poster:
Swiss National
Tourist Office
1934

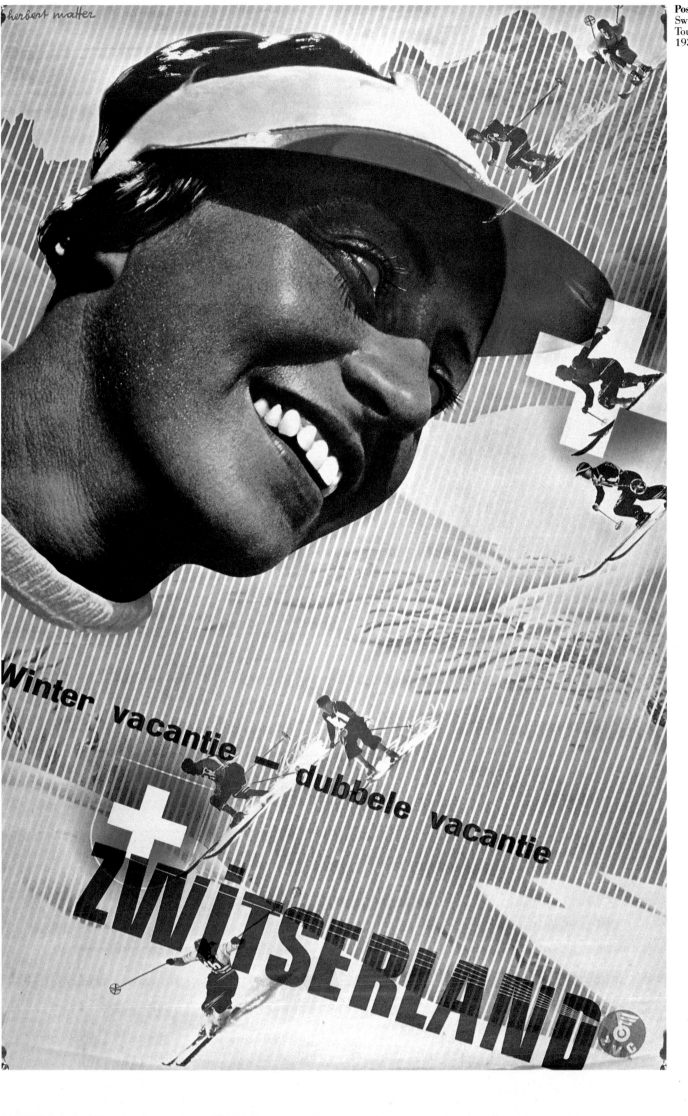

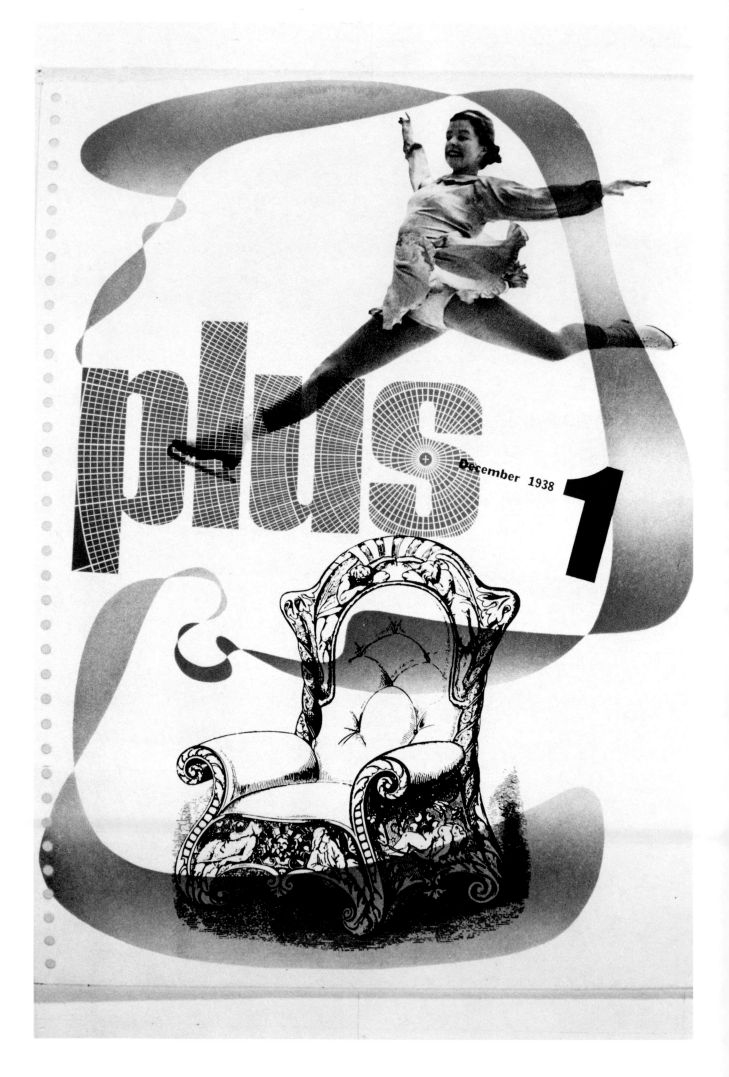

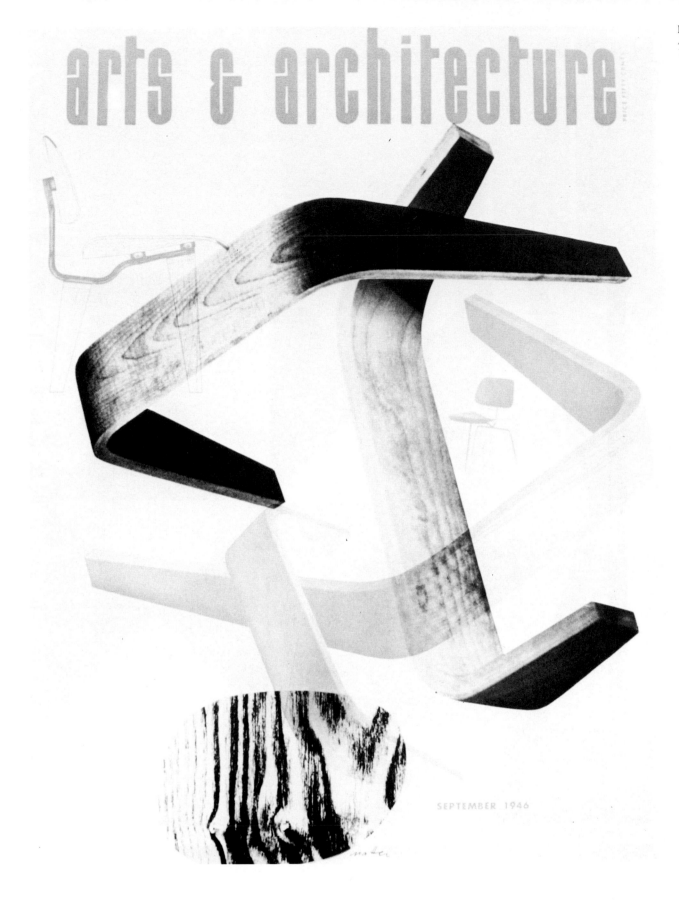

arts & architecture

SEPTEMBER 1946

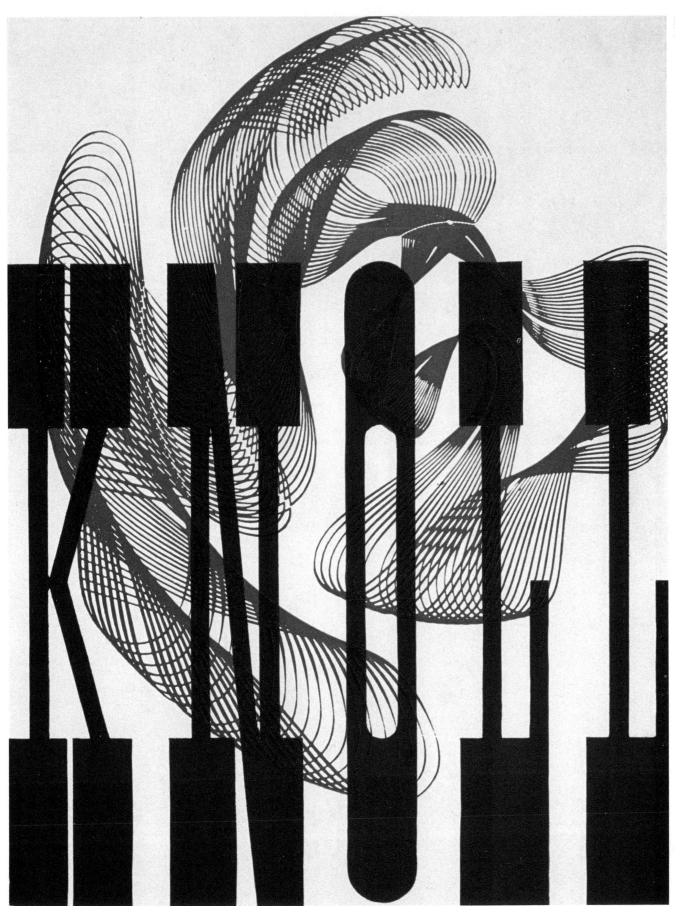

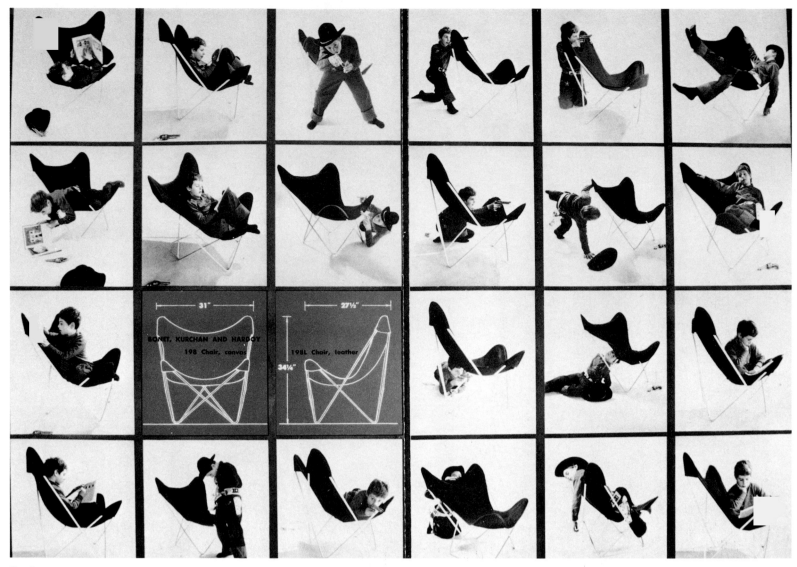

Brochure:
Knoll Assoc., Inc.
1951

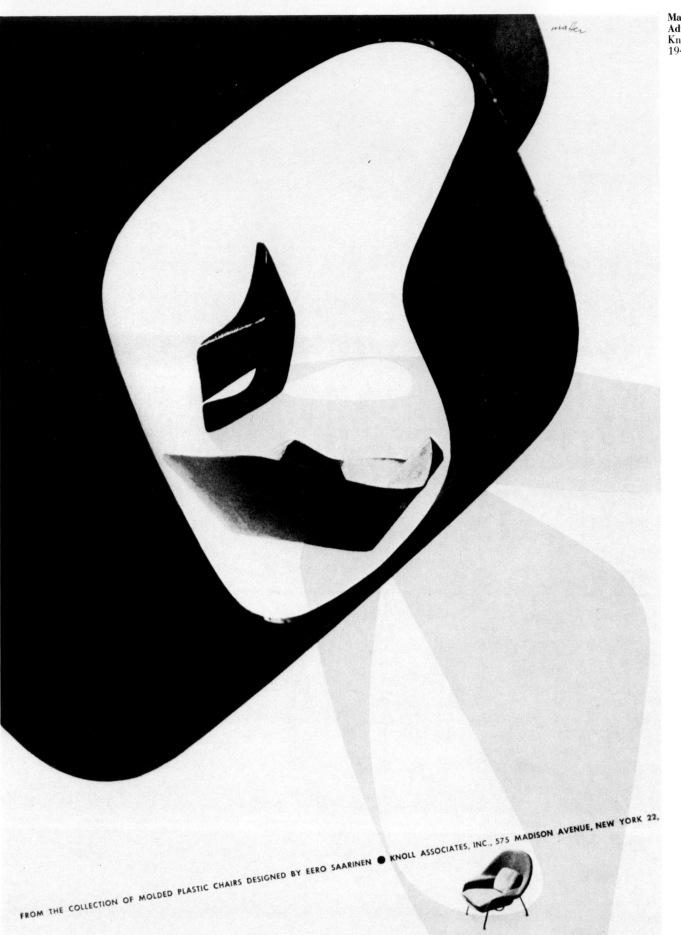

matter

FROM THE COLLECTION OF MOLDED PLASTIC CHAIRS DESIGNED BY EERO SAARINEN ● KNOLL ASSOCIATES, INC., 575 MADISON AVENUE, NEW YORK 22.

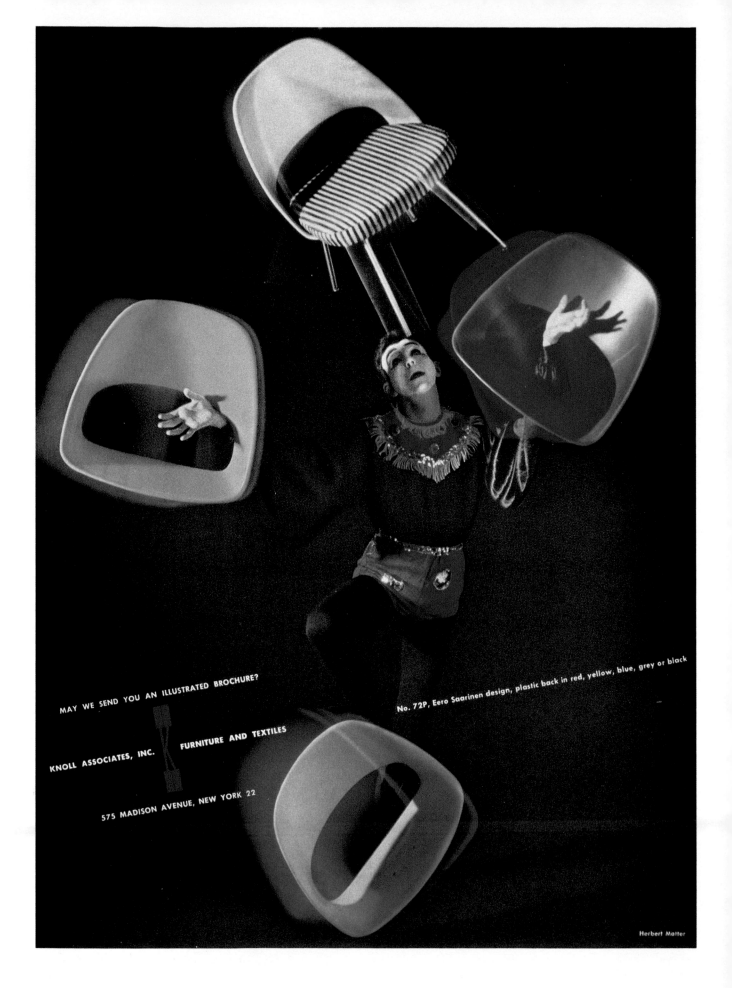

MAY WE SEND YOU AN ILLUSTRATED BROCHURE?

No. 72P, Eero Saarinen design, plastic back in red, yellow, blue, grey or black

KNOLL ASSOCIATES, INC. FURNITURE AND TEXTILES

575 MADISON AVENUE, NEW YORK 22

Herbert Matter

FOR MORE INFORMATION ASK KNOLL

KNOLL ASSOCIATES, INC.　FURNITURE AND TEXTILES

No. 70 Chair Eero Saarinen Design

575 MADISON AVENUE, NEW YORK 22

TRANSPORTATION CLOTH,
new fabric of unsurpassed strength
from the world-wide Knoll collection.
Designed to correlate with the total
architectural scheme...engineered
to meet every specification for
durability and economy.

KNOLL ASSOCIATES, INC. • 575 Madison Avenue, New York 22, N. Y.

Knoll Furniture
Knoll Fabrics
Knoll Planning Unit

As rugged as "Rugby"

An important new advance in
upholstery textile durability.
Exclusive Knoll development in
wool, nylon and cotton
that has extraordinary strength.
Available in a range of seven
exciting two-toned color
combinations.
Write for K200 "Rugby" swatches.

KNOLL TEXTILES INC., 575 MADISON AVE., NEW YORK • BOSTON, CHICAGO, DALLAS, DETROIT, MIAMI, WASHINGTON

Magazine
Advertisement:
(Consecutive Pages)
Knoll Assoc., Inc.
1956

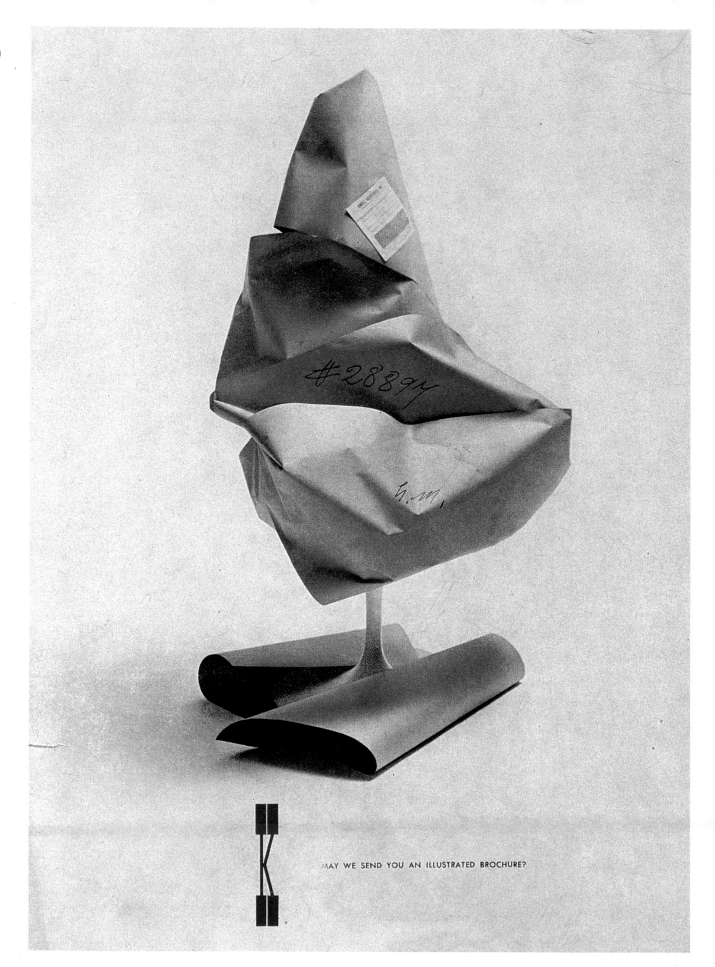

MAY WE SEND YOU AN ILLUSTRATED BROCHURE?

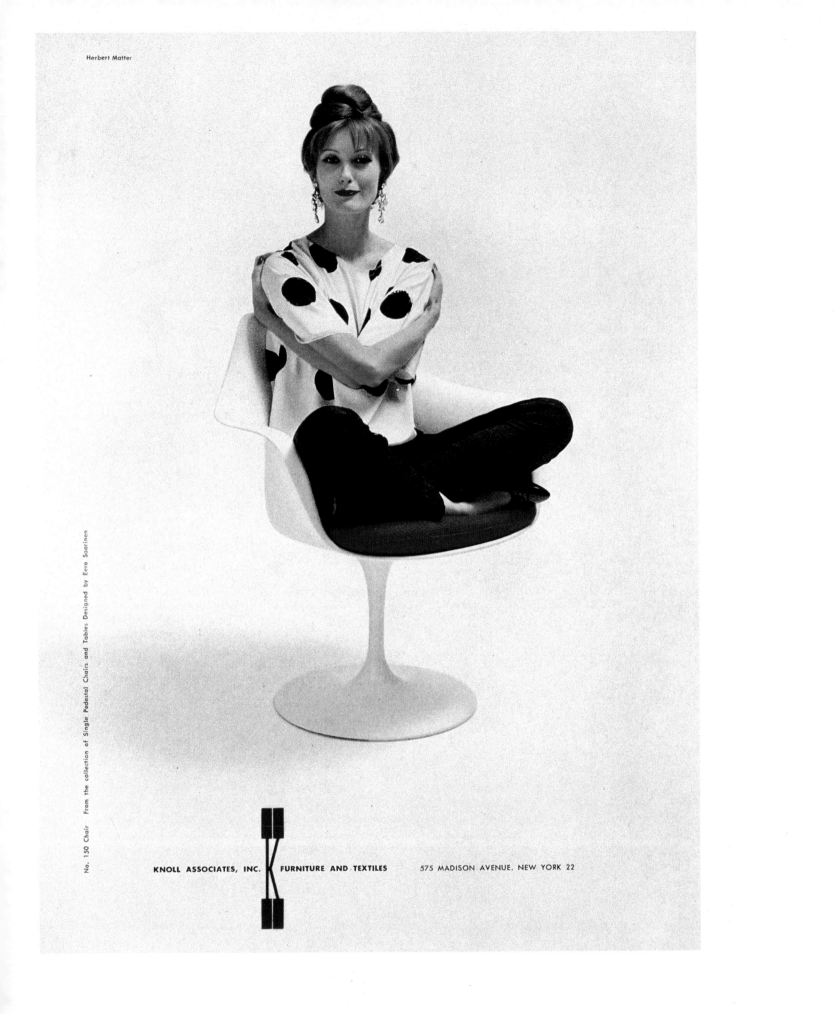

Herbert Matter

No. 150 Chair From the collection of Single Pedestal Chairs and Tables Designed by Eero Saarinen

KNOLL ASSOCIATES, INC. FURNITURE AND TEXTILES 575 MADISON AVENUE, NEW YORK 22

WORLD'S
sheerest
STOCKING

This is it, and no chemist will dispute it. It's Du Pont's new
12-denier nylon—and that's to the 15-denier stocking what the
15-denier stocking was to the heavy 30- and 40-denier yarns of before the war.
(Proof: you're looking through four layers of stocking here.)
How will it wear? It's not for longer wear, but for more beautiful wear
—the point of a 12-denier nylon is looks, is luxury.
When will it be available to women? In the next month, at the latest;
at this writing, the filaments are en route to the looms.

HERBERT MATTER

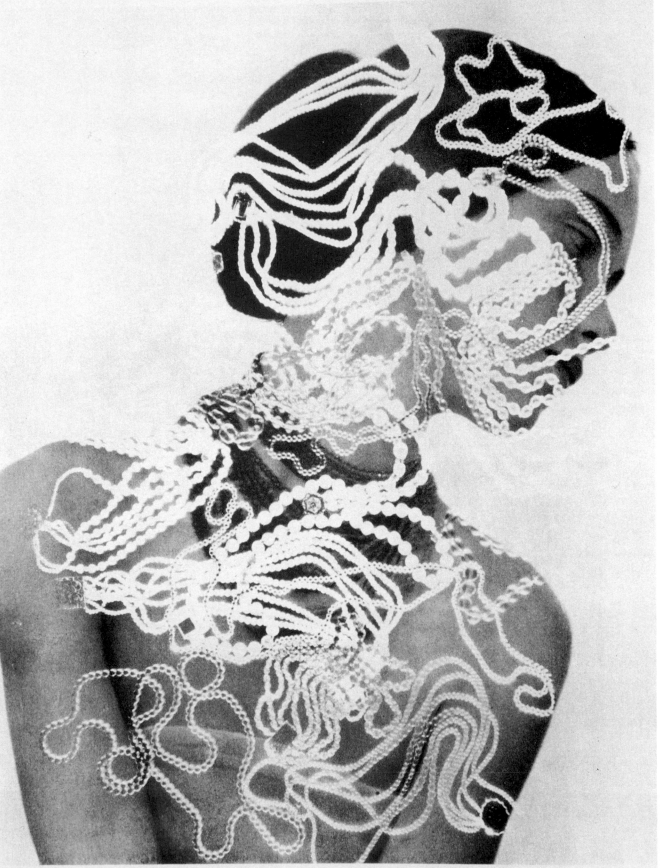

Porträt mit Schmuck, 1947

Rechts: Lichtzeichnung der Bewegungen
eines sich ankleidenden Mannes, 1944

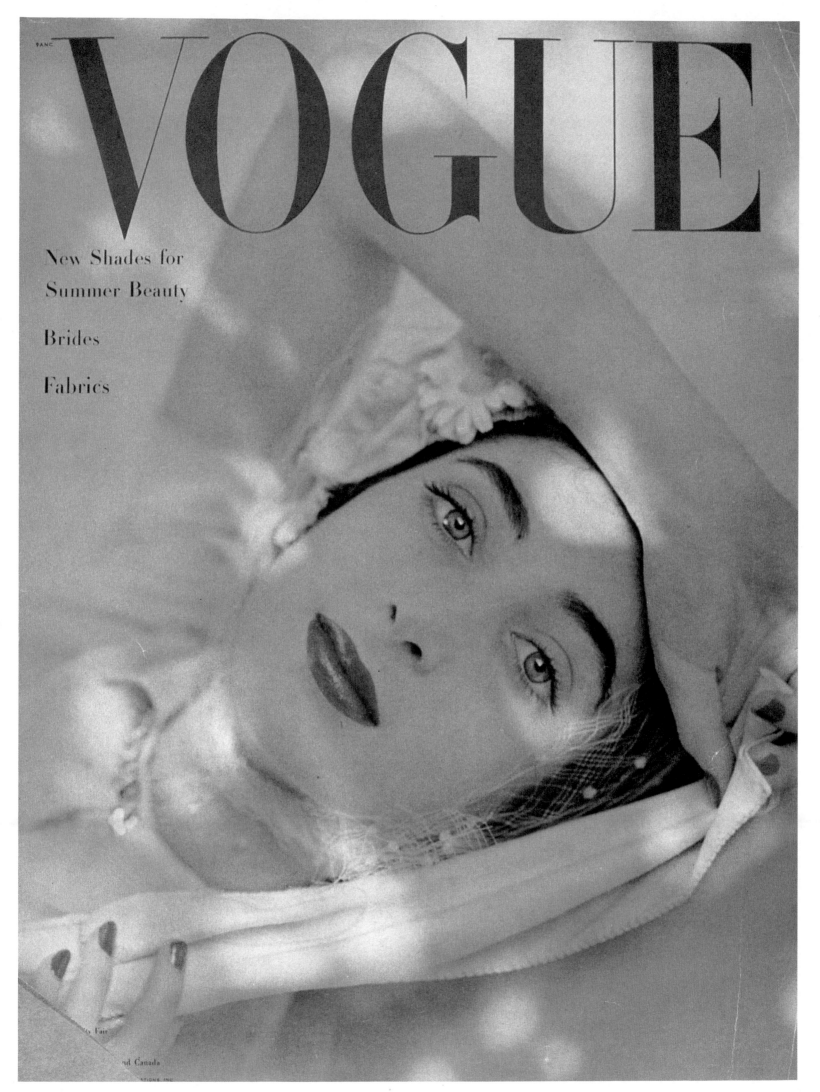

VOGUE

New Shades for
Summer Beauty

Brides

Fabrics

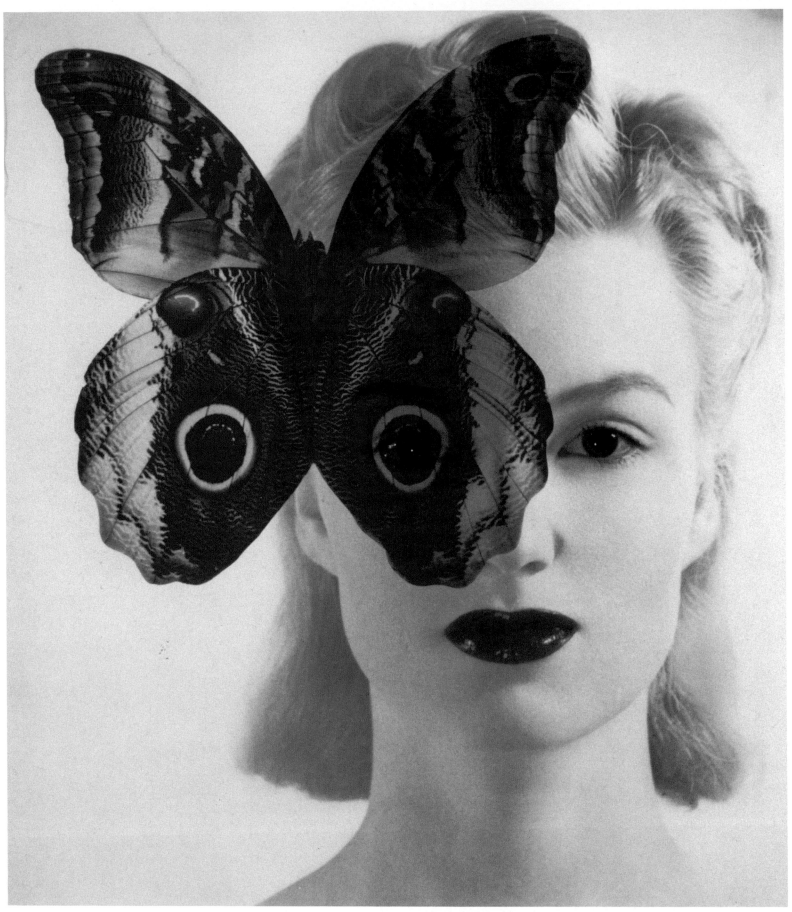

Editorial Photograph

Magazine Cover:
Vogue

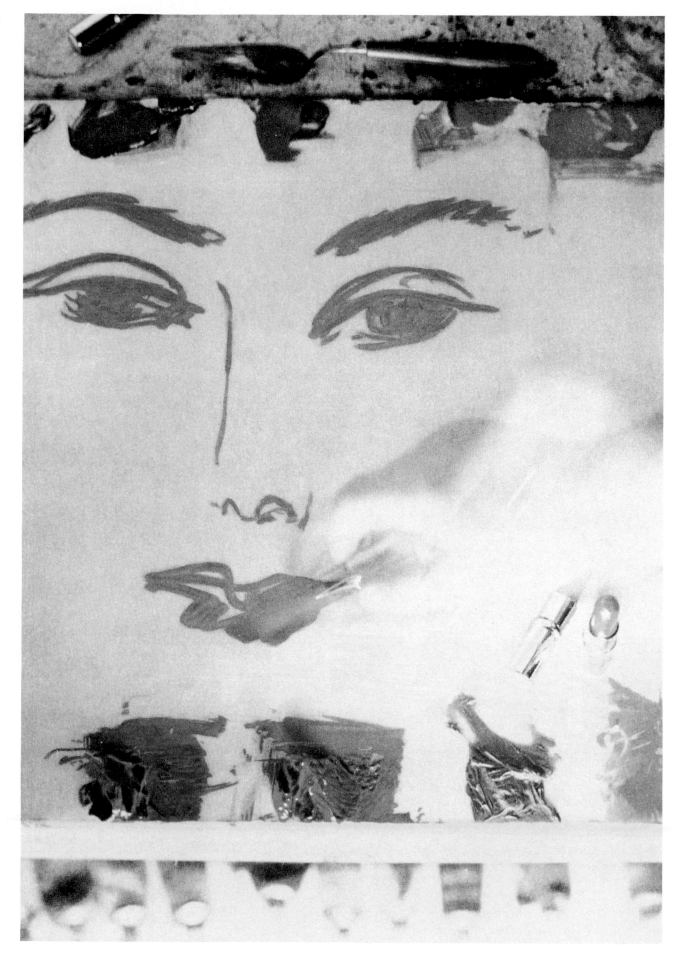

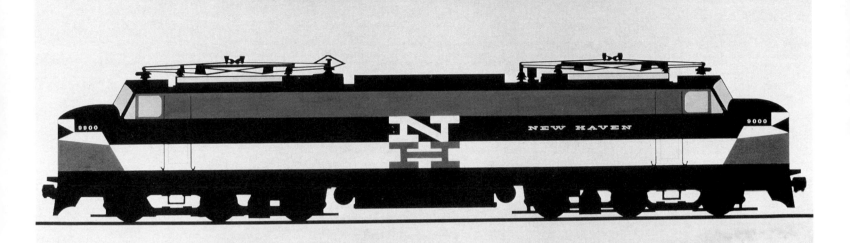

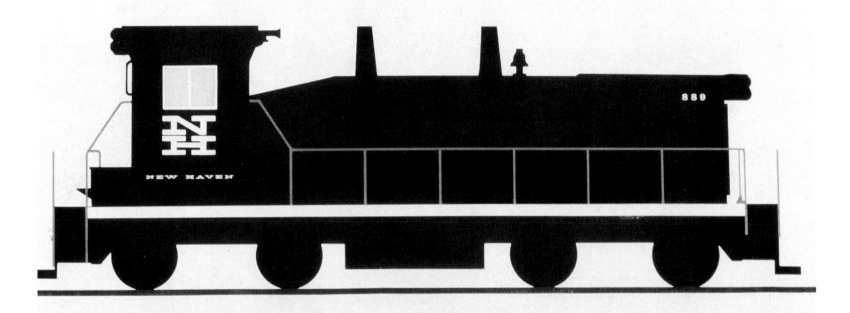

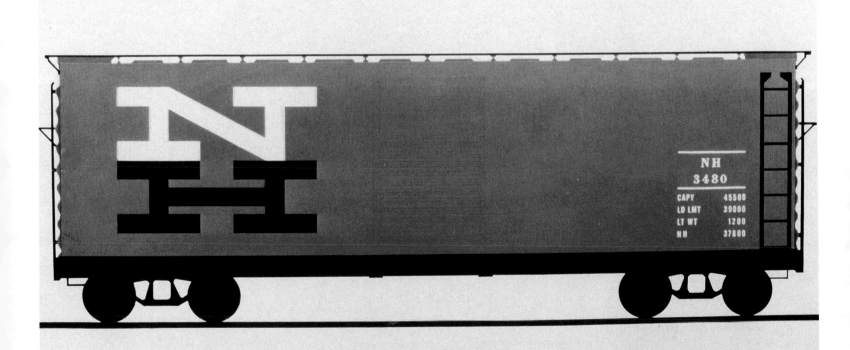

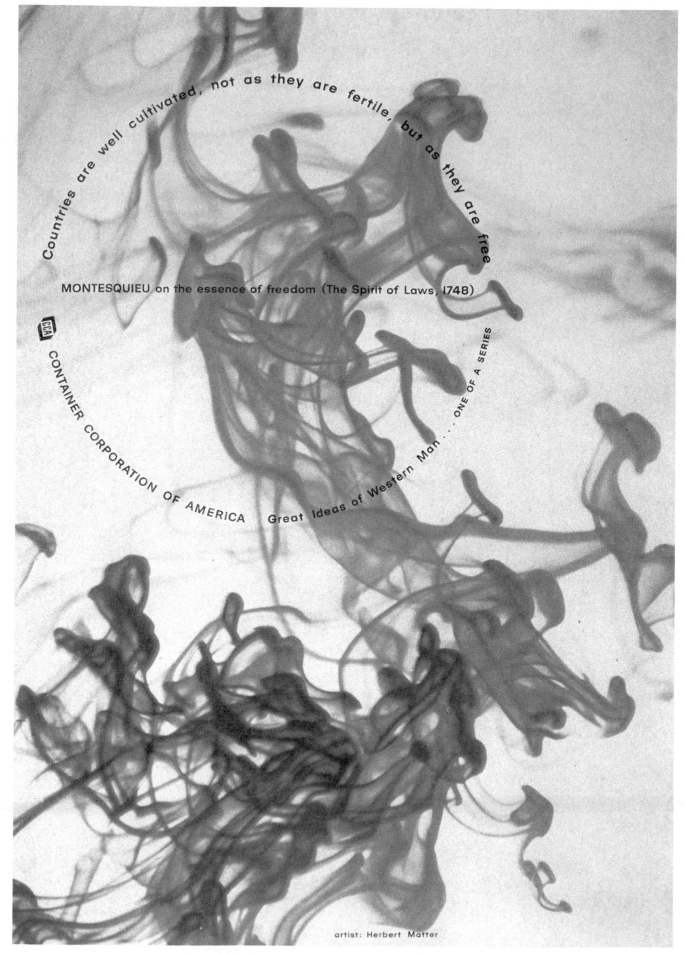

Countries are well cultivated, not as they are fertile, but as they are free

MONTESQUIEU on the essence of freedom (The Spirit of Laws, 1748)

CONTAINER CORPORATION OF AMERICA Great Ideas of Western Man ... ONE OF A SERIES

artist: Herbert Matter

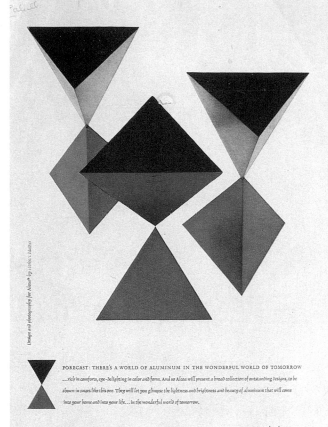

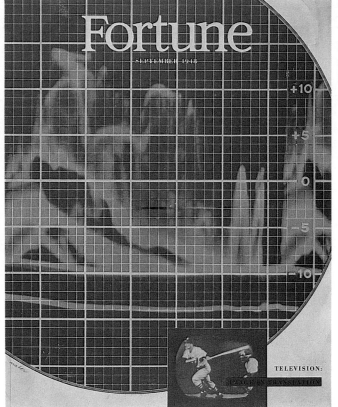

**Magazine
Advertisement:**
Alcoa

**Magazine
Advertisement:**
Fortune
September, 1948

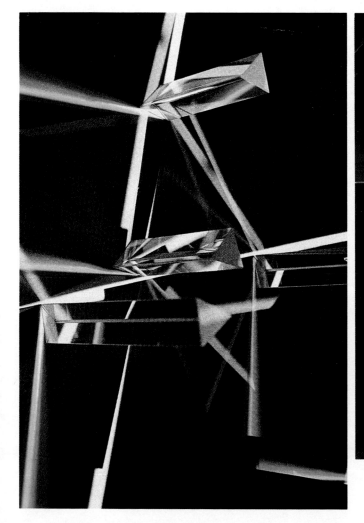

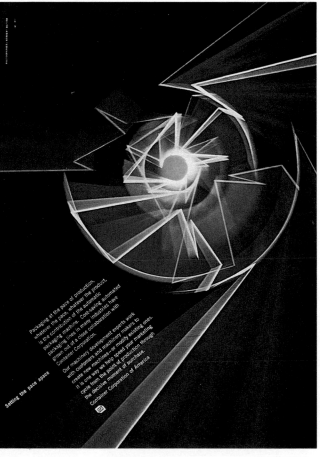

Photograph

**Magazine
Advertisement:**
Container Corporation
of America
1962

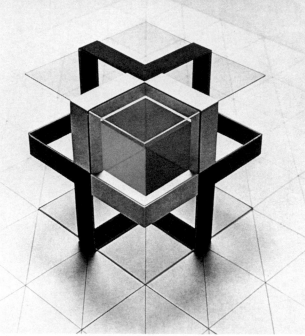

FOR INNOVATION ACTION CCA

New product, or renewed product, the excitement of a
new idea should be conveyed by its package. CCA
programs materials, structure, color, research and design—
along with the human factor—into innovation. For newness
that is more than merely new, action/CCA.
CONTAINER CORPORATION OF AMERICA
38 South Dearborn, Chicago 3

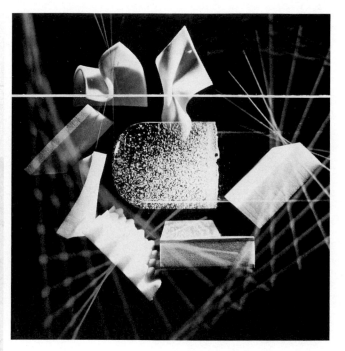

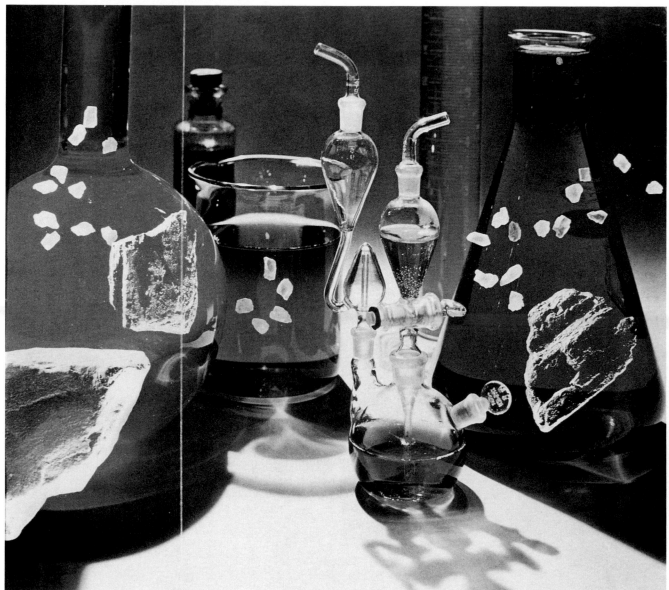

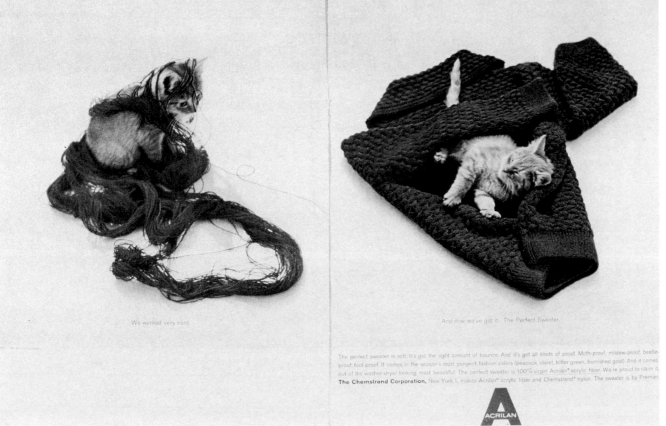

We worked very hard.

And now we've got it. The Perfect Sweater.

The perfect sweater is soft. It's got the right amount of bounce. And it's got all kinds of proof. Moth-proof, mildew-proof, beetle-proof, fool-proof. It comes in the season's most pungent fashion colors (peacock, claret, bitter green, burnished gold). And it comes out of the washer-dryer looking most beautiful. The perfect sweater is 100% virgin Acrilan® acrylic fiber. We're proud to claim it. **The Chemstrand Corporation,** New York 1, makes Acrilan® acrylic fiber and Chemstrand® nylon. The sweater is by Premier.

ACRILAN

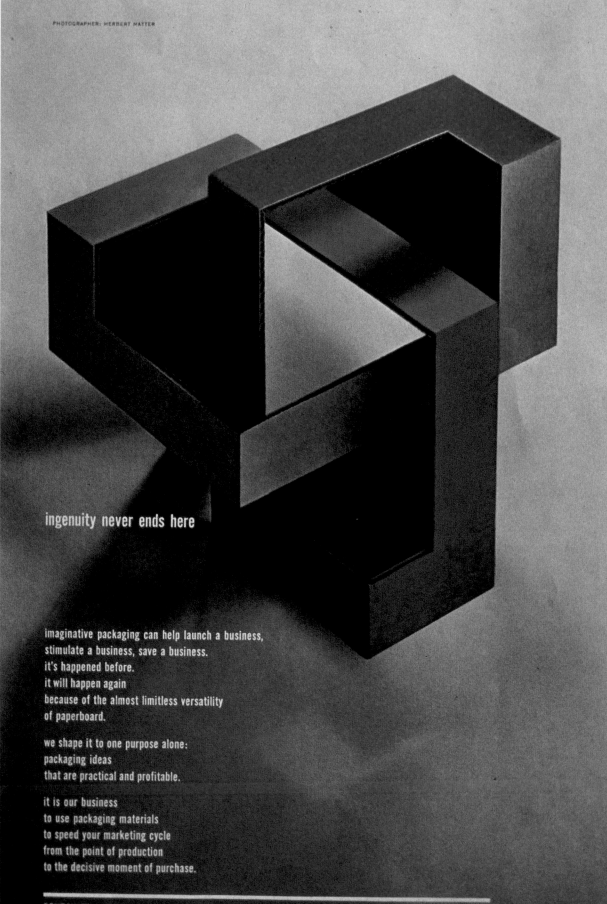

ingenuity never ends here

imaginative packaging can help launch a business,
stimulate a business, save a business.
it's happened before.
it will happen again
because of the almost limitless versatility
of paperboard.

we shape it to one purpose alone:
packaging ideas
that are practical and profitable.

it is our business
to use packaging materials
to speed your marketing cycle
from the point of production
to the decisive moment of purchase.

CONTAINER CORPORATION OF AMERICA

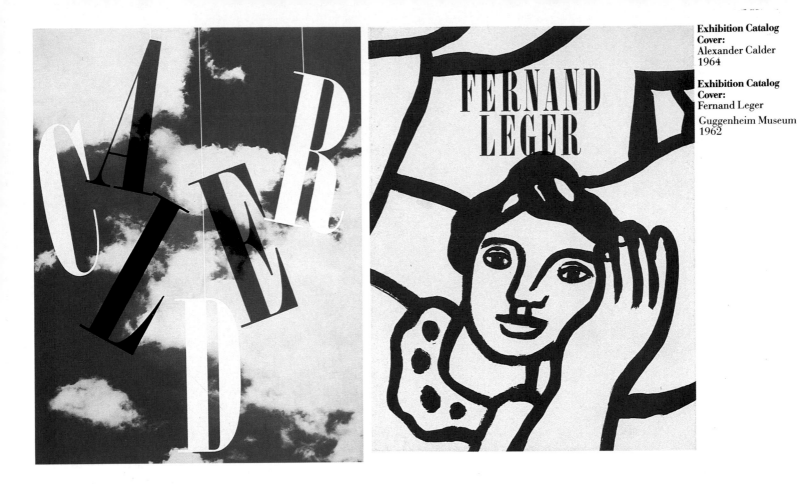

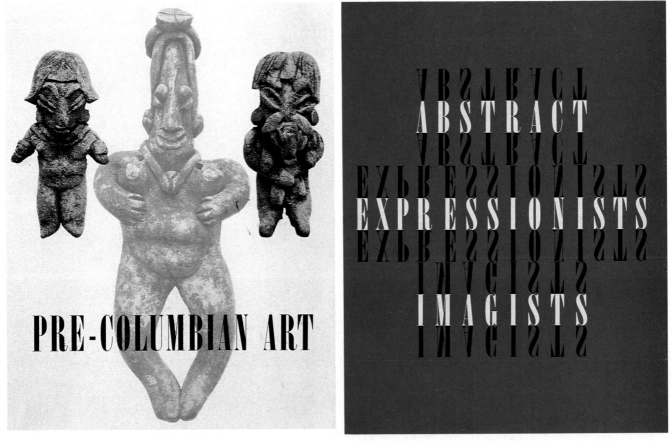

PRE-COLUMBIAN ART

ABSTRACT
EXPRESSIONISTS
IMAGISTS

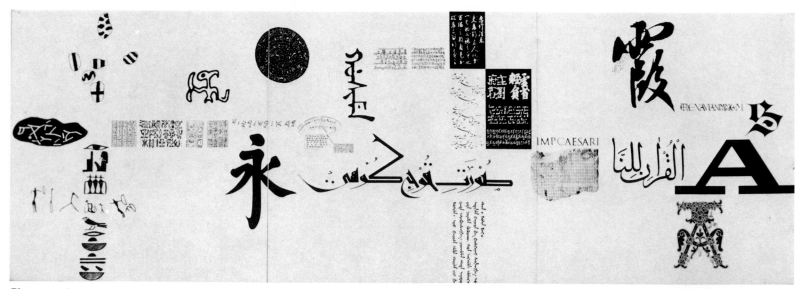

Photo-mural:
History of the
Alphabet

Photo-mural

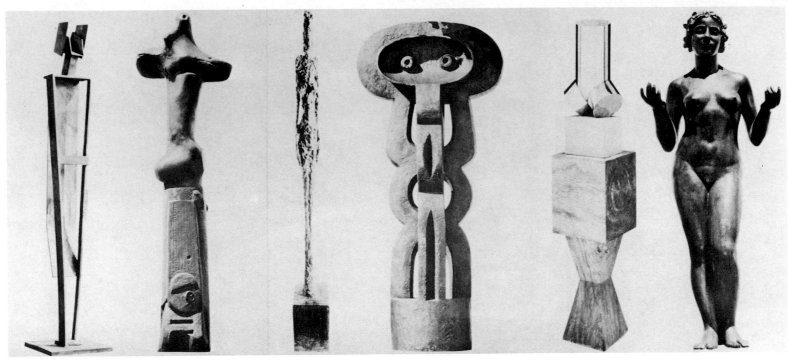

Title Unknown

Mural:
Headquarters, Seagram
Distillers Co.
New York

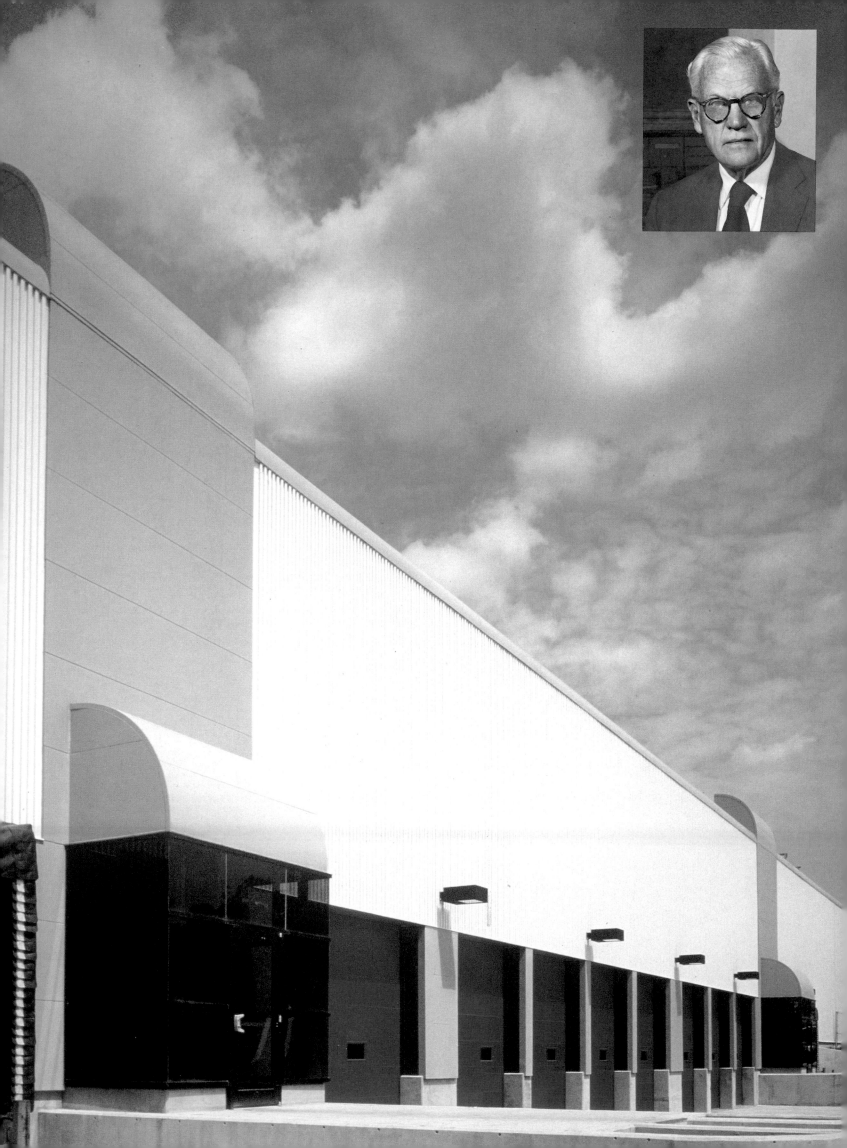

The AIGA Design Leadership Award

The Design Leadership Award of The American Institute of Graphic Arts has been established to recognize the role of the perceptive and forward-thinking client who has been instrumental in the advancement of design by application of the highest standards, as a matter of policy, to all its visual communications. Recipients are chosen by a committee, subject to approval by the Board of Directors. Past recipients have been:

IBM Corporation, 1980
Massachusetts Institute of Technology, 1981
Container Corporation of America, 1982

The AIGA Design Leadership Award 1983:
Cummins Engine Company, Inc.

Chairman:
Gordon Bowman
Director
Corporate Creative Programs
United Technologies

Committee
Rudolph deHarak
President
Rudolph deHarak & Associates
Katherine McCoy
Principal
McCoy & McCoy
Bob Paganucci
Principal
Paganucci & Salpeter
Ken Resen
Principal
Page, Arbitrio & Resen
George Tscherny
Designer

J. Irwin Miller
Chairman of the
Executive and Finance
Committee

Manufacturing Plant:
Consolidated Diesel
Company
Rocky Mount, NC
1983
Architects:
CRS

Cummins Engine Company, Inc.

Among truck manufacturers, truck drivers, mechanics, and heavy equipment makers and operators, Cummins Engine Company is best known for the quality of the diesel engines that power their rigs. Among architects and students of architecture, Cummins is best known as a patron of design excellence unique in the world of business. And among those who think about the proper role of a business enterprise in a complex and changing American society, Cummins is highly regarded for its clear-eyed commitments to the arts and to the towns where its people live and work. Less famous, perhaps, but not at all surprising, has been Cummins' performance in graphic and industrial design: quiet, workmanlike, utterly dependable—like Cummins engines.

Cummins Engine Company was started in 1919 by W. G. Irwin, a banker, and Clessie L. Cummins, Irwin's chauffeur. The company reports its first few years as having been "difficult" ones, until Irwin's great nephew, J. Irwin Miller, only a year out of college, joined the fledgling firm. While Cummins Engine didn't vault into the top rank of American business, neither did it continue to founder. A process began of slow, but steady improvements, evolutionary engineering development, constant adjustment, and line extension in the diesel engine business. Today, Cummins makes about 100 different models of diesels, with from four to 16 cylinders, ranging in size from 50 to 1800 horsepower. About half of all the heavy-duty, on-highway trucks (the "18-wheelers") in North America are powered by Cummins diesel engines, as is an impressive array of off-highway equipment. (Cummins annual reports usually contain photographs of the ways in which its engines are used. They range from Mexican buses to log skidders, from turbochargers for Indy "500" race cars to the "Circle Line" boats that ferry tourists to the Statue of Liberty and around Manhattan Island.) Although a modest corporate giant—$1.6 billion in annual sales and roughly 18,500 employees —Cummins is big in its business, and has earned more than money in its 65 years. It has also earned a leadership position among American businesses for its commitment to design, architecture, the arts, and its own communities.

Upon your approach, Columbus, Indiana looks very much like any small Midwestern city-town, with the familiar strip of gas stations, fast food outlets, and used car lots. But once inside the necklace of kitsch, Columbus reveals itself to be unique and quite extraordinary in its architecture. Here, a church by Eliel Saarinen; there, another church, by son Eero. Banks by Harry Weese and Kevin Roche. Schools by Harry Weese, John Carl Warnecke, Edward Larrabee Barnes, Eliot Noyes, Hardy Holzman Pfeiffer, Mitchell Giurgola, Richard Meier. A library by I. M. Pei, a fire station by Robert Venturi, a post office by Kevin Roche, a town center by Cesar Pelli, "public" sculpture by Henry Moore and Jean Tinguely. Not to mention a magnificent job of renovation and preservation of late 19th and early 20th century buildings that allowed Columbus to lay early claim to architecture of distinction.

What went on in Columbus was (and is) the manifestation of a company's (and its chief executive's) commitment to its home, and to the larger idea that it had another role equal in importance to that of provider of jobs and payer of taxes. Quite simply, what the company said was that design was important. Important enough so that it would pay the fees if the townspeople would choose distinguished architects to design their public buildings. It was an offer Columbus couldn't refuse, and hasn't for almost 30 years.

At about the same time, Cummins retained the services of Paul Rand and Eliot Noyes. The Cummins company magazine, in one of a series of historical articles entitled "The Way We Were," rather self-effacingly attributes this decision to its admiration for IBM: "Part of the image [IBM's] was the sharp business-look of its employees, the graphics of its advertising and the appearance of its products."

Rand designed the Cummins mark—one of the very strongest marks in use today— and the system for its application. Rand also designs the company's annual reports (which are models of elegant, simple, straightforward economy) and other major publications. Other top-flight designers— Rudolph deHarak, Alexander Girard, Dan Kiley, and Saul Bass, for example—also have been engaged for various assignments and projects.

Noyes began a strong tradition in product design, carried on today by a solid internal design group complemented by consultants such as Emilio Ambasz. Noyes also guided much of Cummins' interior design, both in the office and administrative areas and on the plant floor. Between Noyes and Rand, Cummins' course in graphic and industrial design was charted and, through the next decades, the company held to the course.

As with two previous AIGA Design Leadership Award recipients, what the man at the top felt about design had everything to do with how his company performed. Like Watson (IBM) and Paepcke (Container Corporation of America), J. Irwin Miller cares, and he cares for a particularly down-to-earth reason.

Accepting the Tiffany Design Award in 1971, he said: "Design at its best is an exercise in honesty and imagination—not in prettiness. [It] is quite simply the very best that an honest and creative person has in him to do." In 1980, addressing the American Institute of Architects, Miller reminded that audience: "Your second client is not the critic . . . Nor is it the esteem of your peers. Your second client is *yourself*. Only you in your conscience know whether each of your works is the best you can truly do. The only judge of success is your own honest self-appraisal."

The integrity of the design process—and the worth of the individual effort—plus respect for those who must live with its results, are the reasons why design matters at Cummins. It's like Cummins' fine diesel engines: the evolution of true beauty as function became form, from the inside out.

What Paul Rand wrote about the motivation behind design describes Miller and Cummins perfectly: "[design is] art in the service of business, art which enhances the quality of life and deepens appreciation of the familiar world."

Few have been as true to this spirit of design as Cummins Engine Company.

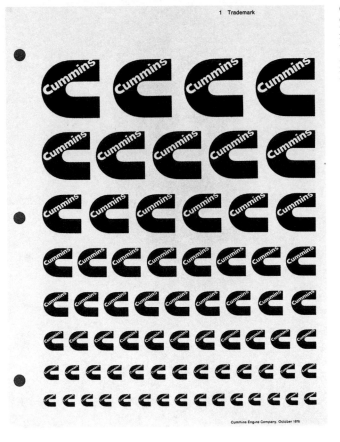

1 Trademark

Cummins Engine Company, October 1975

Corporate Identity:
Cummins Graphic
Design Standards
Manual
1976
Designer:
Paul Rand

Annual Report:
1979
Designer:
Paul Rand

Annual Report:
1976
Designer:
Paul Rand

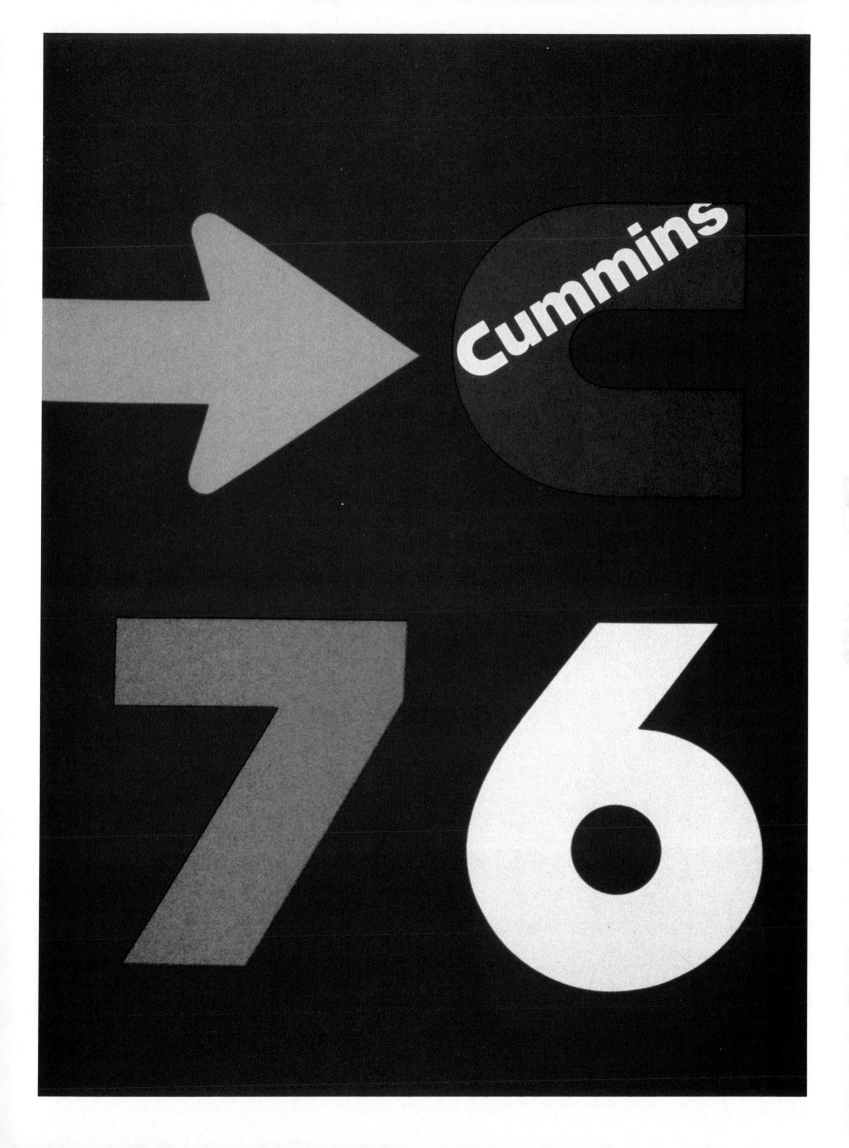

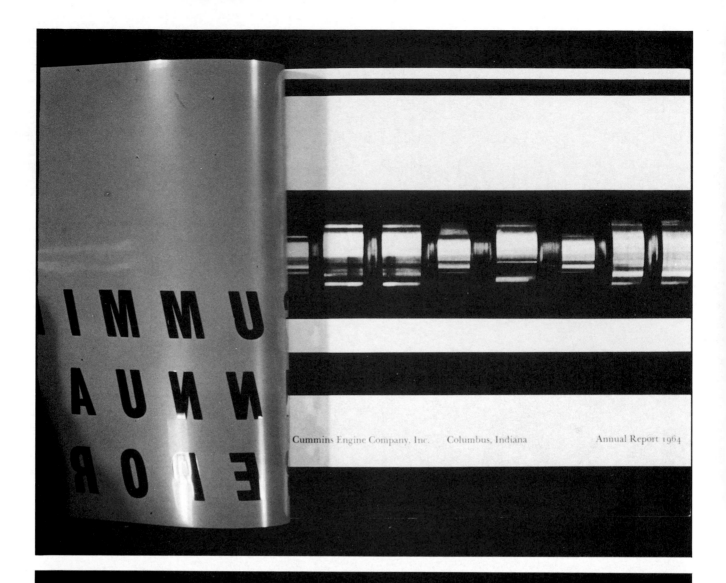

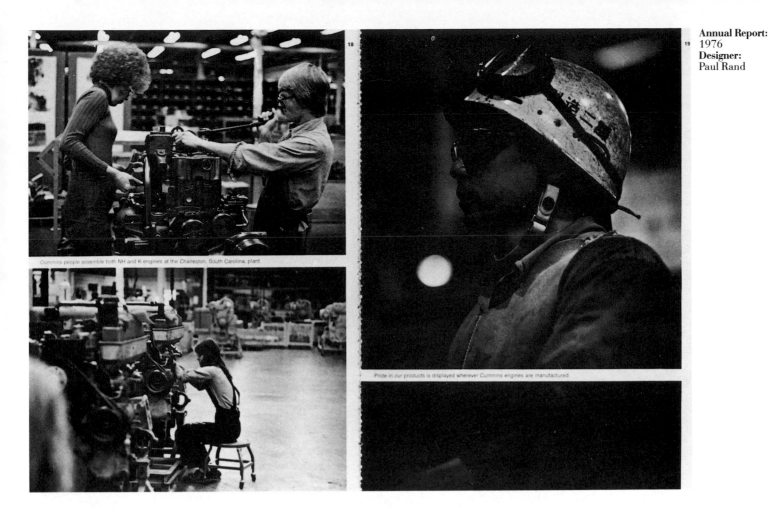

Cummins people assemble both NH and K engines at the Charleston, South Carolina, plant.

Pride in our products is displayed wherever Cummins engines are manufactured.

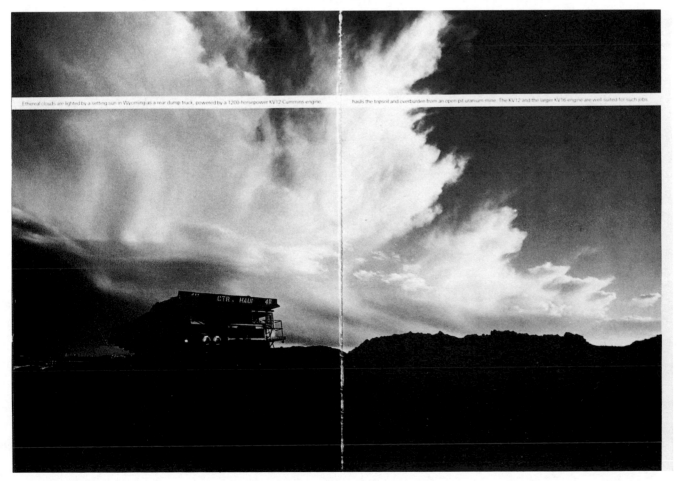

Ethereal clouds are lighted by a setting sun in Wyoming as a rear dump truck, powered by a 1200-horsepower KV12 Cummins engine, hauls the topsoil and overburden from an open-pit uranium mine. The KV12 and the larger KV16 engine are well suited for such jobs.

Annual Report:
1981
Designer:
Paul Rand

Annual Report:
1982
Designer:
Paul Rand

1981 Annual Report

Cummins

Annual Report:
1962
Designer:
Paul Rand

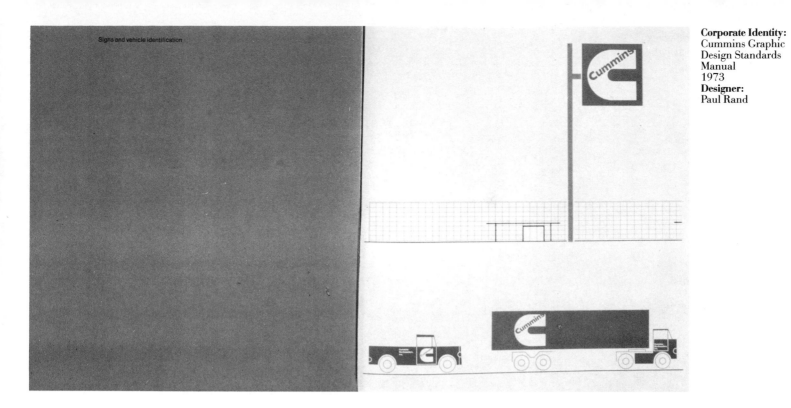

Corporate Identity:
Cummins Graphic
Design Standards
Manual
1973
Designer:
Paul Rand

Corporate Identity:
Cummins Graphic
Design Standards
Manual
1973
Designer:
Paul Rand

International Activity

Sales in 1962 through International Operations reached an all-time high and were 23% greater than in 1961. It is anticipated that international sales will continue to grow during 1963.

The distribution network of Cummins Diesel International Limited now has 254 sales and service locations throughout the world outside the United States and Canada.

Early in 1962 a new firm, Kirloskar Cummins Limited, Poona, India, in which the Company is a fifty percent owner, was formed to manufacture Cummins Diesels. A manufacturing building with floor space of 132,000 square feet is now under construction with completion scheduled during the third quarter of 1963. Machine tools are on order and deliveries have commenced. Limited production of Indian produced Cummins Diesels is expected late in 1963.

Komatsu Manufacturing Co., Ltd., Tokyo, Japan, with which the Company concluded a license agreement in November, 1961, has made excellent progress toward establishing manufacturing facilities in Japan for the production of Cummins H and NH engines. Production will commence in late 1963, as indicated in last year's report to the shareholders.

Cummins Diesel Australia expects substantially improved sales during 1963 when two major Australian truck manufacturers will release new on-highway truck models powered by Cummins engines.

The Company is continuing its investigation and studies of other international markets. During 1963, it expects to conclude additional arrangements for operations overseas.

12 13

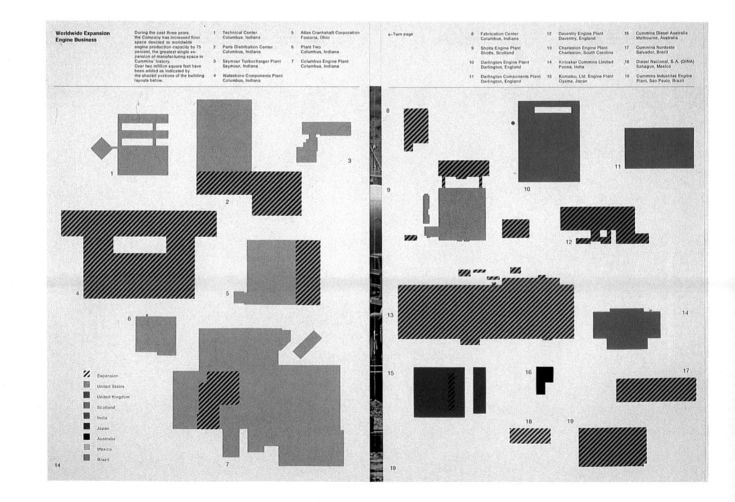

Earnings Per Share—Primary: The relationship of net earnings for the year to the weighted average number of shares of common stock outstanding during the year, adjusted for the possible dilutive effects of common stock equivalents, such as stock options and some convertible securities outstanding.

Earnings Per Share—Fully Diluted: Earnings per share based on the weighted average number of shares of common stock outstanding during the year, adjusted for the possible dilutive effects of all contingently issuable shares of common stock, including common stock equivalents and other outstanding rights to receive or convert to common stock.

Stock Appreciation Rights: Rights granted to officers and key employees allowing them to receive in cash or common shares the appreciation in the value of a specified number of shares of common stock under option.

Dividends Declared: Dividends to be paid to shareholders at a date and in an amount specified by the Board of Directors.

Replacement Cost: An estimate of the lowest amount that would have to be paid if the productive capacity of property, plant and equipment or the utility of inventory was to be replaced at the end of the year. Because of the effects of inflation, this amount is usually higher than the original cost of the asset.

Indexing Method: A method used to estimate the replacement cost of machinery and equipment which might be replaced, under current business conditions, with similar assets. The ratio of the original cost to current purchase price of similar assets is used to estimate replacement cost.

Unit Pricing Method: A method used to estimate the replacement cost of buildings and ground improvements. An estimate of current construction costs per square foot is multiplied by the number of square feet to be replaced to calculate an estimate of replacement cost of these assets.

Direct Pricing Method: A method used to estimate the replacement cost of equipment which might be replaced, under current business conditions, with assets of improved technology. The current purchase price of the assumed replacement asset is used as an estimate of the replacement cost of the older asset.

Industrial Center	Production
Cummins Industrial Center Seymour, Indiana	Final assembly, testing and shipping of engines to industrial customers worldwide

Component Manufacturing	Production
Atlas Crankshaft Fostoria, Ohio	Crankshafts and engine components
Diesel ReCon Chicago, Illinois Los Angeles, California Memphis, Tennessee	Re-conditioned engines and components
Fleetguard Cookeville, Tennessee	Engine filters
Seymour Turbocharger Plant, Seymour, Indiana	Turbochargers
Walesboro Components Plant, Walesboro, Indiana	Engine components
Darlington Components Plant, Darlington, England	Engine components
Holset Halifax, England Huddersfield, England	Turbochargers and engine components

Parts Distribution	
Columbus, Indiana	Gross Gerau, Germany
Newark, New Jersey	Lyon, France
Darlington, England	Ringwood, Australia
Hialeah, Florida	Singapore

North American Sales Offices	
Atlanta, Georgia	Oak Brook, Illinois
Dallas, Texas	San Francisco, California
Norwalk, Connecticut	Mississauga, Ont., Canada

International Sales Offices	
Columbus, Indiana	Manila, The Philippines
Miami, Florida	Mexico City, Mexico
Abidjan, Ivory Coast	Nairobi, Kenya
Athens, Greece	New Malden, England
Bogota, Colombia	Ringwood, Australia
Brussels, Belgium	San Jose, Costa Rica
Genoa, Italy	Sao Paulo, Brazil
Gross Gerau, Germany	Singapore
Johannesburg, South Africa	Tokyo, Japan
Lyon, France	

44

45

Annual Report:
1977
Designer:
Paul Rand

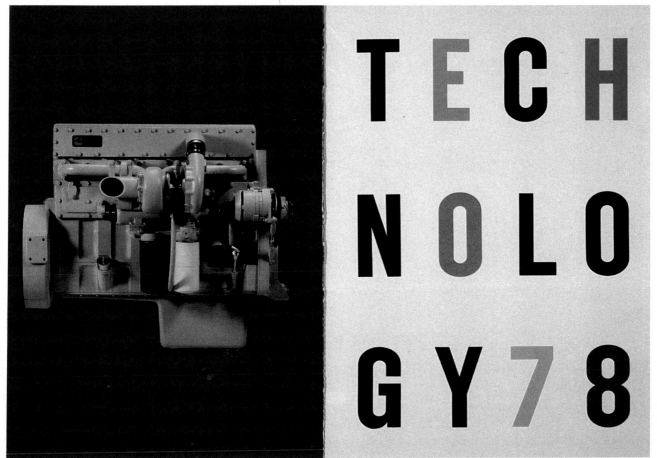

Annual Report:
1978
Designer:
Paul Rand

TECH
NOLO
GY78

Design Leadership 65

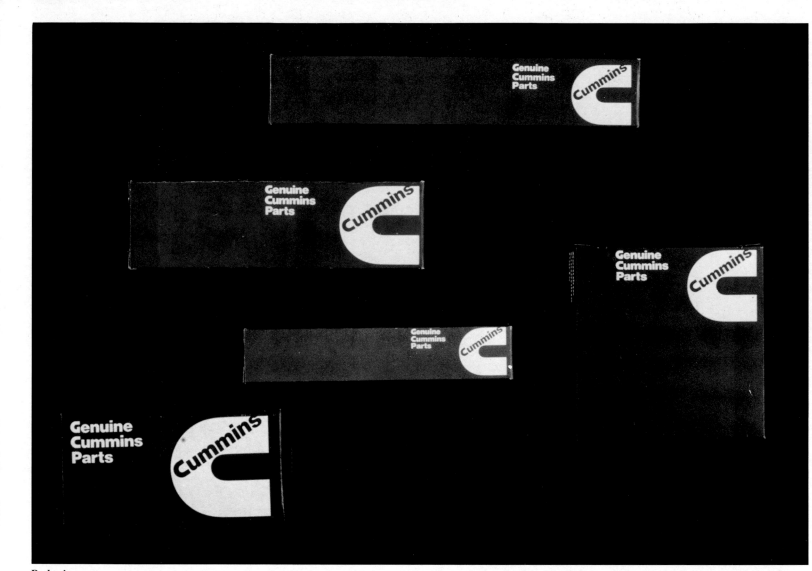

Packaging:
1975
Designer:
Paul Rand

Logo:
Atlas Crankshaft
1964
Designer:
Paul Rand

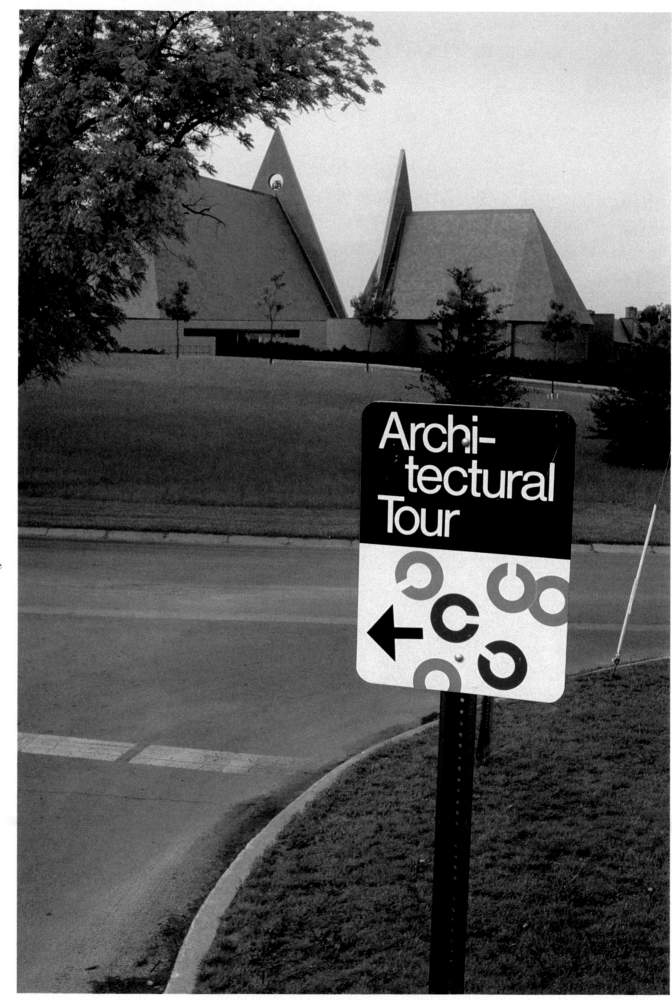

Signage:
Architectural Tour
Columbus, IN
1973
Designer:
Paul Rand

Book:
A Look at Architecture
Columbus, IN
1973
Designer:
Paul Rand

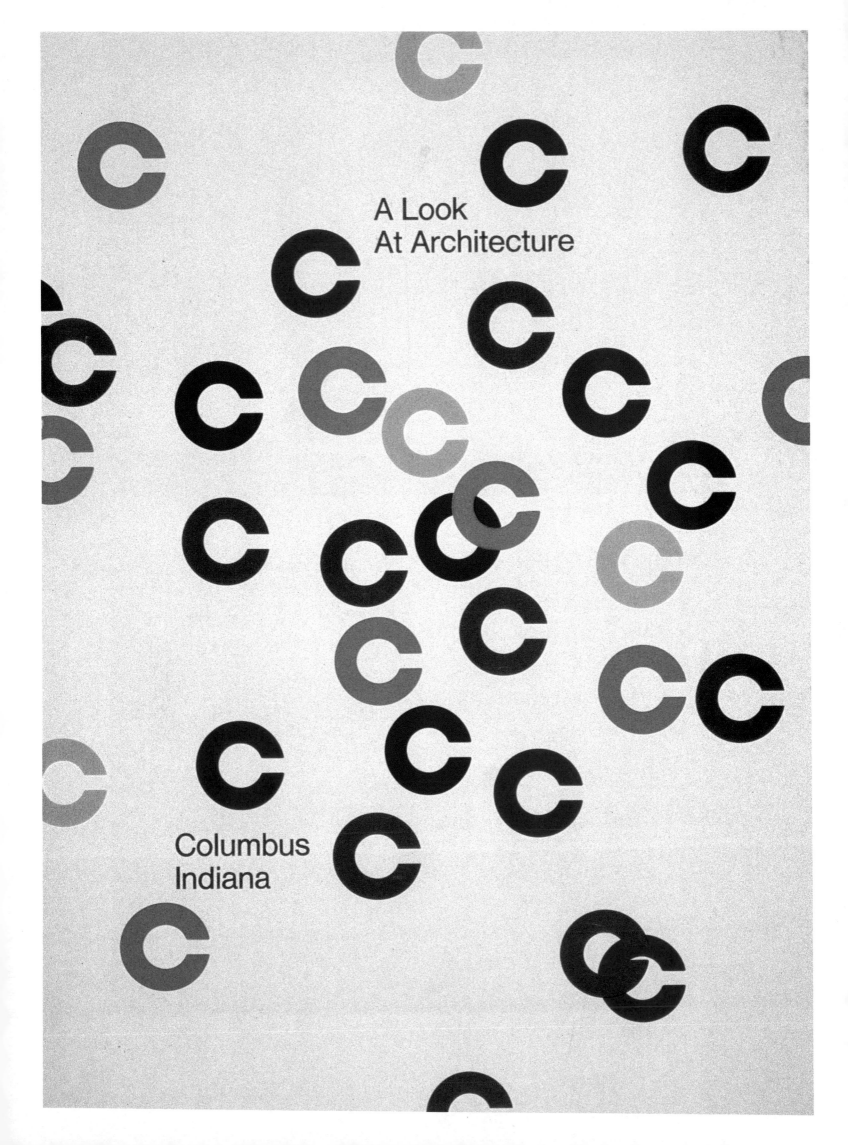

A Look
At Architecture

Columbus
Indiana

Book:
A Look at Architecture
Columbus, IN
1973
Designer:
Paul Rand

1958 Irwin Union Bank & Trust Company
Hope Branch
East Side of Town Square, Hope, Indiana

Harry Weese, Chicago, Illinois

The rust-red brick Hope branch bank building at
Hope was designed to fit a village square en-
vironment, and features a glass clerestory over
which "floats" the roof of pyramidal wooden
domes.

1961 State Street Office Building
State and Mapleton Streets
Harry Weese, Chicago, Illinois

Located in the heart of an industrial area, the
maroon brick office building, which formerly
served as the State Street branch, is in a small
shopping center. The interior is highlighted
with an exposed plank roof and quarry tile floor.

1961 Eastbrook Plaza Branch
Harry Weese, Chicago, Illinois

The gray-glazed brick Eastbrook Plaza branch
bank building features four towers which combine
drive-up teller windows and heating and air-
conditioning units. Bordering on Hawcreek, the
building blends with two nearby bridges; a
small dam creates a reflecting pool.

1966 Taylorsville Branch, Taylorsville, Indiana
Fisher and Spillman Architects, Inc., Dallas, Texas

The branch bank at Taylorsville, eight miles
north of Columbus, is of rust-colored Louisiana
sandstone brick and glass and has been de-
signed to harmonize with existing buildings of the
community and surrounding farm buildings
which can be seen in the distance. The hip-type
roof is of copper with a large skylight.
The landscaping was planned by Dan Kiley of
Charlotte, Vermont.

1974 State and Mapleton Streets Branch
Paul Kennon, Principal Architect
Caudill, Rowlett, Scott, Los Angeles,
California, and Houston, Texas

The new State Street branch bank constructed in
1974 is a two-story masonry building with a
lobby glassed in on three sides. Four drive-up
teller windows are topped with plastic
bubbles above steel lattice work. The grounds
feature a tree-lined parking area and a land-
scaped mini-park.

24 25

1860 Bartholomew County Historical Museum
524 Third Street

Renovated in 1972

The Bartholomew County Historical
Museum is located in the former home of
three prominent early Columbus families.

The home was built by William McEwen,
local businessman and banker. It was sold
in 1870 to David Samuels and in 1889 to
James Marr, a farming family who moved
into the city. Upon his death in 1916,
the house was divided into apartments
and was allowed to deteriorate until
purchased in 1969 by the Bartholomew
County Historical Society for its head-
quarters and museum.

Restoration and renovation have returned
the building to its prosperous appear-
ance at the turn of the century, with the
parlor decorated in Victorian period
furniture. Other rooms display museum
articles. There also is a historical ref-
erence room. A meeting room on the sec-
ond floor is used for classes in the home
arts, meetings and related activities.

10 11

1971

Sculpture: Large Arch
Library Plaza

Sculptor: Henry Moore, Much Hadham,
Hertfordshire, England

Henry Moore's sculpture, "Large Arch,"
which centers the Cleo Rogers Memorial
Library plaza, was commissioned at the
suggestion of I. M. Pei of New York City,
architect for the library. He wanted
Henry Moore, considered one of the great-
est artists of the twentieth century, to
create the plaza centerpiece. Moore, who
was 77 years old when he did the "Large
Arch," said, "As a young sculptor I saw
Stonehenge and ever since I've wanted to
do work that could be walked through
and around."

The organic quality of the "Large Arch" is
a direct contrast to the geometric shapes
of the nearby buildings. It reflects primitive
simplicity and the power evident in mon-
olithic sculpture of the past. It is twenty
feet tall, twelve feet wide and weighs five
and a half tons.

It was designed in Moore's studio at his
home in England and sandcast in bronze
in fifty sections at the Herman Noack
foundry in West Germany. The blades, one-
fourth to one-half inch thick, were welded
with invisible seams. The green patina is a
natural, aged-look for bronze if in a cli-
mate free of air impurities, and was created
through a special process, directed per-
sonally by Mr. Moore at the foundry.

The sculpture, a gift from Mr. and Mrs. J.
Irwin Miller, was dedicated with the library
building, May 16, 1971.

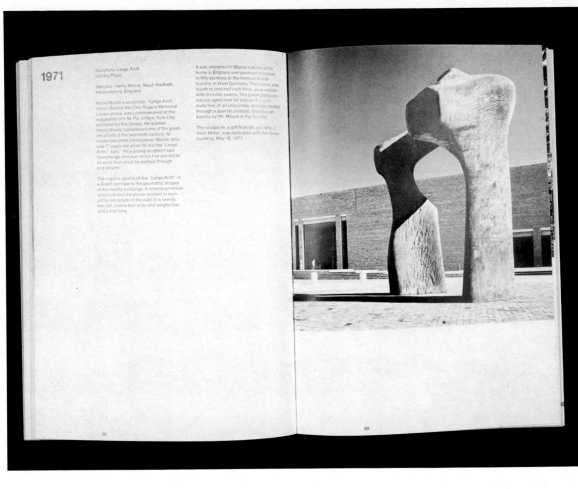

1973

Irwin Union Bank & Trust Company Addition
Fifth and Jackson Streets

Kevin Roche, John Dinkeloo
& Associates, Hamden, Connecticut

In 1973 a three-story adjacent building to
the north of the original bank was de-
signed by Kevin Roche and John Dinkeloo.
Mr. Roche was Eero Saarinen's assistant
in the design of the original structure.

The most striking innovation of the new
addition is "striped" glass. It is a laminate
of two layers of glass, one sprayed in
stripes with a reflecting substance similar
to that used to back mirrors. This tech-
nique reduces the amount of heat ab-
sorbed from the sun in the glass corridor
which runs the full block length from
Washington to Jackson Streets and rises
the full height of the addition. Large
planters in the corridor create an indoor
garden.

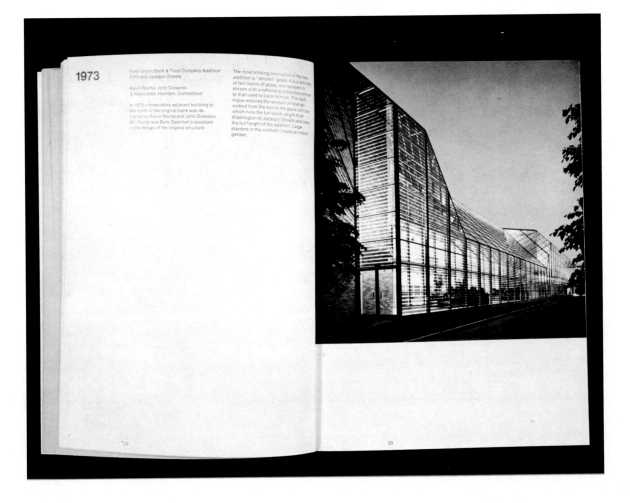

Letterhead:
Visitors Center
1977
Designer:
Paul Rand

Visitors
Center
Columbus
Indiana

506 Fifth Street
Columbus, Indiana
47201

812 372 1954

Button:
Visitors Center
1973
Designer:
Paul Rand

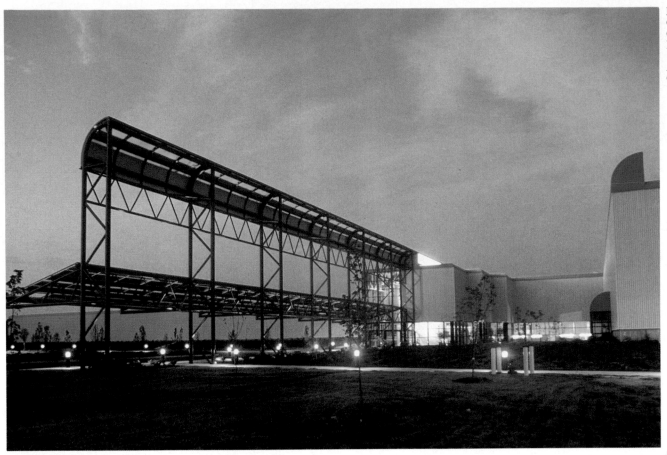

Manufacturing Plant:
Consolidated Diesel
Company
Rocky Mount, NC
1983
Architects:
CRS

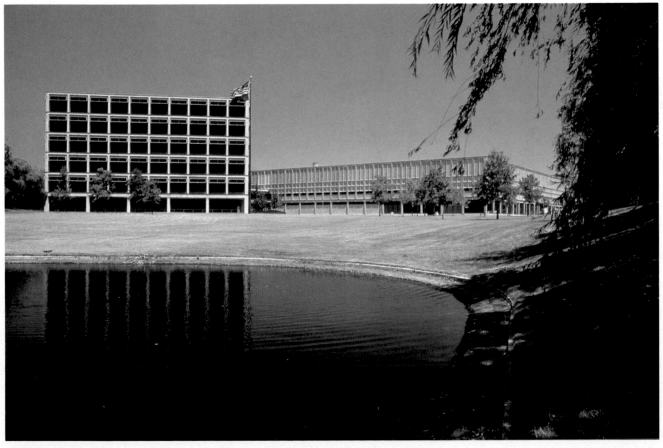

Research Facility:
Cummins Engine
Company, Inc.
Columbus, IN
1968
Architect:
Harry Weese

**Architectural
Tour Map
Columbus
Indiana**

Visitors Center

Located at the corner of
Fifth and Franklin Streets in
downtown Columbus the
Visitors Center is housed in
a restored nineteenth
Century home.

The building includes a room
specially equipped with slide
projection equipment for the
purpose of previewing Col-
umbus architecture. The
Center also contains a gift
shop where maps and
souvenirs may be purchased.

On the second floor is
located a branch of The
Indianapolis Museum of Art
with changing exhibits.

The Visitors Center is open
from 9 a.m. until 5 p.m.
Monday through Saturday.

Sunday hours April through
October are 12 noon until
4 p.m.

Tour Information

Several tour options are
available to individuals or
groups. Tour routes are
marked on this map in
yellow, with optional por-
tions marked by broken
lines. Arrangements can be
made through the Visitors
Center in advance for trained
unpaid volunteer tour guides
and group tours. Cassettes
describing buildings on
either the downtown walking
or the driving tour are
available. Bus rentals can be
arranged if needed. There is
a small charge for these
services.

Walking Tour

Starting at the Visitors
Center buildings numbered
one through sixteen on this
map are in downtown Colum-
bus, all within easy walking
distance.

Driving Tour

Depending on the size of the
group, a driving tour within
the city limits and without
stops can be completed in
approximately two hours. If
stops are included, approx-
imately 20 minutes should
be added for each stop. On
the tour, visitors will see 36
buildings. If all outlying
areas are included, 46
buildings will be seen.

Minibus Tour

The Visitors Center has a
Minibus available for in-
dividuals or groups under
twenty. Minibus tours are by
reservation only.

10 a.m. Monday through
 Saturday
2 p.m. Saturday
1 p.m. Sunday (April
 through October)

As a courtesy, it is requested
that those interested in
visiting particular buildings
make arrangements through
the Visitors Center.

Access to some buildings is
limited.

Visitors Center
Columbus Area Chamber
of Commerce
Post Office Box 29
506 Fifth Street
Columbus, Indiana 47201

812-372-1954

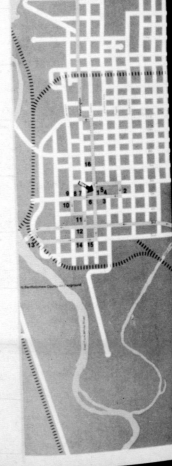

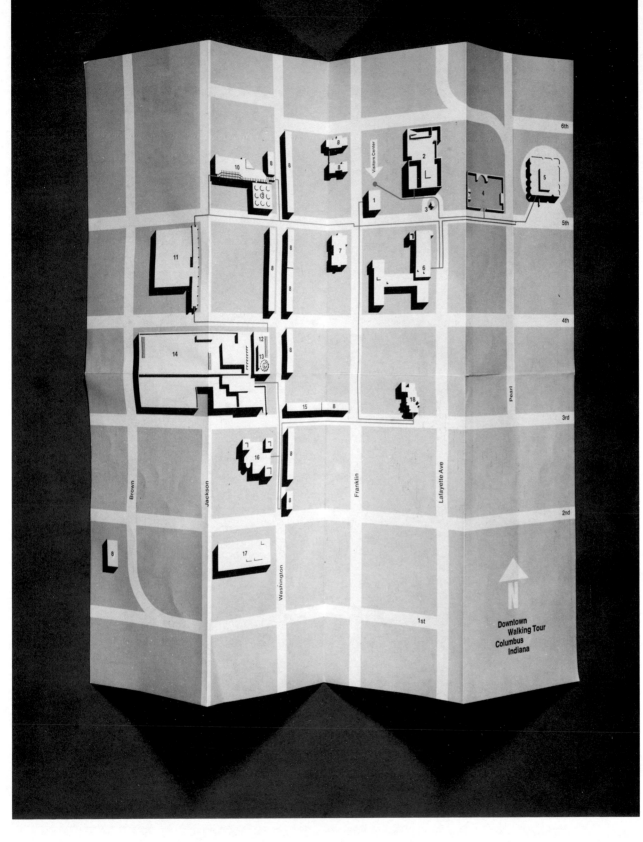

Map:
Architectural Downtown
Walking Tour
Columbus Visitors
Center
Columbus, IN
1973
Designer:
Paul Rand

Map:
Architectural Tour
Columbus Visitors
Center
Columbus, IN
1973
Designer:
Paul Rand

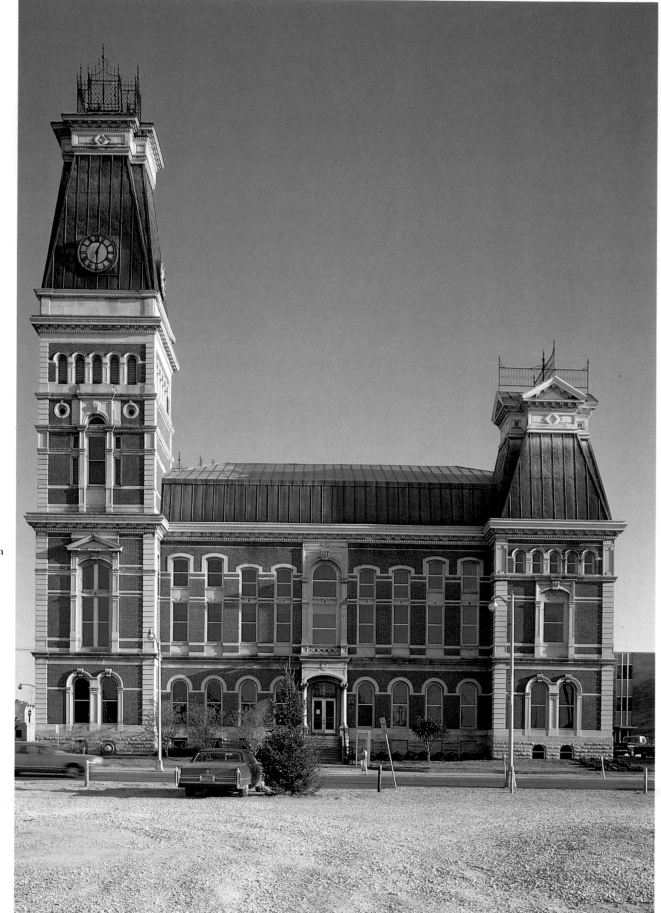

Government Building:
Bartholomew County
Courthouse
Columbus, IN
1874
Architect:
Isaac Hodgson

Church:
North Christian Church
Columbus, IN
1964
Architect:
Eero Saarinen

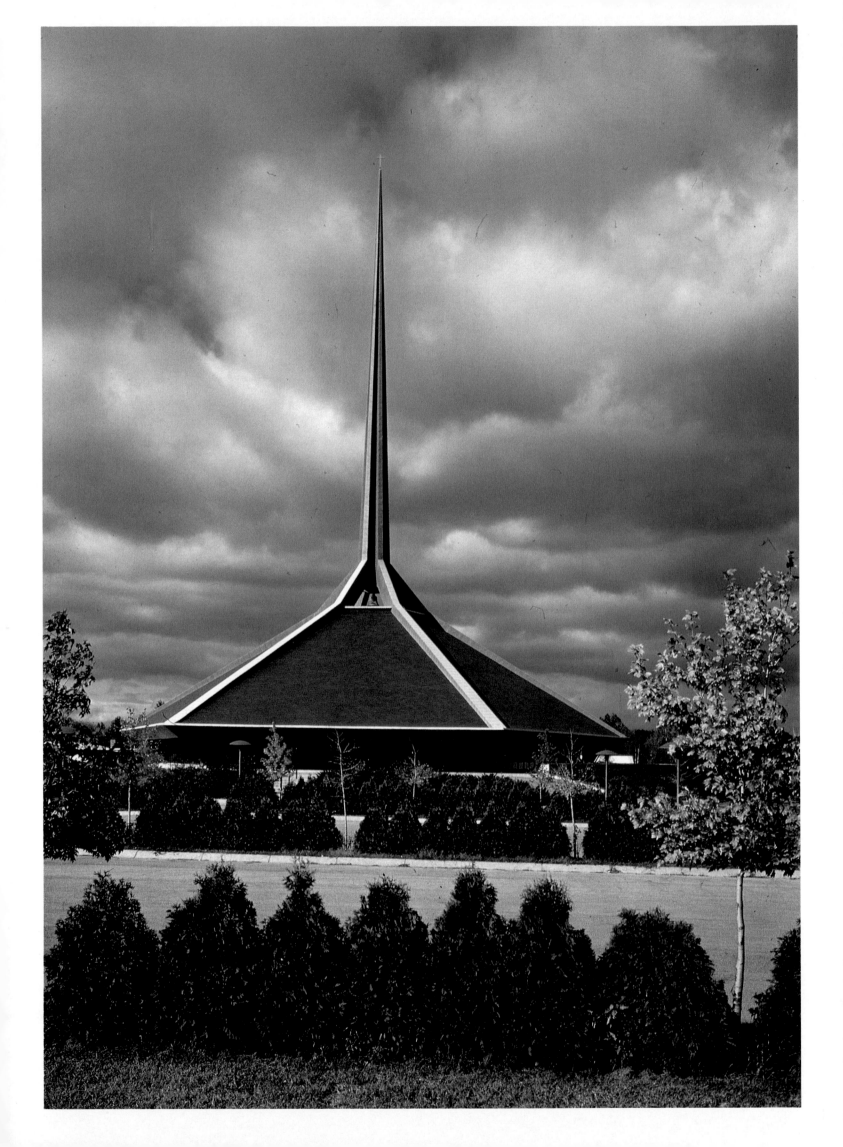

Signage:
1976
Designer:
Paul Rand

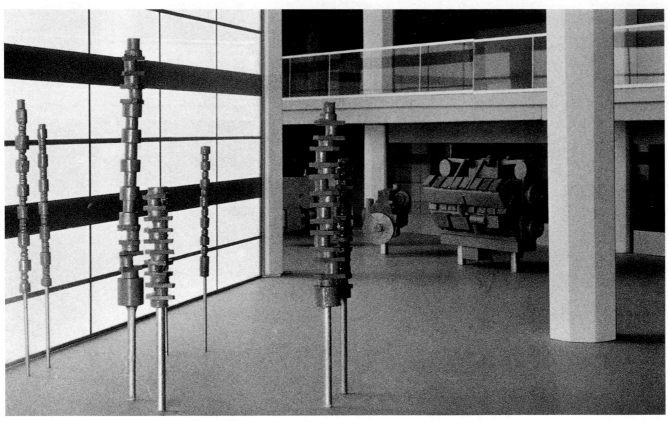

Maquette:
Display Area, Corporate
Office Building
Cummins Engine
Company, Inc.
Columbus, IN
1984
Designer:
Rudolph deHarak

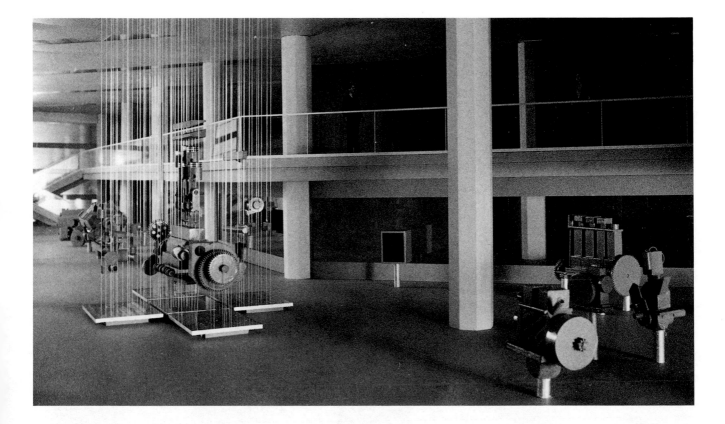

Annual Report:
Irwin Sweeney Miller
Foundation
1971
Designer:
Paul Rand

1971 Annual Report Irwin-Sweeney-Miller Foundation

Annual Report
Irwin-Sweeney-Miller
Foundation

Annual Report:
Irwin Sweeney Miller
Foundation
1973
Designer:
Paul Rand

Annual Report
Irwin-Sweeney-Miller
Foundation

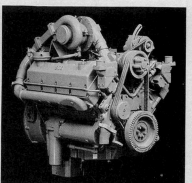
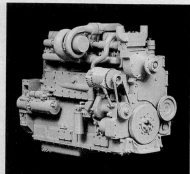
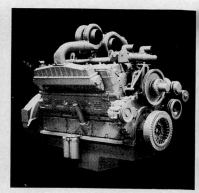

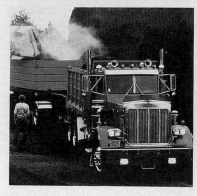
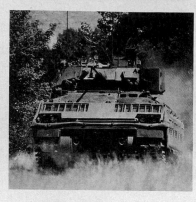
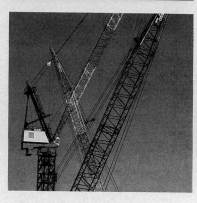
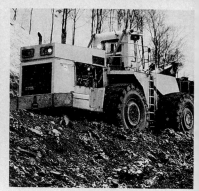

N14 The N14 is a new 14-litre engine, which will achieve major improvements in fuel economy, noise, durability and emissions while retaining enough commonality with today's NT engine to permit use of much of Cummins' present tooling. The N14 will be used in applications currently powered by the NT, including not only heavy-duty on-highway trucks but also agricultural and construction equipment, generator sets, boats and fire pumps.

The N14 will be produced in Columbus, Ind.

Horsepower	300 – 450 hp.
Aspiration	Turbocharged/aftercooled
Configuration	In-line
Cylinders	6
Displacement	855 cubic inches
	14 litres
Length	58.6 inches
Width	33.6 inches
Height	44.2 – 46.1 inches
Weight	2440 pounds

903 The U.S. Army Bradley Infantry Fighting Vehicle depends on the highly durable Cummins 903 for reliable power. Efforts are under way to increase the 903's horsepower to permit use in a wider variety of military applications. Typical uses include amphibious landing craft, front-end loaders, cranes, pleasure boats and agricultural tractors.

The 903 is produced in Columbus, Ind.

Horsepower	225 – 500 hp.
Aspiration	Naturally aspirated, turbocharged or turbocharged/aftercooled
Configuration	V
Cylinders	8
Displacement	903 cubic inches
	14.8 litres
Length	43.9 – 45.3 inches
Width	37.7 – 39.8 inches
Height	48.8 – 50.9 inches
Weight	2200 – 2380 pounds

K19 The K19 is primarily a power source for construction equipment, like these large cranes. This engine features a compact, lightweight design ideal for use in off-highway mobile equipment, marine and other space-limited machinery. Other applications include agricultural tractors, oil-well equipment, pumps, locomotives, hydraulic excavators and crawler tractors.

The K19 is produced at Charleston, S.C.; Kirloskar Cummins Ltd., Pune, India (joint venture); Ssangyong Heavy Industries, Co., Ltd., Seoul, South Korea (licensee); production planned at China National Technical Import Corp., Chong Qing, China (licensee), and DINA-Cummins, S.A., San Luis Potosi, Mexico (joint venture).

Horsepower	450 – 650 hp.
Aspiration	Turbocharged or turbocharged/aftercooled
Configuration	In-line
Cylinders	6
Displacement	1150 cubic inch
	18.9 litres
Length	61.9 inches
Width	31.3 – 38.6 inches
Height	52.9 – 64.0 inches
Weight	3600 – 3800 pounds

V28 This Pennsylvania coal mine requires durable, reliable Cummins engines to power front-end loaders used to load mining trucks. The modern V28 series engines have evolved from the original high-horsepower, high-speed 12-cylinder diesel introduced in 1949. Today's V28 engines provide top performance, reliability, durability and economy in their power package. Typical applications include generator sets, construction equipment, power units, locomotives, fire pumps and marine equipment.

V28 engines are produced in Seymour, Ind., and Kirloskar Cummins Ltd., Pune, India (joint venture).

Horsepower	635 – 900 hp.
Aspiration	Turbocharged or turbocharged/aftercooled
Configuration	V
Cylinders	12
Displacement	1710 cubic inches
	28.0 litres
Length	78.8 inches
Width	51.0 inches
Height	62.7 inches
Weight	5600 – 5800 pounds

Annual Report:
1983
Designer:
Paul Rand

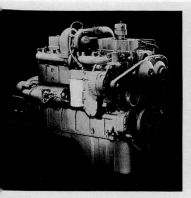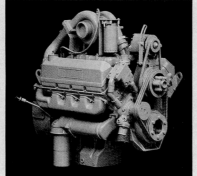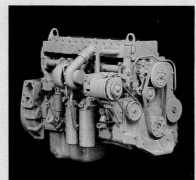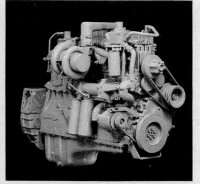

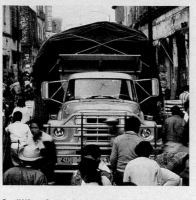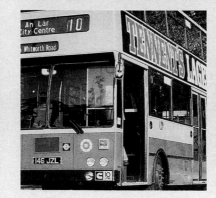

8.3 This largest of the B/C Series engines will provide relia-
ble, fuel-efficient power for a variety of applications, such as this trac-
tor tilling an Indiana farm. A "seeding" program with potential
customers is scheduled to begin this year for the C Series. These
engines will power a broad range of construction, agricultural and
industrial equipment, as well as medium-duty trucks.

Production of the 6C8.3 engine is planned at Consolidated Diesel Co.,
Rocky Mount, N.C. (joint venture with J I Case Co.).

Horsepower	160 – 250 hp.
Aspiration	Naturally aspirated, turbocharged or turbocharged/aftercooled
Configuration	In-line
Cylinders	6
Displacement	505 cubic inches 8.3 litres
Length	43.2 inches
Width	22.8 – 28.9 inches
Height	36.2 – 45.4 inches
Weight	1156 – 1235 pounds

Small V8 Cummins is the preferred power for Mexican trucks
and buses, including this DINA produce-delivery truck. The V8 is avail-
able in both the 504-cubic-inch series and the 555-cubic-inch series.
A companion model, the V6, is produced with 378-cubic-inch
displacement. These Small Vee engines typically power trucks and
urban buses, and a variety of industrial equipment such as cranes,
front-end loaders, excavators, skidders, air compressors, motor
graders and agricultural tractors.

Small Vee engines are produced in Darlington, England, and at Diesel
Nacional, Sahagun, Mexico (licensee).

Horsepower	120 – 320 hp.
Aspiration	Naturally aspirated or turbocharged
Configuration	V
Cylinders	8
Displacement	504 – 555 cubic inches 8.3 – 9.1 litres
Length	39.4 – 42.2 inches
Width	27.6 – 30.4 inches
Height	37.0 – 43.0 inches
Weight	1460 – 1800 pounds

L10 The main transit authority in southern Ireland operates a
large number of L10-powered buses, including this double-decker,
which serves Dublin and Cork. Cummins' new L10 represents a
breakthrough in compact, lightweight, heavy-duty engine develop-
ment. The highly fuel-efficient L10 is enjoying the best acceptance
and performance of any new Cummins product. These diesels are
well suited to a variety of applications, including agricultural tractors,
snowblowers, snow plows, car haulers, airport refuelers, city
delivery trucks, fuel-oil tankers, fire apparatus, bulk-commodity
haulers, dumpers, mixers and refuse trucks.

L10 engines are produced in Jamestown, N.Y., and Shotts, Scotland.

Horsepower	240 – 290 hp.
Aspiration	Turbocharged or turbocharged/aftercooled
Configuration	In-line
Cylinders	6
Displacement	611 cubic inches 10 litres
Length	51.5 inches
Width	31.7 inches
Height	39.2 – 43.1 inches
Weight	1865 – 1975 pounds

NH/NT The mainstay of Cummins' product line, the NH/NT is
the performance standard for the North American heavy-duty truck
market, as well as agricultural and construction equipment, generator
sets, boats, fire pumps and defense products.

The NH/NT is produced in Columbus, Ind.; Charleston, S.C.; Shotts,
Scotland; Cummins Brasil, S.A., São Paulo, Brazil (division); Kirloskar
Cummins Ltd., Pune, India (joint venture); Komatsu Ltd., Oyama,
Japan (licensee); China National Technical Import Corp., Chong Qing,
China (licensee); Ssangyong Heavy Industries Co., Ltd., Seoul, South
Korea (licensee); production planned at DINA-Cummins, S.A., San
Luis Potosi, Mexico (joint venture).

Horsepower	160 – 475 hp.
Aspiration	Naturally aspirated, turbocharged or turbocharged/aftercooled.
Configuration	In-line
Cylinders	6
Displacement	855 cubic inches 14 litres
Length	58.9 – 60.7 inches
Width	28.3 – 34.6 inches
Height	49.0 – 52.9 inches
Weight	2360 – 2870 pounds

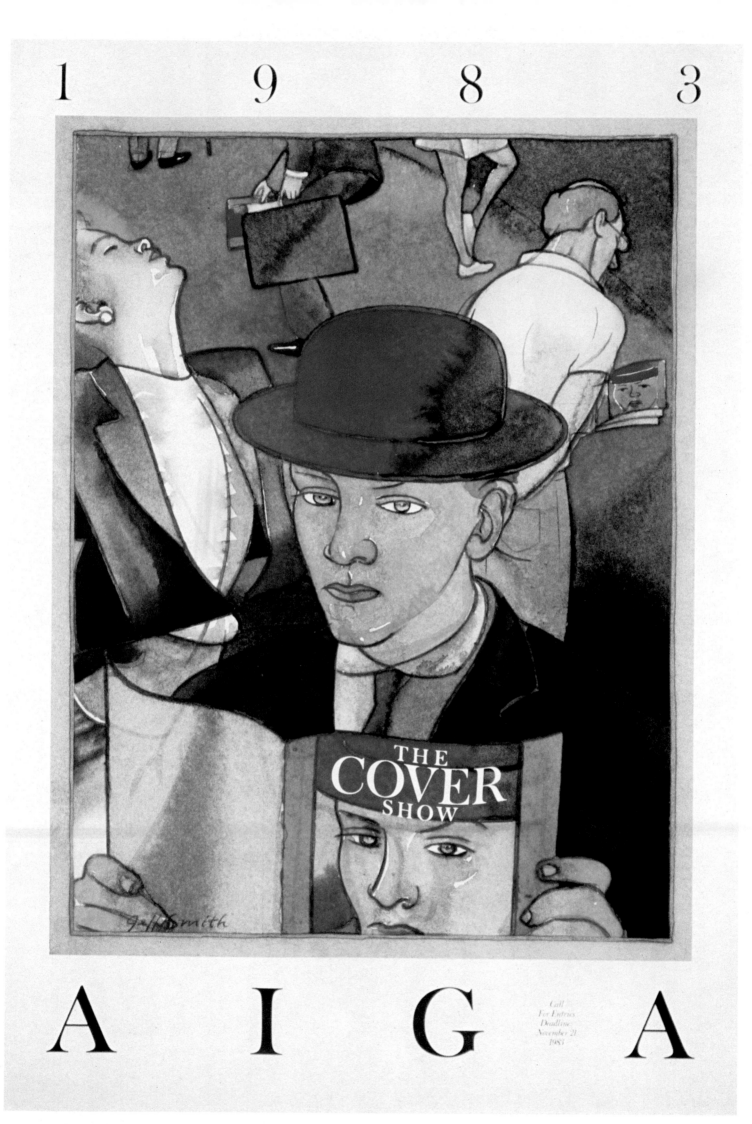

The Cover Show

AIGA 1983 THE COVER SHOW

(poster reproduction — illustrated call-for-entries broadside with dense small text, including sections titled ELIGIBILITY, DEADLINE, FEES, THE AIGA, THE PROCEDURE, THE JURY, AIGA GRAPHIC DESIGN USA:5, CREDITS, REGISTRATION, MEMBERSHIP, ENTRY FORM)

THE JURY
Roger Black, Chairman — Art Director, The New York Times Magazine
Mike Hicks — President, Hixo, Inc., Austin
Harold Hayes — Vice President, Planning, CBS Publications, New York
Annie Leibovitz — Photographer, New York
Dugald Stermer — Designer, San Francisco

THIS is a call for great covers. It is the Call for Entries for The Cover Show of The American Institute of Graphic Arts, the biannual event that celebrates the intriguing, the profound, the beautiful, and the exciting combinations of image and typography that cover magazines, annual reports, record albums—anything (but books) that can be covered. We are looking for the designs that break the formulas and extend the traditions. You have until November 21, 1983 to enter. —THE JURY

Perhaps this past year was simply one of transition. All the New Wave revivals are sliding into old age. One hopes that the new directions are so subtle in this calendar period that they will emerge in force during the next. Like Mt. St. Helens, the design field is always ready to erupt. And, like the rest of the field, covers—sometimes innovative, other times derivative —erupt in stages.

Call for Entry:
The Cover Show
Designer:
Roger Black
Illustrator:
Jeff Smith
Typographer:
Innovative Graphics
International
Printer:
Crafton Graphic Co.
Paper:
Champion International
Color Separator:
Toppan Printing Company
America, Inc.

It is dangerous to make sweeping pronouncements about the design field based on quirky decisions of juries. An intelligently "balanced" group of individuals is relied upon to determine standards of the day, and critics then draw conclusions as to existing trends. These judgements and commentaries are reflections of personal tastes and prerequisites. Consistently good work can be ignored in the search for "innovation," and individual greatness can be overlooked by the bleary-eyed.

With regard to the covers chosen this year (including those on brochures, catalogues, menus, annual reports, records, and magazines—books are surveyed in another show), the paucity of *experimentation* is felt in all areas. With record covers, it is in part due to the recessive economy. With periodicals and annual reports, too many cooks in the corporate kitchens prevent designers from having the necessary control—formats are often determined by committees. Even the government has made its presence known, particularly in publication design, through the ubiquitous, untouchable, and unsightly universal pricing code.

In light of this, one fondly recalls the days when lush and expansive magazines such as *Fortune, Vanity Fair, Vogue, Harpers Bazaar, Esquire* and other highly visible newsstand periodicals proudly strutted their innovative covers. Perhaps these set bad precedents by showing that formats could be flexible and rules were made to be broken—setting high criteria for future innovation. One does, however, wonder how designers, such as M. F. Agha or Alexy Brodovitch, were *allowed* to metamorphose, and sometimes obliterate logos: Were they responding to an inspirational restlessness? Were the marketeers less powerful? Or was creativity simply more respected? Today, economics is a clear determinant in limiting size and shape, as well as content. Distributors demand that a product be consistent, and so graphic surprises are rare. Of course, it is easy to place responsibility on the ofttimes, visually unsophisticated, powers-that-be, and so the buck must stop with the designer. Currently, it seems, many designers are applying their creative energies elsewhere.

Of the 2200 covers judged this year, 125 were chosen. The jurors conceded that all are very good—a few are excellent—but none

are surprising. Chairman Roger Black says: "A consensus is at work that mitigates against anything horrible happening, but levels out anything special occurring. There are no breakthroughs." Furthermore, based on a review of the entries, Black suggests that the problems mentioned above have contributed to a concentric domino effect: "Many art directors have learned a skillful competence. They follow a professionwide standard that one cannot fall below. But given what we've seen, they do not generally rise above it." This year, with few exceptions, *predictability* is the watchword. There are the requisite number of well-done New Wave and Swiss Punk designs—or, as Black laments, "What was done by a few some years ago is now being done by everyone." There is also a curious, and for some a welcome, move toward traditional typographic solutions.

In the area of publication design, classic magazine covers—those employing a strong, single image— have given way to those with multiple images and layers of headlines. And so, the quiet elegance of *The Atlantic* and the booklike treatment of *The Clarion: America's Folk Art Magazine* positively stand out. The regional magazines have still to break the *New York Magazine* mold— now over fifteen years old. "Illustration is also in a woeful state," said one juror. "Editors and art directors do not seem to treat illustrators with respect, but use them simply as tools." In contrast, *Time* magazine's "Private Violence" cover by Matt Mahurin deserves special notice. Apparently, the only consistent adventurism relating to design and illustration emanates from the Sunday newspaper magazine supplements (free, for the most part, from economic constraints). Amidst all the slickness here, coated newsprint has a unique texture that enhances design. For the fourth consecutive year, *The Boston Globe* has taken many of the honors in this category.

Record jacket design is now shockingly minimalist, particularly in contrast to the previous, anything-goes, golden decade. The industry's new life support system— rock video—is syphoning off much of the available finances and creative energy. Annual report cover design is also increasingly more stolid. As Black suggests: "They were very lively a few years ago, before the first bust in the economy. And, although the money has been regenerated, it is used for

deluxe printing and paper. This has not really affected design, except in terms of causing a universal slickness."

There is also a lack of wit across the board —with the exceptions being Red Grooms' Museum of Modern Art Calendar with pull-out crane; the Dalt's "Reflections of Summer" menu produced as a real sun reflector; and the well-conceived and executed *Episcopal Eagle*, the newsletter of the Episcopal School. The humorous, sometimes satiric, photographic and illustrative solutions of previous years are rare— serious, meat-and-potatoes design is the order of the day.

Moreover, there are no clear voices as in previous years. Very few designers show covers with distinct personalities. This is significant, because the presence of the strong designer can not only make the genre look good, but also can offer direction for others.

Perhaps this past year was simply one of transition. All the New Wave revivals are sliding into old age. One hopes that the new directions are so subtle in this calendar period that they will emerge in force during the next. Like Mt. St. Helens, the design field is always ready to erupt. And, like the rest of the field, covers—sometimes innovative, other times derivative—erupt in stages.

Newspaper Supplement:
The New York Times
Magazine
January 30, 1983
Art Directors:
Roger Black
Ken Kendrick
Designer:
Michael Valenti
New York, NY
Artist:
Brad Holland
Publisher:
The New York Times
Typographer:
IGI, Innovative Graphics
International
Printer:
R. R. Donnelley &
Sons Co.

THE WORLD OF
SOVIET PSYCHIATRY

BY WALTER REICH

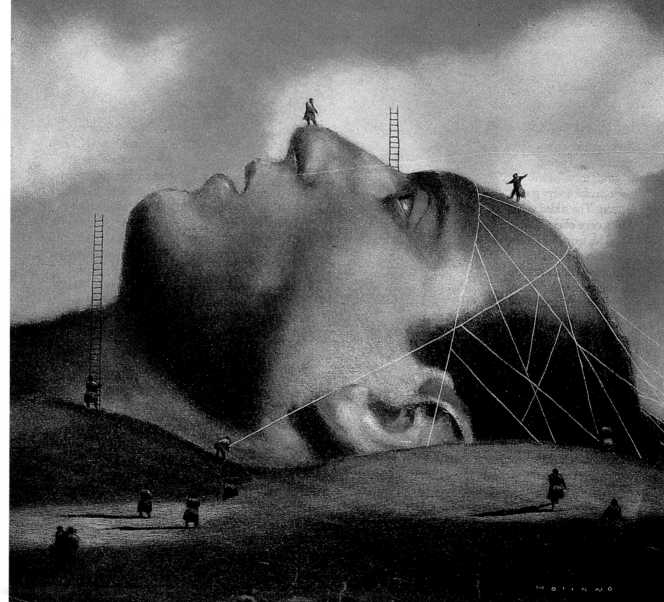

Record Album:
Revenge of Permanent
Wave
Art Director:
Allen Weinberg
Designer:
Allen Weinberg
New York, NY
Artist:
Marshall Arisman
Publisher:
CBS Records
Typographer:
Haber Typographers
Printer:
Shorewood Packaging
Corp.

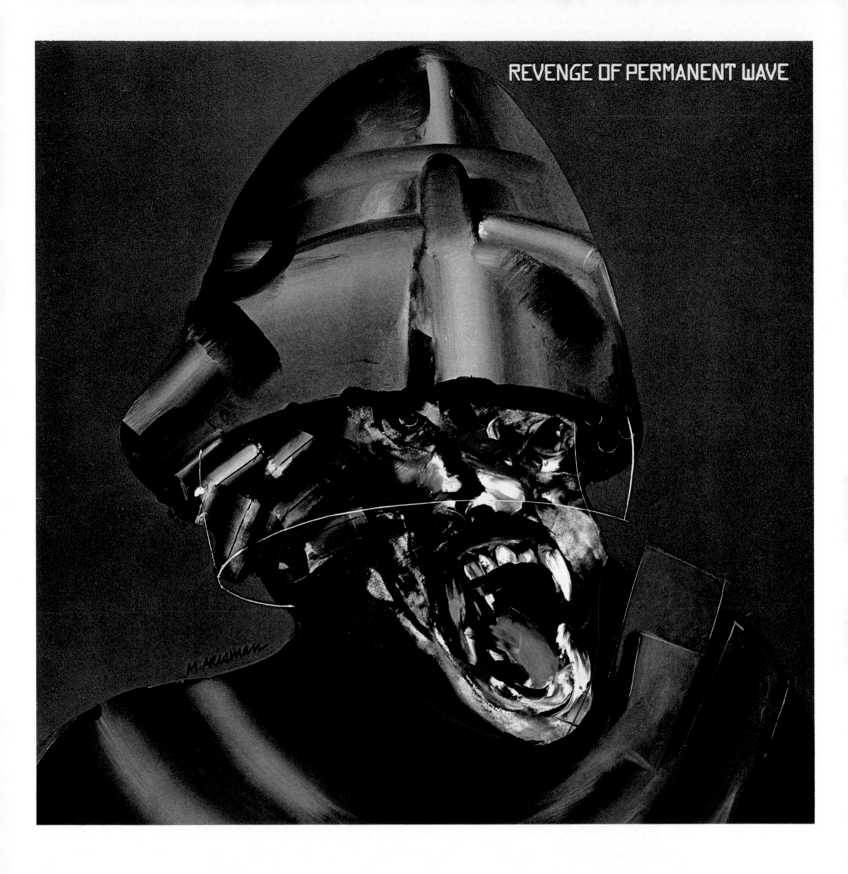

Magazine:
Time, March 1, 1982
Art Director:
Rudolph Hoglund
Artist:
Richard Hess
Roxbury, CT
Publisher:
Time, Inc.
Typographer:
Time, Inc.
Copy Processing
Printer:
R. R. Donnelley &
Sons Co.

Magazine:
Science '81, October
Art Director:
Rodney Williams
Designer:
Rodney Williams
Artist:
Jay Matternes
Design Firm:
Science '83/AAAS
Washington DC
Publisher:
Science '81
Typographer:
CSI & Phil's Photo
Printer:
Judd & Detweiler

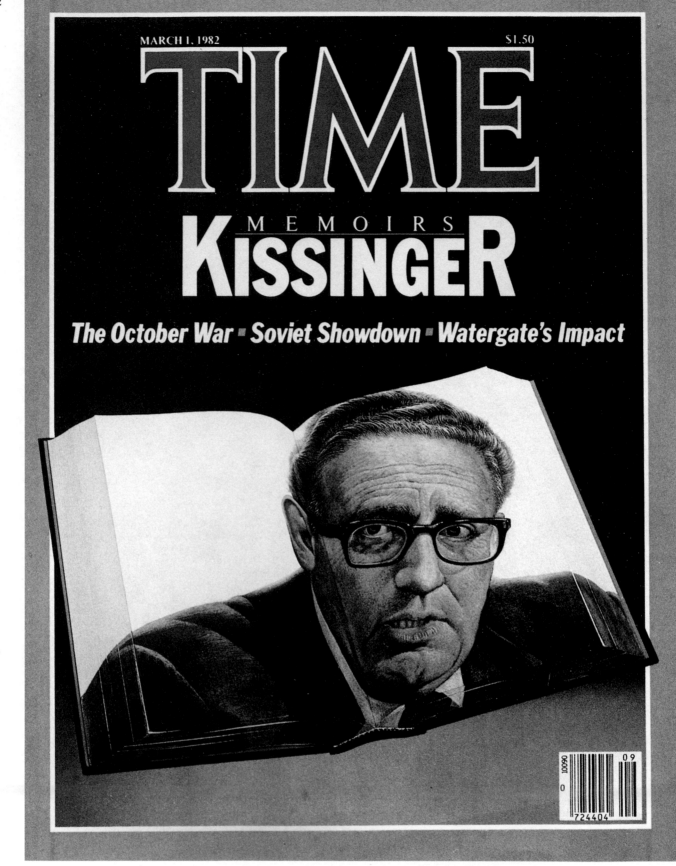

MARCH 1, 1982 $1.50

TIME

MEMOIRS

KISSINGER

The October War ▪ Soviet Showdown ▪ Watergate's Impact

SCIENCE 81

OCTOBER TWO DOLLARS

A NEW FACE
FOR THE
NEANDERTALS

STRIKE OF THE RATTLESNAKE
WHY JOHNNY HATES SCIENCE
BLOODLETTING

Catalogue:
The Workbook: Portfolio
Art Director:
Craig Butler
Designers:
Pearl Beach
Craig Butler
Betsy Rodden
Bob Seidemann
Artist:
Lou Beach
Design Firm:
Craig Butler Design
Los Angeles, CA
Publisher:
Scott & Daughters
Publishing

Catalogue:
The Workbook: Directory
Art Director:
Craig Butler
Designers:
Pearl Beach
Craig Butler
Betsy Rodden
Bob Seidemann
Artist:
Lou Beach
Design Firm:
Craig Butler Design
Los Angeles, CA
Publisher:
Scott & Daughters
Publishing

Magazine:
Mademoiselle
April 1983
Art Director:
Paula Greif
Designer:
Paula Greif
Photographer:
Bert Stern
Publisher:
Conde Nast Publications
Typographer:
ArtintypeMetro
Printer:
R. R. Donnelley &
Sons Co.

APRIL 1983 $1.75

MADEMOISELLE ®

FASHION FLASH!

92 BRIGHT NEW LOOKS

NAB THAT FLAB

5 MINUTES A DAY GETS YOU SLIMMER, TRIMMER

HAIR

SLEEK & SASSY! 4 (NOT-TOO-SHORT) CUTS

NEW LOVERS HOW TO MAKE THE FIRST NIGHT RIGHT

CHIC CHEEKS

HOW TO USE BLUSH LIKE A PRO

The Boston Globe Magazine

September 25, 1983

BY FRED KAPLAN

WAR GAMING
How the wizards of defense formulated nuclear strategy

Newspaper:
The Boston Globe
Magazine
September 25, 1983
Art Director:
Ronn Campisi
Designer:
Ronn Campisi
Boston, MA
Artist:
Marshall Arisman
Publisher:
Globe Newspaper Co.
Printer:
Providence Gravure

Magazine:
Air Brush Digest
September/October
1982
Art Director:
Allen Sheets
Designer:
Allen Sheets
Portland, OR
Photographer:
Steven Steckly
Publisher:
Lelon Dietz
Printer:
Universal Color

Catalogue:
Adult Video Cassette
Catalog,
Summer 1982
Art Director:
Christopher Garland
Designer:
Christopher Garland
Chicago, IL
Photographer:
Robert Meyer
Design Firm:
Xeno
Client:
Noel Gimbel/
Sound Video Unlimited
Typographer:
Master Typographers
Printer:
Redson Rice

Newspaper:
The Boston Globe
Magazine
July 10, 1983
Art Director:
Ronn Campisi
Designer:
Barbara Nessim
New York, NY
Artist:
Barbara Nessim
Publisher:
Globe Newspaper Co.
Printer:
Providence Gravure

Magazine:
Metro, Feb/March 1983
Art Director:
Vincent J. Romaniello
Designer:
Paul Woods
Artist:
Paul Woods
Design Firm:
Metro Magazine
San Francisco, CA
Publisher:
Neal Elkin
Typographer:
Barbara Naiditch
Printer:
Crain Press

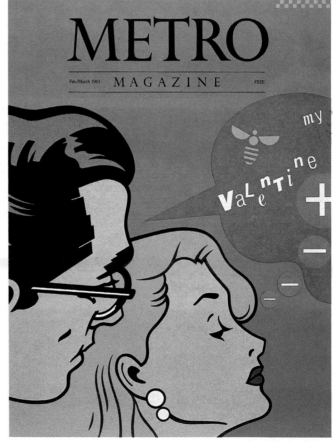

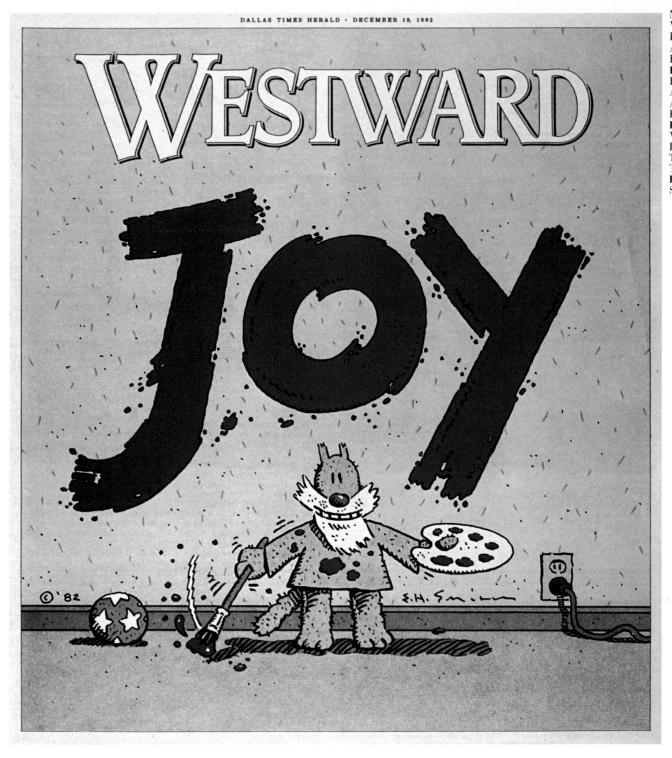

Newspaper Supplement:
Westward
Dec. 19, 1982
Art Director:
Fred Woodward
Designer:
Fred Woodward
Austin, TX
Artist:
Elwood Smith
Publisher:
Westward Magazine/
Dallas Times Herald
Typographer:
Typographics
Printer:
Standard Gravure

Magazine:
California
November 1982
Art Director:
Nancy Butkus
Designer:
Nancy Butkus
Beverly Hills, CA
Photographer:
Bonnie Schiffman
Publisher:
California Magazine
Typographer:
California Magazine
Printer:
Pacific Press

Newspaper Supplement:
California Living
July 17, 1983
Editor:
Leslie Ward
Art Director:
Michael Keegan
Designer:
Massis Araradian
Photographer:
Michael Edwards
Design Firm:
Los Angeles Herald
Examiner
Los Angeles, CA
Publisher:
Los Angeles Herald
Examiner
Printer:
Lienett Co.

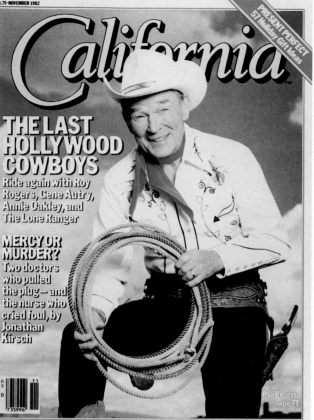

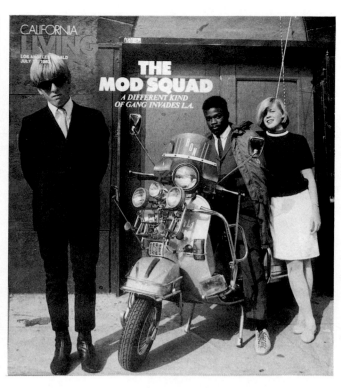

Magazine:
Time, Sept 5, 1983
Art Director:
Rudolph Hoglund
Designer:
Irene Ramp
New York, NY
Artist:
Matt Mahurin
Publisher:
Time, Inc.
Typographer:
Time, Inc.
Copy Processing
Printer:
R. R. Donnelley &
Sons Co.

Magazine:
The Atlantic
January 1983
Art Director:
Judy Garlan
Designer:
Judy Garlan
Boston, MA
Photographer:
Esther Bubley
Publisher:
The Atlantic Monthly
Typographer:
Typographic House
Printer:
Rumford National
Graphics, Inc.

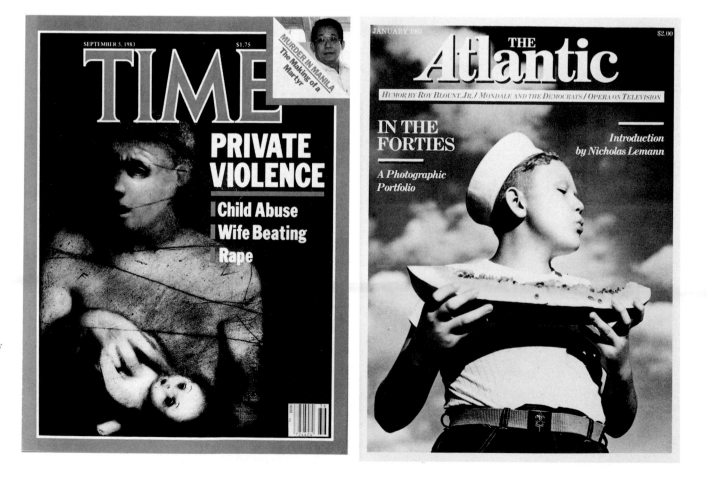

$1.75 · MARCH 1983

INSIDE SAN QUENTIN

California

Hanging Out With
MISS AMERICA
Men, God, and Pasta:
Anaheim's Sweetheart Explains
It All for You, by Kate Coleman

CALIFORNIA UNDER WATER
The Secret World of Tide Pools

MY OAKLAND
There Is a There There,
by Ishmael Reed

0 735996 03

INCORPORATING NEW WEST

Magazine:
California, March 1983
Art Director:
Nancy Butkus
Designer:
Nancy Butkus
Beverly Hills, CA
Photographer:
Helmut Newton
Publisher:
California Magazine
Typographer:
California Magazine
Printer:
Pacific Press

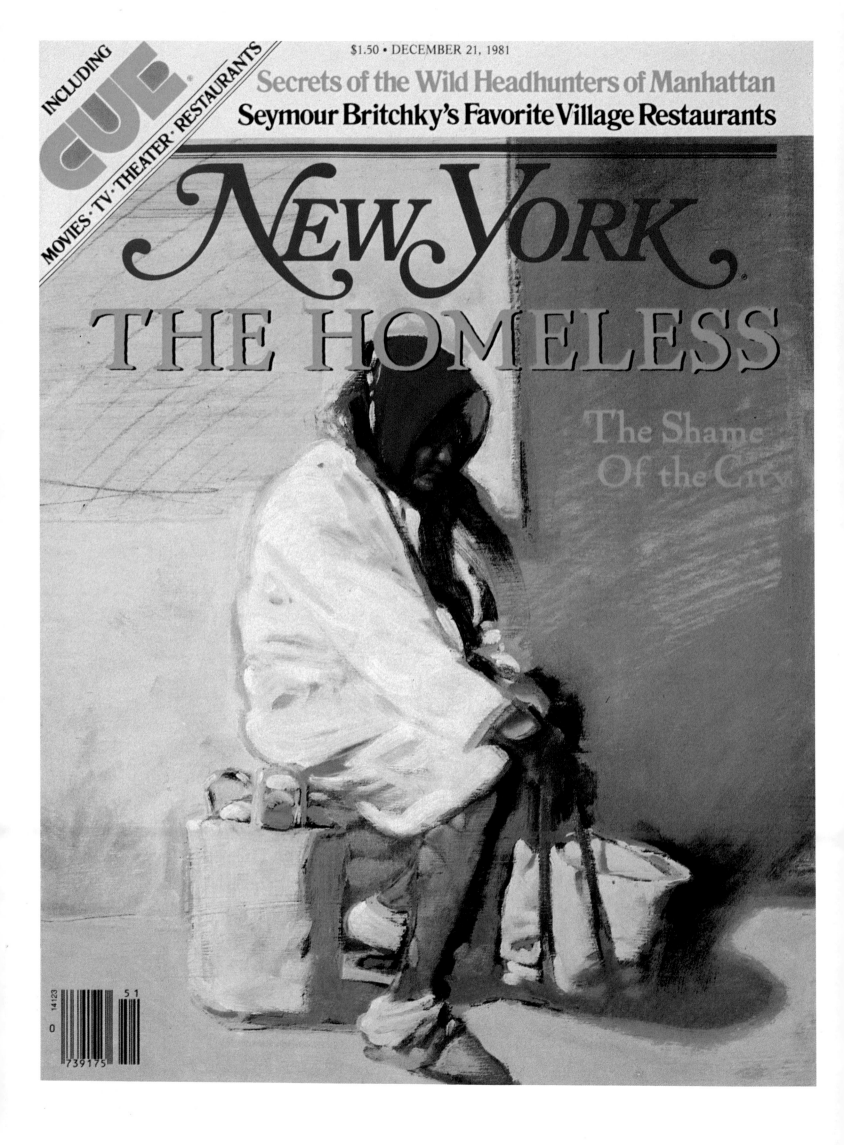

INCLUDING **CUE**

MOVIES · TV · THEATER · RESTAURANTS

$1.50 • DECEMBER 21, 1981

Secrets of the Wild Headhunters of Manhattan

Seymour Britchky's Favorite Village Restaurants

New York

THE HOMELESS

The Shame
Of the City

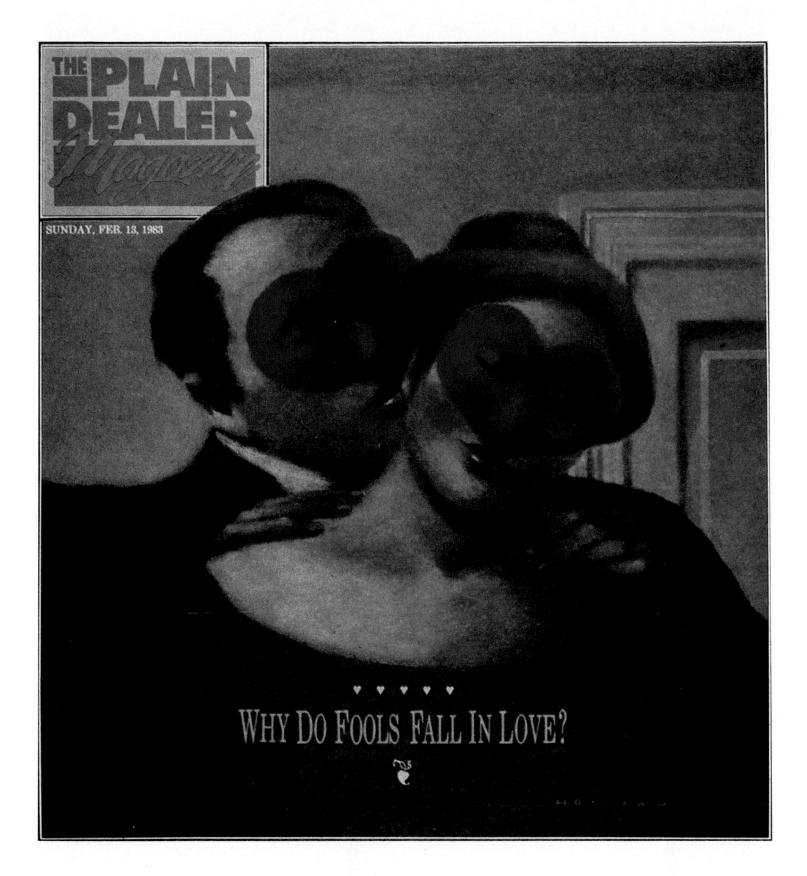

SUNDAY, FEB. 13, 1983

♥ ♥ ♥ ♥ ♥

WHY DO FOOLS FALL IN LOVE?

Magazine:
New York
December 21, 1981
Design Director:
Robert Best
Artist:
Richard Sparks
Design Firm:
New York Magazine
New York, NY
Publisher:
New York Magazine
Printer:
Arcata Graphics

Newspaper Supplement:
The Plain Dealer
Magazine,
February 13, 1983
Art Director:
Greg Paul
Artist:
Brad Holland
Publisher:
The Plain Dealer
Publishing Co.

Record Album:
Toto
Art Director:
Tony Lane
Designer:
Tony Lane
Los Angeles, CA
Artist:
Tony Lane
Publisher:
CBS Records
Printer:
Shorewood Packaging
Corp.

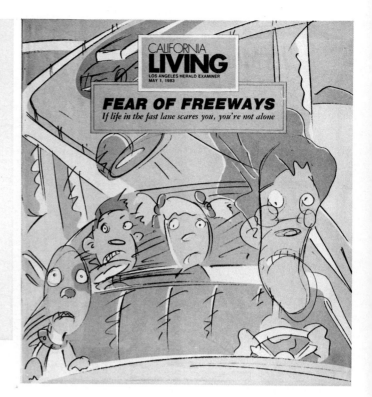

Newspaper Supplement:
California Living
May 1, 1983
Editor:
Leslie Ward
Art Director:
Michael Keegan
Designer:
Massis Araradian
Artist:
Dave Bhang
Design Firm:
Los Angeles Herald
Examiner
Los Angeles, CA
Publisher:
Los Angeles Herald
Examiner
Printer:
Lienett Co.

Annual Report:
Omega Optical Co., Inc.
Annual Report 1981
Art Director:
Woody Pirtle
Designer:
Woody Pirtle
Artists:
Mike Schroeder
Luis Acevedo
Woody Pirtle
Design Firm:
Pirtle Design
Dallas, TX
Client:
Omega Optical Co., Inc.
Typographer:
Southwestern
Typographics

Record Album:
Gary Myrick/Language
Art Director:
Tony Lane
Designer:
Tony Lane
Los Angeles, CA
Artist:
Gary Myrick
Publisher:
CBS Records
Typographer:
It's Enough
Printer:
Shorewood Packaging
Corp.

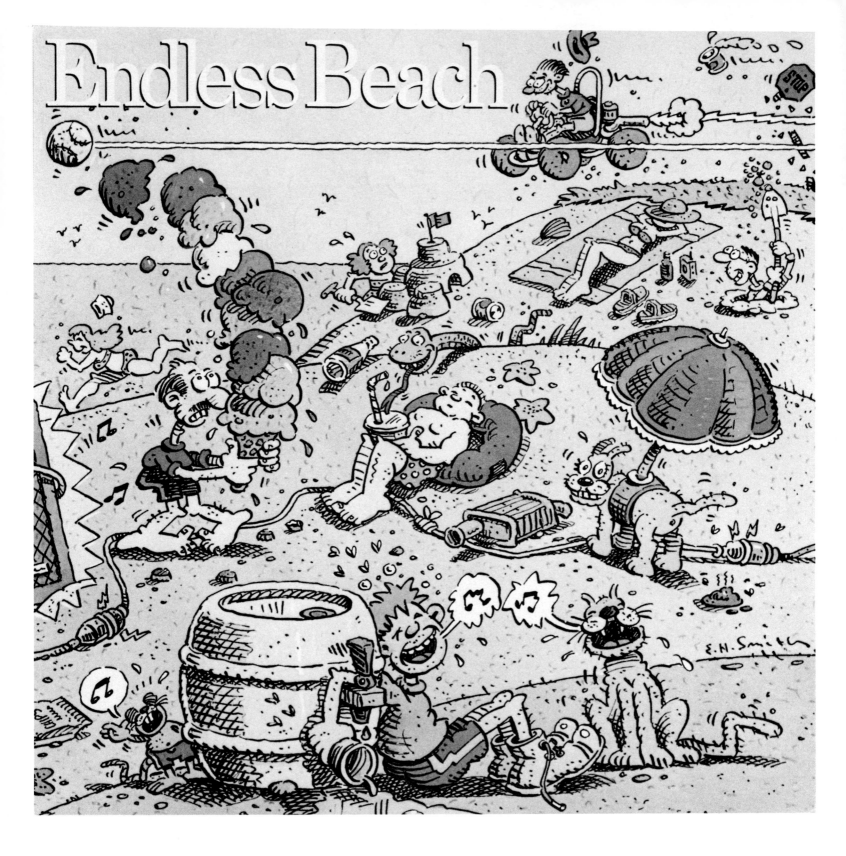

Record Album:
Endless Beach
Art Director:
Paula Scher
Designer:
Paula Scher
New York, NY
Artist:
Elwood Smith
Publisher:
CBS Records
Typographer:
Haber Typographers
Printer:
Shorewood Packaging
Corp.

RED RODNEY and IRA SULLIVAN quintet • SPRINT

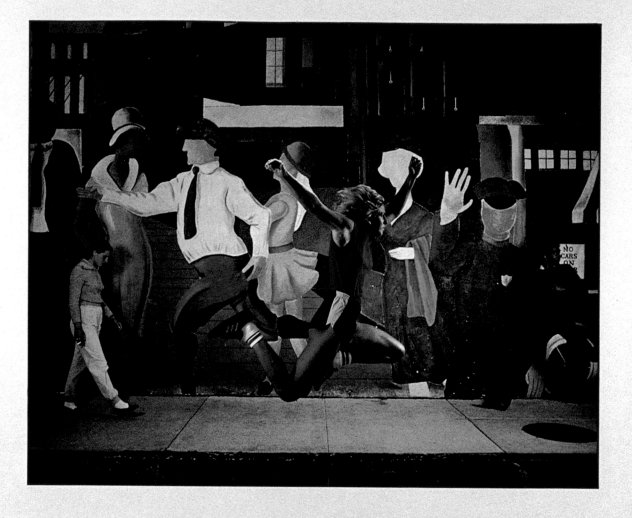

RECORDED LIVE at the JAZZ FORUM

Record Album:
Red Rodney &
Ira Sullivan Quintet
Art Director:
Norm Ung
Designer:
Norm Ung
Redondo Beach, CA
Photographer:
Rumio Sato
Publisher:
Elektra/
Musician Records

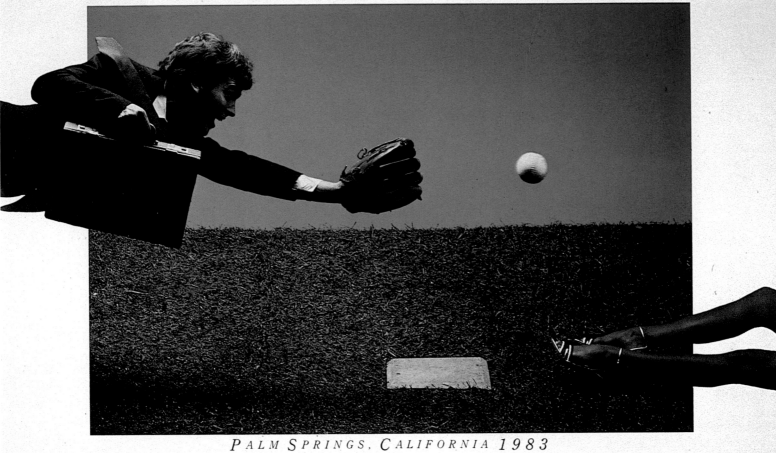

PALM SPRINGS, CALIFORNIA 1983

Program:
The Advertising Softball
World Series
Art Director:
Chris Johnson
Designer:
Chris Johnson
Photographer:
Dick Kaiser
Design Firm:
Chris Johnson
Manhattan Beach, CA
Client:
Los Angeles Advertising
Softball League
Typographer:
Andresen Typographics
Printer:
Southern California
Graphics

Magazine:
Mother Jones
November 1981
Art Director:
Louise Kollenbaum
Designer:
Dian-Aziza Ooka
San Francisco, CA
Photographer:
Eugene Richards
Publisher:
Foundation for National
Progress
Printer:
Quad Printers

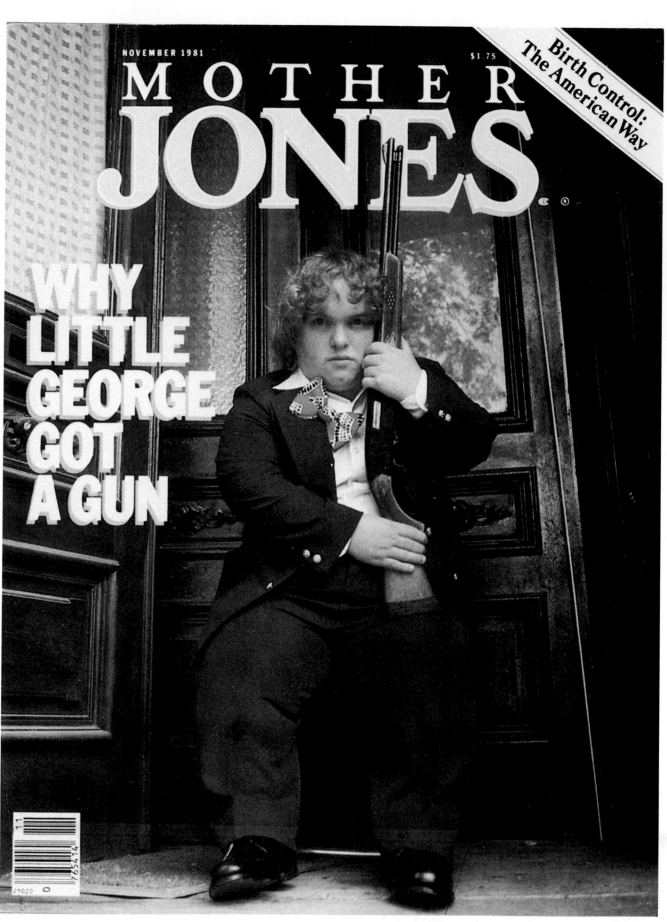

AUGUST 1982
$4.00

GEO

CHILDHOOD'S JOY
AMONG THE AMISH

THE CIVIL WAR:
A SOLDIER'S TALE

HANK AARON'S PATH
TO IMMORTALITY

THE NEW PAINTERS:
HOT, SUCCESSFUL
AND DIVISIVE

Magazine:
GEO, August 1982
Art Director:
Mary K. Baumann
Designer:
Mary K. Baumann
New York, NY
Photographer:
Jerry Irwin
Publisher:
Knapp Publications,
GEO Magazine

Annual Report
Best Times Co., Inc.,
Annual Report 1982
Art Directors:
Rob Carter
Tim Priddy
Designers:
Rob Carter
Tim Priddy
Photographer:
Randy Green
Design Firm:
Best Products Design
Dept.
Richmond, VA
Publisher:
Best Products Co., Inc.
Typographer:
Riddick Advertising Art
Printer:
W. M. Brown & Son

In-house Magazine:
Best Times
October 1983
Art Director:
Rob Carter
Designer:
Rob Carter
Artist:
Mallory Callan
Design Firm:
Rob Carter Design
Richmond, VA
Client:
Best Products Co., Inc.
Typographer:
Type Time
Printer:
Mobility, Inc.

Menu:
Dalts Reflections of
Summer
Art Directors:
Mike Schroeder
Woody Pirtle
Designer:
Mike Schroeder
Artist:
Mike Schroeder
Design Firm:
Pirtle Design
Dallas, TX
Client:
T.G.I. Friday's, Inc.
Typographer:
Southwestern
Typographics
Printer:
Allcraft Printing

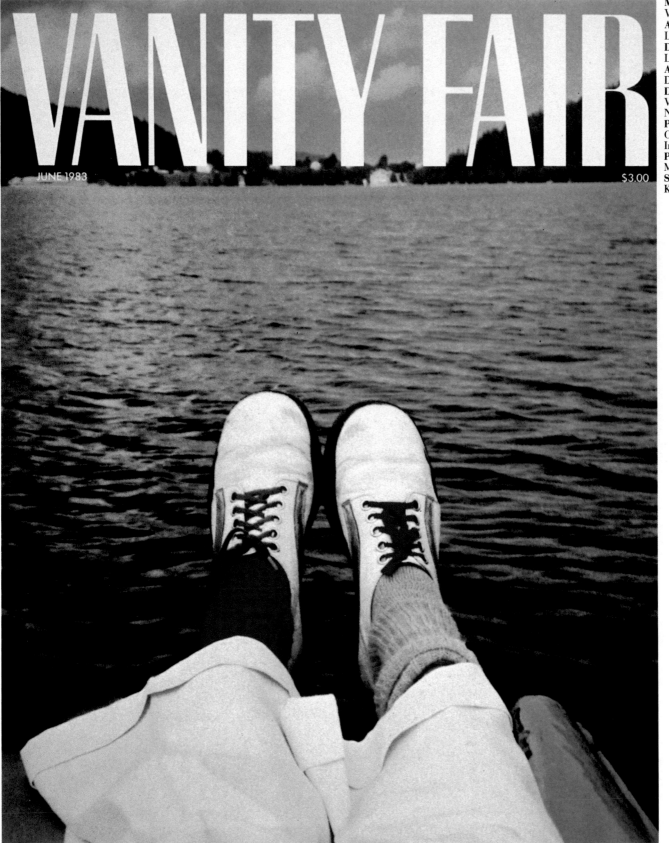

VANITY FAIR

Magazine:
Vanity Fair, June 1983
Art Director:
Lloyd Ziff
Designer:
Lloyd Ziff
Artist:
David Hockney
Design Firm:
Vanity Fair Magazine
New York, NY
Publisher:
Conde Nast Publications
Inc.
Printer:
Meredith-Burda
Separations:
Kordet Color Corp.

JUNE 1983

$3.00

MOHOLY-NAGY
FOTOPLASTIKS:
THE BAUHAUS YEARS

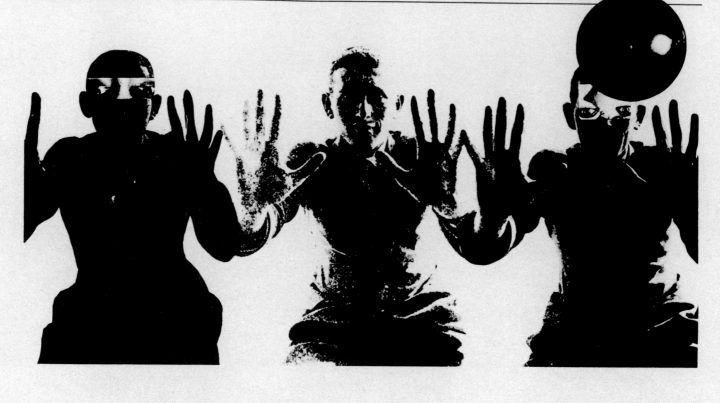

Catalogue:
Moholy Nagy/Fotoplastik/
The Bauhaus Years
Art Director:
Sally Rub
Designer:
Sally Rub
Photographer:
Moholy-Nagy
Design Firm:
Harris & Rub
New York, NY
Publisher:
The Bronx Museum
of the Arts
Typographer:
Fototype Factory
Printer:
Perni Color Process
Corp.

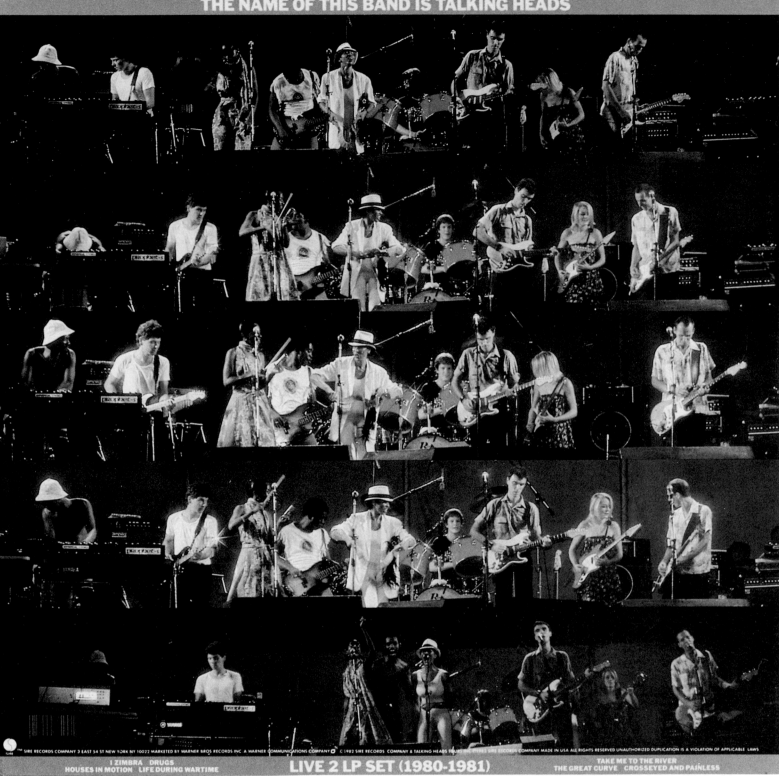

THE NAME OF THIS BAND IS TALKING HEADS

LIVE 2 LP SET (1980-1981)

I ZIMBRA DRUGS
HOUSES IN MOTION LIFE DURING WARTIME

TAKE ME TO THE RIVER
THE GREAT CURVE CROSSEYED AND PAINLESS

Record Album:
The Name of This Band
Is Talking Heads
Art Director:
Tibor Kalman
Designer:
Carol Bokuniewicz
Photographers:
John Dalton
Lynn Goldsmith
Design Firm:
M & Co.
New York, NY
Client:
Sire Records

Magazine:
Industrial Launderer
March 1983
Art Director:
Jack Lefkowitz
Designer:
Jack Lefkowitz
Artist:
Jack Lefkowitz
Design Firm:
Jack Lefkowitz, Inc.
Leesburg, VA
Publisher:
Industrial Launderer
Typographer:
Jack Lefkowitz, Inc.
Printer:
Benton Review Pub.
Co., Inc.

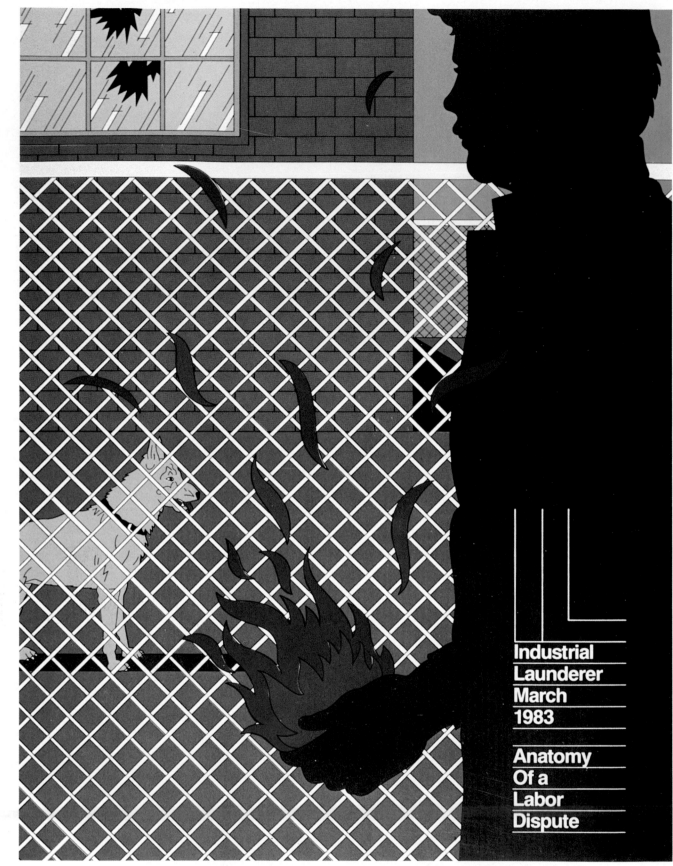

Industrial
Launderer
March
1983

Anatomy
Of a
Labor
Dispute

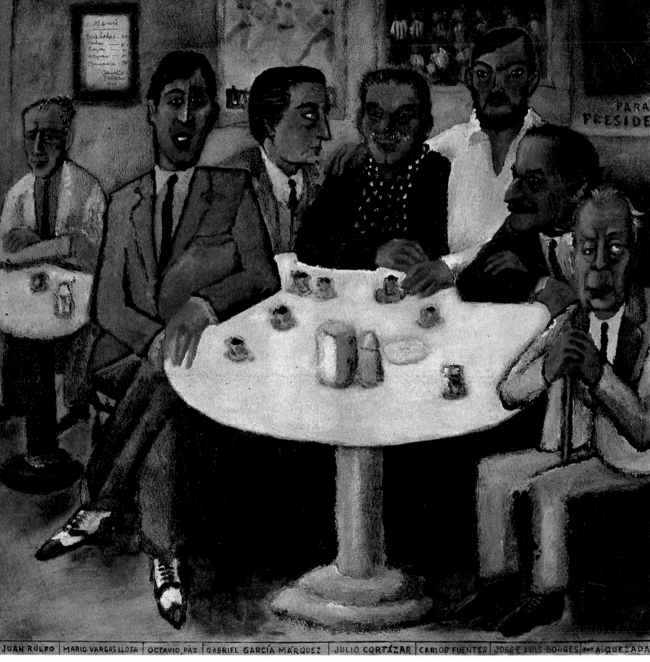

Revolution and the Intellectual in Latin America

BY ALAN RIDING

JUAN RULFO | MARIO VARGAS LLOSA | OCTAVIO PAZ | GABRIEL GARCÍA MÁRQUEZ | JULIO CORTÁZAR | CARLOS FUENTES | JORGE LUIS BORGES | Por A. QUEZADA

Newspaper Supplement:
The New York Times
Magazine,
March 13, 1983
Art Director:
Roger Black
Designer:
Roger Black
New York, NY
Artist:
Abel Quezada
Publisher:
The New York Times
Typographer:
IGI, Innovative Graphics
International
Printer:
R. R. Donnelley &
Sons Co.

The Cover Show 113

Magazine:
Business Week
October 31, 1983
Art Director:
John R. Vogler
Designer:
John R. Vogler
Photographer:
John Ficara/
Woodfin Camp & Assoc.
Design Concept:
B. Martin Pedersen
Jonson Pedersen
Hinrichs
& Shakery, Inc.
New York, NY
Publisher:
Business Week/
McGraw-Hill, Inc.
Typographer:
Cyber Graphics, Inc.
Printer:
W.A. Kreuger & Co.

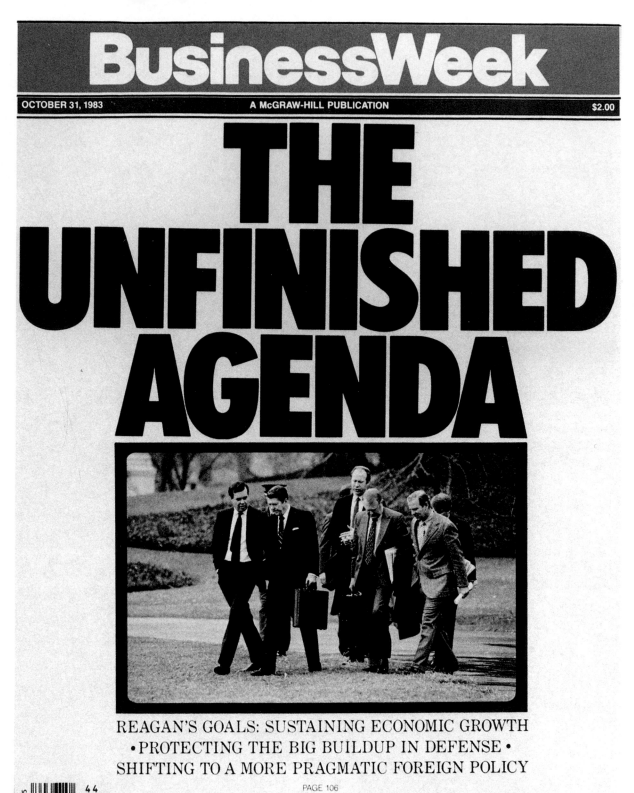

BusinessWeek

OCTOBER 31, 1983 — A McGRAW-HILL PUBLICATION — $2.00

THE UNFINISHED AGENDA

REAGAN'S GOALS: SUSTAINING ECONOMIC GROWTH
• PROTECTING THE BIG BUILDUP IN DEFENSE •
SHIFTING TO A MORE PRAGMATIC FOREIGN POLICY

PAGE 106

0 14115

44

743675

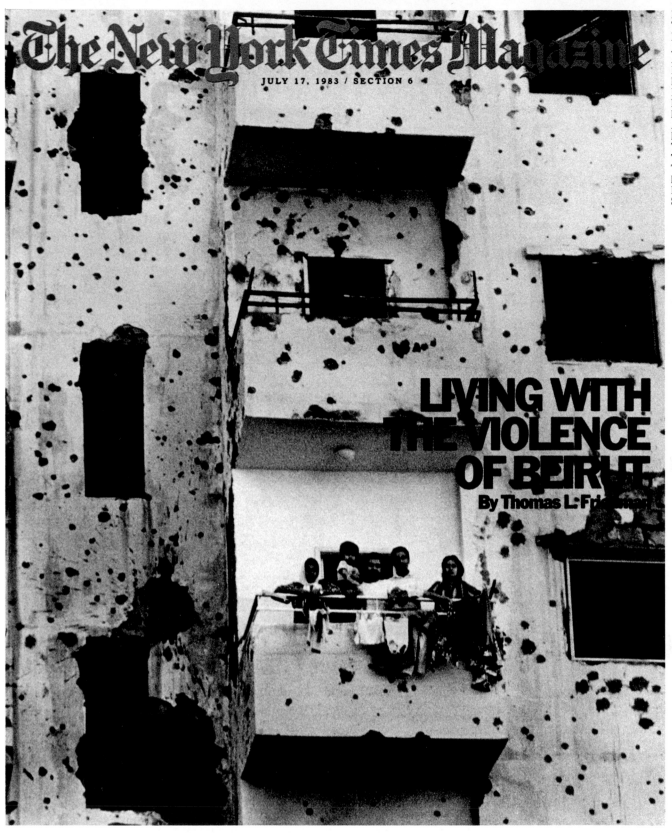

The New York Times Magazine

JULY 17, 1983 / SECTION 6

LIVING WITH THE VIOLENCE OF BEIRUT

By Thomas L. Friedman

Newspaper Supplement:
The New York Times
Magazine,
July 17, 1983
Art Director:
Roger Black
Designer:
Roger Black
New York, NY
Photographer:
Alain Nogues/Sygma
Publisher:
The New York Times
Typographer:
The New York Times
Printer:
R. R. Donnelley &
Sons Co.

Marshall Crenshaw

Record Album:
Marshall Crenshaw
Art Directors:
Spencer Drate
Gary Greene
Designer:
Spencer Drate
Photographer:
Gary Greene
Colorist:
Christinade Lancie
Design Firm:
Dratedesign, Inc.
New York, NY
Client:
Warner Bros. Records
Typographer:
Graphic Word
Printer:
Queens Litho

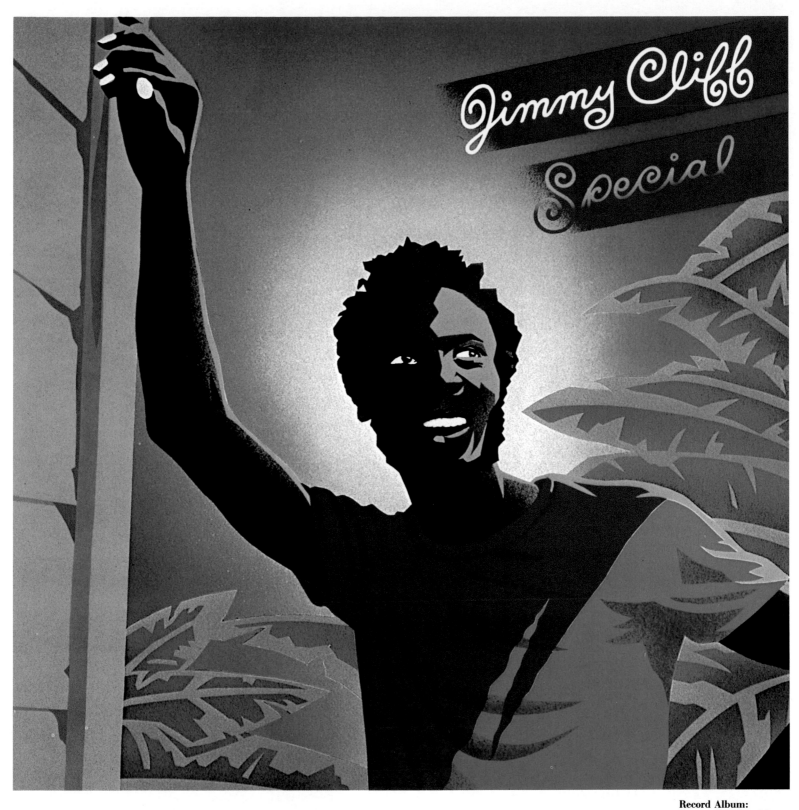

Record Album:
Jimmy Cliff/Special
Art Director:
John Berg
Designer:
Peter A. Alfieri
New York, NY
Artist:
Timothy Eames
Publisher:
CBS Records
Typographer:
Haber Typographers
Printer:
Shorewood Packaging
Corp.

Magazine:
Art Direction Magazine
Art Directors:
Carol Bokuniewicz
Tibor Kalman
Designer:
Carol Bokuniewicz
Artist:
Carol Bokuniewicz
Design Firm:
M & Co.
New York, NY
Client:
Art Direction Magazine

Annual Report:
Champion International
Corporation '82
Designer:
Richard Hess
Stamford, CT
Photographer:
Tom Hollyman
Publisher:
Champion International
Corp.
Typographer:
Franklin Typographers
Inc.
Printer:
Case-Hoyt Corp.

In-house Magazine:
Cornell
Art Director:
Robert Qually
Designer:
Robert Qually
Artist:
Bob Schanker
Design Firm:
Qually & Co., Inc.
Chicago, IL
Client:
Wayne Revord
Publisher:
Cornell Forge Co.
Typographer:
House of Typography
Printer:
Rohner Printing Co.

Catalogue:
Peterbilt Parts &
Accessories
Art Directors:
Doug Akagi
Steven Bragato
Designers:
Doug Akagi
Steven Bragato
Photographer:
George Selland
Design Firm:
The GNU Group
Sausalito, CA
Client:
Peterbilt Motors Co.
Typographer:
Spartan Typographers
Printer:
Continental Graphics

118

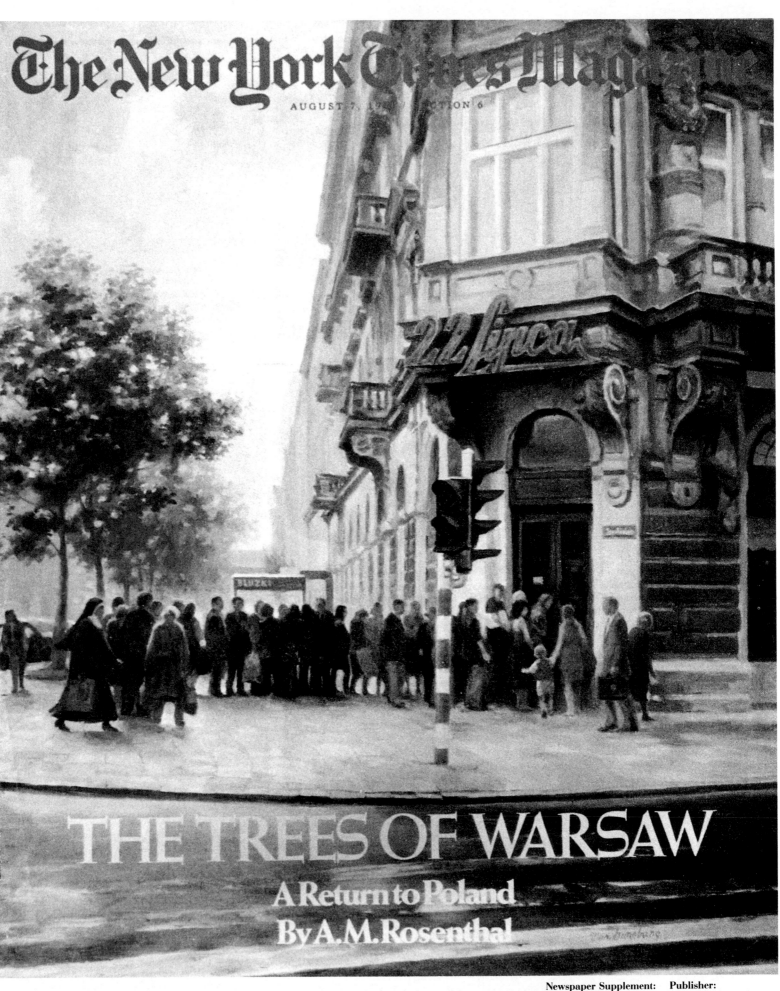

The New York Times Magazine

AUGUST 7, ... SECTION 6

THE TREES OF WARSAW

A Return to Poland
By A. M. Rosenthal

Newspaper Supplement:
The New York Times
Magazine,
August 7, 1983
Art Director:
Roger Black
Designer:
Roger Black
New York, NY
Artist:
Max Ginsburg

Publisher:
The New York Times
Typographer:
IGI, Innovative Graphics
International
Printer:
R. R. Donnelley &
Sons Co.

The Cover Show 119

Magazine:
Print, May/June 1982
Art Director:
Andrew Kner
New York, NY
Designer:
Jean-Jacques Sempé
Artist:
Jean-Jacques Sempé
Publisher:
RC Publications
Typographer:
Latent Lettering
Printer:
Lucas Litho, Inc.

Newspaper:
The Boston Globe
Magazine
January 10, 1982
Art Director:
Ronn Campisi
Designer:
Ronn Campisi
Boston, MA
Artist:
Marty Braun
Publisher:
Globe Newspaper Co.
Printer:
Providence Gravure

Magazine:
House & Garden
September 1983
Art Director:
Lloyd Ziff
Designer:
Lloyd Ziff
Photographer:
Oberto Gili
Design Firm:
House & Garden
Magazine
New York, NY
Publisher:
Conde Nast Publications
Inc.
Printer:
Seiple Lithograph Co.

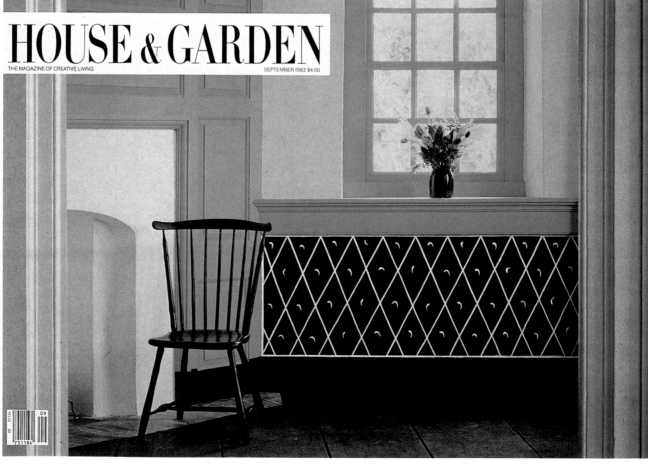

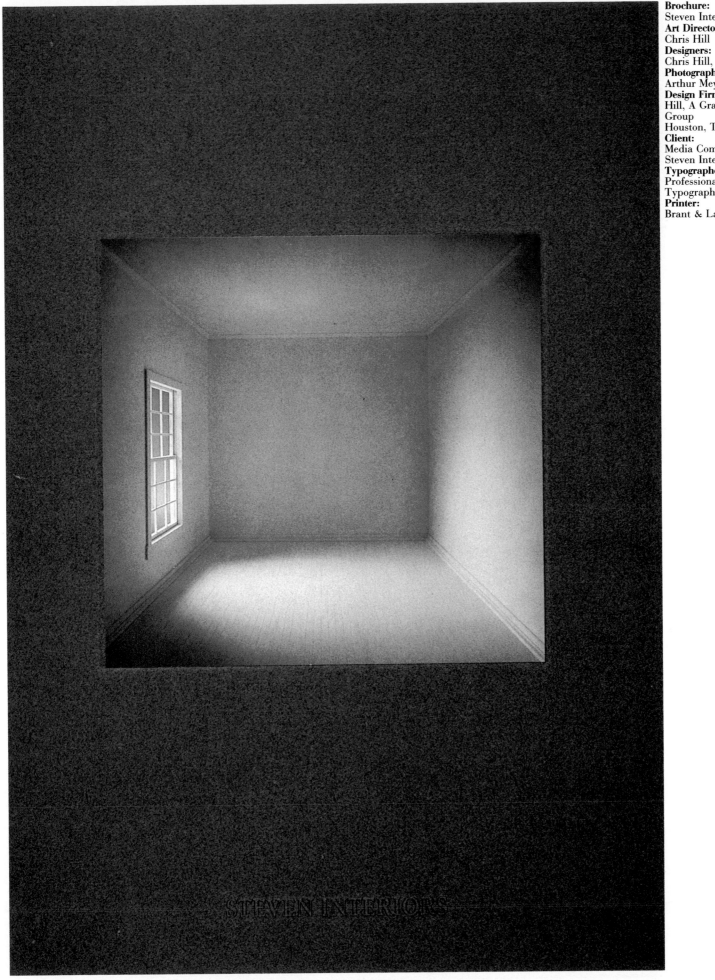

Brochure:
Steven Interiors
Art Director:
Chris Hill
Designers:
Chris Hill, Joe Rattan
Photographer:
Arthur Meyerson
Design Firm:
Hill, A Graphic Design
Group
Houston, TX
Client:
Media Communications/
Steven Interiors
Typographer:
Professional
Typographers, Inc.
Printer:
Brant & Lawson

Catalogue:
HBF Furniture Series
Art Director:
Michael Vanderbyl
Designer:
Michael Vanderbyl
Design Firm:
Vanderbyl Design
San Francisco, CA
Client:
Hickory Business
Furniture Co.

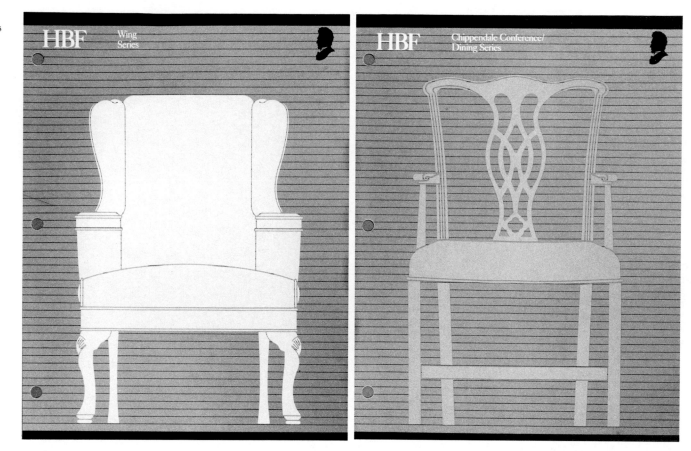

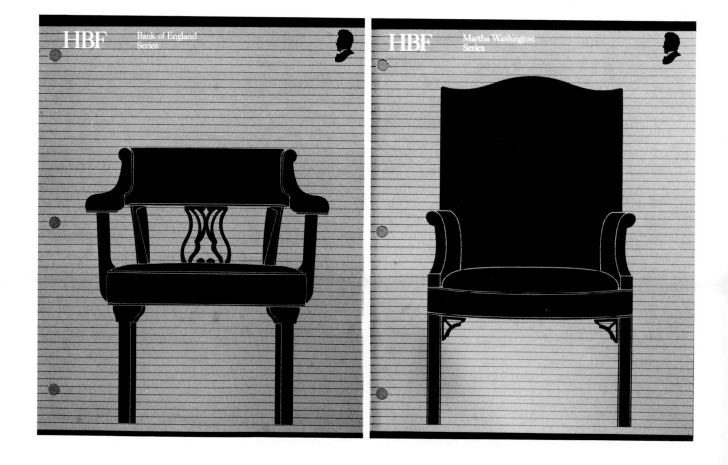

122

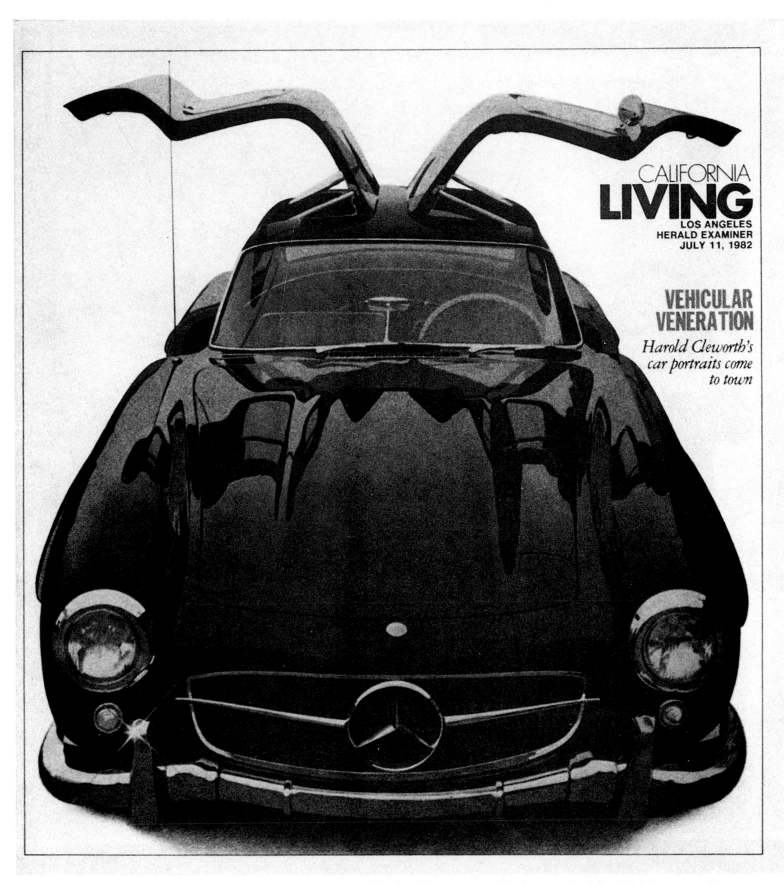

CALIFORNIA
LIVING
LOS ANGELES
HERALD EXAMINER
JULY 11, 1982

VEHICULAR
VENERATION

*Harold Cleworth's
car portraits come
to town*

Newspaper Supplement:
California Living
July 11, 1982
Editor:
Wanda Urbanska
Art Director:
Michael Keegan
Designer:
Massis Araradian

Photographers:
Harold Cleworth
Michael Haering
Design Firm:
Los Angeles Herald
Examiner
Los Angeles, CA
Publisher:
Los Angeles Herald
Examiner
Printer:
Lienett Co.

Calendar:
The Museum of Modern
Art, 1983 Calendar
Art Director:
Antony Drobinski
Designer:
Melissa Feldman
Artist:
Red Grooms
Design Firm:
The Museum of Modern
Art
New York, NY
Publisher:
The Museum of Modern
Art
Typographer:
Custom Composition
Co.
Printer:
Rapoport Printing Co.

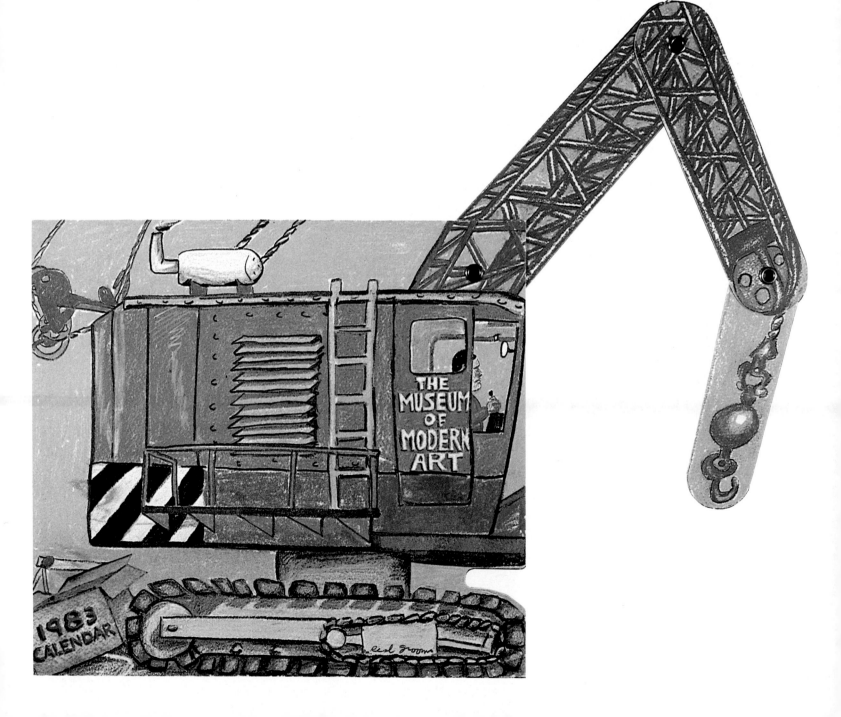

Catalogue:
Clarion Car Audio
Art Director:
Hinsche + Associates
Designer:
Hinsche + Associates
Photographer:
Steven Hulén
Design Firm:
Hinsche + Associates
Client:
Clarion Corp. of America
Typographer:
Skil-Set
Printer:
George Rice & Sons

Newspaper Supplement:
The New York Times
Travel Section,
December 20, 1981
Art Directors:
Louis Silverstein
Tom Bodkin
Designers:
Louis Silverstein
Tom Bodkin
New York, NY
Engravings:
Culver Pictures, Inc.
Photographers:
Claus Meyer/Black Star:
Paddy O'Dea
Publisher:
The New York Times
Typographer:
The New York Times
Printer:
The New York Times

Newspaper Supplement:
The New York Times
Living Section
October 20, 1982
Art Director:
Nancy Kent
Designer:
Nancy Kent
New York, NY
Artist:
Nancy Stahl
Publisher:
The New York Times
Typographer:
The New York Times
Printer:
The New York Times

Newspaper Supplement:
The New York Times
Home Section,
September 10, 1981
Art Director:
Tom Bodkin
Designer:
Tom Bodkin
New York, NY
Photographer:
Robert Levin/NYT
Publisher:
The New York Times
Typographer:
The New York Times
Printer:
The New York Times

Newspaper Supplement:
The New York Times
Travel Section,
May 1, 1983
Art Director:
Tom Bodkin
Designer:
Tom Bodkin
New York, NY
Publisher:
The New York Times
Typographer:
The New York Times
Printer:
The New York Times

Newspaper Supplement:
The New York Times
Magazine,
March 27, 1983
Art Directors:
Roger Black
Ken Kendrick
Designer:
Roger Black
New York, NY
Artist:
David Hockney
Publisher:
The New York Times
Typographer:
IGI, Innovative Graphics
International
Printer:
R. R. Donnelley &
Sons Co.

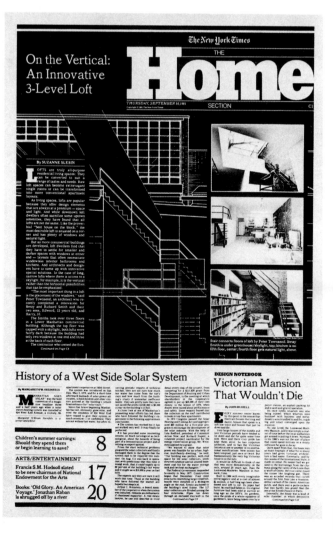

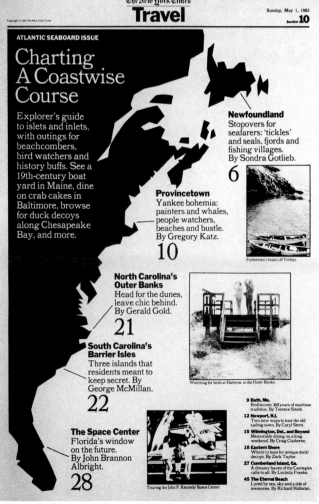

The New York Times Magazine

MARCH 27, 1983/SECTION 6

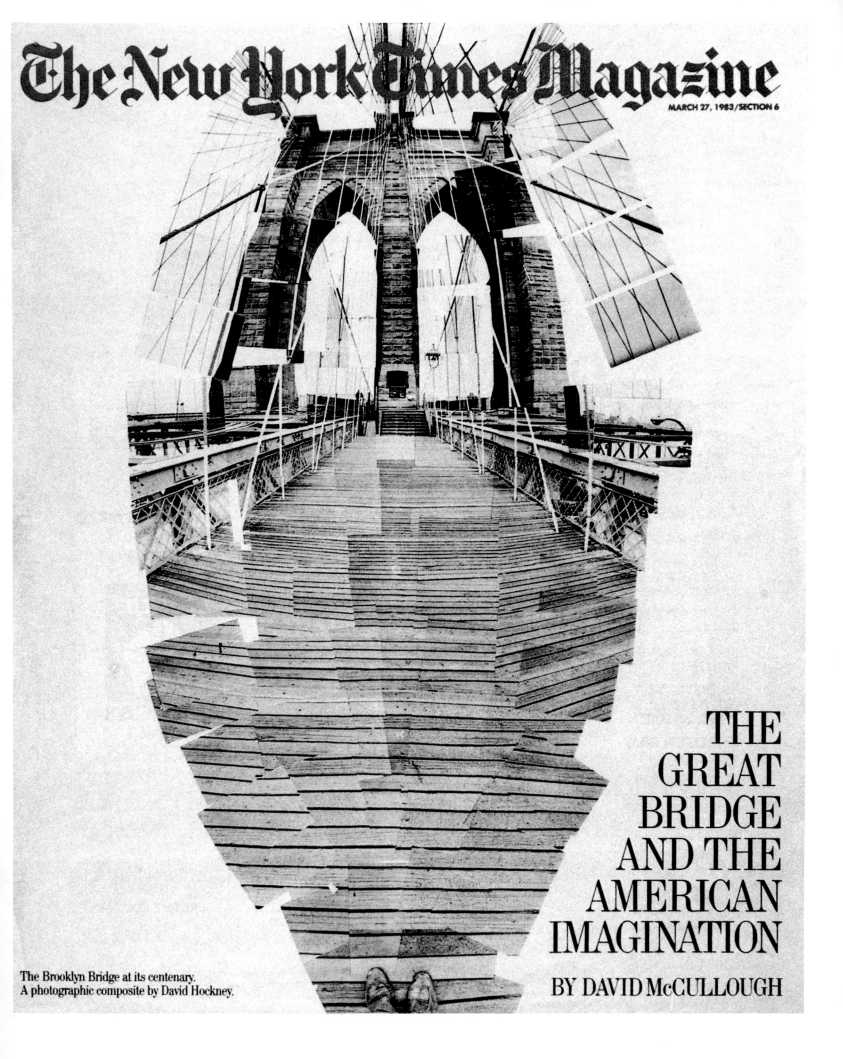

The Brooklyn Bridge at its centenary.
A photographic composite by David Hockney.

THE GREAT BRIDGE AND THE AMERICAN IMAGINATION

BY DAVID McCULLOUGH

Magazine:
Industrial Launderer
March 1982
Art Director:
Jack Lefkowitz
Designer:
Jack Lefkowitz
Artist:
Jack Lefkowitz
Design Firm:
Jack Lefkowitz, Inc.
Leesburg, VA
Publisher:
Industrial Launderer
Typographer:
Jack Lefkowitz, Inc.
Printer:
Benton Review Pub.
Co., Inc.

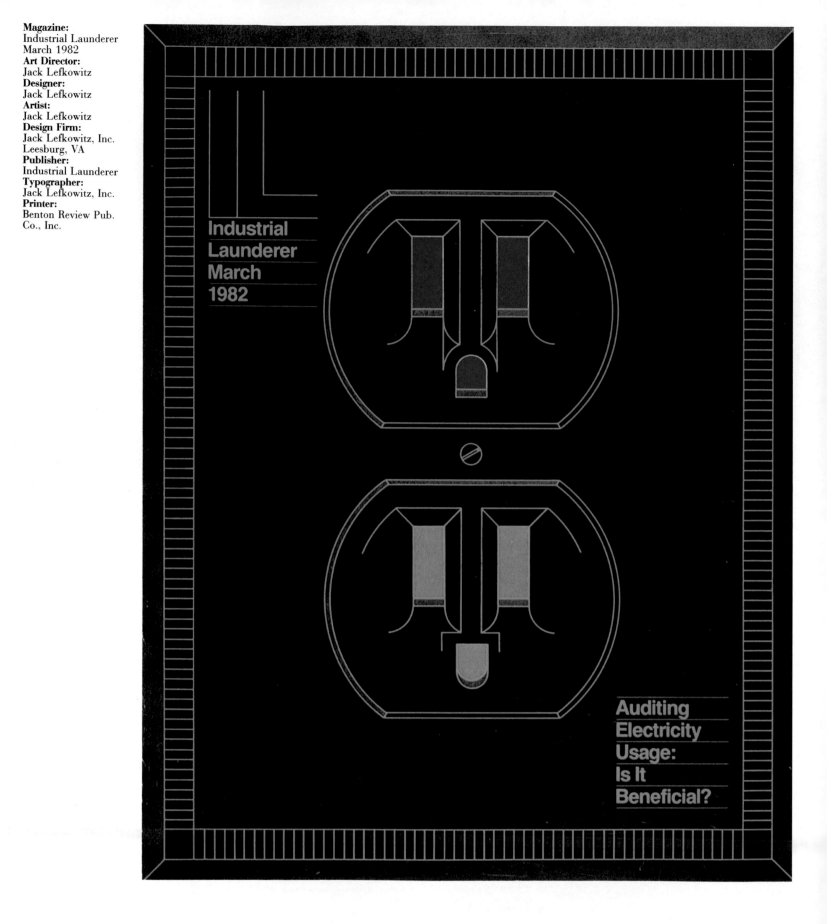

Industrial
Launderer
March
1982

Auditing
Electricity
Usage:
Is It
Beneficial?

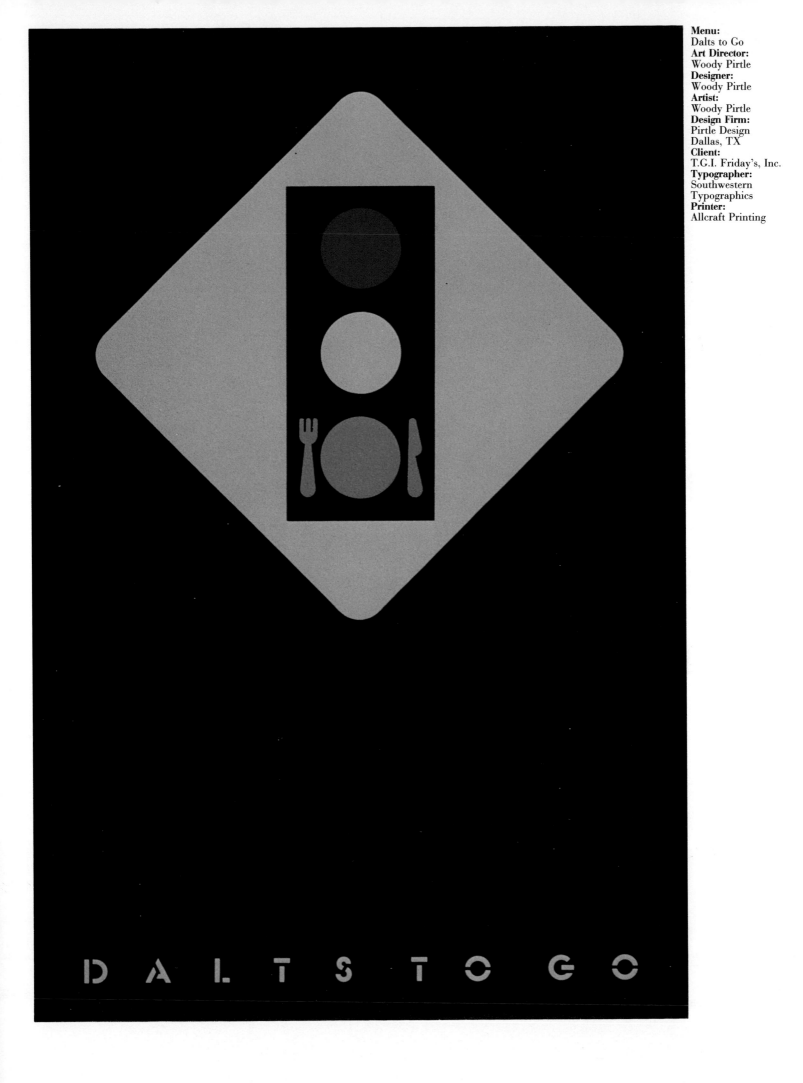

Menu:
Dalts to Go
Art Director:
Woody Pirtle
Designer:
Woody Pirtle
Artist:
Woody Pirtle
Design Firm:
Pirtle Design
Dallas, TX
Client:
T.G.I. Friday's, Inc.
Typographer:
Southwestern
Typographics
Printer:
Allcraft Printing

Record Album:
Billy Cobham's
Glass Menagerie
Art Directors:
Ron Coro, Norm Ung
Redondo Beach, CA
Designer:
John Barr
Photographer:
Michael Kenna
Publisher:
Elektra/
Musician Records

Newspaper Supplement:
The New York Times
Magazine,
August 15, 1982
Art Director:
Roger Black
Designer:
Roger Black
New York, NY
Artist:
Max Ginsburg
Publisher:
The New York Times
Typographer:
IGI, Innovative Graphics
International
Printer:
R. R. Donnelley &
Sons Co.

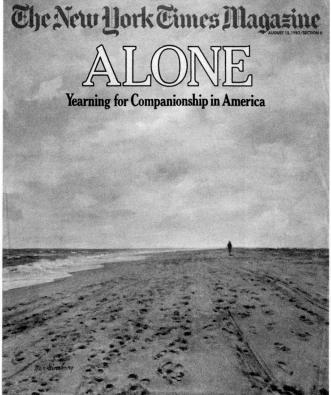

Newspaper:
The Boston Globe
Magazine
June 12, 1983
Art Director:
Ronn Campisi
Designer:
Ronn Campisi
Boston, MA
Artist:
West Berlin 10-year-old
Publisher:
Globe Newspaper Co.
Printer:
Providence Gravure

Record Album:
Bill Evans:
The Paris Concert
Art Director:
Norm Ung
Designer:
Norm Ung
Redondo Beach, CA
Photographer:
Henri Cartier-Bresson
Publisher:
Elektra/
Musician Records

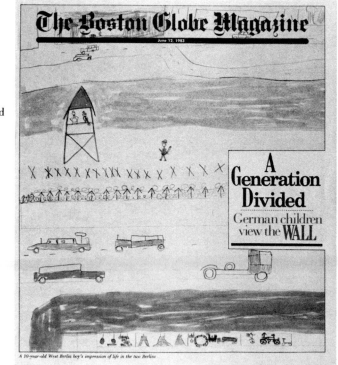

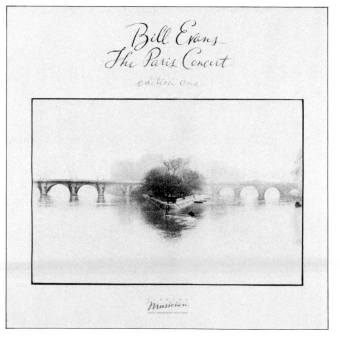

CONTEMPORARY ARTS MUSEUM

Houston, Texas

ANNUAL REPORT October 1980 September 1981

Annual Report:
Contemporary Arts
Museum, Annual Report
October 1980–
September 1981
Art Director:
Eric Morrell
Designer:
Cinda Debbink
Photographer:
Ansel Adams
Design Firm:
Creel Morrell, Inc.
Houston, TX
Client:
Contemporary Arts
Museum
Typographer:
G & S Typesetters
Printer:
Printmasters, Inc.

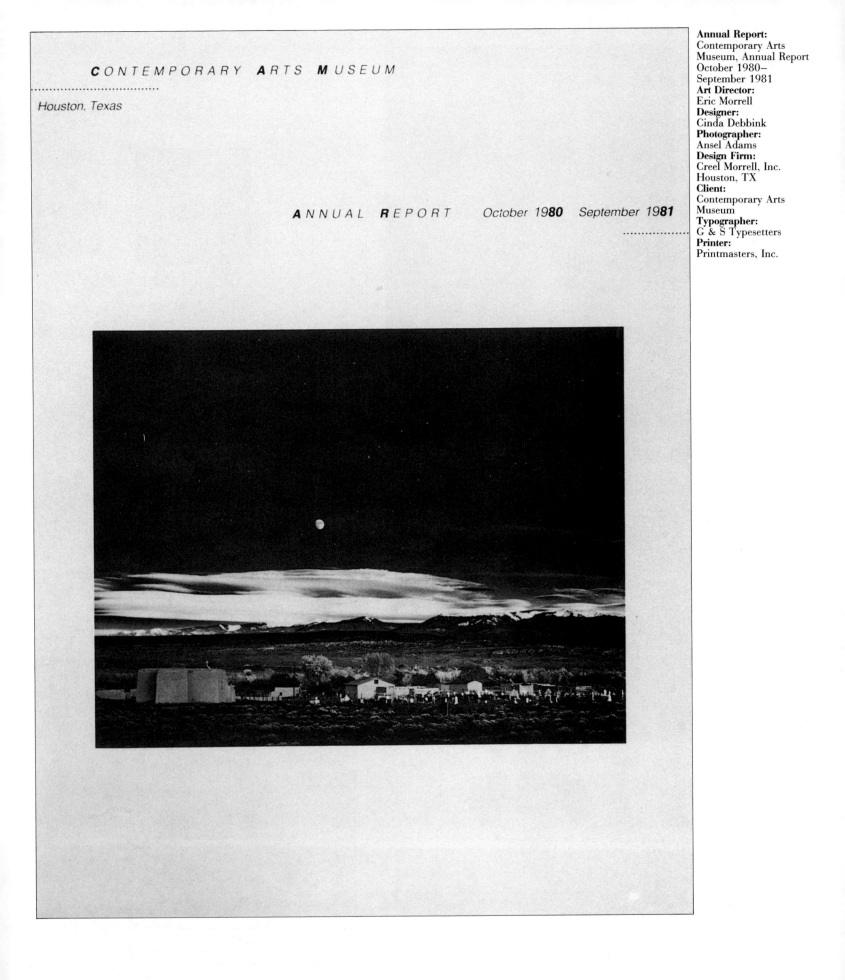

Magazine:
Fine Print
Vol. 9 Number 3,
July 1983
Art Director:
Marie Carluccio
Designer:
Wesley B. Tanner
Artist:
Wesley B. Tanner
Design Firm:
Marie Carluccio Design
San Francisco, CA
Publisher:
Fine Print/
Sandra Kirshenbaum
Typographer:
Wesley B. Tanner
Printer:
Wesley B. Tanner/
Arif Press

Menu:
Sweetish Hill Restaurant
Art Director:
David Shapiro
Designer:
Mike Hicks
Artist:
Mike Hicks
Design Firm:
Hixo, Inc.
Austin, TX
Client:
Sweetish Hill Restaurant
Printer:
Printmasters

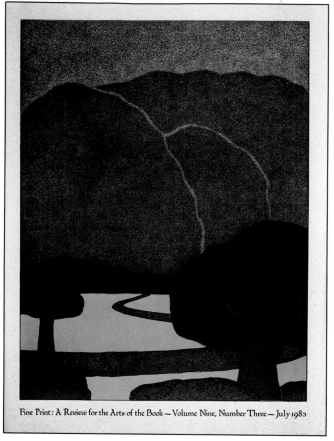

Fine Print: A Review for the Arts of the Book — Volume Nine, Number Three — July 1983

In-house Magazine:
The Barry 6-Color Press
Art Director:
Craig Frazier
Designer:
Craig Frazier
San Francisco, CA
Artist:
Conrad Jorgensen
Client:
James M. Barry, Printers
Typographer:
Omnicomp
Printer:
James M. Barry, Printers

Brochure:
Williamson Printing
Company
Art Director:
Woody Pirtle
Designer:
Woody Pirtle
Design Firm:
Pirtle Design
Dallas, TX
Client:
Williamson Printing Co.
Typographer:
Southwestern
Typographics
Printer:
Williamson Printing Co.

The
Barry
6-Color
Press

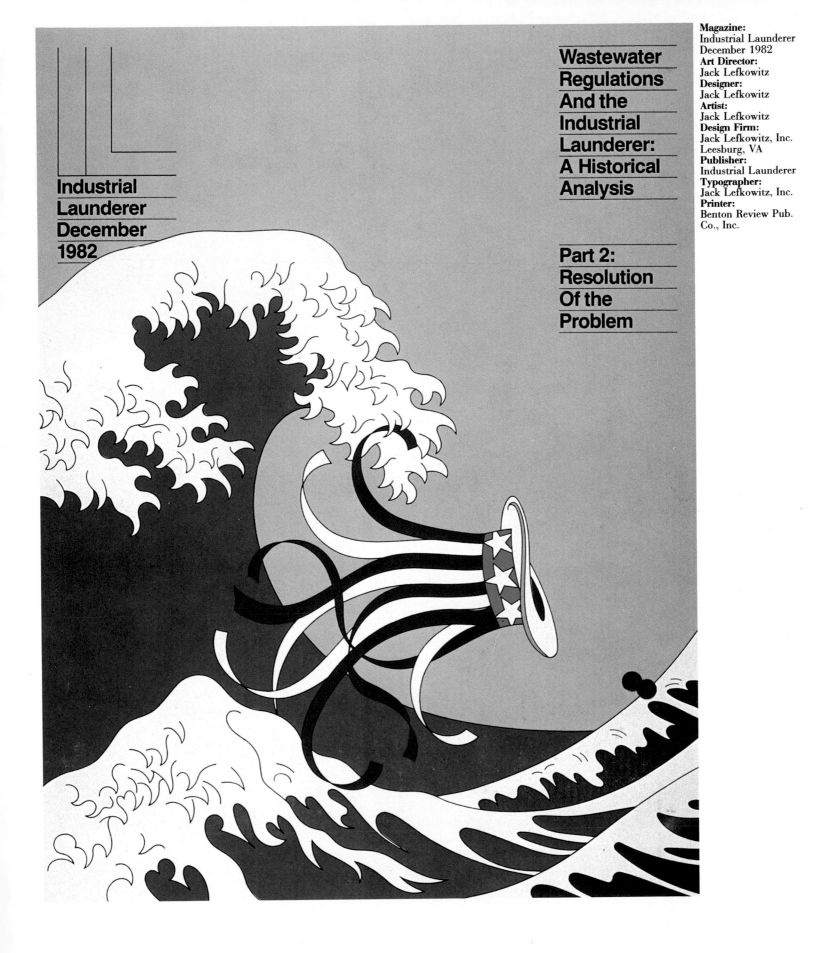

Magazine:
Industrial Launderer
December 1982
Art Director:
Jack Lefkowitz
Designer:
Jack Lefkowitz
Artist:
Jack Lefkowitz
Design Firm:
Jack Lefkowitz, Inc.
Leesburg, VA
Publisher:
Industrial Launderer
Typographer:
Jack Lefkowitz, Inc.
Printer:
Benton Review Pub.
Co., Inc.

IL

Industrial
Launderer
December
1982

Wastewater
Regulations
And the
Industrial
Launderer:
A Historical
Analysis

Part 2:
Resolution
Of the
Problem

Annual Report:
Lomas Nettleton
Mortgage Investors, 1983
Art Director:
Ron Sullivan
Designer:
Ron Sullivan
Photographer:
Andy Post
Design Firm:
Richards, Sullivan,
Brock & Assoc.
Dallas, TX
Client:
Lomas & Nettleton
Mortgage Investors
Typographer:
Chiles & Chiles
Printer:
Heritage Press

Record Album:
Tommy Tutone
Art Director:
Tony Lane
Designer:
Tony Lane
Los Angeles, CA
Photographer:
Bob Seidemann
Publisher:
CBS Records
Printer:
Shorewood Packaging
Corp.

Promotional Binder:
Foster City, California
Art Directors:
David Gauger
Bob Ankers
Designers:
Bob Ankers
David Gauger
Design Firm:
Gauger Sparks Silva, Inc.
San Francisco, CA
Client:
Dividend Development
Corp.
Typographer:
Omnicomp
Printer:
Venture Graphics
Solzer & Hall, Inc.

Brochure:
J. Steve Nail
Art Director:
Hap Owen
Designer:
Rebecca Olack
Artist:
Rebecca Olack
Design Firm:
Communication Arts Co.
Jackson, MS
Client:
J. Steve Nail
Typographer:
Graphic Reproductions
Printer:
Franklin Printers

LOMAS & NETTLETON MORTGAGE INVESTORS 1983 ANNUAL REPORT

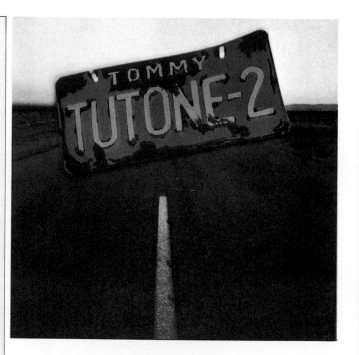

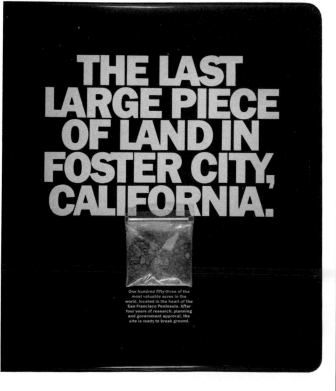

The New York Times Magazine

SEPTEMBER 19, 1982/SECTION 6

Newspaper Supplement:
The New York Times Magazine, September 19, 1982
Art Director:
Roger Black
Designer:
Diana LaGuardia
New York, NY
Photographer:
Sara Krulwich
Publisher:
The New York Times
Typographers:
IGI, Innovative Graphics International
The New York Times
Printer:
R. R. Donnelley & Sons Co.

I went dancing the night before in a black velvet Paris gown, on one of those evenings that was the glamour of New York epitomized. I was blissfully asleep by 3 A.M. Twenty-four hours later, I lay dying, my fingers and legs darkening with gangrene. . . . I have typed the thousands of words of this article, slowly and with difficulty, once again able to practice my craft as a reporter. I have written it—at last—with my own hands.

TOXIC SHOCK

By Nan Robertson

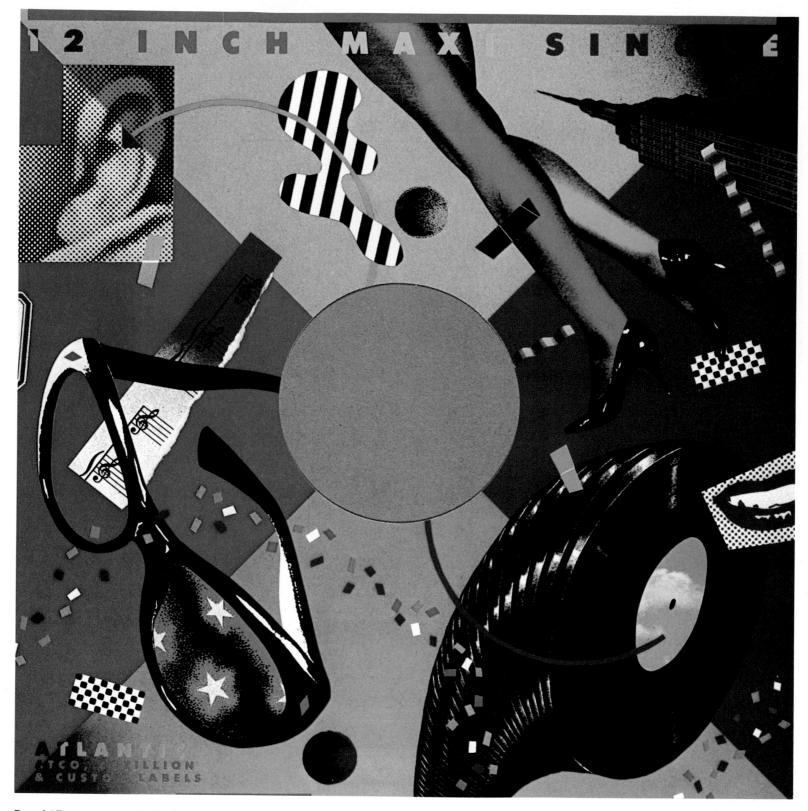

Record Album:
12 Inch Maxi Single
Art Director:
Karen Katz
Artist:
Gene Greif
Design Firm:
Atlantic Records
New York, NY
Publisher:
Atlantic Records
Typographer:
Haber Typographers
Printer:
Album Graphics, Inc.

Magazine:
Industrial Launderer
April 1982
Art Director:
Jack Lefkowitz
Designer:
Jack Lefkowitz
Artist:
Jack Lefkowitz
Design Firm:
Jack Lefkowitz, Inc.
Leesburg, VA
Publisher:
Industrial Launderer
Typographer:
Jack Lefkowitz, Inc.
Printer:
Benton Review Pub.
Co., Inc.

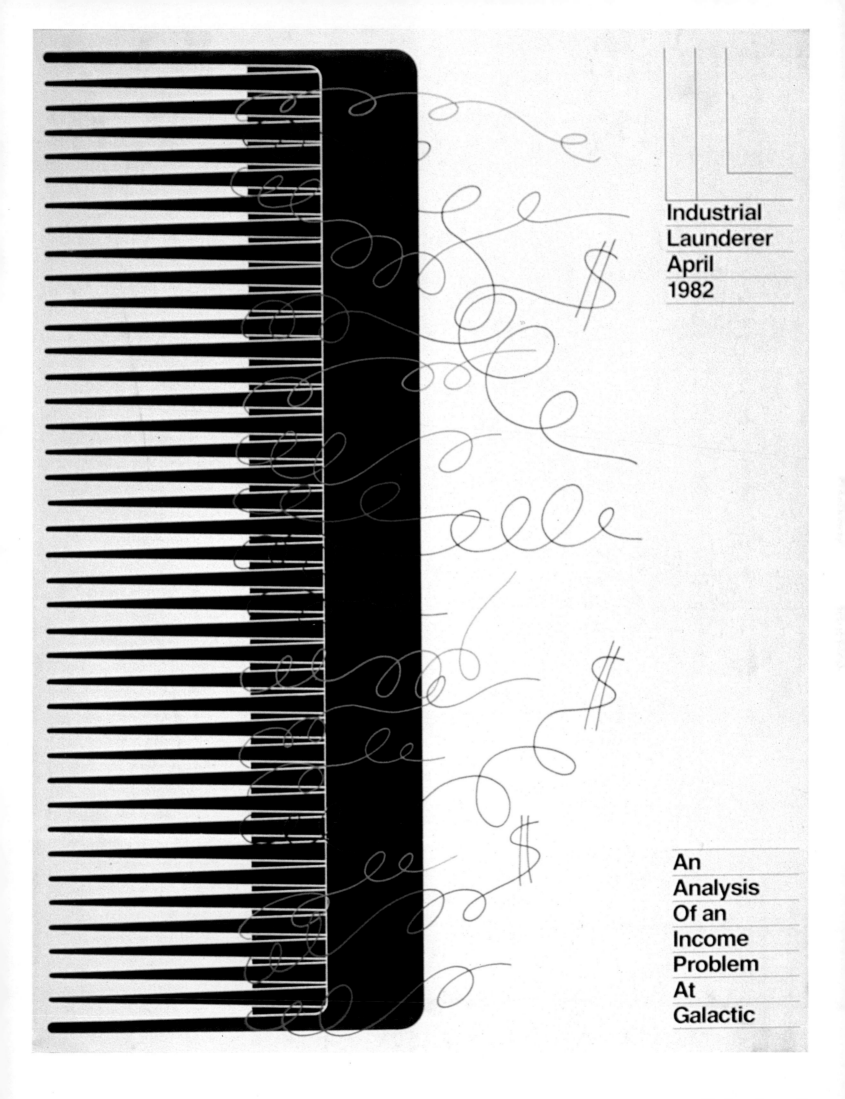

Industrial
Launderer
April
1982

An
Analysis
Of an
Income
Problem
At
Galactic

Corporate Literature:
Organization & Design
The Double Discipline
Art Director:
Scott Thornley
Designer:
Scott Thornley
Artists:
Glynn Bell, Bruce Aitken
Photographer:
Shin Sugino
Design Firm:
Thornley Design Assoc.
Ltd.
Toronto, CAN
Client:
Rice Brydone Ltd.
Typographer:
Crocker Bryant, Inc.
Printer:
Dai Nippon Printing Co.

Promotional Literature:
Dallas Symphony
Orchestra
Art Directors:
D.C. Stipp
Brent Croxton
Designers:
D.C. Stipp
Brent Croxton
Artist:
D.C. Stipp
Design Firm:
Richards, Sullivan,
Brock & Assoc.
Dallas, TX
Client:
Dallas Symphony
Orchestra
Typographer:
Chiles & Chiles
Printer:
Williamson Printing Co.

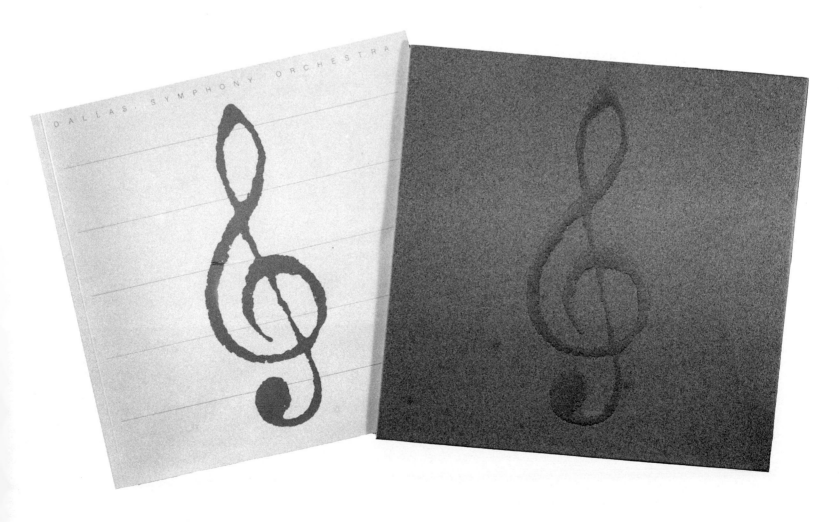

Brochure:
Revolution–Revelation
Art Director:
Stephen Miller
Designer:
Stephen Miller
Artist:
Stephen Miller
Design Firm:
Richards, Sullivan,
Brock & Assoc.
Dallas, TX
Client:
Vecta Contract
Typographer:
Chiles & Chiles
Printer:
Williamson Printing Co.

In-house Magazine:
Maxwell House
Messenger
Art Directors:
Craig Bernhardt
Janice Fudyma
Designers:
Janice Fudyma
Ron Shankweiler
Artist:
Roger Huyssen
Design Firm:
Bernhardt Fudyma
Design Group
New York, NY
Client:
Maxwell House, Division
of General Foods
Printer:
Cedar Graphics

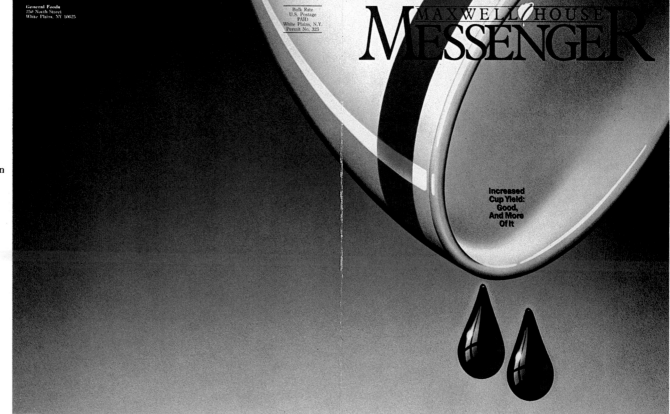

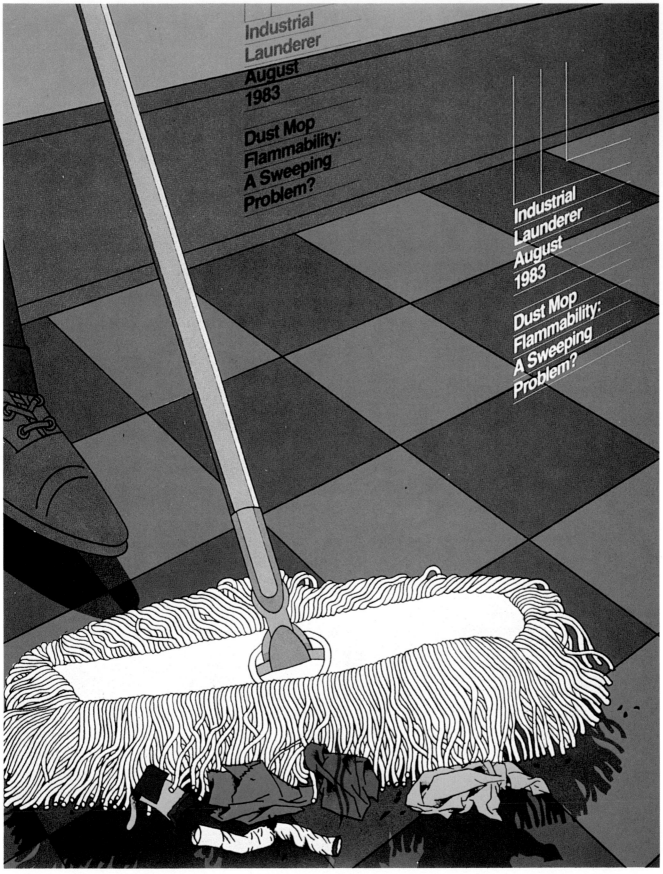

Industrial
Launderer

August
1983

Dust Mop
Flammability:
A Sweeping
Problem?

Magazine:
Industrial Launderer
August 1983
Art Director:
Jack Lefkowitz
Designer:
Jack Lefkowitz
Artist:
Jack Lefkowitz
Design Firm:
Jack Lefkowitz, Inc.
Leesburg, VA
Publisher:
Industrial Launderer
Typographer:
Jack Lefkowitz, Inc.
Printer:
Benton Review Pub.
Co., Inc.

Press Kit:
Xerox, 1075 Sales
Information Guide
Art Directors:
Michael R. Orr
James Selak
Designers:
Michael R. Orr
Robert K. Cassetti,
Martha DeLyra
Illustrator:
Robert K. Cassetti
Design Firm:
Michael Orr &
Associates, Inc.
Corning, NY
Client:
Xerox Corp.
Typographer:
Rochester Mono Co./
Headliners
Printer:
Canfield & Talk

Press Kit:
CIBA-GEIGY
Art Director:
Sigrid Geissbuhler-
Borensiepen
Designer:
Sigrid Geissbuhler-
Borensiepen
Artist:
Sigrid Geissbuhler-
Borensiepen
Design Firm:
Corporate Art Services
CIBA-GEIGY
Ardsley, NY
Publisher:
CIBA-GEIGY Corp.
Typographer:
Carrie Vollrath/
CIBA-GEIGY
Printer:
Burton & Quaker

Magazine:
Repertoire–A Magazine
for the Arts
Art Director:
Don Young
Designer:
Don Young
Design Firm:
The Design Quarter
San Diego, CA

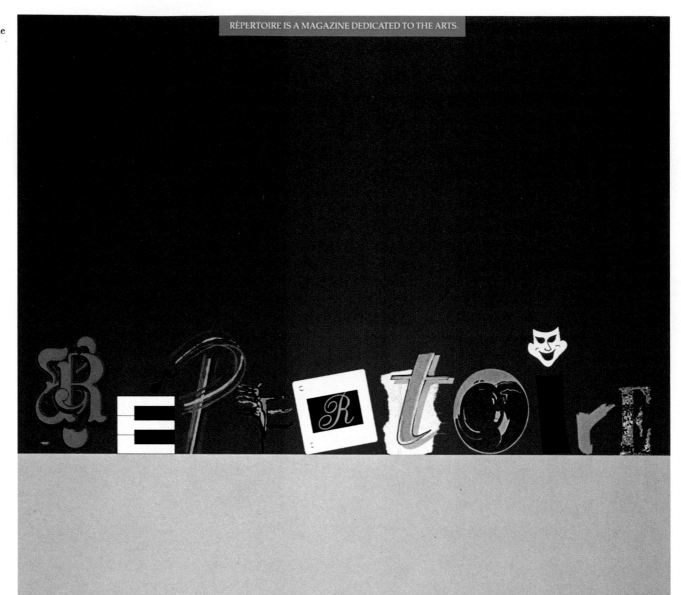

RÉPERTOIRE IS A MAGAZINE DEDICATED TO THE ARTS.

Magazine:
The Clarion
Spring 1982
Art Director:
Michael McGinn
Design Consultant:
Ira Howard Levy
New York, NY
Photographer:
Terry McGinniss
Publisher:
The Museum of
American Folk Art
Typographer:
Ace Typographers
Printer:
Topp Litho Co.

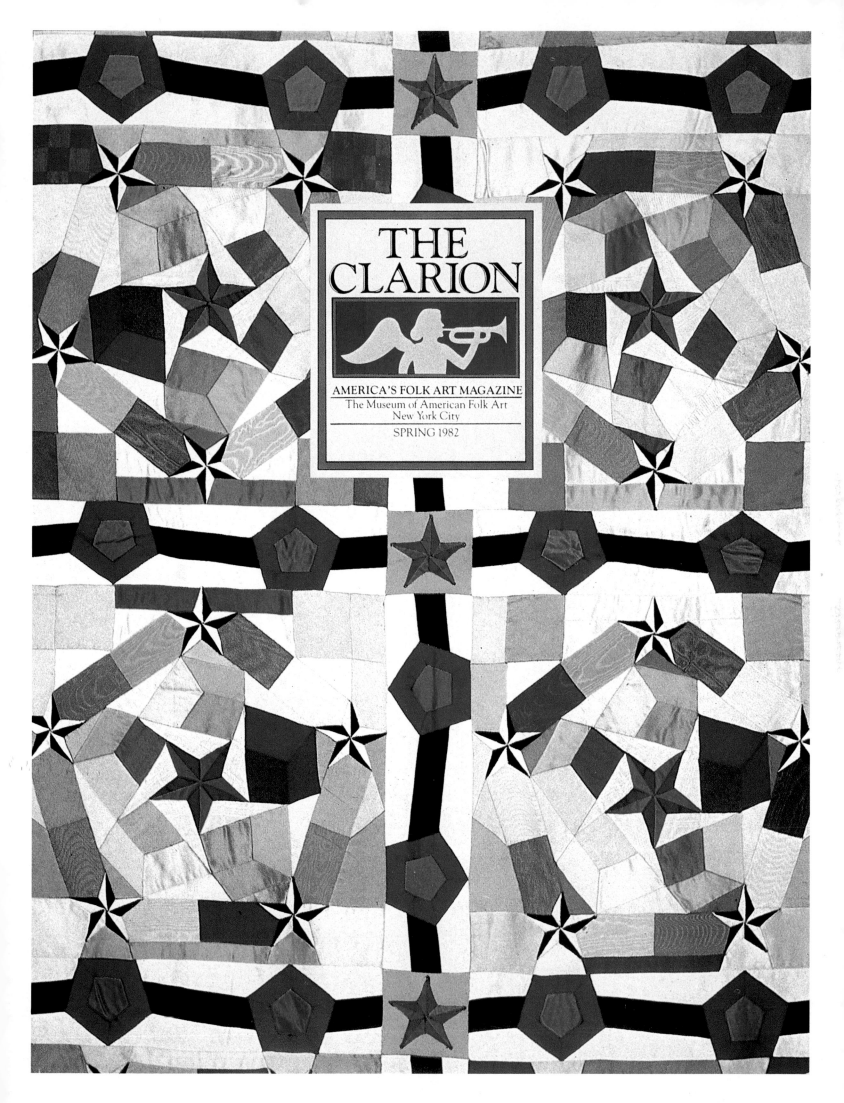

THE
CLARION

AMERICA'S FOLK ART MAGAZINE

The Museum of American Folk Art
New York City

SPRING 1982

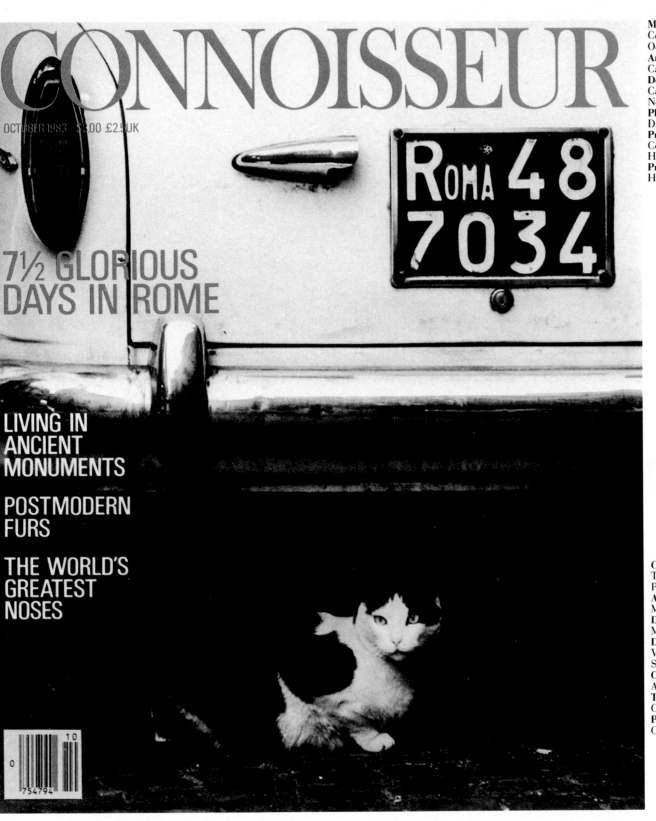

Magazine:
Connoisseur
October 1983
Art Director:
Carla Barr
Designer:
Carla Barr
New York, NY
Photographer:
Dan Budnick
Publisher:
Connoisseur Magazine/
Hearst Corp.
Printer:
Halliday Tyler

Catalogue:
The Nude in Modern
Photography
Art Director:
Michael Vanderbyl
Designer:
Michael Vanderbyl
Design Firm:
Vanderbyl Design
San Francisco, CA
Client:
Art Museum Association
Typographer:
Community Press
Printer:
Cal Central Press

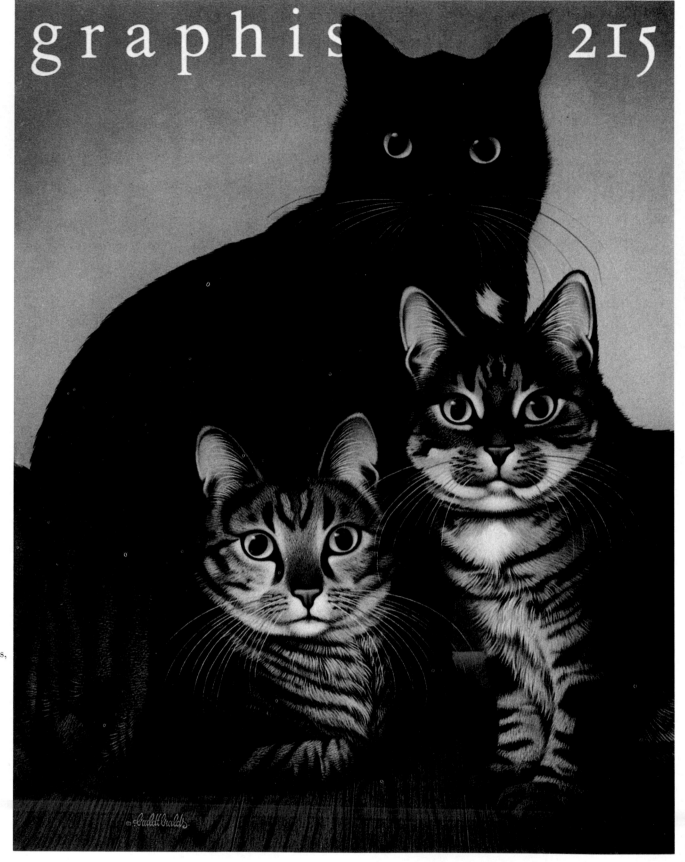

Magazine:
Graphis
Art Director:
Walter Herdeg
Designers:
Walter Herdeg
Braldt Bralds
Artist:
Braldt Bralds
Design Firm:
Pinball Graphics Corp.
New York, NY
Publisher:
Graphis Press Corp.
Printer:
Graphis Press Corp.

Magazine:
GEO, April 1982
Art Director:
Mary K. Baumann
Designer:
Mary K. Baumann
New York, NY
Photographer:
Robert P. Carr
Publisher:
Knapp Communications,
GEO Magazine

APRIL 1982
$4.00

GEO

A CELEBRATION
OF OWLS

ROGER TORY PETERSON:
AN INTERVIEW
WITH THE KING OF
BIRD WATCHERS

THE ANATOMY
OF EARTHQUAKES

AN INFORMAL VISIT
WITH THAILAND'S
ROYAL FAMILY

JEWS WHO LEAVE ISRAEL
TO TRY THE U.S.

THERE'S NOTHING
LIKE THE CIRCUS LIFE

The Boston Globe Magazine

May 22, 1983

BY RICHARD A. KNOX

THE RETURN of the LOON

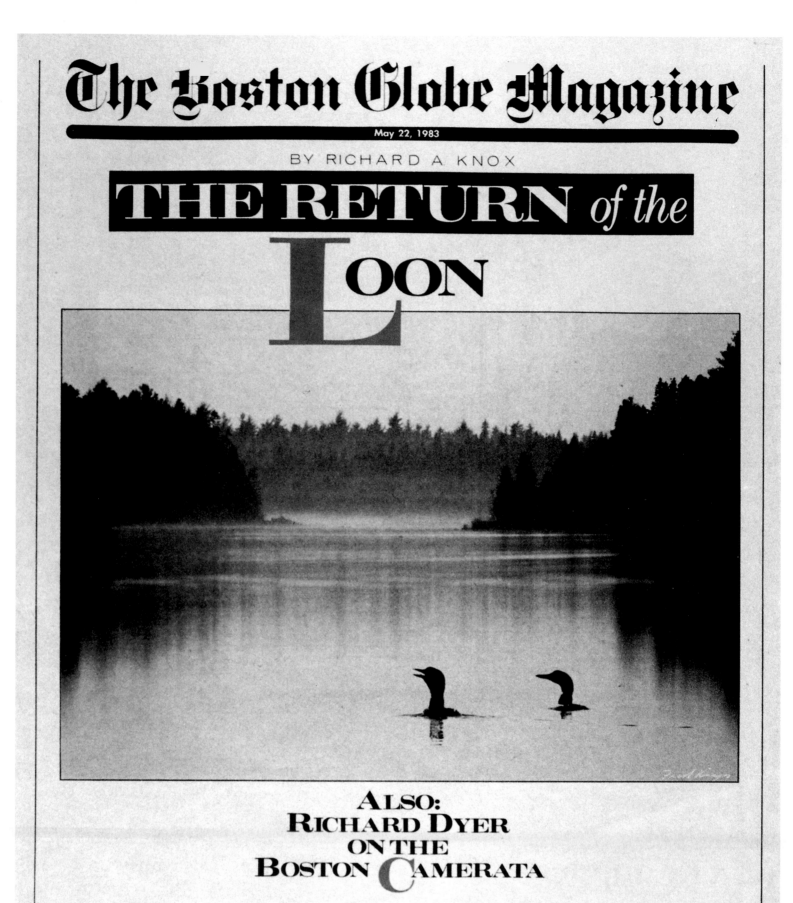

ALSO:
RICHARD DYER
ON THE
BOSTON CAMERATA

Newspaper:
The Boston Globe
Magazine
May 22, 1983
Art Director:
Ronn Campisi
Designer:
Ronn Campisi
Boston MA
Photographer:
Fred L. Knapp
Publisher:
Globe Newspaper Co.
Printer:
Providence Gravure

The New York Times Book Review

Christmas Books 1982

The editors choose the 12 best books of the year ☐ An interview with Gabriel García Márquez ☐ Mario Cuomo, Eudora Welty, John Updike, David Niven, Joyce Carol Oates, William Burroughs, Mary Gordon, James A. Michener, Studs Terkel, James Baldwin and others tell what they enjoyed reading this year ☐ Andy Grundberg on photography books ☐ Mimi Sheraton on cookbooks ☐ Sherwin D. Smith on animal books ☐ John Russell on art books ☐ An annotated list of 300 notable books published in 1982

GIDDAP!

TKK TKK

WHOP!

WHOP!

The Christmas Book Wagon

© George Booth

Moe, Joe, Golly, Weeks, Sy, Moon, Hosea, Chan, Barn and Snarf and the staff of the Book Review say "Merry Christmas and enjoy a good book".

Section 7 Copyright © 1982 The New York Times

Newspaper Supplement:
The New York Times
Book Review,
December 5, 1982
Art Director:
Steven Heller
Designer:
Steven Heller
New York, NY
Artist:
George Booth
Publisher:
The New York Times
Typographer:
The New York Times
Printer:
The New York Times

The Cover Show 151

In-house Newsletter:
Episcopal Eagle
Newsletter
Art Director:
Brian Boyd
Designer:
Brian Boyd
Artists:
Brian Boyd
Gary Templin
Design Firm:
Richards, Sullivan,
Brock & Assoc.
Dallas, TX
Client:
Episcopal School of
Dallas
Typographer:
Typographics
Printer:
Williamson Printing Co.

Booklet:
The Oceanic Society
Field Guide to the Gray
Whale
Art Director:
Dugald Stermer
Designer:
Dugald Stermer
Artist:
Dugald Stermer
San Francisco, CA
Publisher:
Legacy Publishing Co.
Letterer:
Dugald Stermer

Magazine:
Audubon
March 1983
Art Director:
Daniel J. McClain
Designer:
Daniel J. McClain
New York, NY
Photographer:
Jim Fitzharris
Publisher:
National Audubon
Society
Typographer:
Concept Typographic
Services, Inc.
Printer:
Case-Hoyt Corp.

Newspaper Supplement:
Living, California
Nov. 14, 1982
Art Directors:
Dugald Stermer
Bill Prochnow
Designer:
Dugald Stermer
San Francisco, CA
Artist:
Dugald Stermer
Publisher:
San Francisco Sunday
Examiner and Chronicle
Typographer:
San Francisco Sunday
Examiner
Printer:
San Francisco Sunday
Examiner

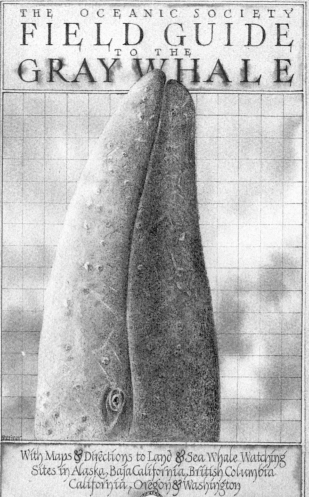

152

LIVING

CALIFORNIA

THE MAGAZINE OF THE SAN FRANCISCO SUNDAY EXAMINER & CHRONICLE NER NOVEMBER 14, 1982

Artificial Insemination: Delivering Hope Where There Had Been Despair

Photograph by Bob Talbot

AUDUBON

November Nineteen Eighty-One · Three Dollars

Magazine:
Audubon
November 1981
Art Director:
Daniel J. McClain
Designer:
Daniel J. McClain
New York, NY
Photographer:
Bob Talbot
Publisher:
National Audubon
Society
Typographer:
Concept Typographic
Services, Inc.
Printer:
Case-Hoyt Corp.

Annual Report:
Delta Drilling
Annual Report 1980
Art Director:
Steven Sessions
Designer:
Steven Sessions
Artist:
Patrick Oliphant
Design Firm:
B & K, Inc.
Houston, TX
Client:
Delta Drilling Co.
Typographer:
ProType
Printer:
Grover Printing

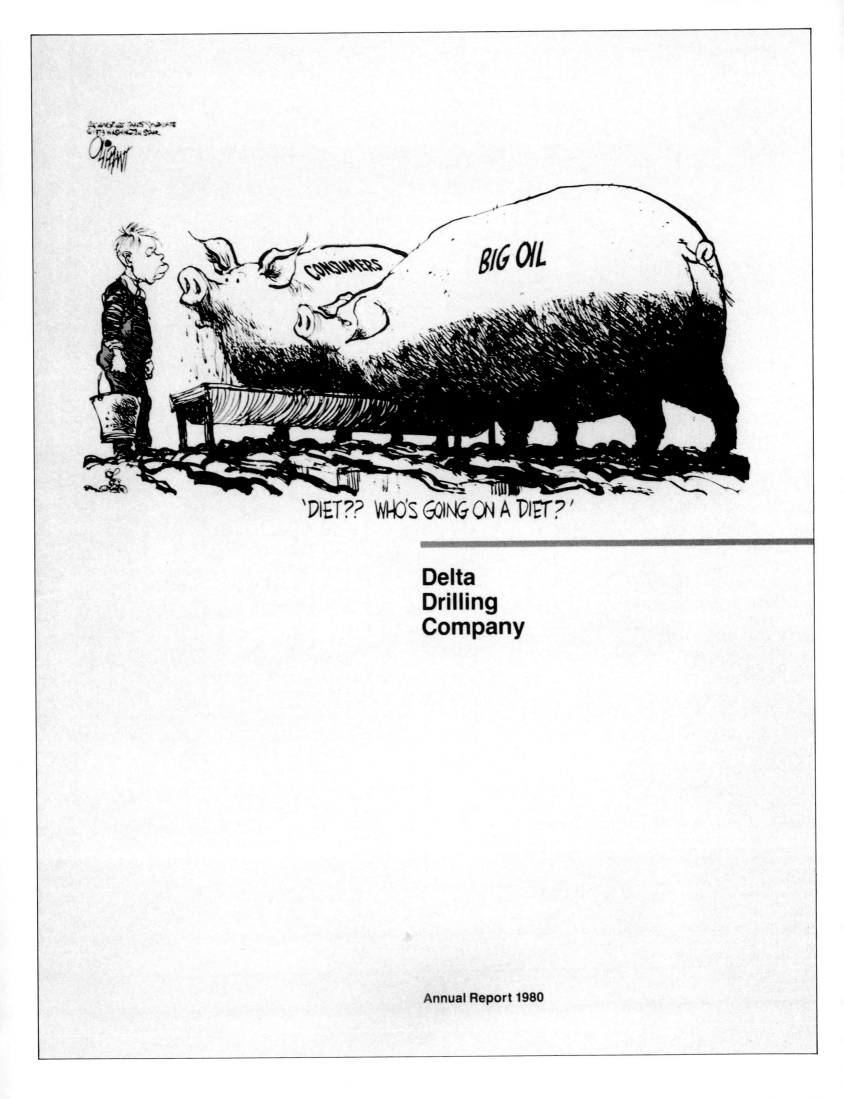

'DIET?? WHO'S GOING ON A DIET?'

**Delta
Drilling
Company**

Annual Report 1980

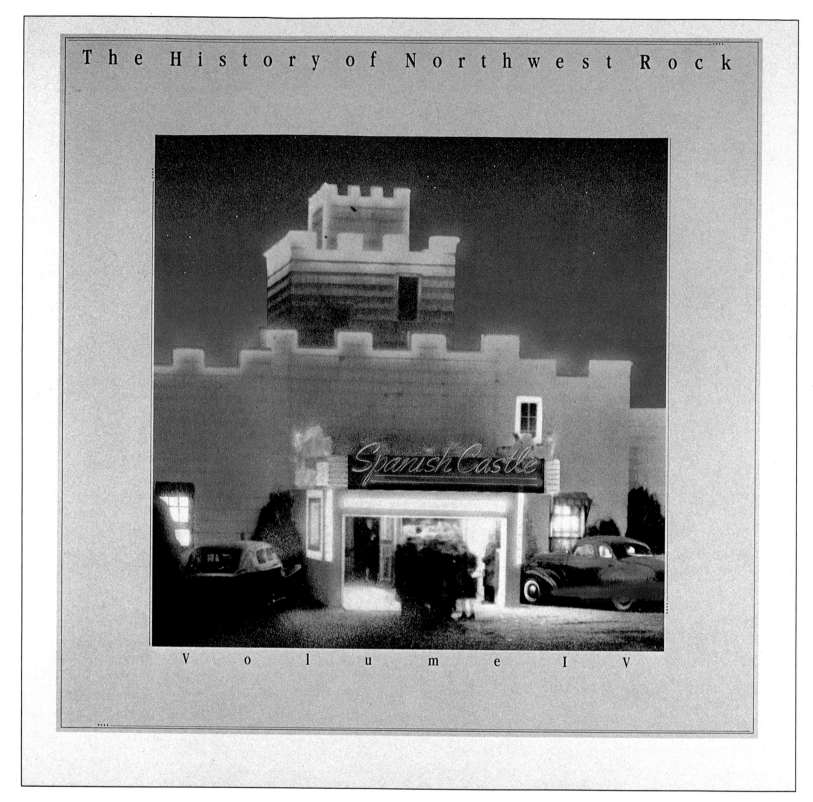

Volume IV

Record Album:
The History of Northwest
Rock, Vol. 4
Art Director:
Art Chantry
Designer:
Art Chantry
Air Brush Artist:
Gary Jacobsen
Design Firm:
Art Chantry Design
Seattle, WA
Client:
First American Records
Inc.
Typographer:
Art Chantry/
Typographics
Printer:
Shorewood Packaging
Corp.

Magazine:
The Clarion
Spring/Summer 1983
Art Directors:
Faye Eng, Anthony Yee
Designers:
Faye Eng, Anthony Yee
Design Firm:
Faye Eng, Anthony Yee
New York, NY
Publisher:
The Museum of
American Folk Art
Typographer:
Ace Typographers
Printer:
Topp Litho Co.

Magazine:
Sierra, May/June 1983
Art Director:
Bill Prochnow
Designer:
Bill Prochnow
Photographer:
David Muench
Design Firm:
Sierra Magazine
San Francisco, CA
Publisher:
Sierra Club
Typographer:
MacKenzie-Harris
Printer:
Craftsman Press

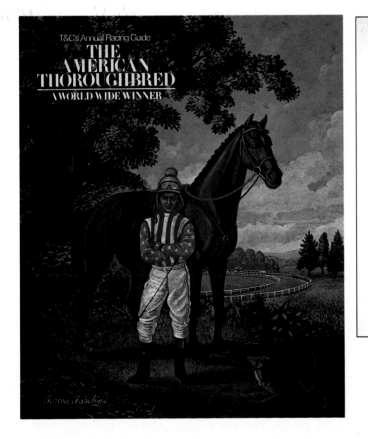

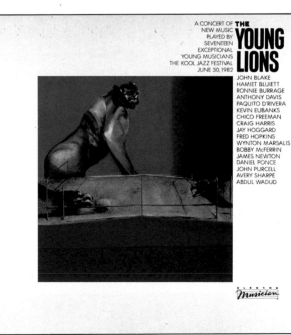

Magazine Supplement:
T & C's Annual Racing
Guide
Art Director:
Melissa Tardiff
Designer:
Leslie Abney
Artist:
Teresa Fasolino
New York, NY
Publisher:
Town & Country/
The Hearst Corp.

Record Album:
The Young Lions
Art Director:
Norm Ung
Designer:
Norm Ung
Redondo Beach, CA
Artist:
Marshall Arisman
Publisher:
Elektra/
Musician Records

AMERICAN
PHOTOGRAPHER

$2.00 MAR 1982

Great Pages
First Annual Awards
for Magazine Photography

The Taking of the President
A Year in the White House
with Photographer Michael Evans

A Master Class
with Ansel Adams

$1.10

Nastassia Kinski photographed by Richard Avedon

Magazine:
American Photographer
March 1982
Art Director:
Will Hopkins
Designer:
Louis F. Cruz
Photographer:
Richard Avedon
Design Firm:
American Photographer
Magazine
New York, NY
Publisher:
CBS Magazines
Typographer:
Lettragraphics, Inc.
Printer:
Judd & Detweiler, Inc.

Chermayeff & Geismar Associates
Art in Architecture

Catalogue:
Chermayeff & Geismar
Assoc.
Art in Architecture
Art Director:
Chermayeff & Geismar
Assoc.
Designer:
Chermayeff & Geismar
Assoc.
New York, NY
Design Firm:
Chermayeff & Geismar
Assoc.
Publisher:
Chermayeff & Geismar
Assoc.
Typographer:
Print & Design
Printer:
Saunders Manufacturing

Menu:
L'Express
Art Director:
Rod Dyer
Designer:
Hoi Ping Law Wong
Artist:
Hoi Ping Law Wong
Design Firm:
Dyer/Kahn, Inc.
Los Angeles, CA
Client:
L'Express Restaurant
Typographer:
Lew Marchese
Printer:
Anderson Printing Co.

Magazine:
Flowers &
April MCMLXXXI
Art Directors:
Dugald Stermer
Elaine Anderson
Designer:
Dugald Stermer
Artist:
Dugald Stermer
San Francisco, CA
Publisher:
Flowers &/Teleflora
Letterer:
Dugald Stermer
Printer:
Graphic Arts

Invitation:
Celebration at the
Gallery
Art Directors:
Scott Eggers, D.C. Stipp
Designer:
Scott Eggers
Artist:
Scott Eggers
Design Firm:
Richards, Sullivan,
Brock & Assoc.
Dallas, TX
Client:
The Rouse Company
Typographer:
Typographics
Printer:
Williamson Printing Co.

Menu:
T.G.I. Friday's Directory
of Specialties
Art Directors:
Luis Acevedo
Woody Pirtle
Designer:
Luis Acevedo
Artist:
Luis Acevedo
Design Firm:
Pirtle Design
Dallas, TX
Client:
T.G.I. Friday's, Inc.
Typographer:
Southwestern
Typographics
Printer:
Allcraft Printing

Magazine:
Human Ecology Forum,
Volume 13, No. 1
Art Directors:
Robert K. Cassetti
Michael Orr
Designer:
Robert K. Cassetti
Photographer:
Don Albern
Design Firm:
Michael Orr &
Assoc., Inc.
Corning, NY
Client:
Cornell University
Typographer:
Partners Composition
Printer:
Brodock Press

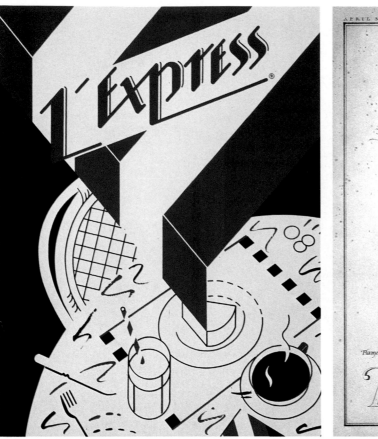

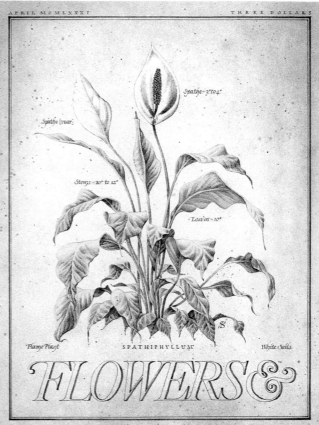

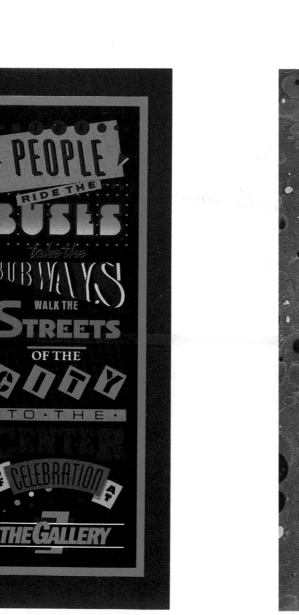

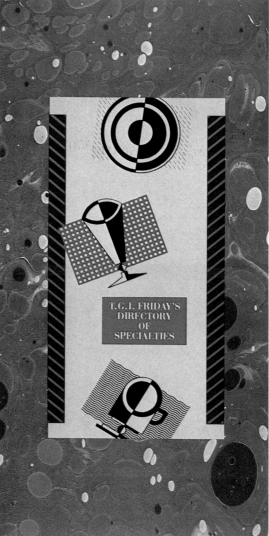

HUMAN ECOLOGY
FORUM

Volume 13 Number 1
Nutrition and Health

THE AMERICAN BOOK AWARDS 1982

Catalogue:
The American Book
Awards 1982
Art Director:
Harlin Quist
Designers:
Harlin Quist, Ken Diamond
Artist:
Brad Holland
Publisher:
The American Book
Awards 1982
Printer:
Cedar Graphics

162

The Coca-Cola Company Annual Report 1982

Just for the taste of it.

Annual Report:
The Coca-Cola Company
Annual Report
1982
Art Director:
Critt Graham
Designers:
Deborah Pinals
Bim Franklin
Artist:
Phillip Vullo
Design Firm:
Critt Graham Graphic
Design, Ltd.
Atlanta, GA
Client:
The Coca-Cola
Company
Typographer:
Alphabet Group

Annual Report:
Domino's Pizza Annual
Report 1982
Art Director:
Ernie Perich
Designer:
Ernie Perich
Photographers:
Dawson Jones
Richard Foster
Design Firm:
Group 243 Design, Inc.
Ann Arbor, MI
Client:
Domino's Pizza, Inc.
Typographer:
Ernie Perich
Printer:
Embossing Printers, Inc.

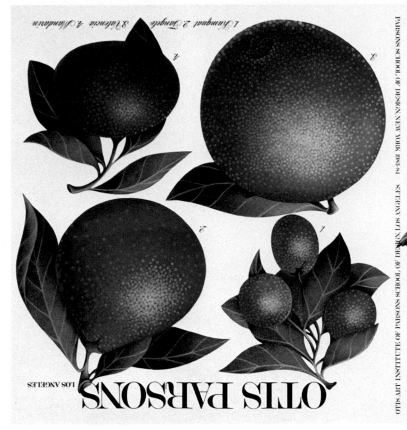

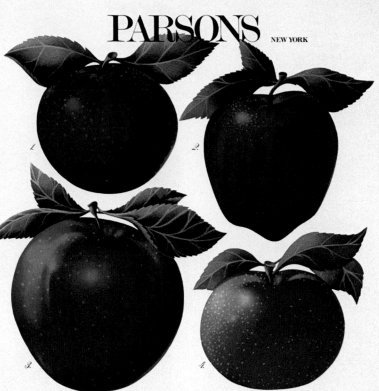

Catalogue:
Otis/Parsons, Los Angeles
Parsons, New York
Art Director:
Cipe Pineles Burtin
Designer:
Cipe Pineles Burtin
Artist:
Janet Amendola
Design Firm:
Parsons School of Design
New York, NY
Publisher:
Parsons School of Design
Typographer:
MKP
Printer:
Conceptual Litho
Reproductions

Annual Report:
Church & Dwight
Co., Inc.
1982 Annual Report
Art Director:
Sheryl Checkman
Designer:
Sheryl Checkman
Design Firm:
Burson-Marsteller
New York, NY
Publisher:
Church & Dwight
Co., Inc.
Typographer:
Typologic, Inc.
Printer:
Neil Graphic Arts/
Eureka

Church & Dwight Co., Inc.
1982 Annual Report

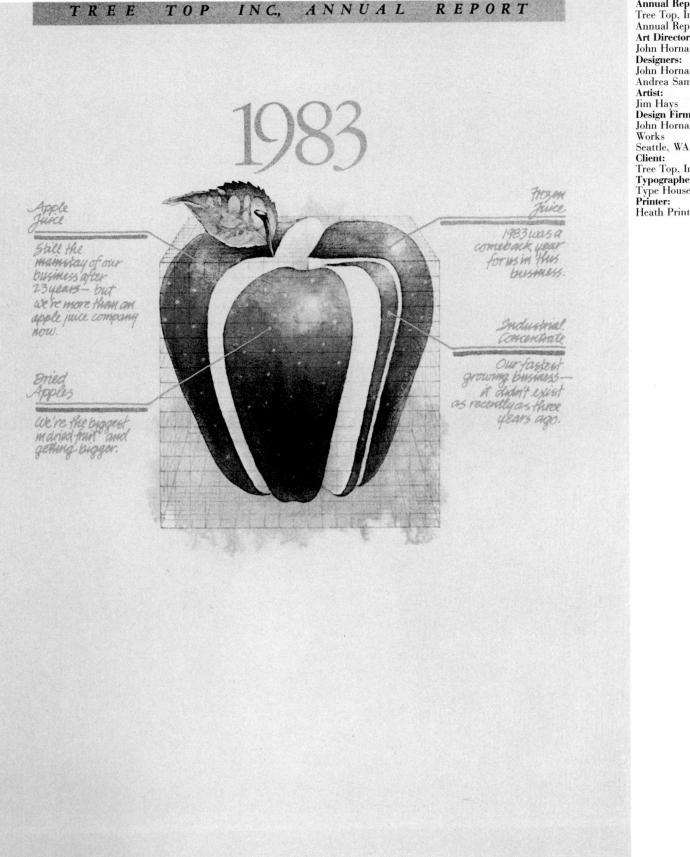

1983

Apple Juice

Still the mainstay of our business after 23 years — but we're more than an apple juice company now.

Dried Apples

We're the biggest in dried fruit and getting bigger.

Frozen Juice

1983 was a comeback year for us in this business.

Industrial Concentrate

Our fastest growing business — it didn't exist as recently as three years ago.

Annual Report:
Tree Top, Inc.,
Annual Report 1983
Art Director:
John Hornall
Designers:
John Hornall
Andrea Sames
Artist:
Jim Hays
Design Firm:
John Hornall Design
Works
Seattle, WA
Client:
Tree Top, Inc.
Typographer:
Type House, Inc.
Printer:
Heath Printers

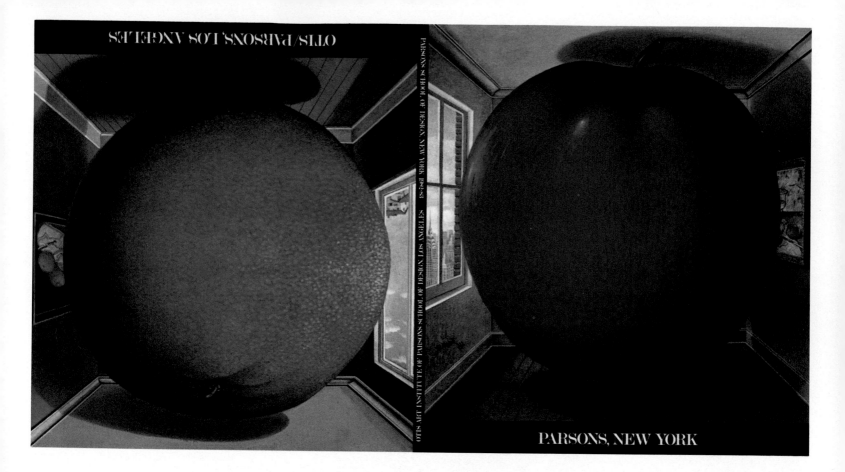

PARSONS SCHOOL OF DESIGN, NEW YORK 1984

OTIS ART INSTITUTE OF PARSONS SCHOOL OF DESIGN, LOS ANGELES

PARSONS, NEW YORK

Catalogue:
Otis/Parsons, Los Angeles
Parsons, New York
Art Director:
Cipe Pineles Burtin
Designer:
Cipe Pineles Burtin
Artist:
Richard Hess
Design Firm:
Parsons School of Design
New York, NY
Publisher:
Parsons School of Design
Typographer:
MKP
Printer:
Conceptual Litho
Reproductions

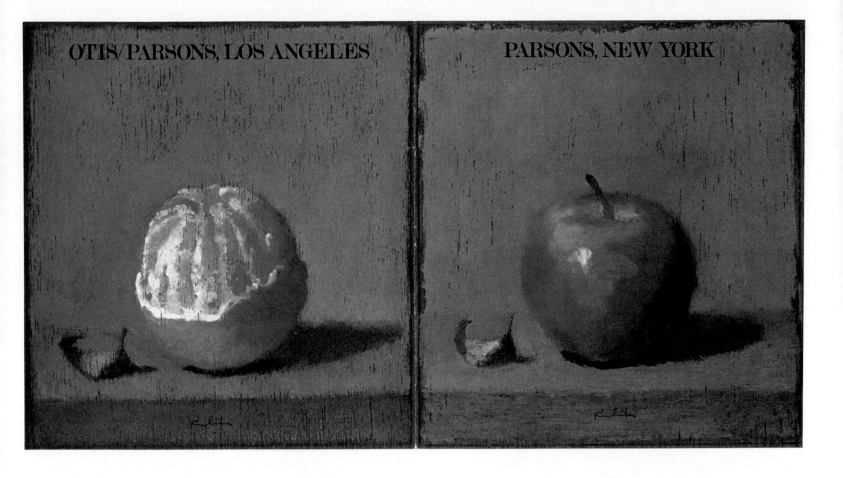

OTIS/PARSONS, LOS ANGELES PARSONS, NEW YORK

Catalogue:
Otis/Parsons, Los Angeles
Parsons, New York
Art Director:
Cipe Pineles Burtin
Designer:
Cipe Pineles Burtin
Artist:
Robert Kulicke
Design Firm:
Parsons School of Design
New York, NY
Publisher:
Parsons School of Design
Typographer:
MKP
Printer:
Conceptual Litho
Reproductions

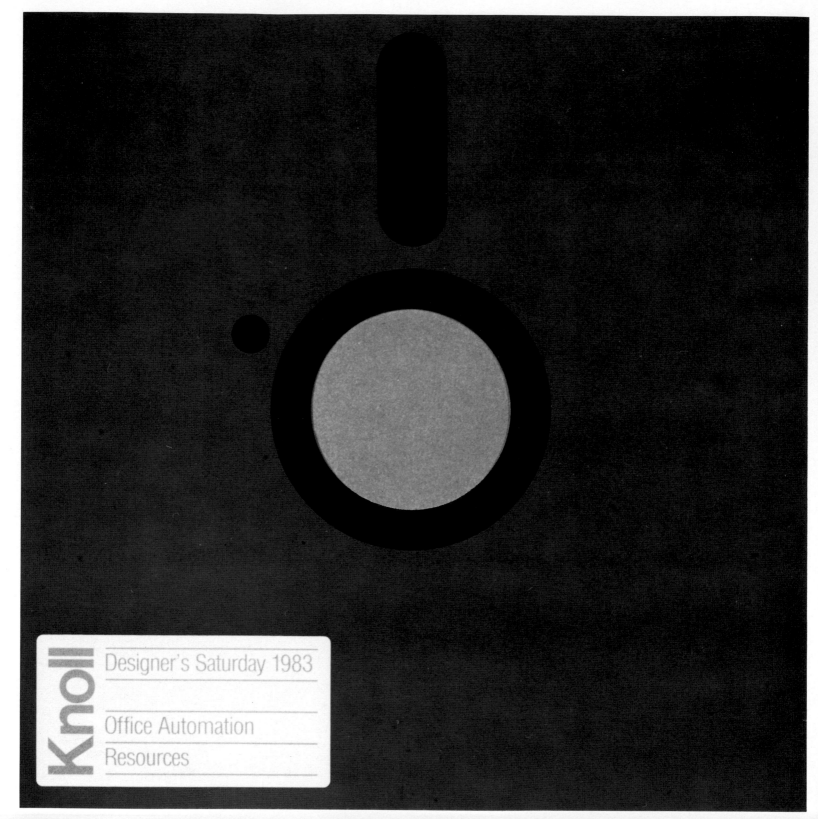

Knoll
Designer's Saturday 1983

Office Automation

Resources

Brochure:
Knoll/Designer's
Saturday 1983
Art Directors:
Harold Matossian
Takaaki Matsumoto
Designer:
Takaaki Matsumoto
Design Firm:
Knoll Graphics
New York, NY
Publisher:
Knoll International
Typographer:
Susan Schechter
Printer:
CGS, Inc.

The Boston Globe Magazine

February 6, 1983

From a new book by Sissela Bok

MILITARY
SECRECY

Scientists developing the atomic bomb
believed they could make war so evil it
would be rejected forever. Insulated
by tight security from outside opinion,
they heard no dissenting views.

Newspaper:
The Boston Globe
Magazine
February 6, 1983
Art Director:
Ronn Campisi
Designer:
Ronn Campisi
Boston, MA
Publisher:
Globe Newspaper Co.
Printer:
Providence Gravure

Catalogue:
University of Texas
Press
Fall and Winter Books,
1983–1984
Art Director:
George Lenox
Designer:
George Lenox
Austin, TX
Photographer:
Carol Cohen
Publisher:
University of Texas
Press
Typographer:
G & S Typographers
Printer:
University of Texas
Printing Dept.

University of Texas Press

Fall and Winter Books, 1983–1984

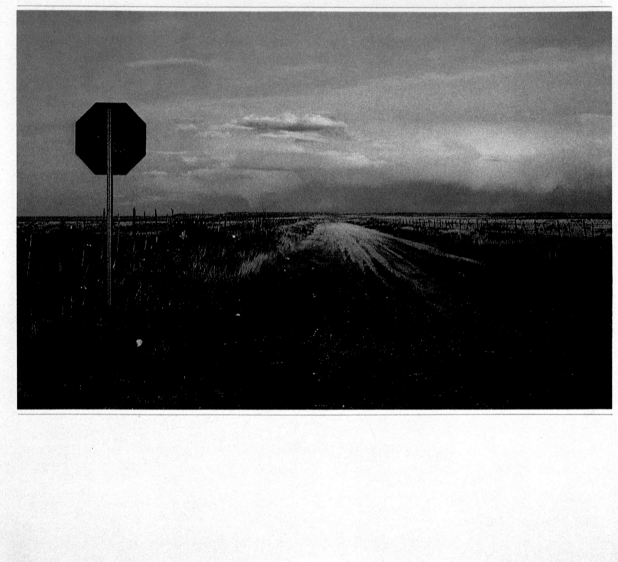

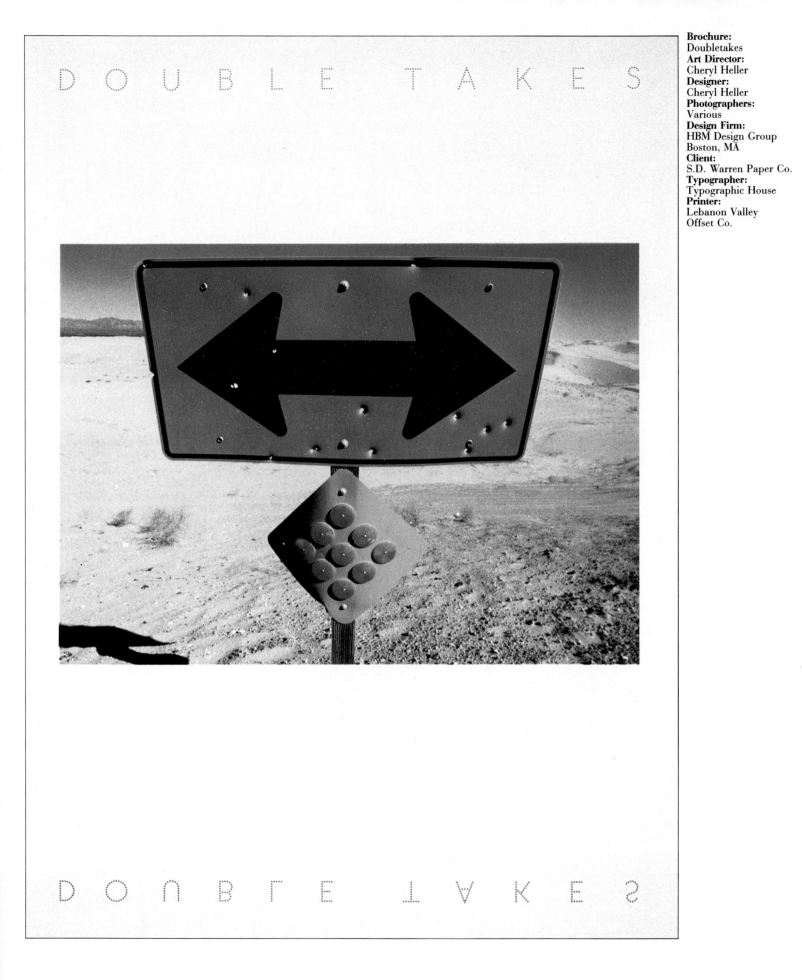

Brochure:
Doubletakes
Art Director:
Cheryl Heller
Designer:
Cheryl Heller
Photographers:
Various
Design Firm:
HBM Design Group
Boston, MA
Client:
S.D. Warren Paper Co.
Typographer:
Typographic House
Printer:
Lebanon Valley
Offset Co.

Newspaper:
The Boston Globe
Magazine
October 3, 1982
Art Director:
Ronn Campisi
Designer:
Ronn Campisi
Boston MA
Artist:
Marty Braun
Publisher:
Globe Newspaper Co.
Printer:
Providence Gravure

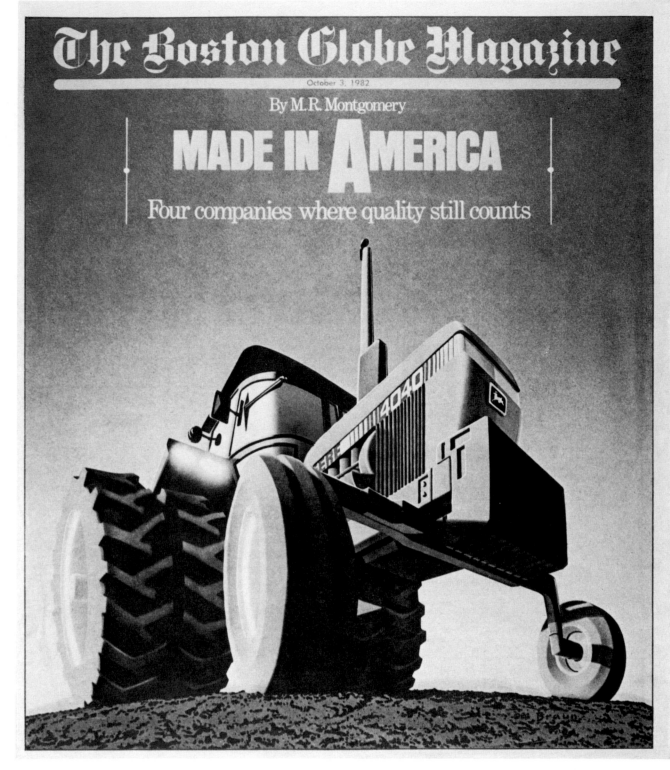

174

Newspaper Supplement:
Upstate Magazine
September 5, 1982
Art Director:
Josh Gosfield
Designer:
Josh Gosfield
New York, NY
Artist:
Josh Gosfield
Publisher:
Rochester Democrat and
Chronicle

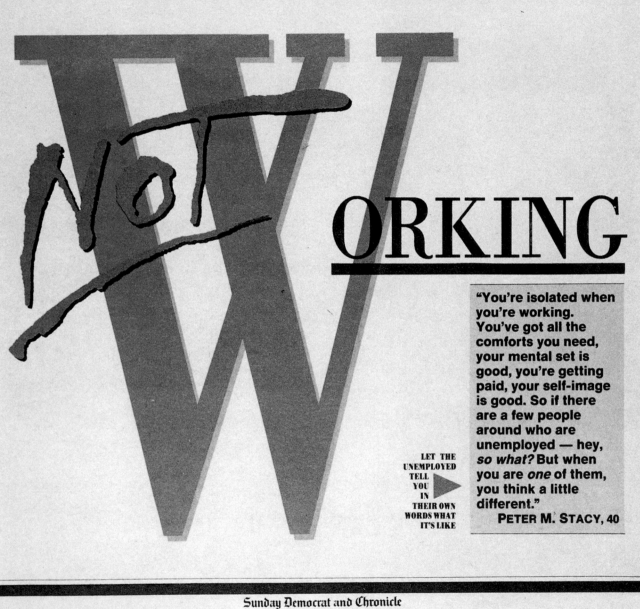

INSIDE: THE BROTHERS AND SISTERS OF KIDS WITH CANCER

UPSTATE
M A G A Z I N E

Not WORKING

"You're isolated when you're working. You've got all the comforts you need, your mental set is good, you're getting paid, your self-image is good. So if there are a few people around who are unemployed — hey, *so what?* But when you are *one* of them, you think a little different."
PETER M. STACY, 40

LET THE UNEMPLOYED TELL YOU IN THEIR OWN WORDS WHAT IT'S LIKE ▶

Sunday Democrat and Chronicle
September 5, 1982

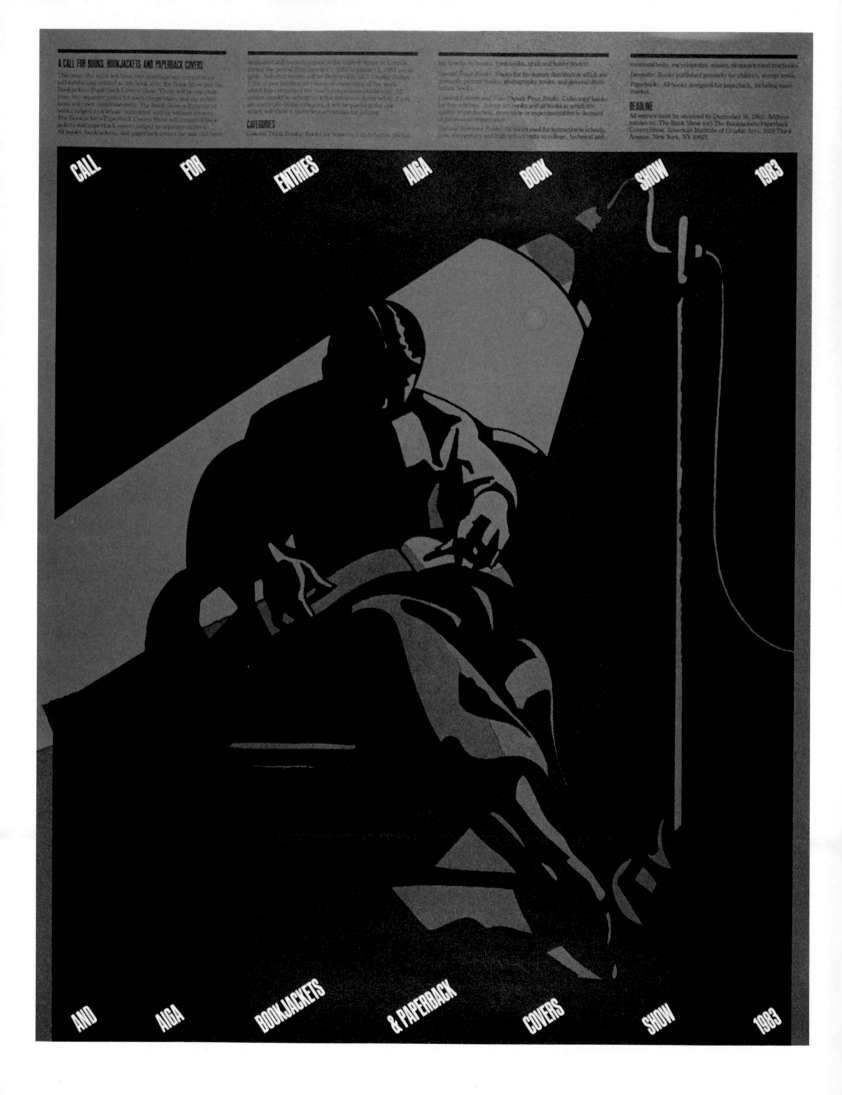

With the exception of the few notable and recognized experiments, book design generally tends to be conservative; inspiration rather than innovation is celebrated. Derivation is not a dirty word, and creativity is often measured by what or how well a designer borrows from other sources.

Call for Entry:
The Book Show/
The Bookjacket and
Paperback Cover Show
Designer:
Milton Glaser
Illustrator:
Milton Glaser
Typographer:
Saxon Graphics
Printer:
Rapaport Printing Co.
Paper:
Simpson Paper Co.

Chairman
Milton Glaser
President
Milton Glaser, Inc.

Jury
Betty Anderson
Art Director
Alfred A. Knopf

Byron Dobell
Editor
American Heritage
Publishing Co.

Alfred Kazin
Writer
City University
of New York

Harris Lewine
Art Director
Harris Lewine Design

Many years ago, an AIGA Book Show took four arduous days to judge—currently, it takes one. In addition to design, every manufacturing detail—from the binding to the headband—was scrutinized. It is said that jurors even tested for durability by dangling the book airborne from its spine —those that broke under the pressure were disqualified, regardless of their respective design merits. A *perfectly* produced book was not as elusive in the days before production budgets were slashed and marketing departments got muscle. Presently, however, the publishing industry, in general, is in a financially tenuous position (albeit stronger this season than in previous years) and, as everyone is aware, book design and production are inexorably tied to the economy. With this in mind, recent Book Show juries have appeared to be less rarefied or parochial in their selections. While searching for excellence, they are decidedly aware of the manifold constrictions. As Milton Glaser, the show chairman, states: "Everybody under- stands that a 1984 Chevy does not have the quality of a 1932 Packard." And so, compromise, if not redefinition of priorities, is an accepted truth.

The composition of this year's jury is an interesting mix of practitioners and aficionados—bibliophiles all—reflecting a *love* of books and an acute awareness of their function. If the entries were not scrutinized as intensely for technical properties, they were judged stringently for the important marriage of design, purpose and content. "The jury's disposition," says Glaser, "was to be slightly more conservative. I responded that way also, for in recent years I've been obsessed by utility and how things work for their audiences." In this regard, eschewed were the ultraflashy designs, or those exhibiting a "dramatic vulgarity," which ignored the prerequisites of the material in favor of unnecessarily personal visions. "We tended not to celebrate the insular books— those which were so *clever* that content was secondary," states Glaser. Instead, a high level of competence is seen in these selections, which Glaser suggests is "dramatically higher than what was done ten years ago."

With the exception of the few notable and recognized experiments, book design generally tends to be conservative; inspiration rather than innovation is celebrated. Derivation is not a dirty word, and creativity is often

measured by what or how well a designer borrows from other sources. As Glaser suggests: "Because of the nature of the business, major shifts in perception are very rare. Moreover, the experiments are not true measures of professional excellence, since they are often not appreciated or *needed* by the public. This year, the experiments simply didn't look too good."

The Book Show is based on an egalitarian principle, with doors open to all the various book genres: trade and mass market, limited and fine press, picture and textbooks, novels, poetry and children's books. (Regrettably, some of the significant limited editions—such as the current crop from the Limited Editions Club—and small press books are rarely submitted, suggesting the possibility of an adjunct show or competition.) With the vast range of possibilities, the selection criterion was how effectively a book worked within its restrictions—in other words, if the book was well designed for its market. Moreover, books in different "categories" were not judged against each other. What emerges is a well-rounded, yet not definitive, survey of the year's best.

Clearly, the value of this show is to see how various design solutions enhance the entire book package. The material in *Antonio Gaudi* is made even more impressive because of its mammoth size, classical design and extremely fine printing. *The Knopf Collector's Guide to American Antiques* is more inviting due to its shape and typographic styling. Once again, plaudits are due to the well-crafted exhibition catalogues, among them *German Expressionist Sculpture* and *Lance Hidy's Posters*, which are books rather than checklists. Ofttimes, the book idea would be rendered useless if not for the design: *The American Weigh* and *Still Life* are two successful examples. Although few mass-market paperbacks were accepted into the show, *Aventura*, a uniquely designed literary series of reprints, offers both tactile and visual stimulation rare to the genre. Textbooks seemed to be the least malleable, frozen into a formula that was a breakthrough a decade ago. "On the whole, they try to be lively," says Glaser, "but it is a Sixties liveliness. The only way to fairly judge them is on their clarity." On the whole, illustrated children's books, judged primarily

for their concept and illustrations, were less inspiring this year than previously. Perhaps it is because in this category, innovation is looked for more seriously.

A significant result of this and recent surveys is that few individual designers stand out. Massimo Vignelli's work is very recognizable, but on the whole, interior design (covers will be discussed in the next section) is anonymous. In the manner that W. A. Dwiggins impressed a visual persona on all Alfred A. Knopf books, few publishers rely on one or two individualists (with the notable exceptions of Pantheon, Black Sparrow Press and David Godine, Inc.) for their identities—the publishing industry simply doesn't base its sales on reputation alone anymore.

Every competition gives rise to Cassandras decrying the *end has come*. Dwiggins, who must be considered one of America's finest bookmen, once argued in a paper, using charts and graphs, that the high professional standards of the turn of the century had plummeted in successive years. Even in the 1920s, book production was at its nadir. Clearly, nothing has changed; each generation looks to the past to support the criticisms of the present. However, as Glaser responds, "Every show has an element of putting in the less worse, but that is a specious commentary, because we are simply trying to show what is happening in the field. Perhaps it is better than previous years, perhaps not." It would be helpful to view the books in this survey individually for now, and only later as part of the continuum.

Book Title:
The Indispensable Cat
Author:
J. C. Suarès
Editor:
Leslie Stoker
Art Director:
J. C. Suarès
Designer:
J. C. Suarès
New York, NY
Illustrators:
Various
Publisher:
Stewart, Tabori & Chang
Publishers, Inc.
Typographer:
U.S. Lithograph, Inc.
Printer:
Amilcare Pizzi, s.p.a.
Production Manager:
Caroline Ginesi
Binder:
Amilcare Pizzi, s.p.a.
Jacket Designer:
J. C. Suarès
Photographer:
Matthew Klein

JEAN-CLAUDE SUARÈS

THE INDISPENSABLE CAT

STEWART, TABORI & CHANG
PUBLISHERS
NEW YORK

B R E E D S

Among the thirty-three breeds of pedigree cats recognized by the Cat Fanciers' Association, there are approximately fifty possible variations in fur color, length, and texture. Purebreds also vary in other qualities such as size, origin, voice, and most important, personality. Not all pedigrees are acceptable for competition; some are either too new, too exotic, or just too peculiar. Here is a brief summary of the identifying characteristics of some of the more familiar as well as some of the more unusual breeds.

Like the Russian Blue, the Siamese was a royal cat; it lived in and guarded palaces and temples in Siam. Although it is sometimes nervous and, like royalty, subject to disorders associated with inbreeding, the Siamese is still the most popular pedigree cat in the world.
Copyright © Neil Leifer/Camera 5.

The Abyssinian, a playful, active cat, was first depicted in ancient Egyptian art. Of all domestic felines, the ruddy-coated Abyssinian is the closest to the wild cat in disposition, yet it makes an excellent, outgoing pet.
Copyright © Neil Leifer/Camera 5.

B R E E D S

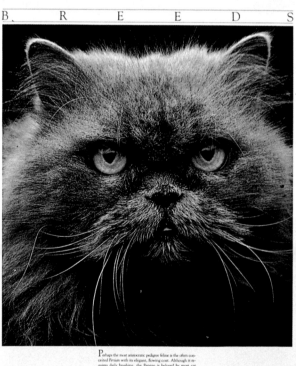

Perhaps the most aristocratic pedigree feline is the often conceited Persian with its elegant, flowing coat. Although it requires daily brushing, the Persian is beloved by most cat fanciers.
Copyright © Michael Skott.

The Rites of Passage

By Anne LaBastille

F

ar out on a mist-shrouded lake, a loon wails again and again. But on this morning in late May, his high-pitched crying elicits no reply. His mate is preoccupied with two olive brown, spotted eggs, almost twice the bulk of a chicken's, cradled in a nest of rushes and matted grasses near the water's edge.

Deep in the Adirondacks of northern New York, these Common Loons have for 29 days taken turns incubating the eggs. Yesterday signs of life stirred within one egg as a loon embryo ruptured its swaddling membrane, reaching the air chamber inside the shell, and began to breathe. Today it utters tiny sounds, and the mother responds by clucking. In this way, some scientists believe, a bond of recognition forms between mother and young before the baby birds hatch.

Now, as the sun burns through the mist, one of the eggs breaks apart. A baby loon, shaking pieces of shell from its head, emerges wet and bedraggled. The albumen rapidly dries and crumbles away, leaving a blackish brown ball of fluff with red eyes and a white belly. As soon as the second nestling struggles free of its calcareous prison, the father, having returned to the nest, carries away the shell fragments and drops them in deep water. This reduces the risk of a sharp-eyed predator locating the nest while the young are most vulnerable.

Just as prudence guides the loons' behavior on an Adirondack lake, so it is with other parent birds across the continent. During spring and summer they must nurture their young, provide for their safety, and

Fresh from the egg, a Wood Duck faces a new world. By William J. Weber.

108

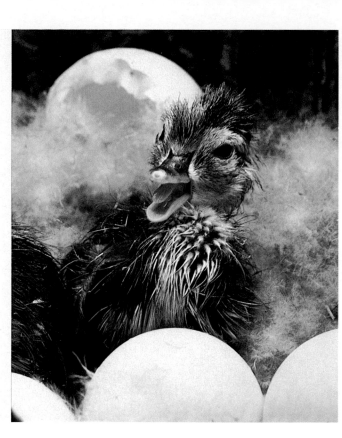

Book Title:
The Wonder of Birds
Editor:
Robert M. Poole
Art Director:
David M. Seager
Designer:
David M. Seager
Washington, DC
Letterer:
Tom Carnase
Publisher:
National Geographic
Society
Typographer:
National Geographic
Photographic Services
Printer:
R.R. Donnelley & Sons
Co.
Production Manager:
Robert C. Firestone
Paper:
S.D. Warren Co.
Binder:
R.R. Donnelley & Sons
Co.
Jacket Designer:
David M. Seager
Jacket Photographers:
Stephen C. Wilson and
Karen C. Hayden,
Entheos
Jacket Letterer:
Tom Carnase

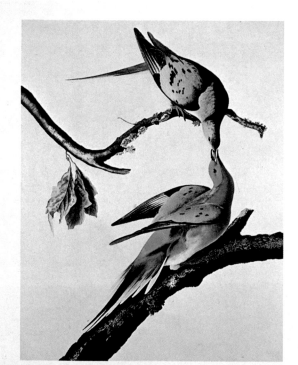

228

Humans will never look upon their kind again. Swift and graceful Passenger Pigeons (opposite) were once so numerous that Audubon wrote: "The air was literally filled . . . the light of noon-day was obscured as by an eclipse." But hunting and the felling of forests reduced pigeon populations from billions to zero by 1914. The shy Labrador Duck (right), only member of the waterfowl family to disappear in North America, had mysteriously vanished by 1875—before scientists could probe its secret life. The Great Auk (below), a flightless seafarer persecuted for food, oil, and feathers, had become extinct before Audubon died in 1851.

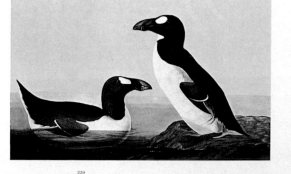

Paintings by John James Audubon, New York Historical Society

229

Book Title:
Shakespeare's Dog
Author:
Leon Rooke
Editor:
Gordon Lish
Art Director:
Betty Anderson
Designer:
Albert Chiang
New York. NY
Publisher:
Alfred A. Knopf. Inc.
Typographer:
Maryland Linotype
Composition. Inc.
Printer:
The Haddon Craftsmen.
Inc.
Production Manager:
Andrew W. Hughes
Paper:
SDW Antique #60
Binder:
The Haddon Craftsmen.
Inc.
Jacket Designer:
James Laughlin/
Jael Graphics
Jacket Illustrator:
Gary Reed Price/
Jael Graphics

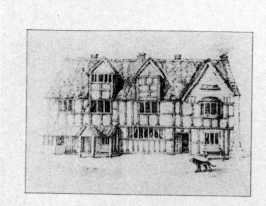

THE BIRTHPLACE

SHAKE-SPEARE'S DOG

a novel by Leon Rooke

ALFRED A.
KNOPF
NEW
YORK
1983

Book Title:
Leonard Baskin's
Miniature Natural History
Editor:
Frances Foster
Art Director:
Denise Cronin
Designers:
Leonard Baskin.
Denise Cronin
New York. NY
Illustrator:
Leonard Baskin
Publisher:
Pantheon Books for
Young Readers
Typographer:
The Press of A. Colish
Printer:
Tien Wah Press
Production Manager:
Steven Bloom
Paper:
120 GSM Matte Coated
Binder:
Tien Wah Press
Jacket Designer:
Leonard Baskin
Jacket Illustrator:
Leonard Baskin

2

For all of this talk on the Regarders in Stratford that day, not much was doing on the surface. A dog digging in mud at Rother Market—to come up with peach pit after all of his trying—told me he'd heard nothing; moreover, that this crew was fictive in my imagination and long since abolished. "The Queen's changed it," he said. "Hooker, old claw, you're living in the past. Too many ticks in your pallet."

Nor did any other canine I saw give nod to the rumor.

Gil Bradley, hammering on anvil at his smithy shed by the mere, had his dog chained up and his jaws bolted, but that roisterer, no friend of mine, told me he'd seen or heard of nothing suspicious. A slow-gaited creature named Onion, son of a cutpurse terrier, testified he too had come across nothing irregular.

And that was the story all over. Though I went on with my upright sniffing.

Down near Old Town past the Sadler house one mutt, half-blind and crazed by mange, said he'd smelled weird blood on Clopton Bridge and seen sharp footprints belonging to twelve strangers, but he couldn't connect

this with any band of coxers and, anyhow, I found his report unreliable.

Fact is, none of the dogs seemed alarmed, and most were too ignorant or too engaged in their duties even to understand the problem. Along the almshouses on Church Street down from the Guild, where death and old age and a thousand miseries were crowded in and smelling to high Heaven, I passed with some curiosity a woman in black hemper gown with red border and long apron, conveying live poultry tethered at each end of her shoulder stick (plus one unplucked under her arm), and the limper trailing her said he'd heard it too, though in his opinion it was naught but gossip meant to raise panic.

If there was dead deer within the county, he said, he'd know it.

I found a few dogs staked by the Avon, looking weary, but they said staking was their owners' custom while practicing archery as part of their home-guard Christian duty.

A lady, so filthy in all of her parts I took her to be inhuman, came by astride a square-backed mule, and though I sniffed her up and trotted alongside them for a duration, I glimmered nothing useful.

In fact, I gleamed nothing whatsoever in the whole of the town and saw no sign of commotion or whoobug out of the ordinary, nor any Two Foot strangers that conveyed the air of anything menacing.

The Quiney boy was taking his monthly bath in the river.

At another spot on the Avon, some triflers were merrymaking with the cucking stool that had been brought out to punish this or that unfortunate scold—probably the Pynder woman, for she had been dunked

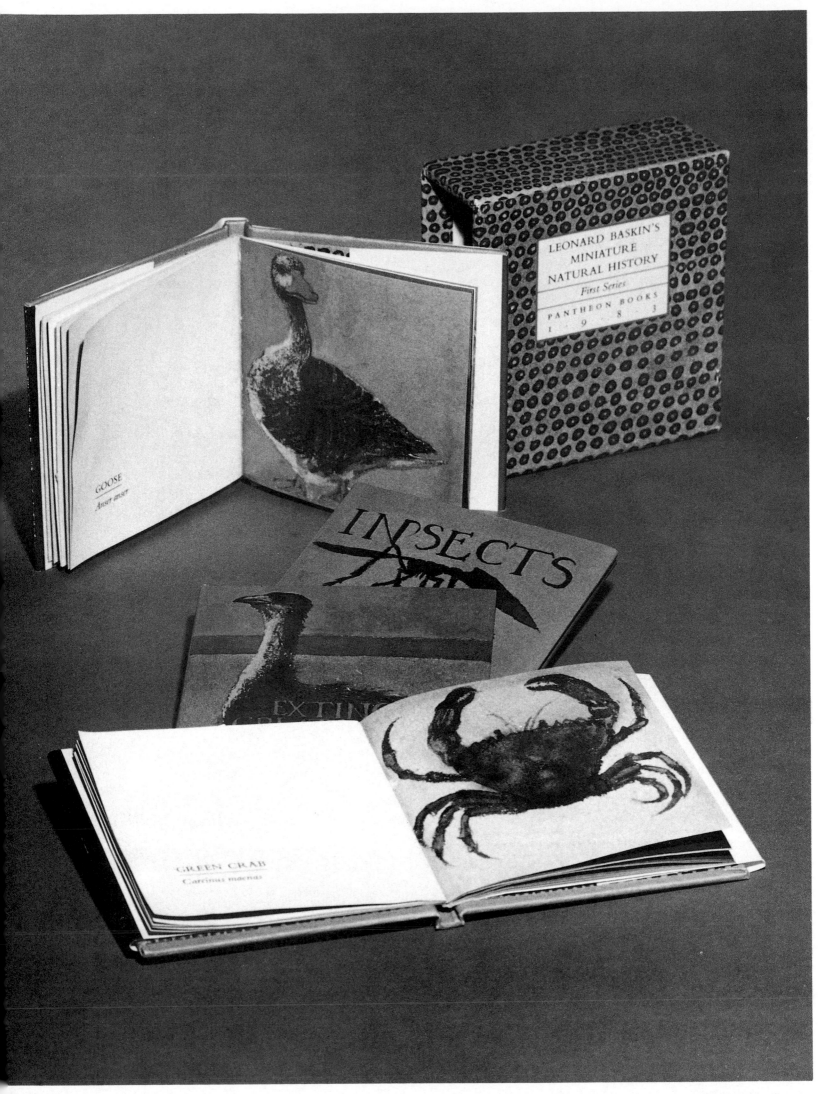

The book on the box reads:

LEONARD BASKIN'S
MINIATURE
NATURAL HISTORY
First Series
PANTHEON BOOKS
1 9 8 3

GOOSE
Anser anser

INSECTS

GREEN CRAB
Carcinus maenas

Book Title:
The Nightgown of
The Sullen Moon
Author:
Nancy Willard
Editor:
Maria Modugno
Art Director:
Rubin Pfeffer
Designer:
Joy Chu
San Diego, CA
Illustrator:
David McPhail
Publisher:
Harcourt Brace
Jovanovich
Typographer:
Thompson Type
Latent Lettering
Printer:
Holyoke Lithograph Co.
Production Manager:
Warren Wallerstein
Paper:
Karma Text #80
Binder:
A. Horowitz & Sons
Jacket Designer:
Rubin Pfeffer, Joy Chu
Jacket Illustrator:
David McPhail

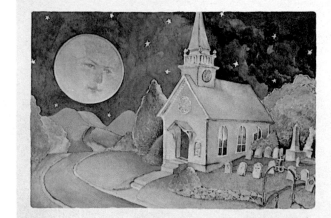

She passed a church,

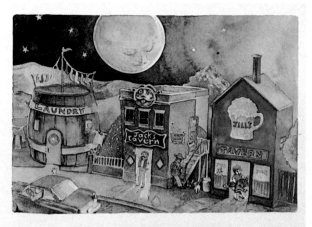

a laundry, and taverns

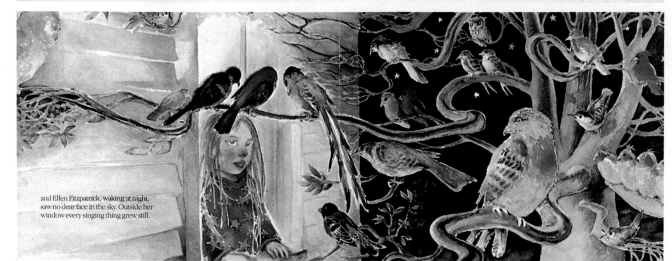

and Ellen Fitzpatrick, waking at night,
saw no dear face in the sky. Outside her
window every singing thing grew still.

Book Title:
A World of Animals:
The San Diego Zoo and
The Wild Animal Park
Editor:
Sheila Franklin
Art Director:
Samuel N. Antupit
Designer:
Bob McKee
New York, NY
Photographer:
Ron Garrison
Publisher:
Harry N. Abrams, Inc.
Typographer:
Precision Typographers,
Inc.
Printer:
Dai Nippon Printing Co.,
Ltd.
Production Manager:
Shun'ichi Yammamoto
Paper:
S.K. Coat 128 g/MZ
Binder:
Dai Nippon Printing Co.,
Ltd.
Jacket Designer:
Bob McKee
Jacket Photographer:
Ron Garrison

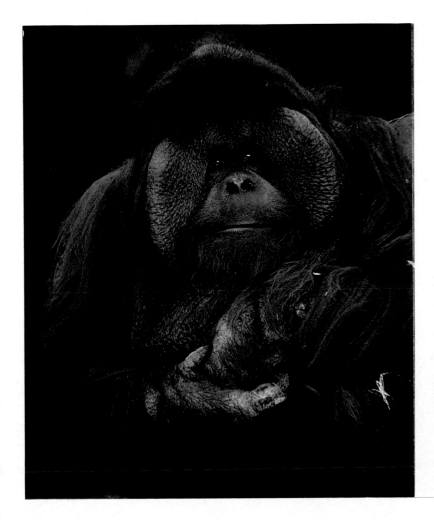

BOB, THE BORNEAN ORANGUTAN

With his jocular jowls, his whimsical expression, and his sheer size (nearly 325 pounds), Bob was one of the Zoo's most photogenic animals. He was three years old when he arrived from the island of Borneo in 1958 and he lived another twenty-two years, leaving ten offspring behind him, all of whom are carrying on his line in zoos from Brazil to China.

"Bob was a really good animal," says keeper Gale Foland, "and I don't want to run him down, but he did have one unfortunate trait: he was somewhat of a wife-beater. The orangs are asleep when I come to work in the morning, and when I'd wake Bob up, he would proceed to roll his mate around the cage for about five minutes. He wouldn't bite Maggie, but he'd get down low and shoulder her about, roughing her up. Rather than fight back—which she knew was futile—she'd go into passive resistance and just take a little abuse. After that, Bob would be fine the rest of the day. I guess he was trying to impress me; it certainly wasn't for her benefit."

Veteran keeper Harold ("Mitch") Mitchell recalled one of Bob's more benign morning rituals. "In good weather, when we let him out on exhibit, he'd always climb to the top of the play structure for a look around. If the sun was out, he'd put a hand up to shade his eyes and lie there, watching the people as they watched him."

It is estimated that less than four thousand orangutans now survive in the tropical forests on the islands of Borneo and Sumatra. They are protected there, yet deforestation threatens their ultimate survival in the wild. Although there has been hybridization of Borneans and Sumatrans in captivity, the San Diego Zoo maintains a strong, separate genetic line for each. If purebred, the Borneans are easily distinguishable from the Sumatrans, for the former have characteristic cheek flanges and a heavier build.

After Bob died in 1980, the Zoo's Bornean colony fluctuated and curator Diane Brockman tried different ways of populating the group, searching for the right chemistry. She tried to incorporate Billy, a proven breeder from the Lincoln Park Zoo in Chicago, but he attacked the San Diego females—biting them severely—instead of mating with them. Then Brockman decided to let nature take its course with ten-year-old Ken-Alan, one of Bob and Maggie's offspring who was reaching sexual maturity. Sure enough, he mated with Mary Fred, a wild-born orang, and in March, 1982, she gave birth to Kent.

Opposite:
The Bornean orangutan Bob

Bob on the play-structure platform

Book Title:
Dear Zoo
Author:
Rod Campbell
Editors:
Matthew Price
Norma Jean Sawicki
Art Directors:
Janetta Otter-Barry
Kathleen Westray
Designer:
Rod Campbell
New York. NY
Illustrator:
Rod Campbell
Publisher:
Four Winds Press
Typographer:
Bob McNad
Printer:
Tien Wah Press
Production Manager:
John McGrory
Paper:
230GSM C2S Art Board
Binder:
Tien Wah Press
Jacket Designers:
Rod Campbell
Kathleen Westray
Jacket Illustrator:
Rod Campbell

So they sent me a ...

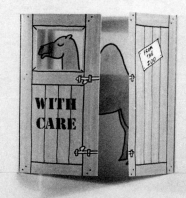

He was too grumpy!
I sent him back.

Book Title:
Field Guide to the Birds
of North America
Editor:
Shirley L. Scott
Art Director:
David M. Seager
Designer:
David M. Seager
Washington. DC
Illustrators:
Various
Publisher:
National Geographic
Society
Typographer:
National Geographic
Photographic Services
Printer:
Kingsport Press
Production Manager:
Robert C. Firestone
Paper:
Mead Paper Co.
Binder:
Kingsport Press
Jacket Designer:
David M. Seager
Jacket Illustrators:
David M. Seager
Patricia A. Topper

Kingfishers (Family Alcedinidae)

Stocky, short-legged body; large head, with oversize bill and, in two species, a ragged crest. Look for kingfishers near woodland streams and ponds and in coastal areas. They hover over water or watch from low perches, then plunge headfirst to catch a fish. Heavy bill and stubby feet also serve for digging long nest burrows in stream banks.

Belted Kingfisher *Ceryle alcyon* *L 13" (33 cm)*
The only kingfisher seen in most of North America. Both male and female have slate blue breast band. Female has rust belly band and flanks, may be confused with female Ringed Kingfisher where ranges overlap; note white belly and undertail coverts. Juvenile resembles adult but has rust spotting in breast band. Common along rivers and brooks, ponds and lakes, estuaries; perches conspicuously. Solitary except in nesting season. Call is a loud, dry rattle.

Ringed Kingfisher *Ceryle torquata* *L 16" (41 cm)*
Similar to but larger than Belted Kingfisher; generally frequents larger rivers and ponds, perches on higher branches. Male is entirely rust below. Female has slate blue breast, narrow white band, rust belly and undertail coverts. Juveniles resemble adult female, but juvenile male's breast is largely rust. Resident in lower Rio Grande Valley; occasionally wanders northward to central Texas in fall and winter. Call is a harsh rattle, lower pitched and slower than in Belted Kingfisher. In flight, gives a slow, measured series of *chack* notes.

Green Kingfisher *Chloroceryle americana* *L 8¾" (22 cm)*
Smallest of our kingfishers; crest inconspicuous. Green above, with white collar; white below, with dark green spotting. Male has rust breast band; female has a band of green spots. Juvenile resembles adult female. Fairly common resident of lower Rio Grande Valley; less common on Edwards Plateau. A few wander along the Texas coast in fall and winter; rare straggler in southern Arizona in winter. Call is a faint but sharp *tick tick*. Often perches on low, inconspicuous branches.

262

186

Book Title:
Up a Tree
Author:
Ed Young
Editor:
Laura Geringer
Art Director:
Harriett Barton
Designers:
Ed Young
Harriett Barton
New York. NY
Illustrator:
Ed Young
Publisher:
Harper & Row.
Publishers. Inc.
Typographer:
Cardinal Type Service.
Inc.
Printer:
Rae Publishing Co.
Production Manager:
John Vitale
Paper:
P & S Regular Offset
#70
Binder:
The Book Press. Inc.
Jacket Designer:
Ed Young
Jacket Illustrator:
Ed Young

Tall City, Wide Country

A Book to Read Forward and Backward

By Seymour Chwast

The Viking Press
New York

Book Title:
Tall City, Wide Country
Author:
Barbara G. Hennessy
Editor:
Deborah Brodie
Art Director:
Barbara G. Hennessy
Designers:
Barbara G. Hennessy
Seymour Chwast
New York, NY
Illustrator:
Seymour Chwast
Publisher:
The Viking Press
Typographer:
Haber Typographers
Printer:
Rae Publishing Co.
Production Manager:
Linda Prather
Paper:
Baldwin Paper Co.
Binder:
A. Horowitz & Sons
Jacket Designer:
Seymour Chwast
Jacket Illustrator:
Seymour Chwast

Cows moo

Crowds
cheer

Book Title:
The Knopf Collector's
Guide to American
Antiques: Dolls
Author:
Wendy Lavitt
Art Director:
Carol Nehring
Designer:
Massimo Vignelli
New York, NY
Photographer:
Schecter Me Sun Lee
Publisher:
Alfred A. Knopf, Inc.
Typographer:
Dix Type, Inc.
Printer:
Dai Nippon Printing Co.,
Ltd.
Production Manager:
Helga Lose
Paper:
Kinfuji 105 gram Satin
Art Dull Coated
Binder:
Dai Nippon Printing Co.,
Ltd.
Jacket Photographer:
Schecter Me Sun Lee

266 David Copperfield and Tiny Betty

Description
All-composition boy and girl dolls with molded and painted features including side-glancing eyes, pointed chins, and pug noses. Blond wigs. One-piece heads and bodies; jointed limbs. Left: David Copperfield with wig tied back in ponytail. Original black jacket, white collar, and purple and white striped pants; molded white socks and black shoes. Right: Tiny Betty in original gray velvet dress with yarn trim at cuffs and hem, red felt bonnet with yarn trim, red stockinet mittens. Molded white socks and black Mary Jane shoes.

Materials, Marks, and Dimensions
Composition. "MME ALEXANDER" embossed on backs. Height: 7".

Maker, Origin, and Period
Madame Alexander. New York City. c. 1935–43.

Comment
These are among the first composition dolls Madame Alexander produced. Over the years the company featured dolls of more than 50 characters from children's and classic literature, including Dickens's *David Copperfield*. Such subject matter reflected Madame Alexander's belief that dolls should be educational. Tiny Betty is a miniature figure from the firm's line of Betty-type dolls, which came in various sizes.

Hints for Collectors
Like many manufacturers, Madame Alexander created several basic doll types—including Princess Elizabeth, Wendy-Ann, Margaret, and Cissy—which, through a change of clothing or hairstyle, could portray any number of characters. The specific character may be identified by a cloth label sewn inside the clothing.

267 Fern Deutsch dolls

Description
Girl and boy dolls with composition heads and molded and painted features. Original costumes based on 19th-century styles. Left: Girl with long black hair wears lace-trimmed pink taffeta dress, 2 white slips, and white lace pantaloons. Picture hat. White stockings and white leather boots. Small doll held in arms wears blue taffeta dress, green taffeta diaper, and white satin booties. Right: Boy with blond hair holds hoop in left hand and stick in right. Wears white cotton shirt with lace-trimmed collar and cuffs; black velvet suit, tie, and hat. White stockings and spats and black leather shoes.

Materials, Marks, and Dimensions
Composition heads and hands; cloth bodies over wire armatures. Height: 13¾" (left); 13½" (right).

Maker, Origin, and Period
Fern Deutsch and Besse McGee. San Antonio, Texas. Left: c. 1967. Right: c. 1964.

Comment
Fern Deutsch learned about doll construction from her mother, a noted designer of display figures for New York City department stores. Commissioned by collectors and museums, Deutsch began making dolls in the 1940s. She concentrated on the design and modeling of heads and hands, while her aunt, Besse McGee, specialized in the body construction. Each item of clothing was researched to ensure its authenticity.

Hints for Collectors
Deutsch dolls have bodies made of padded fabric or chamois built over wire armatures. The heads and hands are made from specially formulated composition, then covered with kidskin and painted in oil. Few, if any, are on the market today.

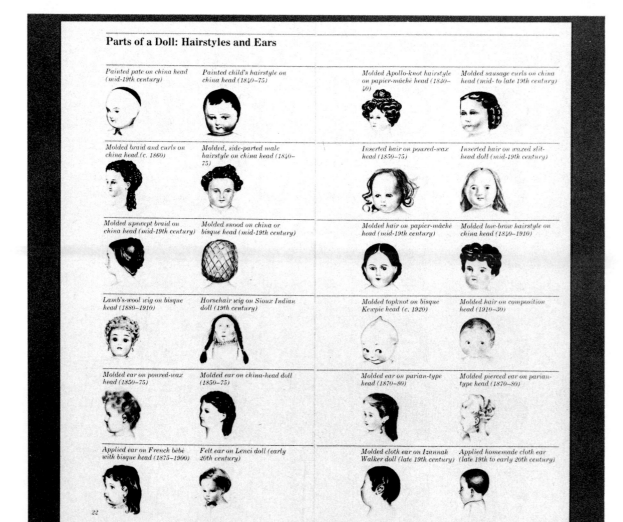

Parts of a Doll: Hairstyles and Ears

Painted pate on china head (mid-19th century)

Painted child's hairstyle on china head (1840–75)

Molded Apollo-knot hairstyle on papier-mâché head (1830–40)

Molded sausage curls on china head (mid- to late 19th century)

Molded braid and curls on china head (c. 1860)

Molded, side-parted male hairstyle on china head (1840–75)

Inserted hair on poured-wax head (1850–75)

Inserted hair on waxed slit-head doll (mid-19th century)

Molded upswept braid on china head (mid-19th century)

Molded snood on china or bisque head (mid-19th century)

Molded hair on papier-mâché head (mid-19th century)

Molded low-brow hairstyle on china head (1840–1910)

Lamb's-wool wig on bisque head (1880–1910)

Horsehair wig on Sioux Indian doll (19th century)

Molded topknot on bisque Kewpie head (c. 1920)

Molded hair on composition head (1910–30)

Molded ear on poured-wax head (1850–75)

Molded ear on china-head doll (1850–75)

Molded ear on parian-type head (1870–80)

Molded pierced ear on parian-type head (1870–80)

Applied ear on French bébé with bisque head (1875–1900)

Felt ear on Lenci doll (early 20th century)

Molded cloth ear on Izannah Walker doll (late 19th century)

Applied homemade cloth ear (late 19th to early 20th century)

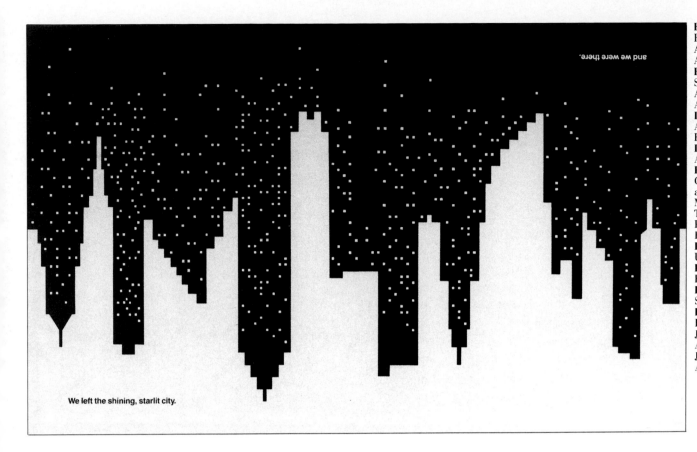

and we were there.

We left the shining, starlit city.

Book Title:
Round Trip
Author:
Ann Jonas
Editor:
Susan Hirschman
Art Director:
Ava Weiss
Designer:
Ann Jonas
Brooklyn, NY
Illustrator:
Ann Jonas
Publisher:
Green Willow Books,
a division of Wm.
Morrow & Co., Inc.
Typographer:
Pastore DePamphilis
Rampone
Printer:
United Lithographers
Production Manager:
Eugene Sanchez
Paper:
Sterling Litho Matte #80
Binder:
Rae Bindery
Jacket Designer:
Ann Jonas
Jacket Illustrator:
Ann Jonas

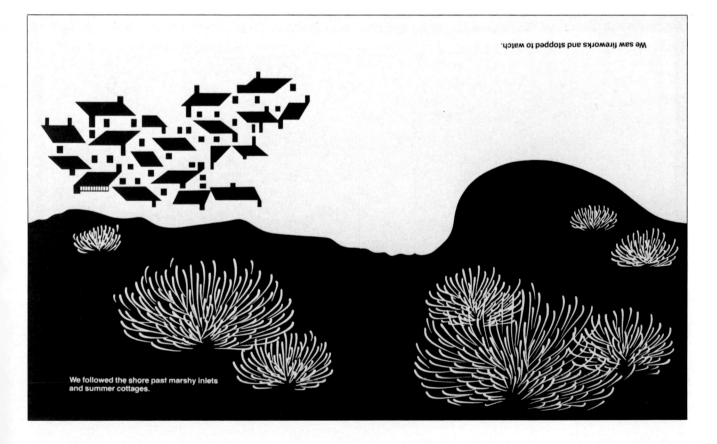

We saw fireworks and stopped to watch.

We followed the shore past marshy inlets
and summer cottages.

Book Title:
Bunny Rabbit Rebus
Author:
David A. Adler
Editor:
Barbara Fenton
Art Director:
Harriett Barton
Designer:
Al Cetta
New York, NY
Illustrator:
Madelaine Gill Linden
Publisher:
T. Y. Crowell
Typographer:
Cardinal Type Service, Inc.
Printer:
Rae Publishing Co.
Production Manager:
John Vitale
Paper:
Moist Rite Matte
Binder:
The Book Press, Inc.
Jacket Designer:
Al Cetta
Jacket Illustrator:
Madelaine Gill Linden

The rebuses in this
GLOSSARY
are in the order that they first appear
in the story.

👁'm = I'm	U = you	Ccret = secret
🐰 = Little Rabbit	C = see	🐰 = rabbit
told = told	8 = ate	cl⊘mbed = climbed
👁 = I	o⁄ed = opened	🪑 = chair
2 = to, too, two	🌿 = pantry	cupboard = cupboard
🐢 = Mother Rabbit	🚪 = door	⊘h⊘nd = behind
4 = for	⚡ = top	🍽️🍽️ = dishes
🍖 = food	⊙f = shelf	🧺 = basket
🪑 = table	🌿 = lettuce	MT = empty
🐷 = bare	O = oh	🐇 = head
🥕 = carrots	🔔 = well	E10 = eaten
h🐇 = here	m👁 = my	🌐 = we'll

30

road = road	st⊘ped = stopped	⊘shed = finished
🏠 = house	= would	🎩 = roll
📖 = pillow	⚡p = keep	🐁 = Mouse
👁👁 = eyes	le = pile	🦌 = dear
🍹 = can	⊘l = bowl	R = are
☆ted = started	🐔 = Hen	🌽 = corn
w8 = wait	barrel = barrel	NEthing = anything
⊘2d = need	⊘lding = holding	🧀 = cheese
⊘⊘⊘ = feathers	= not	⊘4 = before
🐤 = Duck	pick = pick	🪣 = pail
may⊘ = maybe	le = whole	🍓 = berries
loo⊘ = looking	👢 = bag	⁄me = home
th⊘ = think	🌱 = seeds	🛏️ = bed
⊘ = rain	⊘ful = mouthful	ma⊘ = making
⊙⊙ = clouds	E = ready	⊘ = sign
⊘yond = beyond	⊘ = straw	
🌲🌲 = trees	🧹 = broom	

31

🐢 said. "Did U C them?"

"👁 8 them," 🐰 told her.

🐢 o⁄ed the 🌿 🚪. She looked on the ⚡ ⊙f.

"👁 was sure 👁 had some 🌿 h🐇."

"U did," 🐰 said. "But 👁 8 it."

"O 🔔," 🐢 said. "👁 shall look in m👁 Ccret place. There is always a 🥕 or 2 there 4 a hungry little 🐰."

🐢 cl⊘mbed on a 🪑. She o⁄ed the cupboard. She reached ⊘h⊘nd some 🍽️🍽️

4

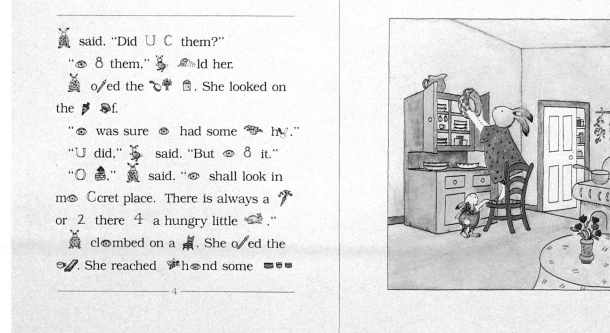

Book Title:
WHO?
Author:
Leo Lionni
Editor:
Frances Foster
Art Director:
Denise Cronin
Designer:
Leo Lionni
Porcignano, Italy
Illustrator:
Leo Lionni
Publisher:
Pantheon Books for
Young Readers
Typographer:
Haber Typographers
Printers:
National Litho
Rae Publishing Co.
Production Manager:
Elaine Silber
Paper:
Gulfstate 24 pr.
E.Z. Low Board
Binder:
Deridder-Thurston
Jacket Designers:
Leo Lionni
Minna Greenstein
Jacket Illustrator:
Leo Lionni

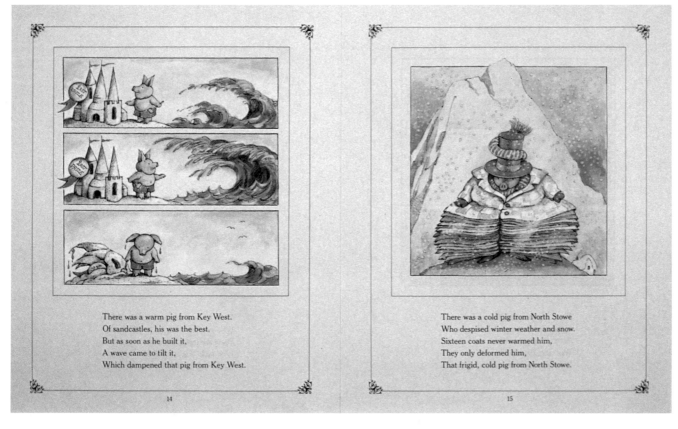

There was a warm pig from Key West.
Of sandcastles, his was the best.
But as soon as he built it,
A wave came to tilt it,
Which dampened that pig from Key West.

14

There was a cold pig from North Stowe
Who despised winter weather and snow.
Sixteen coats never warmed him,
They only deformed him,
That frigid, cold pig from North Stowe.

15

Book Title:
The Book of Piggericks
Author:
Arnold Lobel
Editor:
Elizabeth Gordon
Art Director:
Harriett Barton
Designers:
Arnold Lobel
Harriett Barton
New York, NY
Illustrator:
Arnold Lobel
Publisher:
Harper & Row,
Publishers, Inc.
Typographer:
Cardinal Type Service,
Inc.
Printer:
Rae Publishing Co.
Production Manager:
John Vitale
Paper:
Moistrite Matte #80
Binder:
A. Horowitz & Sons
Jacket Designer:
Arnold Lobel
Jacket Illustrator:
Arnold Lobel

Book Title:
Hooray for Hollywood
Author:
Jim Heimann
Art Director:
Jim Heimann
Designer:
Paul Mussa
San Francisco, CA
Illustrators:
Various
Letterer:
Paul Mussa
Publisher:
Chronicle Books
Typographer:
Type By Design
Printer:
Dai Nippon Printing Co.,
Ltd.
Production Manager:
David Barich
Paper:
Glossy #80
Binder:
Dai Nippon Printing Co.,
Ltd.
Jacket Designer:
Paul Mussa
Jacket Letterer:
Paul Mussa

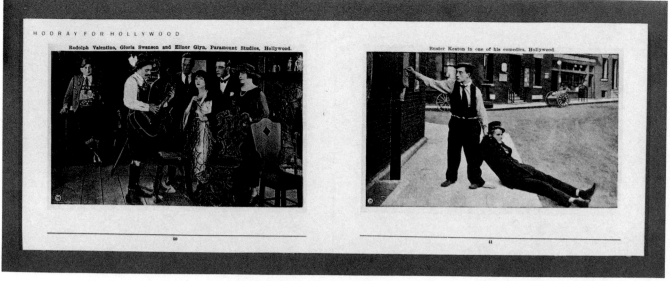

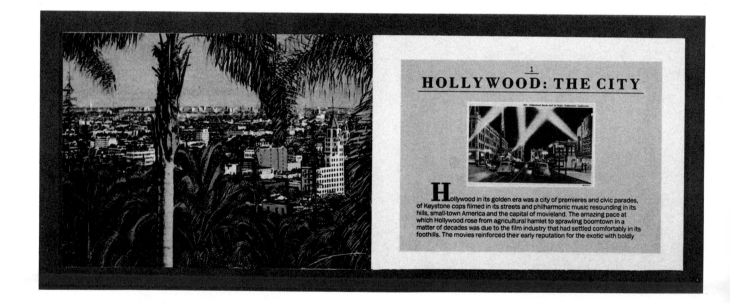

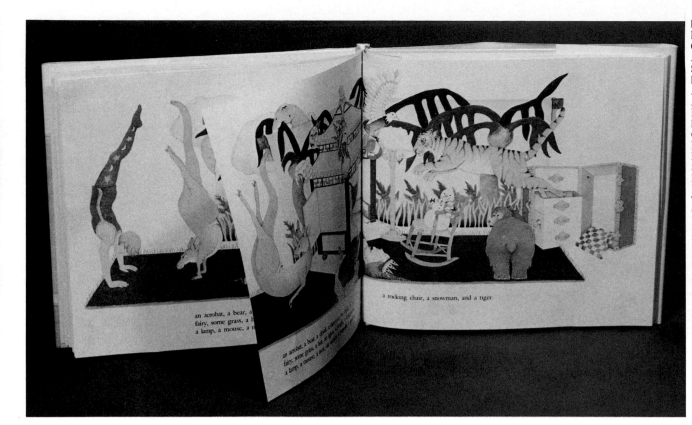

Book Title:
I Unpacked My
Grandmother's Trunk
Author:
Susan Hoguet
Editor:
Ann Durell
Art Director:
Riki Levinson
Designer:
Claire Counihan
New York, NY
Illustrator:
Susan Hoguet
Publisher:
E. P. Dutton, Inc.
Typographer:
Cardinal Type Service,
Inc.
Printer:
Dai Nippon Printing Co.,
Ltd.
Production Manager:
David Zable
Paper:
128 GSM Matte Coated
#86
Binder:
Dai Nippon Printing Co.,
Ltd.
Jacket Designer:
Claire Counihan
Jacket Illustrator:
Susan Hoguet

Catullus Reads My Manifesto

Put off by fashion—Manhattan
To Indian reservations—I handed
Catullus my manifesto.
'It's all right.' He gave it back.
All dressed up at 10 A.M.,
He mixed me a screwdriver.
I lit a cigarette, pushed back
My hair, preparing myself.
'I don't see a hill—green, brown,
Blue—or a tree, much less a flower
Screaming its yellow heart
At the sun. Write as you please,
Only—and don't take offense—
Write me beautiful women, particular
Ones, or ugly women, particular
Ones, or in-between, particular
Ones, to read about. Or
The river, yellow as lemon peel,
You didn't mention.'
 'I might
As well get drunk,' I said.
He mixed me another screwdriver.

You Asked Me

You really want my opinion,
Catullus? I wouldn't touch her.
You'll probably get syph, front and back.
That young man she's been sleeping with—
He takes anything to bed: man, woman, dog.
Marijuana and a little booze, he's ready.
I know you don't want my opinion.
But I'd wash her up and check her out
And see if that boy's in the closet.

Book Title:
My Confidant. Catullus
Author:
Thomas McAfee
Designer:
Barbara Cash
Mt. Carmel, CT
Artist:
Andrea Palladio
Publisher:
Barbara Cash/Ives Street
Press
Typographer:
Barbara Cash
Printer:
Barbara Cash, Ives Street
Press
Paper:
Masa
Binder:
Barbara Cash

Book Title:
The Sky is Full of Song
Poem Selection:
Lee Bennett Hopkins
Editors:
Charlotte Zolotow
Antonia Markiet
Art Director:
Harriett Barton
Designer:
Al Cetta
New York, NY
Illustrator:
Dirk Zimmer
Publisher:
Harper & Row,
Publishers, Inc.
Typographer:
Cardinal Type Service,
Inc.
Printer:
Rae Publishing Co.
Production Manager:
John Vitale
Paper:
P&S Regular Offsett D13
Binder:
The Book Press, Inc.
Jacket Designer:
Al Cetta
Jacket Illustrator:
Dirk Zimmer

Sidewalk Measles
Barbara M. Hales

I saw the sidewalk catch the measles
When the rain came down today.
It started with a little blotching—
Quickly spread to heavy splotching,
Then as I continued watching
The rain-rash slowly dried away.

April
Lucille Clifton

Rain is good
for washing leaves
and stones and bricks and
even eyes,
and if you hold
your head just so
you can almost see
the tops of skies.

26

27

The Shadow Tree
Ilo Orleans

I'd love to sit
 On the highest branch
But it's much too high
 For me;

So I sit on the grass
 Where the shadow falls,
On the top of
 The shadow tree.

The City
David Ignatow

If flowers want to grow
right out of the concrete sidewalk cracks
I'm going to bend down to smell them.

28

196

He was about to aim his rifle, when the thought occurred to him that the wolf could have eaten the old lady and she might still be saved. He didn't shoot but took scissors and began to cut open the belly of the sleeping wolf.

Book Title:
Little Red Cap
Authors:
The Brothers Grimm
Editor/Translator:
Elizabeth D. Crawford
Art Directors:
Cynthia Basil
Sylvia Frezzolini
Designer:
Cynthia Basil
New York, NY
Illustrator:
Lisbeth Zwerger
Publisher:
Morrow Junior Books
Typographer:
Expertype, Inc.
Printer:
Worzalla Publishing Co.
Production Manager:
John Wahler
Paper:
Sterling Litho Matte #80
Binder:
Worzalla Publishing Co.
Jacket Designer:
Sylvia Frezzolini
Jacket Illustrator:
Lisbeth Zwerger

Once there was a sweet little girl, beloved by everyone who laid eyes on her, but most of all by her grandmother, who couldn't do enough for the child. One time the grandmother gave her a little cap of red silk, and because it pleased her so much and she wore it all the time, she was known as Little Red Cap.

One day her mother said to her, "Come, Little Red Cap, here's a cake and a bottle of wine to take to your grandmother. She is ill and weak, and they will be a treat for her. Now go along before it gets hot, and be sure to walk carefully and don't stray from the path. Otherwise, you may fall and break the bottle, and then Grandmother will have nothing. And when you go into her room, don't forget to say good-day, and don't stare at every corner first."

"I will do everything right," said Little Red Cap, and she gave her mother her word on it.

Book Title:
Baltimore: When She
Was What She Used To Be
Authors:
Mame and Marion
Warren
Editors:
Nancy Essig
Jane Warth
Art Director:
James S. Johnston
Designers:
Gerard A. Valerio, Mame
and Marion Warren
Baltimore, MD
Photographers:
Various
Publisher:
The Johns Hopkins
University Press
Typographer:
Service Composition Co.
Printer:
Collins Lithographing &
Printing Co.
Production Manager:
James S. Johnston
Paper:
Warren's Lustro Offset
Enamel, Dull #80
Binder:
The Optic Bindery, Inc.
Jacket Designers:
Gerard A. Valerio, Mame
and Marion Warren

WEARY WANDERERS

116. Altamont Hotel, Eutaw Place and Laurale Street, accommodated 125 persons at a rate of $2.50 to $4.00, American plan [22 February 1897]

60

61

BALTIMORE

When She Was What She Used to Be,
1850-1930

MARION E. WARREN
AND
MAME WARREN

THE JOHNS HOPKINS UNIVERSITY PRESS
BALTIMORE AND LONDON

1983

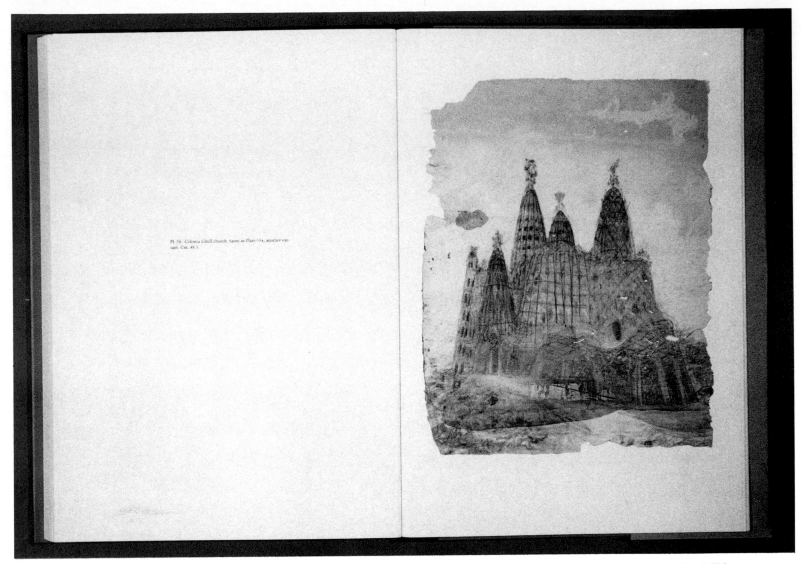

Pl. 56. Colonia Güell church. Same as Plate 55a, another variant. Cat. 48.5.

Book Title:
The Designs and
Drawings of Antonio
Gaudi
Authors:
George R. Collins
Juan Bassegoda Nonell
Editor
Christine Ivusic
Art Director:
Frank J. Mahood
Designer:
Frank J. Mahood
Princeton, NJ
Artist:
Antonio Gaudi
Publisher:
Princeton University
Press
Typographer:
Princeton University
Press
Printer:
Princeton University
Press
The Meriden Gravure Co.
Production Managers:
Joe Evanchik
Alan Rodgers
Paper:
Mohawk Superfine
Binder:
A. Horowitz & Son
Jacket Designer:
Frank J. Mahood

Book Title:
Widows
Author:
Ariel Dorfman
Editor:
Tom Engelhardt
Art Director:
Susan Mitchell
Designer:
Naomi Osnos
New York, NY
Publisher:
Pantheon
Typographer:
Com Com, a division of
Haddon Craftsmen, Inc.
Printer:
R. R. Donnelley & Sons
Co.
Production Manager:
Rebecca Woodruff
Paper:
S.D. Warren #55
Binder:
R. R. Donnelley & Sons
Co.
Jacket Designer:
Louise Fili
Jacket Illustrator:
Bascove

reporter had set temporarily on the table. The captain used it to signal to the sergeant.

"Captain!"

"Bring in the prisoner."

For about two seconds there was absolute stillness, as if everyone were waiting for all the traces of the captain's words to disappear. Then the women jumped to their feet and turned toward the door. They began rustling, buzzing.

"Quiet!" shouted the lieutenant. "Nobody in here moves without permission."

The captain kept his eyes on the old one. She was the only one who hadn't moved. Very carefully and with great dignity, now she rose and turned her back on him to look, with the rest of the women, at the door of the hall through which the man called "the prisoner" would enter.

The photographer extravagantly shot off his flash.

Then the captain shoved back his chair and fixed his eyes on the reporter.

"No," the captain said, handing her pencil back and smiling slightly. "Tomorrow. You'll leave tomorrow."

78

c h a p t e r
f i v e

Book Title:
Pigs in Hiding
Author:
Arlene Dubanevich
Editor:
Norma Jean Sawicki
Art Director:
Kathleen Westray
Designers:
Arlene Dubanevich
Kathleen Westray
New York, NY
Illustrator:
Arlene Dubanevich
Letterer:
Arlene Dubanevich
Publisher:
Four Winds Press
Typographer:
Innovative Graphics, Inc.
Printer:
Rae Publishing Co.
Production Manager:
Doris Barrett
Paper:
Glatco Matte #70
Binder:
A. Horowitz & Son
Jacket Designer:
Arlene Dubanevich
Kathleen Westray
Jacket Illustrator:
Arlene Dubanevich

200

POTTED SHRIMPS

Potted shrimps are a traditional English savory spread, served with brown bread and butter, or wholewheat toast with slices of lemon as part of an hors d'oeuvre, or as a light snack.

½ cup butter

1 lb peeled shrimps

¼ tsp powdered mace

¼ tsp cayenne pepper

salt and freshly ground black pepper

clarified butter

METHOD: Melt the butter over moderate heat. Stir in the shrimps, mace, and cayenne pepper. Continue stirring until the mixture is heated through, but do not allow to boil. Add salt and pepper to taste. Pour into small pots or crocks and seal with clarified butter. Will keep in the refrigerator for up to 2 weeks. *Yield: about 3 cups*

AUTUMN

62

WALNUT GARLIC OIL

Once you have had this oil around your kitchen, you will wonder how you ever did without it! Its subtle flavors enhance sautéed meats, salads, or marinades. Use a light French olive oil instead of the vegetable oil if you prefer.

5 cloves garlic, peeled and halved

8 walnut halves

2 cups vegetable oil

METHOD: Drop the garlic and walnut halves into a pint bottle. Warm the oil slightly and pour into the bottle. Seal and store in a cool place for at least a week, to allow the flavors to penetrate the oil.

AUTUMN

63

RASPBERRY PASTILLES

in France this recipe is made with black currants, and I have adapted Anne Willan's recipe for *pâte de cassis*, from her excellent *French Regional Cooking*, to use raspberries. These delectable little jellies can be cut into fancy shapes and served with a glass of kir (white wine and a tablespoon of *cassis*), or lemonade on a summer's afternoon. Store in an airtight container in a cool place.

2 lbs raspberries (approximately 3 pints), washed and picked over

2⅓ cups sugar • sugar for rolling

METHOD: Lightly oil an 8-inch cake pan. Put the raspberries in a saucepan, cover, and simmer until the fruit can be easily mashed to a pulp. Remove from the heat and push through a sieve. Return to the pan, stir in the sugar, and heat gently until dissolved. Boil for 20-25 minutes, stirring constantly with a wooden spoon and skimming occasionally, until the mixture comes away from the sides of the pan and reaches 230°F on a sugar thermometer. Pour into the oiled pan. Leave in a cool place for several days. Cut into about 1-inch cubes (or shapes) and roll in sugar. *Yield: about 1½ lbs*

SUMMER

36

Book Title:
Seasonal Gifts from the Kitchen
Author:
Emily Crumpacker
Editor:
John Smallwood
Art Director:
Larry Kazal
Designer:
Larry Kazal
New York, NY
Illustrator:
Vivienne Flesher
Producer/Client:
Smallwood & Stewart
Publisher:
William Morrow & Co.
Typographer:
Jackson Typesetting Co.
Printer:
Arnoldo Mondadori Editore
Paper:
Phoenix Imperial #100

Book Title:
Chief Joseph of the Nez Perce
Author:
Robert Penn Warren
Editor:
Albert Erskine
Art Director:
Bernard Klein
Designer:
Elissa Ichiyasu
New York, NY
Publisher:
Random House
Typographer:
Maryland Linotype
Composition, Inc.
Printer:
R.R. Donnelley & Sons
Co.
Production Manager:
Marilyn Doof
Paper:
S.D. Warren Sebago
Antique
Binder:
R. R. Donnelley & Sons
Co.
Jacket Designer:
Elissa Ichiyasu

In my opinion the non-treaty Nez Perces cannot in law be regarded as bound by the treaty of 1863 and in so far as attempts to deprive them of a right to occupancy of any land in its provisions are null and void.

MAJOR H. CLAY WOOD,

ADJUTANT TO GENERAL O. O. HOWARD

"How far away, and wavering
Like mist in dawn wind, was the law! You have seen
How mist in creek bottoms to nothing burns
When the sun-blaze strikes. How far away
Sat the Great White Father!
But we heard how in his heart he holds goodness.
His word came to us to give rejoicing."

Executive Mansion, June 16, 1873

It is hereby ordered that the tract of country described Nez Perces Cession, 1855 be withheld from entry and settlement as public lands and that the same be set apart as a reservation for the roaming Nez Perces, as recommended by the Secretary of Interior and the Commissioner of Indian Affairs.

U. S. GRANT

"But it faded like mist in the day's heat."

8

II

"But what is a piece of white paper, ink on it?
What if the Father, though great, be fed
On lies only, and seeks not to know what
Truth is, or cannot tell Truth from Lie?
So tears up the paper of Truth, and the liars,
Behind their hands, grin, while he writes a big Lie?

"Yes, what is a piece of white paper with black
Marks? And what is a face, white,
With lips tight shut to hide forkèd tongue?
Too late, too late, we knew what was the white spot
In distance—white cover of cloth, leather-tough,
On wagons that gleamed, like white clouds adrift
Afar, far off, over ridges in sunlight:
But they knew where they went, and we knew.
This knowledge, like lead of a rifle, sagged heavy in flesh—
Healed over, but there. It ached in the night."

But no recollection of former services could stand before the white man's greed.

MAJOR J. C. TRIMBLE

"My father held my hand, and he died.
Dying, said: 'Think always of your country.

9

Book Title:
Poland
Author:
James A. Michener
Editor:
Albert Erskine
Art Director:
Bernard Klein
Designer:
Carole Lowenstein
New York, NY
Cartographer:
Jean Paul Tremblay
Publisher:
Random House, Inc.
Typographer:
Com Com, a division of
The Haddon Craftsmen
Printers:
R. R. Donnelley & Sons
Co.
The Haddon Craftsmen
Production Manager:
Marilyn Doof
Paper:
S.D. Warren Antique
#50
Binders:
The Haddon Craftsmen
R.R. Donnelley & Sons
Co.

POLAND • 54

he had been in when he had only one. But Danuta could not imagine getting the horses the way she had, cutting men's throats to do it, and then surrendering them, so she refused to yield them to her master.

The argument was carried to Krzysztof himself, and in a solemn hearing convened in Castle Gorka, now with a roof, he listened patiently as his liege Zygmunt tried to establish his claim. At the conclusion the red-headed knight delivered his decision:

'It is unthinkable that a knight, even a minor one like Zygmunt of Bukowo, should have only one horse. Great knights ought to have thirty. But it is also unthinkable that a brave woman like Danuta, whose men tried so valiantly to save this community and who herself captured the two horses and rode them with such difficulty back to our village, should have them taken away from her.

'My decision! The big black horse to Zygmunt, the smaller brown horse to Jan the Forester.' (It would never have occurred to him to give it to Danuta.)

So Bukowo was reestablished, and once again its two castles guarded the Vistula, and the number of both its cottages and its inhabitants increased. But to the Tatars, always restless in Kiev, the lure of Golden Krakow was irresistible, and they returned on great foraging expeditions in 1260 and most forcefully in 1287, leveling the village on their way and burning its castles. Each time, the patient Poles rebuilt, for it was ingrained in them to love their land, even though they had not yet found a way to protect it.

They even succeeded in transmuting the hideous invasions into one of the golden legends of European history: during one attack on Krakow the Tatars crept close to the walls at midnight and would have captured the city had not a trumpeter stationed in the watchman's tower sounded a bold call that awakened the defenders. But as he blew a repeat of his warning, eager to alert everyone, a Tatar archer shot him through the throat, silencing him.

Thereafter, every hour on the hour, in the great square in Krakow, a trumpeter from that tower has sent forth the same call. But just as the melody seems about to establish itself, the trumpeting stops. The arrow has struck home.

Since that night seven hundred years ago, thousands, millions have stood in the square and heard the trumpeter of Krakow, and as they listened to his brief, brave warning some have dedicated themselves: 'When the Tatars return I must be ready.'

III

From
the West

I N THE YEAR 1378 A REMARKABLE marriage ceremony took place in Hungary, one which was to have considerable significance for Poland.

The father of the bride was a man of French descent, Louis d'Anjou, who ruled as King of Hungary, and also of Poland, a country he rarely visited. He was a wise king of great personal attractiveness and would be remembered in Hungarian history as Louis the Great and in Poland as Louis the Hungarian. He had three charming daughters, and the later years of his life were preoccupied with finding them husbands and kingdoms of their own.

The bridegroom was a handsome German prince, Wilhelm of Habsburg, who had been reared in Vienna and who gave promise of becoming an excellent king in either Austria, Hungary or, more likely, Poland. He was a good catch for the Anjou family, and King Louis was pleased with the match.

But the radiant star of this marriage was the bride, an adorable princess with an inborn grace, a winsome smile and a beauty which set her apart in whatever crowd she graced. She had a charming habit of looking directly into the eye of anyone to whom she spoke and in this way enchanted kings, cardinals, generals and financiers. She was known widely as one of the choice princesses of Europe, and she was five years old.

The wedding was of course ceremonial, but it was also real, because in conformance with a royal custom followed by various countries, as soon as

Dufresque proportions of the square—and a gloom that is not merely aesthetic. For the Law has laid a damp hand on the Île de la Cité: what with the Préfecture de Police, the Palais de Justice, the Quai des Orfèvres, and the hardly less penitential Hôtel-Dieu, the whole island is now crisis beyond redemption. The streets that Haussmann pulled down might by now have gone anyway, so extreme was their decomposition. The reader of Balzac, or of Eugène Sue, will not need to be reminded of what they were like: ". . . so narrow were the roads that the mud-gray houses, with their worm-eaten window frames, almost touched at the top. Dark and foul alleys led to even darker, even fouler staircases so steep that you had to haul yourself up with the help of a rope. On the ground floors of these houses coal-merchants, fruiterers, and bad-meat butchers lived side by side, and although their wares were next-to-worthless the shop-fronts were solidly barred with iron, such was the audacity of the thieves who abounded there."

This was what people really meant when they twaddled on about Héloïse and Abélard and the cradle of France. And yet there is little to be said for a solution that turns the very beginnings of Paris into a flavorless city center with overtones of informer, executioner, and attorney's clerk. There are few places in the Île de la Cité where one can walk, and still fewer where one can sit, with pleasure. Haussmann was proud of the way in which the Boulevard Saint-Michel gives on to the spire of the Sainte-Chapelle, but the truth is that although he touched not a stone of the Chapelle be robbed it of all its significance in the Parisian landscape. We should laugh at anyone who used a Cellini saltcellar as a doorstop, but that is how Haussmann treated the Sainte-Chapelle, and I know of few beautiful buildings so oddly abused.

The Sainte-Chapelle was completed a little over seven hundred years ago. Not much of what we see today can be said to go back to those times, however, for spire, doors, sculpture, stained glass, gilded timberwork, and paintings are almost all either of the nineteenth century or very thoroughly restored. But even if much of it is no more venerable than, let us say, the Cathedral of Saint John the Divine in New York, the proportions remain of a marvelous delicacy, there are still some pieces of thirteenth-century glass, and the visitor to the Musée de Cluny can see four of the statues of Apostles which once stood

Above: Playing-Card Factory in a House on the Place Dauphine. Anonymous, c. 1680

Opposite: The Sainte-Chapelle. A. F. Kersting photograph

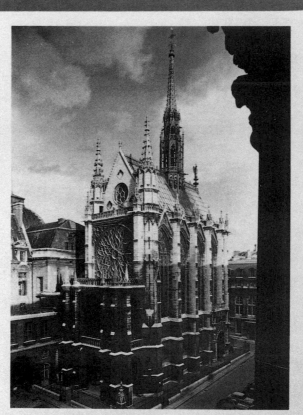

Opposite: The Île de la Cité. Alain Perceval photograph

XII

The River and the Islands

The Île de la Cité Seen from the Pont Saint-Nicolas. Alexandre-Jean Noël, c. 1780

It is not easy for a city to come to terms with its river. Moving water is a symbol of impermanence, and as such unwelcome to the city fathers. Rivers have bad habits, too; they overflow, on the one hand, and on the other they dry up at inconvenient moments. Architecturally speaking, they set difficult problems; few buildings look their best across a ditch up to a hundred yards wide. Socially, too, a river may soon become unmanageable; the water's edge lends itself too well to low amusement. Trade drives away the private resident, as in the City of London; and it is a mistake, as in Budapest, to have too sharp a class division between one bank and another. Small wonder that the Liffey in Dublin is half causeway, half gutter, that Vienna keeps the Danube in its backyard, and that in Berlin the Spree is kept as nearly as possible out of sight.

Paris is the only city in which a great river has been used for mile after mile, on right bank and left, as the natural center of a work of art. Between the Pont d'Austerlitz

Book Title:
Paris
Author:
John Russell
Editor:
Robert Morton
Art Director:
Samuel N. Antupit
Designer:
Dirk Luykx
New York, NY
Illustrators:
Various
Letterer:
Dirk Luykx
Publisher:
Harry N. Abrams, Inc.
Typographer:
Precision Typographers, Inc.
Printer:
Toppan Printing Co., Ltd.
Production Manager:
Shun'ichi Yammamoto
Paper:
Fukiage Matte Coated; 157 GM2
Binder:
Toppan Printing Co., Ltd.
Jacket Designer:
Dirk Luykx
Artist:
Claude Monet
Letterer:
Dirk Luykx

Book Title:
Hawaii Recalls: Selling
Romance to America
Author:
DeSoto Brown
Editor:
DeSoto Brown
Designer:
Anne Ellett
Honolulu, HA
Illustrators:
Various
Photographer:
Gary Giemza
Publisher:
Editions Limited-
Gaylord Wilcox and
David Rick
Typographer:
Studio Graphics
Printer:
Tien Wah Press
Jacket Illustrator:
Charles Valoroso

That funny South Sea dance: here are hula dancers both serious and sensuous, cheerful and carefree. The lady on the cover of "Do The Hula" (RIGHT) seems to know some rather unconventional movements. Her bare-breastedness is also rather unconventional for 1936, but as usual a handy flower lei keeps her within the limits of propriety. Besides, being from another culture, she's allowed to bend the rules a bit. More familiar is the pose of the simply-drawn girl (LEFT) who serves as a colorful motif in The Story of Hawaii, a fairly extensive and ornately written promotional booklet published by the Hawaii Tourist Bureau around 1930 and made available by mail. (The same title was used for other editions of similar pieces of literature put out by the Bureau for several years.)

(FACING PAGE): two groups of hula dancers display a degree of synchronization beyond the capacity of real human beings: (FAR RIGHT), a slightly malevolent-looking trio gestures in a detail from a fresco painted by artist and sculptor Marguerite Blasingame in the foyer of the original Waikiki Theater in 1936; and (NEAR RIGHT), a happy quartet forms a sarong sorority in one of the Matson Lines' menus painted by Eugene Savage between 1938 and 1940. Executed

first as six 4-by-8 foot murals, these works were not used commercially by Matson until about seven years after their completion. By 1951 more than 125,000 copies of the menus bearing these designs had been given away to ship passengers or sold at a small cost, and they had also been selected to become a permanent part of the collection of the Smithsonian Institute.

"Thus was born the hula . . . the dream of a goddess, translated into the poetry of movement."

Hawaii U.S.A., 1942

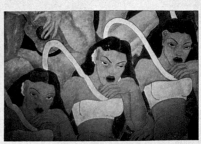

58 59

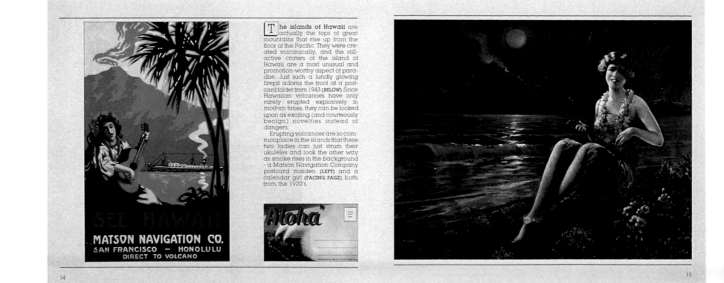

The islands of Hawaii are actually the tops of great mountains that rise up from the floor of the Pacific. They were created volcanically, and the still-active craters of the island of Hawaii are a most unusual and promotion-worthy aspect of paradise. Just such a luridly glowing firepit adorns the front of a postcard folder from 1943 (BELOW). Since Hawaiian volcanoes have only rarely erupted explosively in modern times, they can be looked upon as exciting (and courteously benign) novelties instead of dangers.

Erupting volcanoes are so commonplace in the islands that these two ladies can just strum their ukuleles and look the other way as smoke rises in the background - a Matson Navigation Company postcard maiden (LEFT) and a calendar girl (FACING PAGE), both from the 1920's.

14 15

204

Book Title:
Still Life
Authors:
Diane Keaton
Marvin Heiferman
Editors:
Diane Keaton
Marvin Heiferman
Art Director:
Lloyd Ziff
Designer:
Lloyd Ziff
New York, NY
Photographers:
Various
Illustrator:
Mick Haggarty
Letterer:
Mick Haggarty
Publisher:
Callaway Editions, Inc.
Typographer:
Crosby Typographers
Printer:
Gardner/Fulmer
Lithograph Co.
Production Manager:
Christopher Green
Paper:
Quintessence Dull Text
#100
Binder:
Publishers Book Bindery
Jacket Designer:
Lloyd Ziff
Jacket Illustrator:
Mick Haggarty

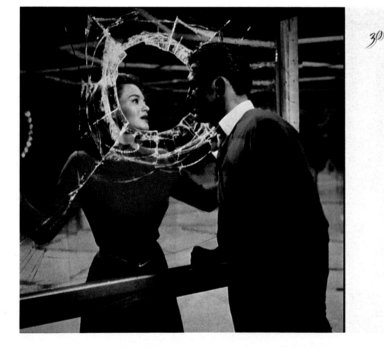

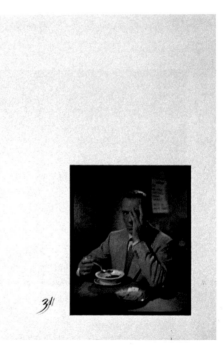

Book Title:
One Day of Life
Author:
Manlio Argueta
Editor:
Erroll McDonald
Art Director:
Elissa Ichiyasu
Designer:
Elissa Ichiyasu
New York. NY
Publisher:
Vintage Books
Typographer:
Maryland Linotype Co.
Printer:
The Murray Printing Co.
Production Manager:
Beth Facter
Paper:
Bookbinder's Suede
Binder:
The Murray Printing Co.
Jacket Designer:
Keith Sheridan
Jacket Illustrator:
Daniel Maffia

MANLIO ARGUETA

why the guardsmen side with the rich. Ticha's son, for example, is a guardsman, and we all know the misery she undergoes to feed herself and the grandchildren that her daughters left her when they went to the capital to better themselves.

One understands these things, it's true; one knows. What's difficult is to know how to explain them. Don Sebastián also knows. Maybe even Ticha herself; the poor woman goes around in rags because, you see, everything she and her husband earn goes for beans and corn for all the kids. There are five grandchildren.

José also understands, and sometimes he knows how to explain things with words.

36

MARIA ROMELIA

Well, yes, I was one of those who went down to the Bank to get an answer concerning a cheaper price for insecticides and fertilizer, but the Bank was closed. We staged a little demonstration. Then someone yelled at us to run. And we ran, you'd better believe, we ran. Well, eight radio patrol cars were coming after us. They started shooting and they hit me—a bullet made a shallow wound in my left arm. Then we arrived at the place where the buses were parked, but they weren't there; the police had driven them away. And we didn't know our way around San Salvador. I was with my cousin Arturo; I stayed close to him because he is, or was, smart for a fifteen-year-old. And he told me that we should go to the nearby church, the San Jacinto church, I believe. But the police had already occupied the church in case we had any intentions of seeking refuge there. At that moment we saw a number 38 bus, and my cousin yelled: "Look, it says Chalate." And we ran toward the bus. By

37

Book Title:
The Life and Letters of
Alexander Wilson
Author:
Clark Hunter
Editor:
Carole LeFaivre
Art Director:
Freeman Keith
Designer:
Freeman Keith
Lunenberg. VT
Publisher:
American Philosophical
Society
Typographer:
The Stinehour Press
Printer:
The Stinehour Press.
Meriden Gravure Co.
Production Manager:
Freeman Keith
Paper:
Rising Book Laid
Binder:
The Stinehour Press
Jacket Designer:
Freeman Keith

292 ALEXANDER WILSON

lars for the knowledge of birds." Taking up a newspaper he began to read. I lifted the book, and without saying a word, walked off with a smile of contempt for this very polite, and very learned Governor. If science depended on such animals as these, the very name would long ere now have been extinct.

The city Recorder declared, that he never read or bought books on animals, fishes, plants or birds—he saw no use in them. Yet this same reptile could not abstain from acknowledging the beauty of the plates of the Ornithology.

❦[CX]❧

LOC

To Thomas Jefferson.

Saturday noon 17 December 1808.

Alexander Wilson, author of *American Ornithology*, would be happy to submit the first volume of this work to the inspection of Mr. Jefferson, if he knew when it would be convenient for the President.

A. WILSON[1]

UOV

To Richard Fitzhugh esquire.

Washington, 19 December 1808.

Dear Sir

You will perhaps recollect the having spoken to me of a Mr Coffer[2] in your neighborhood who had made himself very partic-

1. At the meeting which resulted from this letter Jefferson gave Wilson a letter of introduction to a friend, Richard Fitzhugh. The letter is not only evidence of the president's interest in ornithology, but of his good will towards Wilson.

2. Joshua Coffer of Fairfax County, Virginia. He became a subscriber to the *American Ornithology* and is mentioned by Wilson in his essay on the humming-bird (vol. 2, pp. 29-30).

THE LETTERS 293

ularly acquainted with the history & habits of the different birds of our country, & that I often expressed a wish to obtain a communication of his knolege. My object in this was to forward it to a Mr. Wilson, whom I knew to be engaged in a work on the birds of our country. Mr. Wilson having come to this place with the first volume of his work, I mentioned yourself & Mr. Coffer to him as persons who I thought could communicate to him more original information as to his subject than perhaps any other persons. On this he sollicited an introduction to you, and hopes through you to be made known to Mr. Coffer. he is accordingly the bearer of this letter and on behalf of the world for whose information he is writing I sollicit your favorable attention to him, and your good offices with Mr. Coffer, and that you will both be so kind as to communicate to him the observations you have made on the birds of our country; in this way your information will be preserved, and will be the more valuable as the opportunities of obtaining such are very rare. With my best respects to Mrs. Fitzhugh. I salute you with friendship & respect.

TH. JEFFERSON

Rich.ᵈ Fitzhugh esq.

❦[CXI]❧

LOC

To Thomas Jefferson.

Washington, 24 December 1808.

Sir,

The person who is the Bearer of this, has in his possession specimens of *Copper Ore* found in Orange County, State of Virginia, which he is solicitous to show to the President. Considering this

Tina, Los Angeles, by Edward Weston, 1921
Collection: Center for Creative Photography, Tucson, Arizona

Next page:
Tina, Los Angeles, by Edward Weston, 1921
Collection: Center for Creative Photography, Tucson, Arizona

40

41

Book Title:
Tina Modotti
Author:
Mildred Constantine
Designer:
Massimo Vignelli
New York, NY
Photographers:
Tina Modotti
Edward Weston
and others
Publisher:
Rizzoli International
Typographer:
Candice Odell
Printer:
Amilcare Pizzi, s.p.a.
Production Manager:
Solveig Williams
Paper:
115 gsm Matte-Coated
Jupiter
Binder:
Amilcare Pizzi, s.p.a.
Jacket Designer:
Massimo Vignelli
Photographer:
John Hagemeyer

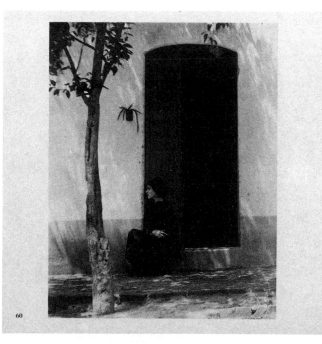

60

It is not certain what brought about Weston's decision to leave wife and family and go off with Tina on what Ben Maddow calls a "psychic voyage." Was it perhaps a newfound confidence in himself and his work, gained from his trip to New York, as well as the warm reception of his work in Mexico? It may have been the fear of losing Tina when she left the United States for Mexico. Or it may have been the endless pressures of his family life in Glendale. Whatever combined to stimulate him into action, Tina, Edward, and his eldest son Chandler, then thirteen years old, left for Mexico on July 30, 1923, on board the S.S. Colima. They left "after months of preparation, after such endless delays that the proposed adventure seemed but a conceit of the imagination, never actually to materialize."¹ On board, Weston's jealousy manifested itself. "Thanks to Tina – her beauty – though I might have wished it otherwise! El Capitan has favored us in many ways: the use of his deck, refreshing drinks in his cabin, his launch to carry us ashore."

Their first overland trips from the port city of Manzanillo and then by train to Colima and Guadalajara gave them glimpses of the beauty and sharp contrasts of the Mexican landscape. One thing pleased them – there were no questions either in hotels or apartments as to the personal relations of the travelers.

Finally they reached Mexico City and their first house in Tacubaya, a suburb about forty minutes' trolley ride from the city. Weston describes it in a Daybook entry (p. 15). "We have leased an old and beautiful hacienda for six months; ten rooms, each opening onto a spacious patio, 85 × 100, high ceilings and tall arched windows, barred, heavily shuttered, seeming to suggest possible attack... the brick walls of our casa are fifteen inches thick and plastered in and out..." They both enjoyed shopping and bargaining in the rambling market; Tina's familiarity with the language (she spoke Spanish with an Italian lilt) made these occasions both profitable and enjoyable. They bargained for everything and bought the Indian wares and food, as well as the bizarre objects sold in the market place. From their roof they could see the snow-capped volcanoes, Ixtacihuatl and Popocatepetl, and even sometimes the spires of the cathedral in Mexico City.

Unlike many other Americans who came to "attend" a revolution or to study the Aztec and the Mayan, and who tended to befriend fashionable intellectuals, Weston and Tina associated with artists and revolutionists. From the beginning they were not without friends in Mexico. Tina had already met many artists and intellectuals through Gómez Robelo. She was eager for Edward to meet them and see their work, as well as to have them know Weston's photographs. They met the painters, the poets, the writers. Tina renewed her acquaintance with Xavier Guerrero, then a young painter working

Opposite page:
Tina, Mexico, by Edward Weston, initialed EW and dated 1923
Collection: Mr. and Mrs. Ralph Bettelheim, New York

61

Book Title:
German Expressionist
Sculpture
Authors:
Various
Editors:
Lynn Dean
Andrea Bellolo
Barbara Einzig
Art Director:
Jeffrey Mueller
Designer:
Jeffrey Mueller
Los Angeles, CA
Photographer:
Lawrence Reynolds
Publisher:
Los Angeles County
Museum of Art
Typographer:
Continental Typographics
Printer:
Nissha Printing Co., Ltd.
Production Manager:
Hank Sackman
Paper:
ESPEL
Binder:
Nissha Printing Co., Ltd.
Jacket Designer:
Jeffrey Mueller
Jacket Photographer:
Lawrence Reynolds

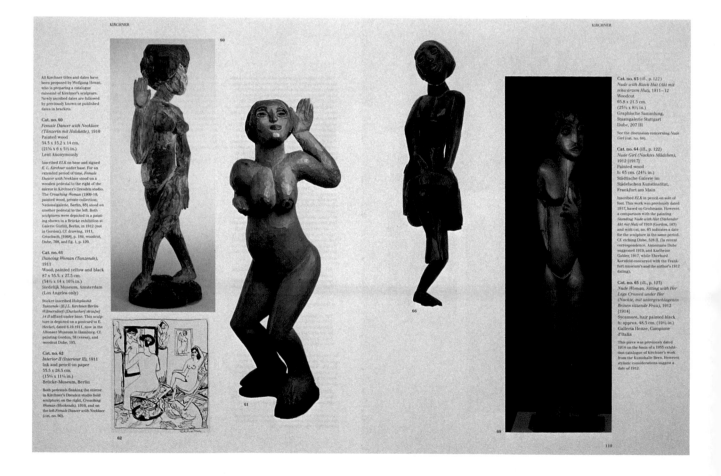

208

The Indian's war-horse, or buffalo horse, was his most cherished possession, his pride made manifest, and his greatest security in a hazardous life.

In 1837 another artist of the Plains, Alfred Jacob Miller of Baltimore, made a sketch of a party of mounted Blackfeet on the warpath, which he subsequently worked up into a watercolor (plate 175). The Blackfeet, he observed, "have the worst reputation for war and aggression of all the Indians of the North-West. Their very name is a terror to most of the Indian tribes, and are so strong in numbers, so determined in their vengeance, that indiscriminate slaughter follows victory."

Their hatred was directed at the white man, also, especially at those who trespassed on their beaver streams, robbing them of the wealth in trade that they gleaned from those preserves. However hazardous that made the trapper's quest, it did not deter him: "No toil, no danger, no privation can turn the trapper from his pursuit," wrote Washington Irving. "In vain the most vigilant and cruel savages beset his path." Miller, too, noticed their undaunted spirit and pointed to it in a number of drawings (plate 176).

The trapper's most highly prized quarry was the beaver, whose pelt was a prime commodity in eastern and, especially, European markets, where it was used to make fashionable hats (plate 177). By 1840, however, the

175. Alfred Jacob Miller. Blackfoot Indians on the War Trail. 1850s. Watercolor, 9¼ × 13¼". Walters Art Gallery, Baltimore

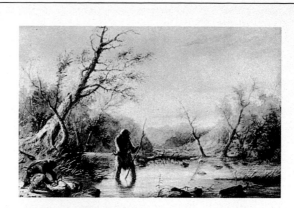

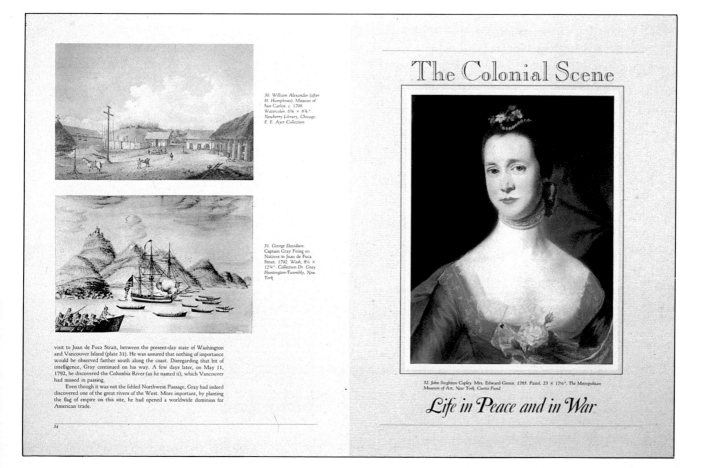

vogue for beaver hats was waning, and silk hats came into style just in time to save the little "varmints" from extinction.

The wild western backcountry was a cosmopolis of sorts, peopled by adventurers who, in the 1820s and 1830s, came from many different lands, to reap, among other things, the harvest of furs that were in demand all

176. Alfred Jacob Miller. Trapping Beaver. 1850s. Watercolor, 8¼ × 13¼". Walters Art Gallery, Baltimore

177. Alexander Jackson Davis. Leonard Bond's Hat Warehouse. c. 1828. Watercolor, 7⅝ × 9". Museum of the City of New York

143

Book Title:
The Drawing of America
Author:
Marshall B. Davidson
Editor:
Sheila Franklin
Art Director:
Samuel N. Antupit
Designer:
Dirk Luykx
New York, NY
Illustrators:
Various
Letterer:
Dirk Luykx
Publisher:
Harry N. Abrams, Inc.
Typographer:
Precision Typographers, Inc.
Printer:
Dai Nippon Printing Co., Ltd.
Production Manager:
Shun'ichi Yammamoto
Paper:
Fukiage Matte Coated 128 GM2
Binder:
Dai Nippon Printing Co., Ltd.
Jacket Designer:
Dirk Luykx
Jacket Illustrator:
George Hayward
Photographer:
Dennis Bradbury
Letterer:
Dirk Luykx

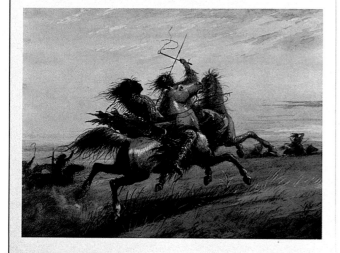

30. William Alexander (after H. Humphries). Mission of San Carlos. c. 1798. Watercolor, 6¼ × 8½". Newberry Library, Chicago. E. E. Ayer Collection

31. George Davidson. Captain Gray Firing on Natives in Juan de Fuca Strait. 1792. Wash, 8½ × 12¾". Collection Dr. Gray Huntington-Twombly, New York

visit to Juan de Fuca Strait, between the present-day state of Washington and Vancouver Island (plate 31). He was assured that nothing of importance would be observed farther south along the coast. Disregarding that bit of intelligence, Gray continued on his way. A few days later, on May 11, 1792, he discovered the Columbia River (as he named it), which Vancouver had missed in passing.

Even though it was not the fabled Northwest Passage, Gray had indeed discovered one of the great rivers of the West. More important, by planting the flag of empire on this site, he had opened a worldwide dominion for American trade.

34

The Colonial Scene

32. John Singleton Copley. Mrs. Edward Green. 1765. Pastel, 23 × 17¼". The Metropolitan Museum of Art, New York. Curtis Fund

Life in Peace and in War

Book Title:
The Young Lukacs
Author:
Lee Congdon
Editor:
Sandra Eisdorfer
Designer:
Richard Hendel
Chapel Hill, NC
Publisher:
The University of North
Carolina Press
Typographer:
The University of North
Carolina Press
Printer:
Thomson-Shore, Inc.
Production Managers:
Richard Hendel
Heidi Perov
Paper:
Warren's Number 66
Antique
Binder:
John H. Dekker and
Sons
Jacket Designer:
Richard Hendel

Book Title:
Religions of the World
Author:
Various
Editor:
Richard Steins
Art Director:
Betty Binns
Designer:
Betty Binns
New York, NY
Illustrator:
Vantage Art
Picture Research:
Robert Sietsema
Publisher:
St. Martin's Press
Typographer:
Waldman Graphics, Inc.
Printer:
American Book/
Stratford Press
Production Manager:
Marcia Cohen
Paper:
Bookman Matte #45
Binder:
American Book/
Stratford Press
Cover Designer:
Betty Binns
Cover Illustrator:
Madelaine Sanchez

Book Title:
Canova
Author:
Fred Licht
Editor:
Nancy Grub
Art Director:
Ulrich Ruchti
Designers:
Ulrich Ruchti/
Leslie Rosenberg
New York, NY
Photographer:
David Finn
Publisher:
Abbeville Press
Typographer:
Martin Type
Printer:
Amilcare Pizzi s.p.a.
Production Manager:
Dana Cole
Jacket Designer:
Ulrich Ruchti
Jacket Photographer:
David Finn
Letterer:
Ulrich Ruchti

Passport photograph of György Lukács, 1917
Courtesy Magyar Tudományos Akadémia Filozófiai Intézet
Lukács Archívum és Könyvtár
(Lukács Archives and Library, Institute of Philosophy,
Hungarian Academy of Sciences), Budapest

C·H·A·P·T·E·R

1

The Drama

The Thália Theater

Lukács's experience of alienation accounted for his fascination with the drama. In an effort to understand his sense of loneliness and his inability to establish a close relationship with the members of his family, he focused his attention on that form of art that portrayed the human condition as the dialectical playing out of the struggle between men. For the drama, man was indeed a "social animal," whose destiny was revealed in his relationships with his fellows, and hence, as Lukács pointed out in a 1906 essay, dialogue was its essence. "The relationship of human beings to one another; the scarcely audible cadences of their drawing nearer to one another and moving away from one another emanate from it."[1] At the theater, Lukács witnessed the ritual rehearsal of those problematic relationships that defined human existence, and as a member of the audience, he was able to experience an identification with others that was impossible for him in the world outside.

At home, Lukács read every drama he could find. He admired greatly Ibsen's *Ghosts*, which in his view represented "the new tragedy of fate concerning the futility of everything, the inevitable lateness of all knowledge, the eternal foreignness of people confronting one another."[2] Inspired by the Norwegian playwright, he began to write dramas, all of which he judged to be failures.[3] The painful experience of self-criticism led him to literary criticism and he soon came under the influence of Alfred Kerr, who had been an early champion of Ibsen's work. Eager to try his own hand, Lukács secured, through family connections, an

does away with the sly tensions of the earlier nude. The same directness of approach is equally strong in the *Sleeping Nymph*. Though the facial types and proportions of the figures are identical with those that appear in earlier works, it would seem that Canova was moving toward a slightly more realistic approach, which manifested itself very hesitantly in Italian sculpture of the 1820s and finally triumphed in the work of Lorenzo Bartolini (1777–1850).

MARS AND VENUS

Only very superficial similarities link this group (plate 223), executed for King George IV of England, to the much earlier *Farewell of Venus and Adonis*. That first group was lyrical in mood, tender in composition and detail. *Mars and Venus*, on the other hand, was intended from the beginning as an allegory of War and Peace. Consequently, the artist chose an entirely different composition, which is far less intimate and more overtly rhetorical. Mars turns resolutely away from Venus. The open space between his right flank and the spear as well as the broad interval between his right and left legs gives a breadth of lateral development to the group that is quite different from the centripetal relationship of forms in the earlier sculpture. By the same token, Venus in the present group does not actively and yearningly restrain her lover from departing as she did in the *Venus and Adonis*. Her stance is more balanced, her attitude less clinging. Even the finish of the two statues is different, though the earlier sculpture was actually refinished after the *Mars and Venus* was completed. Attention to subtle modulation and variety of surface textures

is somewhat diminished in the *Mars and Venus* when compared to the *Venus and Adonis*. The difference in the size of the groups also militates against intimacy. One is involuntarily tempted to approach *Venus and Adonis* closely, whereas the group of *Mars and Venus* demands a higher installation and a more distant point of view.

ENDYMION

Just as the *Naiad*, *Dirce*, and *Sleeping Nymph* represent Canova's efforts to assimilate the impact made on him by the female figures of the Parthenon, so *Endymion* (plate 224) expresses his new ideals of beauty in the youthful male. The pose recalls both the Genius of Death from the tomb of Clement XIII and the dancing figures of the *Sons of Alcinous* (plate 258). The anatomical articulation and the effect of potential activity within repose also make it akin to the *Naiad*.

Of particular delicacy and inventiveness is Endymion's hunting dog. Counterposed to the total abandon and passivity of the lower part of Endymion's body, the alert and sprightly animal strikes a very happy contrast, which Canova may have derived from late medieval tombs in which the dog (a symbol of fidelity) often lies at the feet of his deceased master or mistress. Compositionally, however, Canova goes beyond the merely additive and emblematic use of the dog. The curve of his back, the direction of his muzzle, and the pertly raised ears provide simultaneously a fine balance for the raised torso of the sleeping hunter and a beautiful "pointer" to the head of Endymion. The dog also returns us from the world of sensuous revery to the active state of waking existence.[44]

221, 222. *Sleeping Nymph*, 1820–22
Marble, 76½ x 31½ in. (194.3 x 80 cm.)
Victoria and Albert Museum, London
(See color plates, pages 3 and 47)

223. *Mars and Venus*, 1816–22
Marble, height: 82½ in. (210 cm.)
Buckingham Palace, London

224–27. *Endymion*, 1819–22
Marble, 36⅝ x 72⅝ in. (93 x 185 cm.)
Devonshire Collection, Chatsworth, England

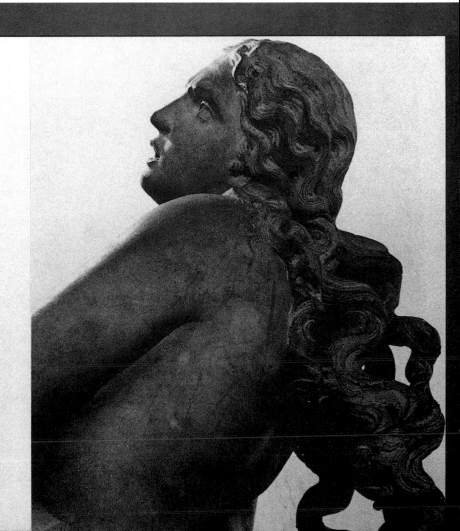

IV. MYTHOLOGIES AND ALLEGORIES

Throughout Western history, artists of certain periods have turned from the observation of reality to themes that have no exact counterpart in the real world. To Canova and to the epoch he represents, mythology was just such a theme, permitting maximum freedom to express highly personal formal, intellectual, and emotional preferences. Portraiture, as we have seen, was only occasionally adequate to Canova's innermost demands. Very few works in that category were motivated by his own desire to do a portrait; most were commissioned by personages whose whims Canova felt obliged to satisfy. The tomb, also, though certainly a category in which Canova had proved the originality of his talent, was so obdurately associated with Christian and with moral traditions as to prove less responsive to Canova's highly personal ideals of sculpture.

There is a world of difference between Baroque attitudes toward mythological themes and Neoclassical interpretations of the same stories. Certainly both the young Bernini and Canova dealt with a mythology that had no direct religious currency for either of them. But for Bernini, the fundamental ideas that made mythology a living part of his civilization were still very much part of his daily life. His belief in the existence of divine powers, of a world beyond sensory perception, was totally intact and gave his every thought and action an ethical logic. Daphne and Apollo may represent a pagan myth of dubious morality, and certainly one would be hard-

pressed to put any kind of Christianizing construction on it in the manner of medieval concordances. Nonetheless, there are some basic religious premises underlying this Greco-Roman idyll that could be assimilated into Bernini's own religious beliefs. The beauty of the body, the conflict of passion and chastity, the power of the divine to transform sensory reality by means of miraculous intervention—all of these are fully credible, in terms of Christian doctrine, to Bernini and to Bernini's contemporaries.

To the Rococo, myth was a welcome costume through which the daily concern with pleasure shone forth all the more delightfully, with all the ornaments of wit and lightly worn erudition.[29] Boucher's nymphs, Tiepolo's goddesses, Fragonard's shepherdesses are a last, brilliant reflection of the Renaissance love for classical thought and sentiment. But above all, these creatures offer the cheerful guarantee that all the attributes of Olympian beings can be found in our own world. The Rococo artist teaches us to see the Graces, Helen, or the Callipygous Aphrodite in every attractive young woman. Canova's interest in these same subjects is motivated by a very different intent. Instead of showing us how close humanity is to the Olympians, he shows us how infinitely distant his poetic ideal is from quotidian reality. For all the refined eroticism with which Boucher chronicles the love of the gods, he makes no distinction of kind between Jupiter's loves and ours. The miraculous nature of love, as well as the validity of miracles as such, is taken for granted. For Canova and his contemporaries, miracles have no connection whatsoever with the world in which they live.

Canova's mythologies are designed to make us dwell on transcendent states of existence available to us exclusively through our aesthetic sensibility and not through our direct experience. When we look at a work by Canova, we do not feel challenged to compare his mythologies with our own lives. Their eroticism—and nearly all of Canova's mythological themes are erotic—does not parallel our own erotic fantasies and does not satisfy our desires as do the candidly carnal pictures by Boucher or Fragonard. Instead, the sentiment of a longing that cannot be appeased is at once peculiarly modern in its titillating qualities (the Rococo, being explicit, never teases) and peculiarly inaccessible to tastes shaped by twentieth-century psychological investigations of Eros. We are all too prone to turn to easy slogans like "sublimation" when faced with such equivocal expressions of love as Canova's *Cupid and Psyche* (plate 152). But this very suggestion of "sublimation" in the Freudian sense puts such statues decisively on our side of the border between the late Baroque and the modern periods.

Canova's intent, as Professor H. W. Janson has pointed out, was to produce modern classics.[30]

132, 134. *Eurydice*, 1773–75
Stone, 75⅝ x 29½ in. (193 x 75 cm.)
Museo Correr, Venice

133. *Orpheus*, 1775–76
Stone, 75⅝ x 33½ in. (193 x 86 cm.)
Museo Correr, Venice

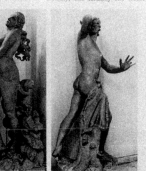

Book Title:
The American Cowboy
Author:
Lonn Taylor
Ingrid Maar
Editor:
Simon Michael Bessie
Designer:
Derek Birdsall
New York, NY
Illustrators:
Various
Publisher:
Harper & Row,
Publishers, Inc.
Library of Congress
Typographer:
Balding + Mansell, Ltd.
Printer:
Garamond Pridemark
Press
Production Manager:
Martin Lee
Paper:
Mohawk Superfine Text
#80
Lustro Offset Enamel
#80
Binder:
A. Horowitz & Son
Jacket Typographer:
Kim Llewellyn
Jacket Photographer:
Carl Fleischhauer

"Wagon Wheels"
Lithograph
Paramount Productions, Inc.
Copyright 1934
Randolph Scott (b. 1903), who first came to Hollywood in 1928, is an important figure in the transference of the strong, silent, man-of-action characterization of the cowboy to the western hero in general. Scott, who played a minor role in the 1929 production of *The Virginian*, made a series of westerns based on Zane Grey novels for Paramount in the 1930s. In them he played not only cowboys but badmen, outlaws, and marshals with the same soft-spoken, understated approach. In 1939 he portrayed a courageous and sympathetic lawman in *Jesse James* and Wyatt Earp in *Frontier Marshal*. In *Western Union* (1941), his outlaw became the real hero of the film. Scott presented western heroes on the screen for more than thirty years. His last film, *Ride the High Country*, was released in 1962.
Poster Collection
Prints and Photographs Division
Library of Congress

"Along Came Jones"
Offset
RKO Radio Pictures, Inc.
Copyright 1945
Gary Cooper (1901–1961) played cowboy roles in the tradition established by William S. Hart. To some degree the strong, silent attitude may have been natural to Cooper, who was born in Helena, Montana, in 1901 and grew up on his father's Montana ranch. One of his first film roles was that of the Virginian in the 1929 film version of Owen Wister's tale, and he carried the quiet, self-assured confidence of the Virginian into his later cowboy roles, presenting that version of the cowboy to several generations of moviegoers. The plots of his films often set eastern sophistication against western directness, as in *Saratoga Trunk* (1946) and *Along Came Jones* (1945). His most memorable performance was in *High Noon* (1952), in which he made the Virginian-like courage of Marshal Will Kane part of a national allegory.
Poster Collection
Prints and Photographs Division
Library of Congress

THE CHILDREN'S HERO

The cowboy hero has appealed to juveniles since the days of Buffalo Bill, but he has loomed especially large in children's eyes during the period from the 1930s through the early 1950s. Cowboy costumes for children first became popular in the mid-thirties, replacing soldier and sailor suits, and they remained in style until the mid-1950s. During World War II, when many fathers were away from home, cowboy actors and radio stars became surrogate fathers for American children, advising them over the air waves on diet, health, and behavior and offering their own wholesome way of life as a model. Gene Autry even codified ten "Cowboy Commandments" for children.

Child in Cowboy Suit
Riding a Pony
Photographer unknown, ca. 1938
Mrs. Charles R. Faks
Oxford, Ohio

Boy in Cowboy Outfit
Photograph, 1947
Stuckey Studio
Arlington, Virginia
Private Collection

Child Wearing Cowboy Outfit
Photograph, ca. 1935
The Cobbs Studio
Albuquerque, New Mexico
Photo Archives
The Museum of New Mexico
Santa Fe, New Mexico

Roy Rogers Clothes Rack
Hopalong Cassidy Hat
Lone Ranger Vest
Lone Ranger Chaps
Hat, ca. 1950
Vest and chaps, ca. 1940
Hake's Americana & Collectibles
P.O. Box 1444
York, Pennsylvania 17405

Book Title:
Big Bend: Official
National Park Service
Handbook
Authors:
Various
Art Director:
Vincent Gleason
Designer:
Massimo Vignelli
New York, NY
Photographers:
Various
Publisher:
National Park Service
Division of Publications
Typographer:
Government Printing
Office
Printer:
Government Printing
Office
Production Manager:
Vincent Gleason
Paper:
Garamond-Pridemark
Press, Inc.
Binder:
Garamond-Pridemark
Press, Inc.

The Fur Trade

Gray fox · Mule deer · Bobcat · Kit fox · Coyote · Badger

Furs were an active commodity in the Big Bend until about 1940. Beaver once abounded along the river and its tributaries. Both fur bearers and predators were taken. The bighorn sheep was largely extirpated, selling for a time as "Mexican goat." Wolves were extirpated before the park could provide refuge. Not all species were trapped. The javelina was hunted during World War I, for use in gloves, coats, and suitcases. The bristles went into brushes. Elmo Johnson (photo) bought furs from trappers at his trading post. Good profits required a good eye for raw furs, which Johnson possessed. Furs not trapped during the animal's winter prime were nearly worthless, and values depended on their condition generally. No fur market existed in Mexico, so furs trapped there were sold at Texas trading posts, destined for the fur houses in St. Louis, Missouri. Only a portion of Johnson's fur stocks shows in this 1929 photograph. Furs were a good business for him, because trappers took their value in goods, his first profit in the transaction. He then sold the furs for his second profit. Later, salaried government trappers worked this area to control predators. Today, all wildlife in the park is protected.

82 · 83

Floating the River

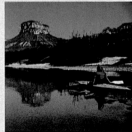

Boulders dwarf the raft of Park Service employees (top) landing in Santa Elena Canyon. A kayaker (bottom) drifts into reflections.

If you stumbled onto the Rio Grande upstream of the park, between El Paso and Presidio, during most of the year you'd say "Oh well, forget floating!" That stretch is most often dry, sapped by irrigation projects. But the Rio Grande gets a new lease on life as the Rio Conchos, draining Mexican mountains, flows into it at Presidio. You can thank the Rio Conchos for the prospects of floating the Big Bend. Along the park boundary and down to the Terrell-Val Verde County Line, the Rio Grande is designated a national wild and scenic river for 307.8 kilometers (191.2 miles). The "scenic" goes without saying. When you hit the rapids or a cross-channel current hits you, the "wild" designation rings true as well.

Below is general information about floating the river. Particulars—including descriptions of the canyons and some rapids—are contained in, among others, the river guide series published by the Big Bend Natural History Association. (See Armchair Explorations.)

The first fact: You need a permit to float the Rio Grande in the park, including the Rio Grande Wild and Scenic River. The free permit is available from park headquarters and ranger stations, or any park ranger. Permits will not be issued if the river is at flood stage. In high water the river is outright dangerous. The annual high water season is July through October. Flash floods are a great danger through summer and early fall. The best months for river running are November through February, when water levels are relatively stable and the heat is moderate. By late April or early May and after the heat can be a problem.

The recommended craft is the inflatable raft. It is not as prone to damage from submerged rocks as are kayaks and canoes. Any rigid craft may break up when slammed into the canyon's rock walls by treacherous cross-channel currents. No craft or accessory gear is available for rental within the park. You must bring your own, or make arrangements with an outfitter. (Call or write the park for information on local outfitting services.)

A second fact: Any float party, as the name implies, should consist of two or more people for obvious safety reasons. Fact three: Everybody should be able to swim . . .

You will need two vehicles, one for put-in and one for take-out. Gear should include: approved personal flotation device for each person and one extra for each boat; boat paddle for each person; waterproof duffle; freshwater; flashlight; lash lines and a 15-meter (50-foot) bow line and 15-meter (50-foot) stern line; extra paddle for each boat; first aid kit; and boat patching kit. Lash all these items to prevent their loss in the event that your craft capsizes.

Lest you be discouraged by the safety warnings and logistical considerations, suffice it to say that from the river inside Big Bend's magnificent gorges you will experience an intimate immensity rare on this Earth.

Fishing

Most of the park's native fish are of minnow size but the Rio Grande does attract anglers. The major attractions are catfish, gizzard shad, carp and suckers, the freshwater drum, and an occasional longnose gar. The complete list of fish recorded in the park and its immediate surroundings includes 35 species, including bluegill and sunfish species.

Most anglers are after the blue, channel, and flathead catfish. The blue and flathead are favored food fish. The longnose gar may reach over a meter (4 feet) in length and is predatory, as its long snout and sharp teeth suggest. You do not need a fishing license to fish in the national park. For advice on fishing spots and preferred methods, ask a park ranger.

Yellow cat up to 45 kilos (100 pounds) have been taken from the river, and 14-kilo (30-pound) cats are not uncommon. Channel and blue cats also provide fine sport and good eating. These deepwater species feed on aquatic plants, insects, and smaller fish, both living and dead. They spawn in depressions and sheltered nooks in river banks and canyon cliffs. While catfish account for most of the recreational fishing in the Rio, many other interesting species swim the brown waters: the predatory garfish, needlenosed and shaped like a torpedo; the humpbacked carp that can survive even in limited waters; smallmouth buffalo, sheepshead, and green sunfish; the bullhead that favors quiet waters and can endure higher temperatures and lower oxygen content than most other fish; and of course the minnows, as plentiful and gregarious as sparrows, with a preference for running water and rocky or sandy bottoms.

122 · 123

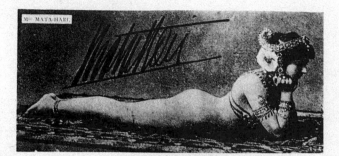

MATA HARI (1876–1917)

Circa 1907. She was born Gertrud Margarete Zelle, but that was hardly
a name for an exotic dancer. The notorious World War I spy,
executed by the French in 1917, must have been better
at concealing secrets than is apparent here.

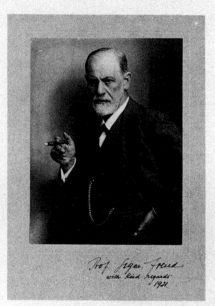

SIGMUND FREUD (1856–1939)

Dated 1921. This famous photograph of the founder of psychoanalysis
was taken by his nephew Max Halberstadt, and it may be
the only existing print made from the original negative.
The inscription is unusual in that it is inscribed
in English and uses the title "Professor."

IGOR STRAVINSKY (1882–1971)

Dated 1950. Generally considered the most
important composer of the twentieth
century. His avant-garde ballet *The Rite of
Spring* caused a riot at its first performance
in Paris in 1913.
>

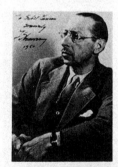

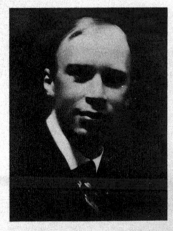

SERGEI PROKOFIEV (1891–1953)

Dated 1920. Prokofiev is best known in the United States for his
symphonic fairy tale *Peter and the Wolf.* His numerous symphonies,
operas, ballets, and film scores are much beloved in his native
Russia.

BÉLA BARTÓK (1881–1945)

Dated January 21, 1928. Inspired by peasant songs from his native
Hungary, Bartók transformed them into some of the most
innovative modern music of this century.

JEAN SIBELIUS (1865–1957)

Circa 1950. At age thirty-two the Finnish composer was awarded a
lifetime government grant to devote his career to the glory of
Finnish music. He responded appropriately and brilliantly; his
great masterpiece is *Finlandia,* composed in 1900. This somber
portrait seems in keeping with his music.

MAURICE RAVEL (1875–1937)

Circa 1928. A French exponent of the impressionist style, his
compositions have something of the atmosphere of his
compatriots' impressionist paintings.

THE LAW
OF THE GUN

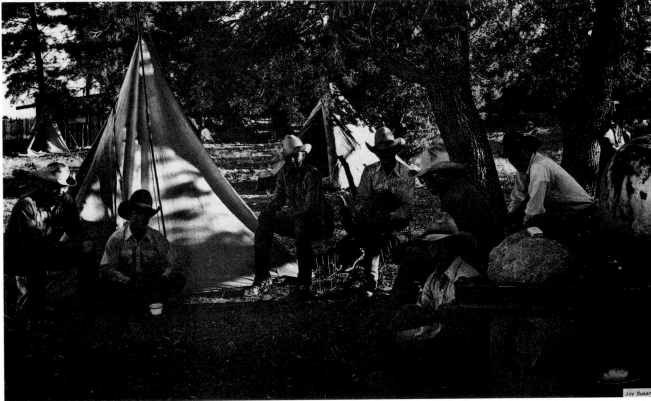

THE EDITOR OF THE ABILENE, KANSAS, CHRONICLE DECLARED ON JUNE 8, 1871, that the time had come for civilized people to quit carrying guns. Law and order had come to Abilene in the form of Chief of Police James B. "Wild Bill" Hickok, who had declared that he would vigorously enforce the Kansas statute against carrying weapons inside towns and cities. The editor was pleased. "That's right," he wrote. "There's no bravery in carrying revolvers in a civilized community. Such a practice is well enough and perhaps necessary when among Indians or other barbarians, but among white people it ought to be discontinued."

Bona fide law enforcement and judicial agencies were not established until long after the first immigrants had made themselves at home in the West. In the early days, the citizenry had to become its own protector, forging flimsy rules maintaining basic order rather than establishing judicial principles. And in wild and chaotic cattle towns like Abilene, the gun was the only arbiter of order available. Samuel Colt's six-shot revolvers and a series of Winchester carbine rifles became the "peacemakers" only because they represented a life-threatening and often fatal alternative to peace. Hickok wanted to disarm Abilene's rowdy populace not to help make the people more "civilized," but in order to give his law—his guns—more force by lessening everyone else's firepower. Because institutional law remained scarce in the frontier West, guns were a ready substitute; they could coerce, and they could quickly punish.

Violence has always been basic to America's people, regardless of their degree of civility. The first immigrants to the continent waged war against

Early Texas Rangers, LEFT, and fictional lawmen like William S. Hart and comrades, administered a justice backed not by the tenets of law, but by the force of gunfire.

271

Jay Dusard

Book Title:
Cowboy: The Enduring Myth of the Wild West
Author:
Russell Martin
Editor:
Leslie Stoker
Art Director:
Hans Teensma
Designer:
Hans Teensma
Cambridge, MA
Illustrators:
Various
Publisher:
Stewart, Tabori & Chang Publishers, Inc.
Typographer:
TGA Communications, Inc.
Printer:
Amilcare Pizzi, s.p.a.
Paper:
150 gsm. R400
Binder:
Amilcare Pizzi, s.p.a.
Jacket Designer:
Hans Teensma
Jacket Photographer:
Ernst Haas

Book Title:
Sincerely Yours: The Famous & Infamous As They Wanted to Be Seen
Author:
M. Wesley Marans
Editor:
Betty Childs
Designer:
Susan Marsh
Photographers:
Various. Autographed Photographs from the Collection of M. Wesley Marans
Letterer:
Susan Marsh
Publisher:
New York Graphic Society/ Little, Brown and Co.
Typographer:
The Stinehour Press
Printer:
The Murray Printing Co.
Production Manager:
Dale Cotton
Paper:
Michigan Matte
Binder:
The Murray Printing Co.
Jacket Designer:
Susan Marsh
Jacket Photographers:
R. Thiele (Tolstoy), Mayall (Victoria), others unknown
Letterer:
Susan Marsh

Book Title:
The Modern Drawing
Author:
John Elderfield
Editor:
Francis Kloeppel
Art Director:
Christopher Holme
Designer:
William Thomason
New York, NY
Photographer:
Mali Olatunji
Artists:
Various
Publisher:
The Museum of Modern
Art
Typographer:
Concept Typographics
Services, Inc.
Printer:
Arti Grafiche Brugora
Color Separations:
L. S. Graphics, Inc.
Color Supervision:
Tim McDonough
Paper:
Text: 150 GSM Solex
Dull
Cover: 350 GSM Solex
Cover
Binder:
Torriani & Co.
Jacket Designer:
William Thomason
Jacket Photographer:
Mali Olatunji

George Grosz

GERMAN, 1893–1959

THE ENGINEER HEARTFIELD (1920.) Watercolor, pasted postcard, and halftone, 16½ x 12" (41.9 x 30.5 cm)
Gift of A. Conger Goodyear

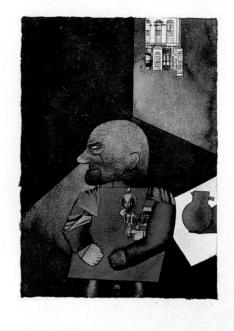

The sly, pugnacious character with the machine heart does not much resemble the artist's friend and Dada coconspirator Helmut Herzfelde, alias John Heartfield. Toughness and belligerence have been added. If the result evokes a convict, imprisoned in his cell, with a broken water-jug beside him, then that, surely, was how Grosz conceived the antiauthoritarian Berlin Dadaist.

The blue smock suggests prison garb; also, however, the outfit of a mechanic. Heartfield was known as "Monteur-Dada," for his concentration on photomontage—which term (wrote Raoul Hausmann) "translates our aversion at playing artists . . . thinking of ourselves as engineers, we intended to assemble, construct [montieren] our works." Berlin was the most aggressive of Dada centers. In Berlin, wrote its leader, Richard Huelsenbeck, "Dada . . . loses its metaphysics and reveals its understanding of itself as an expression of this age which is primarily characterized by machinery and the growth of civilization. It desires to be no more than an expression of the times." When Dada began in Zurich, it opposed machinery and civilization, as associable with the First World War and the materialism that had produced it, and proposed instead—most notably in Arp's work—an instinctive and primitive escape from its times. Outside that neutral oasis, however, such an approach seemed far too passive. In hungry, war-weary Berlin, it seemed simply "metaphysical," and there Dada engaged with the instinctive. Hence the importance of photomontage, and of the caricature-based documentary realism that frames it here. Dada was to replace art by documentation, and thus provide a more authentic record of the world than a picture of a narrative could. (Which is why "art" was to be opposed; it "lied.")

But, of course, there is no such thing as inchoate experience; neither can anything that is crafted be simply "an expression of the times." It was all a Dadaist fiction: a way of giving factual shape to the alogical world of instinct that lay at the heart of the Dada imagination. Dada in Berlin, no less than in Zurich, opposed the technological with the instinctive. But whereas Arp presented a world that was purely instinctive, virtually every other important Dadaist—including those in Berlin—sought rather to reveal the instinctive within the modern. Common to Dadaists as different as Man Ray, Max Ernst, Kurt Schwitters, and Grosz, is a duality of affiliation—commitment to an instinctive ideal and responsibility to their own time—which manifests itself in the use of modern subjects or materials to tell of a spontaneous kind of existence that opposes the world of technology yet does not seek to escape it. In Berlin, it produced photomontage and documentary realism. For what was required were forms that could give to something unsealable the appearance of something real that had actually been documented, thus to subvert mechanically the modern machinist world and discover within it a primitive internal world as "real" as the world outside. And when, as here, the space of this world needs to be shown, the irrational perspective of de Chirico (p. 115) is used to define it. But whereas the effect of de Chirico's art is of traditional techniques used for modern purposes, that of Grosz's is exactly the opposite. Modern techniques are employed for traditional purposes, namely didactic and ideological ones. Modernism is used but not engaged. "Doubt became our life," wrote Huelsenbeck of Dada in Berlin. "Doubt and outrage." It was a kind of doubt so fundamental as to suspect even the language in which it was spoken.

Arthur G. Dove

AMERICAN, 1880–1946

NATURE SYMBOLIZED. (c. 1911–12.) Charcoal, 20⅞ x 17⅞" (54 x 45.4 cm)
Gift of The Edward John Noble Foundation

Dove's drawing, very modern for its date, has also a look to it of the decorative *moderne*. The work is composed of overlapping planes that stand like theater flats against the blocked-off backdrop, its shallow convexities seemingly upholstered into the image of a rising sun. Stylistically, it joins the emphatic contouring and flat patterning of Gauguin or Matisse to the geometric simplifications of early Cubism, and adds to that a hint of Futurism in the abrupt energy of its line. Fusion of these disparate sources produces a highly charged vocabulary of modern elemental forms. The space they inhabit, however, though certainly shallow (even by modern standards), is almost premodern. It is the squeezed-in space of the theater. Nature is "symbolized" not only by being abstracted; also by being dramatized, thus to convey its latent dynamism and inner, organic life.

Prior to its acquisition by the Museum, this drawing had twice been exhibited, in recent years, in an upside-down position as compared to its reproduction here, and with dates significantly later than now proposed. Its revised presentation was suggested by its similarity to a 1911–12 pastel known as *Nature Symbolized No. 1*, which shows a composition of roofs and factory chimneys interspaced with more organic forms. This too would seem to address, though more abstractly, that familiar—and particularly American—modern theme that Leo Marx has aptly defined: the machine in the garden.

Only rarely in Dove's work do we find even a hint of the industrial. Except in a few works of the period of this drawing, his is an affirmatively pastoral iconography that rejoices in its freedom from man's works. But when he did bring country and city together, it was not (surprising though it may seem) in the usual American oxymoron: Contrast, certainly, but then analogy is the informing structure of this drawing. Man's works, when treated, are celebrated as parts of nature itself. The industrial is rooted in, and rises triumphantly from, the natural in a confident phallic image of regenerative growth. Contrast is assured by the two forms of line drawing that Dove himself defined as operative in his work: "character lines," which mark the dark perimeters of objects, showing their meeting and intersection with their neighbors, and "force lines," which express their vital inner structure. Both are apparent here, the foreground cluster of abstracted roofs, chimney, and (possibly) trees being delineated by the former, and the generalized scalloped backdrop being divided by the latter to create a sense of radiant energy metaphoric of organic growth or of the spreading light of the sun that generates it. But what drawing this separates, spatial compression joins. The backdrop pushes palpably forward, forcing analogous reading of its raylike divisions and the triangular roofs beneath them. And the light that seeps out behind the architectural masses—a beautifully transitional dark light of dawning day—infiltrates the whole composition with an almost pantheistic resonance: it glows with immanence through the velvety softness of its tones.

Book Title:
The Wreck of the Zephyr
Author:
Chris Van Allsburg
Editor:
Walter Lorraine
Art Director:
Susan M. Sherman
Designer:
Susan M. Sherman
Boston, MA
Illustrator:
Chris Van Allsburg
Publisher:
Houghton Mifflin Co.
Typographer:
Roy McCoy
Printer:
Acme Printing Co.
Production Manager:
Donna Baxter
Papers:
Warren Lustro dull #80
Warren Lustro dull #100
Binder:
A. Horowitz & Son
Jacket Designer:
Susan M. Sherman
Jacket Illustrator:
Chris Van Allsburg

"The wind whistled in the rigging as the *Zephyr* pounded her way through the water. The sky grew black and the waves rose up like mountains. The boy struggled to keep his boat from going over. Suddenly a gust of wind caught the sail. The boom swung around and hit the boy's head. He fell to the cockpit floor and did not move.

"The boy made his way down to the harbor, to the dock where his boat was tied. He met a sailor who smiled when he saw the boy. Pointing to the *Zephyr* he asked, 'Yours?' The boy nodded. The sailor said they almost never saw strangers on their island. It was surrounded by a treacherous reef. The *Zephyr* must have been carried over the reef by the storm. He told the boy that, later, they would take him and the *Zephyr* back over the reef. But the boy said he would not leave until he learned to sail above the waves. The sailor told him it took years to learn to sail like that. 'Besides,' he said, 'the *Zephyr* does not have the right sails.' The boy insisted. He pleaded with the sailor.

"He steered well. Before the night was over, he saw the moonlit spire of the church at the edge of his village. As he drew closer to land, an idea took hold of him. He would sail over the village and ring the *Zephyr*'s bell. Then everyone would see him and know that he was the greatest sailor. He flew over the tree-topped cliffs of the shore, but as he reached the church the *Zephyr* began to fall.

─ II ─

The Light

THE PHOTOGRAPHERS SET OUT

In the late 1840s and early 1850s photography joined forces with the modern passion for mobility. Owing partly to the paper negative's light weight and fairly predictable handling, French photographers set out on foot for nearby hamlets, woods and parks, laden with presensitized paper and camera and tripod over the shoulder (fig. 32). They traveled by coach or rail to the great cathedral towns, châteaux and game forests of France or endured the long passage to Egypt or the Middle East. Their journeys were historical, leading them to remote pockets of the world that held the past in stones and mortar. This communication with time was intensified by the very act of photographing, which necessitated a calculated study of daylight's mercurial changes and the alternating textures of weather and season. The pictorial implications of climate for photography were recognized immediately, especially by those previously trained as artists; some others rigorously trained on the spot became artists through the discipline of using the camera.

Although they possessed an instrument capable of fixing attention on an infinitude of subjects, what and how they photographed were conditioned by an artistic vision already well-formulated in the art of romanticism, especially through the graphic arts of lithography and wood-engraved illustration. The literary and poetic metaphors for darkness spun by Hugo, de Nerval, Gautier and others also nourished the art of calotype's somber depths. Such influences and associations hardly need reemphasis in the study of art except to avert a die-hard conception where photography is concerned, that its mechanically produced images, inevitably bound to what is there, are somehow exempt from cultural influence or the peculiar stamp of style. Today we prize photography in part for showing the here and now as a moment frozen and neatly extracted from time. This is a current conception imposed on the camera and achieved through technical perfections that make it visible. In the great confluence of varied interests that characterize the motives behind photographic practice, there were some entrepreneurs around 1850 who conceived a photography of instantaneity with new techniques that stopped time in its flow and astonished the crowds on the boulevards. The activity of these photographers has received perhaps more emphasis than accurately describes the full complement of concerns during the period, this selectivity occurring because it justifies our own period's obsession with momentariness in photography. But technical fascination with contemporaneity has little to do with the mid-nineteenth-century artist-

photographer's overriding concern to equate past and present. Photographing in the present, they like all romantics were preoccupied with history and continuity.

The romantic revolt against an increasingly unfamiliar and repellent modernity lingered on in the aesthetic (and moral) position of many photographers drawn to create an art of the paper negative. Devastating social changes were dismantling their physical surroundings. Disruption and discontinuity were constant and all-pervasive. The solace-seeking lovers Frédéric and Rosanette in Flaubert's *L'Education sentimentale* found that even the Forest of Fontainebleau could not be depended upon for asylum. Fleeing the Paris street fighting of 1848, they arrived under the trees only to confront the inescapable din of workers' hammers breaking up the woodland stones. Moved by similar revelations, the photographers sought to conserve

old memories through favorite forgotten corners or monuments that seemed to them to survive or resist change, and they photographed for safekeeping. Their choice of technique abetted the search, the long exposures required by paper virtually limiting them to the unmovable.

They did not neglect Paris. Mindful of its past glories but equally bent on studying the new excavations in their backyards, they combed old neighborhoods and photographically collected the touchstones of their lives as parts of the city were turned into debris overnight. This massive urban change had begun to occur well before 1853 when Baron Haussmann, appointed Prefect of the Seine by Napoleon III, transformed Paris' medieval byways into capacious streamlined vistas of a modern city. Just as they conserved beloved remnants of cathedrals and tattered country churches for the sake of medieval Catholicism

32. Édouard-Denis Baldus and Fortuné-Joseph Petiot-Groffier, *Millstream in Auvergne*, 1854 (detail).

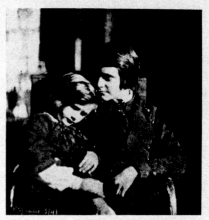

IV. Victor Regnault, *The Sons of the Photographer*, c.1850, h.137 × w 132 mm. S.F.P.

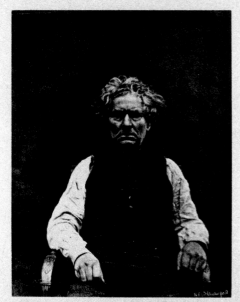

V. Victor Regnault, *Portrait of an Unknown Man*, c.1850, h.227 × w 176 mm. S.F.P.

Book Title:
The Art of French Calotype
Author:
A. Jammes, E.P. Janis
Editor:
Margot Cutter
Art Director:
Jan Lilly
Designer:
Jan Lilly
Princeton, NJ

20 Tales

Hawthorne

A selection of 20 short stories
by Nathaniel Hawthorne,
1804-1864,
who is honored this year
with a commemorative stamp
issued by the
United States Postal Service

The portrait
reproduced on the stamp
is a detail of the painting, 1850,
by Cephas Giovanni Thompson,
which is in the collection
of the Grolier Club,
New York

Westvaco

Book Title:
Twenty Tales by
Nathaniel Hawthorne
Author:
Nathaniel Hawthorne
Designer:
Bradbury Thompson
Riverside, CT
Illustrations:
Old engravings
Publisher:
Westvaco Corp.
Typographer:
Finn Typographical
Service
Printer:
Meriden Gravure Co.
Production Manager:
Marie T. Raperto
Paper:
Westvaco Corp.
Binder:
Tapley-Rutter

Chippings with a Chisel
13

Passing a summer, several years since, at Edgartown, on
the island of Martha's Vineyard, I became acquainted with
a certain carver of tomb-stones, who had travelled and
voyaged thither from the interior of Massachusetts, in
search of professional employment. The speculation had
turned out so successful that my friend expected to trans-
mute slate and marble into silver and gold to the amount
of at least a thousand dollars, during the few months
of his sojourn at Nantucket and the Vineyard. The
secluded life, and the simple and primitive spirit which still
characterizes the inhabitants of those islands, especially of
Martha's Vineyard, insure their dead friends a longer and
dearer remembrance than the daily novelty, and revolving
bustle of the world, can elsewhere afford to beings of the
past. Yet while every family is anxious to erect a memorial
to its departed members, the untainted breath of ocean
bestows such health and length of days upon the people of
the isles as would cause a melancholy dearth of business
to a resident artist in that line. His own monument,
recording his decease by starvation, would probably be an
early specimen of his skill. Grave-stones, therefore,
have generally been an article of imported merchandise.
 In my walks through the burial-ground of Edgar-
town – where the dead have lain so long that the soil,

209

Book Title:
The Klondike Quest
Author:
Pierre Berton
Editor:
Janet Craig
Art Director:
Frank Newfeld
Designer:
Frank Newfeld
Agincourt, CAN
Photographer:
Pierre Berton
Photographic Research:
Barbara Sears
Publishers:
McClelland & Stewart
Ltd.; Atlantic Monthly
Press; Little, Brown & Co.
Typographer:
Frank Newfeld
Printer:
Everbest Printing Co.,
Ltd.
Production Manager:
Peter Scaggs
Paper:
140 GSM Matte Coated
Art
Binder:
Everbest Printing Co.,
Ltd.
Jacket Designer:
Frank Newfeld
Jacket Photographer:
Michael Bedford
Jacket Photographs:
Washington State
Historical Society;
University of Washington

Book Title:
Karsh, A Fifty-Year
Retrospective
Author:
Yousuf Karsh
Editor:
Betty Childs
Designer:
Carl Zahn
Boston, MA
Photographer:
Yousuf Karsh
Publisher:
New York Graphic Society/
Little Brown & Co.
Typographer:
Typographic House
Printer:
Imprimerie Jean Genoud
Production Manager:
Nan Jernigan
Paper:
Imperial Matte 150 gram
Binder:
Imprimerie Jean Genoud
Jacket Designer:
Carl Zahn
Photographer:
Yousuf Karsh
Letterer:
Carl Zahn

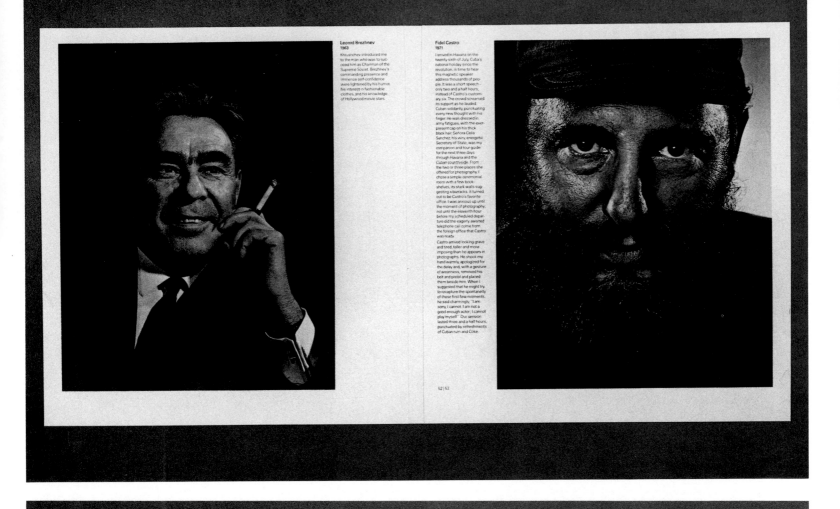

Leonid Brezhnev
1963

Khrushchev introduced me to the man who was to succeed him as Chairman of the Supreme Soviet. Brezhnev's commanding presence and immense self-confidence were lightened by his humor, his interest in fashionable clothes, and his knowledge of Hollywood movie stars.

Fidel Castro
1971

I arrived in Havana on the twenty-sixth of July, Cuba's national holiday since the revolution, in time to hear this magnetic speaker address thousands of people. It was a short speech—only two and a half hours, instead of Castro's customary six. The crowd screamed its support as he lauded Cuban solidarity, punctuating every new thought with his finger. He was dressed in army fatigues, with the ever-present cap on his thick black hair. Señora Celia Sanchez, his wiry, energetic Secretary of State, was my companion and tour guide for the next three days through Havana and the Cuban countryside. From the two or three places she offered for photography, I chose a simple ceremonial room with a few bookshelves, its stark walls suggesting a barracks. It turned out to be Castro's favorite office. I was anxious up until the moment of photography; not until the eleventh hour before my scheduled departure did the eagerly awaited telephone call come from the foreign office that Castro was ready.

Castro arrived looking grave and tired, taller and more imposing than he appears in photographs. He shook my hand warmly, apologized for the delay and, with a gesture of weariness, removed his belt and pistol and placed them beside him. When I suggested that he might try to recapture the spontaneity of those first few moments, he said charmingly, "I am sorry, I cannot. I am not a good enough actor; I cannot play myself." Our session lasted three and a half hours, punctuated by refreshments of Cuban rum and Coke.

52 | 53

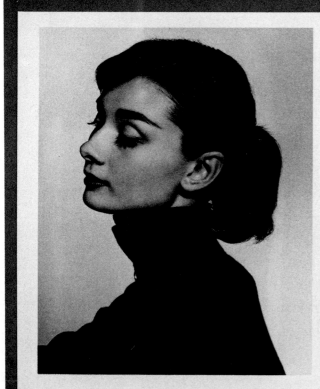

Audrey Hepburn
1956

The French novelist Colette picked her out of a ballet lineup to play Gigi on stage, and her career was launched. When I photographed her in Hollywood and commented on her quality of sophisticated vulnerability, she told me of her harrowing experiences during the Second World War. Years later, in the Kremlin, Chairman Brezhnev agreed to sit for me only if I made him "as beautiful as Audrey Hepburn."

Grace Kelly
1956

The future Princess of Monaco took me to her New York apartment before her fiancé, Prince Rainier, arrived so that we might select gowns for their photographs. The following day she was involved in whirlwind preparations for her forthcoming spectacular marriage to the Prince, but she remained fresh and serene throughout the sitting. It was evident, even then, that she was to bring both beauty and dignity to her role as the Princess of Monaco.

160 | 191

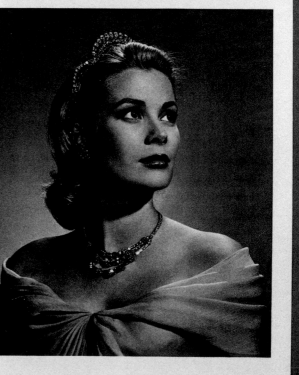

Book Title:
Biology
Author:
Leland G. Johnson
Editors:
Mary M. Monner
John Stout
Art Directors:
Marilyn A. Phelps
Designer:
David A. Corona
Dubuque, IO
Illustrators:
Various
Photographers:
Various
Publisher:
Wm. C. Brown Publishers,
College Division
Typographer:
Wm. C. Brown Publishers,
Manufacturing Division
Printer:
Wm. C. Brown Publishers,
Manufacturing Division
Photopress
Production Managers:
David Corona
Roger Meyer
Paper:
S.D. Warren Bookman
Matte #45
Binder:
Cuneo
Jacket Designer:
David A. Corona
Jacket Photographer:
Nelson Max,
Lawrence Livermore
Laboratory

Part **5** Evolution

Conceptions of present-day organisms are enhanced by the recognition that all living things are both products of and participants in a continuing evolutionary process.

Scientific perceptions of the evolutionary process developed relatively slowly until Charles Darwin proposed his theory of natural selection. His proposals regarding the causes of evolutionary change had an accelerating effect on the study of evolution.

Current concepts of evolution still rest on principles of natural selection, but modern evolutionary theories have incorporated principles of population genetics that have been developed since Darwin's time. And modern evolutionary research incorporates techniques of the physical sciences that make possible determination of the ages of fossil organisms and detailed molecular evolutionary studies of contemporary organisms.

Exciting progress also is being made in the investigation of human evolution as newly discovered human fossils provide more information on the origins of modern humans.

In chapters 27–29 the origins of evolutionary theory, some modern concepts of evolution, and the status of the study of human evolution are examined.

Book Title:
Nuremburg,
A Renaissance City,
1500–1618
Author:
Jeffrey Chipps Smith
Editor:
Barbara Spielman
Art Director:
George Lenox
Designers:
George Lenox,
Catherine Lenox
Austin, TX
Illustrators:
Various
Publisher:
University of Texas Press
Typographer:
G & S Typesetters
Printer:
The Meriden Gravure Co.
Production Manager:
David S. Cavazos
Paper:
Mohawk Superfine Text
#70
Binder:
John D. Ellis Bindery, Inc.
Jacket Designer:
George Lenox

Box 17.1
The First Site of Fatigue

When a muscle has contracted many times, it becomes fatigued. Its reserve of glycogen and its supply of creatine phosphate are depleted, and a great deal of lactic acid has accumulated. Animals feel fatigue, however, before these chemical changes, especially the lactic-acid buildup, threaten muscle fibers with permanent damage. Thus, a sense of fatigue normally causes an animal to rest and recover. But what happens if continued exercise is forced under extreme conditions?

The nerve of an isolated nerve-muscle preparation can be stimulated repeatedly until the muscle no longer contracts in response to further stimulation. What has failed to function? Electronic studies of axons under these conditions indicate that the axons still are able to conduct action potentials, and if electrodes are applied directly to the muscle, the muscle can contract strongly in response to direct stimulation. Thus, muscle fibers still are able to contract. These findings have led physiologists to conclude that during heavy exercise under experimental conditions, neuromuscular junctions are the initial sites of fatigue-induced failure.

It is assumed that fatigue-induced failure protects muscles from damage caused by excessive lactic acid accumulation or other chemical damage due to massive fatigue. But it is not clear how these experimental findings relate to nerves and muscles in an intact normal body. Would muscles actually stop at some point if heavy muscular exercise continued too long? Do muscle cramps, which start much earlier in the fatigue process, normally help to keep motor units from reaching this "freeze-up" point? In the case of heavy exercise in humans, what is the role of determination ("willpower")? Do long distance runners who "run through" cramps and muscle pain risk serious muscle damage (box figure 17.1A)? More research is needed to deal with these questions and to relate results of experimental studies of muscle functioning to general exercise physiology.

Box figure 17.1A An athlete displaying symptoms of muscle fatigue. Sebastian Coe crossing the finish line in a world record setting performance.

T Tubules and Cisternae

In the late 1940s, L. V. Heilbrunn and his colleagues injected a number of substances into muscle fibers and found that, of all those tested, only calcium salts caused fiber contraction. This discovery led to a proposal that permeability changes that occur in the sarcolemma during the action potential allow calcium ions (Ca^{2+}) to enter the cell and that these calcium ions diffuse inward and set off contraction of the contractile proteins.

This hypothesis was challenged as more research was done over the following years. One major problem is that very little calcium actually enters a muscle fiber as a result of action potentials in the sarcolemma. Another objection is that calcium ions moving inward by diffusion would reach outer myofibrils much sooner than the ones deep in the center of the cell, and yet, all of the myofibrils of a muscle fiber contract at exactly the same time. It seems, therefore, that if calcium ions actually do initiate contraction events in the myofibrils, some mechanism must permit simultaneous delivery of calcium ions throughout the interior of the muscle fiber.

Such a mechanism does exist. It is based on the functions of two networks of membranous structures that exist in the spaces among the myofibrils of the muscle fiber. One membranous network is the **sarcoplasmic reticulum**, the muscle fiber's endoplasmic reticulum (see chapter 3 for additional information on the endoplasmic reticulum). Expanded sacs of sarcoplasmic reticulum, called **terminal cisternae** (singular: **cisterna**), lie near the Z lines of the myofibrils. These cisternae contain a large quantity of calcium ions.

The second network of membranous structures is a system of hollow tubules whose walls are continuous with the sarcolemma. These tubules, which open to the outside of the cell, are called **T tubules** (for transverse tubules). They penetrate all parts of the cell and their tips come in contact with the cisternae of the sarcoplasmic reticulum (figure 17.18).

Each wave of action potentials passing along the sarcolemma results in depolarization of the membranes of all of the T tubules. When an electrical change in the membrane arrives at the tip of a T tubule near a terminal cisterna, it somehow triggers an abrupt change in the membrane of

At rest

Extracellular space Sarcolemma

(a) Ca^{2+} T tubule

Contraction

(b) T tubule Terminal cisterna of sarcoplasmic reticulum

Z line Ca^{2+} Z line

Relaxation

(c)

Figure 17.18 Simplified diagram of control of actin and myosin filament sliding by calcium release and recovery. (a) T tubules, which are continuous with the sarcolemma, actually branch extensively and penetrate all parts of the muscle fiber. (b) When action potentials pass down the T tubules, calcium is released from terminal cisternae, and filament sliding occurs. (c) Relaxation occurs when the terminal cisternae recover calcium ions. Cisternae membranes no longer permit calcium ions to flow outward, and cisternae quickly recover calcium by active transport inward across their membranes.

3. HARTMANN SCHEDEL, LIBER CHRONICARUM (NUREMBERG CHRONICLE)

Nuremberg: Anton Koberger, 12 July 1493
326 leaves; 47 × 32.5 cm
1804 woodcuts using 645 different woodblocks
The University of Texas at Austin, The Humanities Research Center [ex. Hanley Collection]

After Johann Gutenberg's forty-two-line Bible (Mainz, 1453–1456), Hartmann Schedel's *Nuremberg Chronicle* is the most famous fifteenth-century publication.[1] It is a lavishly illustrated history of the world from creation to 1493, following the format of many late medieval chronicles.[2] It is distinguished from its predecessors both by Schedel's careful scholarship and by the unprecedented number of illustrations. Publisher Anton Koberger's advertisement promised the prospective buyer that "nothing like this has hitherto appeared to increase and heighten the delight of men of learning and of everyone who has any education at all . . . Indeed, I venture to promise you, reader, so great delight in reading it that you will think you are not reading a series of stories, but looking at them with your own eyes. For you will see there not only portraits of emperors, popes, philosophers, poets, and other famous men each shown in the proper dress of his time, but also views of the most famous cities and places throughout Europe. Farewell, and do not let this book slip through your hands."[3] Although the portraits are not as accurate as Koberger suggested, the thirty-two accurate views of such cities as Jerusalem, Constantinople, Rome, Venice, Nuremberg (illustrated here), and other German towns, as well as the many more fanciful city representations, do successfully transport the armchair traveler across the continent.[4]

The creation of the *Nuremberg Chronicle* is well documented.[5] In either late 1487 or early 1488, Nuremberg patricians Sebald Schreyer, the superintendent of St. Sebaldus, and his brother-in-law Sebastian Kammermeister contracted Wolgemut and Pleydenwurff to illustrate Schedel's text, which was still being written, and Anton Koberger to publish the work.[6] This contract was restated on 29 December 1491. The artists were paid 1,000 gulden and they were to equally divide any subsequent profits with the two investors.

Work was well under way by 1490, the date on Wolgemut's magnificent drawing *God the Creator* (London, British Museum) that is the design for the opening woodcut (page 1 verso).[7] These two masters created exemplars or layout models for both the Latin and German editions of the *Nuremberg Chronicle*.[8] The earlier, Latin exemplar ranges from extremely sketchy outlines to fairly complete drawings.[9] The Wolgemut-Pleydenwurff workshop produced 645 woodblocks, many of which were used repeatedly to illustrate different historical figures or distant cities.[10]

The contract specified that during the printing either Wolgemut or Pleydenwurff would be present in Koberger's publishing house to correct any defects. One such mistake occurs in the copy exhibited accidentally, the woodblock for Moses receiving the Ten Commandments was

set above that showing Moses leading the Israelites across the Red Sea on page XXX verso. This mistake appeared in a few early impressions but was soon corrected. Another reason for requiring the artists' presence at the publisher's was to guard against theft or the possible loss of a block, and, indeed, the contract required Koberger to set aside a locked room for storing the woodblocks. However, these precautions did not prevent Augsburg publisher Hans Schönsperger from printing a pirated edition of the chronicle in 1496.[11]

As mentioned above, the *Nuremberg Chronicle* was published in Latin and German editions. The more carefully laid out and printed Latin edition appeared first, on 12 July 1493. The Latin text is also longer, with additional woodcuts. The German edition, *Das Buch der Croniken*, was printed on 23 December 1493. Scholars have estimated that approximately 1,500 Latin and 1,000 German copies were published.[12] The cost of an unbound and uncolored copy was slightly under 2 gulden (Rhine guilder).[13] This price can be compared with the average annual salaries of

a printer (32 gulden), a legal court scribe (40 gulden), or a physician (100 gulden): the rough equivalent of buying 542 pounds of beef at prices for the year 1500. Thus the price, while not exorbitant, was relatively high. By contemporary standards, the *Nuremberg Chronicle* sold fairly well. When the final settlement of the artists and investors was made on 22 June 1509, 509 Latin and 49 German copies remained unsold. Interestingly, the records of 1509 provide a glimpse into Koberger's marketing and distribution system, for copies were held by booksellers throughout central Europe, France, and Italy.

1. The literature on the *Nuremberg Chronicle* is vast. Most of the comments below are based upon E. Rücker, *Die Schedelsche Weltchronik—Das grösste Buchunternehmen der Dürer-Zeit*; Wilson, *Nuremberg Chronicle*. On Schedel, see Wilson, pp. 158f., and the comments in Section 2 above.

2. It is divided according to the six ages of mankind: (1) Creation to the sons of Noah; (2) Noah's Ark to the destruction of Sodom and Gomorrah; (3) Abraham to Saul; (4) David to the destruction of Jerusalem; (5) the Babylonian captivity to the death of John the Baptist; and (6) the birth of Christ to the present. The illustrations are linked to the text.

3. A copy of this rare book advertisement is in Schedel's own Latin edition of the chronicle (Munich, Staatliche Bibliothek, Clm 587, folio 2 of the pages added before the text). Also attached in Elizabeth's *Road Map of Central Europe* (cat. nr. 1). See Wilson, *Nuremberg Chronicle*, pp. 208–209 (gives the full text), 217.

4. Wolgemut's depiction of Nuremberg will be discussed in cat. nrs. 163–164. On the views of cities and some of the sources, see Rücker, *Weltchronik*, pp. 72–77, 83–135.

5. The documents are published in Wilson, *Nuremberg Chronicle*, pp. 33–54.

6. The 1487–1488 document no longer survives. Schedel, Schreyer, Kammermeister, Wolgemut, and, presumably, Pleydenwurff were all neighbors. On their relationships and careers, see above Section 4 (Schreyer). Rücker, *Weltchronik*, pp. 17–18; Wilson, *Nuremberg Chronicle*, pp. 16–17, 22–33 (comments by P. Zahn).

7. Dept. of Prints and Drawings, 1880.7.3.43. See Rücker, *Weltchronik*, fig. 43, and cf. S. A. Wilson, "The Early Drawings for the *Nuremberg Chronicle*," *Master Drawings* 13 (1975): 115–130.

8. Nuremberg, Stadtbibliothek, Cent. II.98 (Latin) and II.99 (German). See Rücker, *Weltchronik*, pp. 20–42; Wilson, *Nuremberg Chronicle*, pp. 42, 93–174. Four additional but separate layout drawings are also in the Stadtbibliothek; see Rücker, *Weltchronik*, pp. 17f.

9. An adequate analysis of the specific roles of Wolgemut, Pleydenwurff, and the individual shop members has yet to be done. See Wilson, *Nuremberg Chronicle*, pp. 93–246. Equally unclear is the contribution of the young Dürer; see J. Sladeczek, Albrecht Dürer und die Illustrationen zur Schedelchronik (Strasbourg, 1965); and F. Panofsky, *The Life and Art of Albrecht Dürer*, pp. 28–30.

10. Schönsperger commissioned Augsburg artists to make reduced-size copies of all of the prints in the *Nuremberg Chronicle*. His edition is much smaller (20.5 × 29 cm vs. 47 × 32 cm) and cheaper. This edition undercut the market and prevented the Nuremberg group from continuing with their original plan to publish a new edition; see Rücker, *Weltchronik*, p. 82, figs. 1, 62.

11. Wilson, *Nuremberg Chronicle*, p. 43. The large editions explain why so many copies of this book survive. For instance, the University of Texas at Austin possesses five Latin (one hand-colored) and two German copies.

12. Ibid., pp. 237–241, for the following.

13. Ibid., pp. 229–236.

94 95

50. WILD MAN AND HIS FAMILY

1530 (1545)
Woodcut on two blocks
25.3 × 28.4 cm (image); 26.1 × 27.7 cm (sheet)
Geisberg, nr. 1106; Dodgson, II, p. 53
Lent by the Metropolitan Museum of Art, New York, Gift of Harry G. Friedman, 1957

The concept of the wild man enjoyed tremendous popularity in Germany during the later fifteenth century and the first half of the sixteenth. The wild man, a forerunner of the werewolf or the modern Big Foot, resembled man except that most of his body was covered with thick hair. Occasionally, leaves and branches would hang about his head and genitals. The wild man was a primitive creature who lived simply in the dense German forests. He avoided man except when he occasionally left the forest to steal a child for his dinner.[1] Schäufelein shows him with an uprooted tree for a walking staff, a reference to his wild, physical power.

During the early sixteenth century, the image of the wild man began to change.[2] He was no longer devoid of intelligence. He had become a noble creature cleansed by the purity of nature who criticizes mankind and its social structures. The woodcut exhibited here lacks its original eighty-five lines of verse by Hans Sachs, which were used for the 1530 and 1545 editions of this print as published by Hans Guldenmund of

Nuremberg.[3] The correct title is *Klag der wilden Holtzleut über die ungetrewen Welt* or *Lament of the Wild Forest Folk over the Perfidious World*. Using the wild man as his spokesman, Sachs offers a blistering commentary upon man's corrupt behavior. The wild man, not the civilized urban burgher, is the superior creature.

Portions of Sachs's text read as follows.

> Alas! Society corrupts
> And rampant perfidy erupts
> As justice suffers out of sight
> Injustice prospers in the light
> The loan shark sits in Honor's seat
> While honest workers cannot eat
>
> The world's in such a sorry state
> With lies, and knavery, and hate
> And so to sum it up in short
> We find the things of evil sort
> Embraced by all society
>
> A man who would be well employed
> And finds the world in such a mess
> Must forsake this faithlessness
> And so we left our worldly goods
> To make our home in these deep woods
> With our little one protected
> From that falsehood we rejected
> We feed ourselves on native fruits
> And from the earth dig tender roots
>
> And thus removed from civilization's
> Shams we've lived for generations
> United in our simple life

When all the world will see the light
And everyman live true, upright,
In equal, unconniving good
Will soon be man in tears
Of joy. We've waited for years and years
And reason mankind in tears
Of joy. We've waited for years and years.
Will soon occur, hopes friend Hans Sachs.[3]

The transformations in the wild man's image belong to a broader trend that glorified the beauty and simplicity of the natural world in contrast to the complex and often immoral, man-made cities. In art, Albrecht Altdorfer and other Danube School painters and printmakers created wild, evocative scenes of forests and mountains.[5] Some are arcadian, others powerfully pantheistic. Whether the hero is the wild man or Altdörfer's satyr, he embodies a simpler, more primeval stage in man's evolution.

1. T. Husband and G. Gilmore-House, *The Wild Man: Medieval Myth and Symbolism*, provides an excellent introduction to this subject and its transformations; see their nrs. 52 (a pair of ewers) and 58 (Dürer's *Coat of Arms of Death*) for other Nuremberg examples of this theme. Carnival actors dressed as wild men and wild women were frequently part of the annual Schembart festival in Nuremberg; see S. L. Sumberg, *The Nuremberg Schembart Carnival*, pp. 98–103, figs. 16, 17.

2. See Lucas Cranach the Elder's woodcut (ca. 1510–1515; Geisberg 619); Husband and Gilmore-House, *The Wild Man*, nr. 25.

3. Ibid., pp. 15–17.

4. On this print, see Rottinger, *Die Bilderbogen des Hans Sachs*, nr. 405; *Die Welt des Hans Sachs*, nr. 71; Husband and Gilmore-House, *The Wild Man*, nr. 33. Guldenmund probably published the first edition of the print that appeared on 2 June 1530. Husband and Gilmore-House, fig. 81, illustrates the ca. 1530 version (Berlin, Kupferstichkabinett), which has a more complete landscape background. Guldenmund's name appears at the bottom of the text of the more numerous 1545 edition. Husband and Gilmore-House, *The Wild Man*, nr. 33. The publisher Wolfgang Strauch produced a third edition in 1569. Strauch's print is not mentioned in Strauss, *The German Single Leaf Woodcut, 1550–1600*, III, p. 1063, where he discusses Strauch's career; however, see Rottinger, *Die Bilderbogen des Hans Sachs*, nr. 405.

5. The translation is by F. Childs and is published in Husband and Gilmore-House, *The Wild Man*, pp. 202–204.

6. Talbot and Shestack, eds., *Prints and Drawings of the Danube School*, esp. pp. 10–14. Also see L. Silver, "Forest Primeval: Wilderness Images by Albrecht Altdörfer (1506–1516)," which will appear in *Simiolus* in 1983.

148

51. PRINCES' WEDDING DANCE: DANCING COUPLE

1531–1535 or 1570
Woodcut
24.7 × 17.8 cm (block); 25.3 × 19.3 cm (sheet)
Geisberg, nr. 1078; Dodgson, II, p. 52 (nr. 213)
Lent by the Art Museum, Princeton University (Junius S. Morgan Collection)

The *Dancing Couple* is one of the series of nineteen woodcuts that comprise the *Princes' Wedding Dance*. The actual composition of this series, the artists involved, and the date have puzzled many critics, including Geisberg and Dodgson. Röttinger's solution is now accepted.[1] He claimed that this series consisted of nineteen woodcuts, sixteen by Schäufelein, one by Pencz, and two by Schön.[2] A second, unrelated series of different dimensions was made by Pencz and Hans Sebald Beham.[3] Briefmaler Hans Guldenmund of Nuremberg published the series sometime between 1531 and 1535. The original edition contained Guldenmund's signature and texts penned by Hans Sachs above each figure.[4] Although the *Dancing Couple* may be from this first edition with the accompanying inscriptions cut off, the lack of Guldenmund's signature beneath the text of this couple and the imperfect impression suggest that it belongs instead to the incomplete 1570 edition published in Nuremberg by Wolfgang Strauch.[5] Nuremberg form-

schneider Peter Steinbach produced a later, third edition.[6]

The series has been variously titled. The *Princes' Wedding Dance* appears to be correct since the seventeen couples are richly attired and several of the men wear the collars of the Order of the Golden Fleece.[7] One of Schön's two woodcuts depicts the bride and groom. Schäufelein provided representations of the dance leader, the torch bearer, musicians, and even an audience.

While the cycle is not intended to commemorate any specific occasion, it does recall the elaborate patrician dances held in the great hall of the Nuremberg Rathaus.[8] Schäufelein was certainly familiar with the mural paintings of musicians and onlookers executed in this chamber by Pencz and others after Dürer's designs.[9]

1. Röttinger, *Die Bilderbogen des Hans Sachs*, pp. 39–40, nr. 198s; also see *Die Welt des Hans Sachs*, nrs. 94–112.

2. Geisberg, nrs. 1061 (Pencz), 1064, 1079 (Schäufelein), 1169–1170 (Schön). The total length of the series would be about 5 to meters. For an incomplete view of the ensemble, see Hyate and von Henninger, *Kunsthistorische*, fig. 33.

3. Röttinger, *Die Bilderbogen des Hans Sachs*, nr. 130; Geisberg, nrs. 248–258 (Beham), 1063–1067 (Pencz).

4. Röttinger, *Die Bilderbogen des Hans Sachs*, pp. 42–46, provides the entire text; the text for the *Dancing Couple* is given in lines 71–80. See Geisberg, 1078, for an illustration of this print with its text and Guldenmund's signature.

5. Röttinger, *Die Bilderbogen des Hans Sachs*, p. 40, provides information about the different editions. Strauch was active between 1554 and 1572; see Strauss, *The German Single Leaf Woodcut, 1550–1600*, III, p. 1063, nr. 52.

6. Steinbach was active between 1577 and 1616. He also republished Schäufelein's *Triumphal Procession of Emperor Charles V* (cat. nr. 54).

7. On the costumes and general figure types, cf. the revelers in Hans Sebald Beham's contemporary *Feast of Herodias* (cat. nr. 84).

8. A mid-sixteenth-century watercolor illustrating a patrician dance in the great hall is reproduced in *Reformation in Nürnberg*, nr. 79. Also see the later watercolor of a dance held sometime between 1540 and 1545; Pfeiffer and Schwemmer, *Bilddokumente*, fig. 80.

9. Mende, *Rathaus*, I, nr. 191; see cat. nr. 213 for a discussion of these paintings.

149

Book Title:
The Trial
Author:
Franz Kafka
Editor:
Joan Giurdanella
Art Director:
Michael Mendelsohn
Designer:
Maria Epes
New York, NY
Illustrator:
Jarmila Maranova
Publisher:
The Franklin Library
Typographer:
Progressive
Typographers, Inc.
Printer:
R. R. Donnelley & Sons
Co.
Production Manager:
Janet Sessa
Paper:
P. H. Glatfelter
Binder:
The Sloves Bindery
Jacket Designer:
Brian Molloy

Book Title:
Lance Hidy's Posters:
Designs Personal &
Public
Authors:
Alan Fern, Lance Hidy
Editor:
Lance Hidy
Art Director:
Lance Hidy
Designer:
Lance Hidy
Berkeley, CA
Illustrator:
Lance Hidy
Letterer:
Lance Hidy
Publisher:
Alphabet Press
Typographer:
Meriden-Stinehour Press
Printer:
Meriden-Stinehour Press
Production Manager:
Lance Hidy
Paper:
Mohawk Superfine
Binder:
Meriden-Stinehour Press

I had always been aware of the expressive power of color, but had been timid about using it in its full strength. In 1968 I read Chevreuil's laws of color harmony, though I never made much conscious application of them, preferring to trust my intuition. When I began reading about color again in 1979, I decided to test the theories. Again, the pure, solid colors of popular art and the extravagance of daily flower bouquets from our garden encouraged me to override my natural inclination to use realistic color and to try instead color that was decorative and symbolic and which set a desired mood. I did three more posters in safe earth colors and finally took the plunge into COLOR! The breakthrough poster for that was "David R. Godine, Publisher" (p. 57).

I used the black and white contrast to draw attention to the book, and a triad of the pure secondary colors—orange, violet, and green—to unify the woman's figure; the warm yellow is the complement (opposite on the color wheel) of the violet; and these two colors mixed, plus white, resulted in the neutral mustard color of the couch. The exercise reminded me more of geometry than art, but it was immediately apparent that laws of harmony are useless unless balanced by a sensitivity to the poetic connotations of colors. Color and its emotional effect are the most interesting parts of poster design for me, and the most difficult. I make as many as ten or fifteen paintings in gouache, in one-quarter size,

1980, 29 × 21″, hand silk screen by L.H., 450 numbered and signed copies. Lettering by Stephen Harvard. Model, Carolyn Coman.

56

57

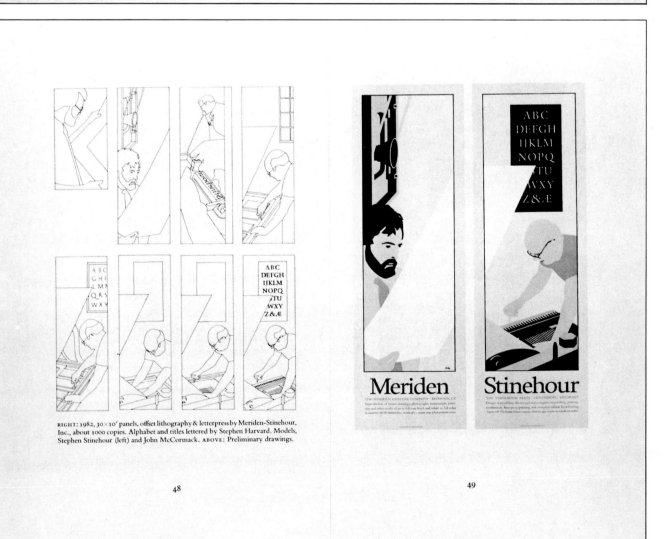

RIGHT: 1982, 30 × 10″ panels, offset lithography & letterpress by Meriden-Stinehour, Inc., about 1000 copies. Alphabet and titles lettered by Stephen Harvard. Models, Stephen Stinehour (left) and John McCormack. ABOVE: Preliminary drawings.

48

49

THE
AENEID
VIRGIL

TRANSLATED BY
ROBERT FITZGERALD

RANDOM HOUSE
NEW YORK

Book Title:
The Aeneid
Author:
Virgil
Translator:
Robert Fitzgerald
Editor:
Anne Freedgood
Art Director:
Bernard Klein
Designer:
J.K. Lambert
New York, NY
Publisher:
Random House, Inc.
Typographer:
Centennial Graphics, Inc
Printer:
R.R. Donnelley & Sons
Co.
Production Manager:
Patrick Lee
Paper:
S.D. Warren Medium
1854
480 ppi #60
Binder:
R.R. Donnelley & Sons
Co.
Jacket Designer:
Robert Aulicino

Your trunk dismembered, all your mangled body?
This—is this all of yourself, my son,
That you bring back to me? By sea and land
Did I keep this beside me?
 Put your spears
Into me, Rutulians, if you can be moved,
Let fly your javelins all at me, and let me
Be the first you kill. Or else take pity,
Father of the great gods, with your bolt
Dispatch this hateful soul to the abyss.
I cannot else break off my tortured life."
All hearts were shaken by her cries, and groans
Of mourning came from all, their strength for battle
Broken and benumbed. At the behest
Of Ilioneus and Iulus, weeping hard,
The woman, as she fanned the flame of grief,
Was brought inside, supported on the arms
Of Actor and Idaeus, and given rest.

But now a far-off trumpet sang in bronze
Heart-chilling clamor, and a battle shout
Re-echoed from the sky, as Volscians charged
Under cover of shields evenly locked
To fill the moat and tear the rampart down.
Some tried to find a way over and in
With scaling ladders at points lightly manned,
Where gaps showed in the high line of defenders,
Not so close-packed. But the Trojans, trained
In their long war, knew how to hold a wall.
They rained all kinds of missiles down, and used
Tough poles to push off climbers. Stones as well
Of deadly weight they rolled and tumbled over
To crack the shield-roofed ranks. Nevertheless,
Beneath a "tortoise shell" so thick, those troops
Were glad to take their chances. Yet the time

Lines 401–515

Came when they could not. Where the massed attackers
Threatened, Trojans trundled a mass of stone
And heaved it down to fell men in a swathe
And smash their armored shell. Now Rutulians
No longer cared to fight blind under shields
But strove to clear the wall with archery.
Mezentius in his quarter of the field,
A sight to quail at, shook his Etruscan pine,
His firebrand, and lobbed in smoking darts.
Messapus, Neptune's child, tamer of horses,
Breached a wall and called for scaling ladders.

Calliopë, I pray, and Muses all,
Inspire me as I sing the bloody work,
The deaths dealt out by Turnus on that day,
And tell what men each fighter sent to Orcus:
Help me to spread the massive page of war.
There was one tower of commanding height
And served by catwalks, in a strategic place.
Italian troops with might and main
Struggled to conquer this or bring it down
With every trick of siege. And for their part
The Trojans held it with a hail of stones
And shafts they shot through loopholes. Turnus now
Became the first with his thrown torch
To lodge a fire in the tower's side.
Blazing up there with wind, it caught the planks
And clung around the portals it consumed.
The garrison, in panic at this horror,
Having no exit, herded to that side
Still free of deadly fire; but the tower
Under the sudden shift of weight went down,
All heaven thundering with its crash. Men dropped
Half-dead with all that mass of ruin to earth,
Impaled on their own weapons, or run through

Lines 515–543

Book Title:
Life: The Science of
Biology
Authors:
William K. Purves,
Gordon H. Orians
Editor:
Andrew Sinauer
Art Director:
The Biology Bookist
Designer:
Martin Lubin/
Betty Binns Graphics
New York, NY
Photographic Research:
Biological Photo Services
Illustrators:
Various
Publisher:
Sinauer Assoc./
Willard Grant Press
Typographer:
DEKR Corp.
Printer:
R.R. Donnelley & Sons
Co.
Production Coordinator:
Joseph J. Veseley
Paper:
Bookman Matte #45
Binder:
R.R. Donnelley & Sons
Co.
Cover Designer:
Marty Lubin/
Betty Binns Graphics
Cover Illustrator:
J.F. Lansdowne

CHAPTER ONE

THE SCIENCE OF BIOLOGY

FIGURE 19 A FOSSIL TRILOBITE
Trilobites were among the earliest arthropods, a phylum that now includes insects, mites, spiders, and crustaceans. An extensive fossil record bears witness to the occurrence of various trilobites in Earth's oceans for several hundred million years, but the last of them became extinct a quarter of a billion years ago. We can learn much about trilobites from their fossils, but uncounted kinds of other extinct organisms had soft parts that did not fossilize well, or had their traces destroyed by geological events.

changes in the rate of evolutionary change. These fluctuating rates do not necessarily mean that new mechanisms must be postulated; but they require careful study—a problem to which we shall return in Chapter 38.

In sum, it can be seen that Darwin's theory of natural selection answered some major biological questions. At the same time, it raised important new ones; and the study of mechanisms of evolution remains at the forefront of modern biological research.

The importance of the world view

Biologists develop hypotheses, devise tests, and modify their ideas in the light of experimental results; but these activities are carried out within a broader framework. All people, whether they are scientists or not, operate within the framework of a general world view (called a **paradigm**). The paradigm determines which problems are interesting and which are not. It strongly influences the responses we make to information that seems to run counter to the predictions of our paradigm.

Biology began a major change in paradigms a little over a century ago with the general acceptance of Darwin's theory of evolution by natural selection. The changeover has taken a long time because it

required abandonment of many components of a different world view. The pre-Darwinian world was thought to be a young one in which living organisms had been created in essentially their current forms. The Darwinian world is viewed as an ancient one in which both Earth and its inhabitants have been evolving from forms very different from the ones they now have. It is a world in which we would not recognize former living organisms if we were to be transported back in time, nor organisms of the future if we were transported forward in time. Acceptance of this paradigm involves not only acceptance of the process of natural selection. It also involves coming to grips with the evolving world that the mechanism provides.

History suggests that the Darwinian paradigm will, in turn, be replaced by another; but the form of the new one and when it will emerge are, of course, unknown to us. Current guesses about the nature of future paradigms are likely to be incorrect. When Newton first proposed his gravitational view of the world, there were many objections. The Newtonian paradigm has been replaced by a new one (quantum mechanics); but the new one does not in any way resemble the objections made about Newton's theories by his contemporaries.

This book, then, is a discussion of Darwin's paradigm, of how the science of biology appears from

that perspective, and of the kinds of problems that seem legitimate to biologists who accept this general view. The "new" ideas we discuss are not new in the sense of proposing new paradigms. Rather, they are novel interpretations of some areas of biology to which the application of Darwin's ideas has progressed more slowly than elsewhere.

Levels of organization in biology

Biologists study processes at many different levels of organization, ranging from determining the structure and functioning of some molecule to measuring the transfer of solar energy through complex systems involving many different species of living organisms (Figure 20).

Many biologists work at the level of the cell; and others work at subcellular levels, characterizing specific molecules and particular chemical pathways within cells. Others focus on the individual organism. It is the individual organism that is acted upon most powerfully by natural selection, and the organism is therefore a basic unit in evolution. Many biologists study how individuals function and how they maintain themselves in an ever-changing environment.

Many important biological problems find their focus at the level of **populations** (groups of interbreeding individuals). Populations have properties (such as density, dispersion, birth rates, and death rates) that are not possessed by individuals. No population of organisms exists in isolation from other populations and the physical environment. Organisms eat

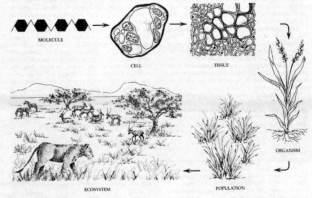

MOLECULE CELL TISSUE ORGANISM

ECOSYSTEM POPULATION

FIGURE 20 LEVELS OF BIOLOGICAL ORGANIZATION
Biologists attempt to learn about nature at various levels of size and complexity, from molecules through ecosystems. The sequence of levels in the drawing is roughly the sequence that will emerge in this book.

16

17

Book Title:
Wind and Sand
Authors:
Lynanne Wescott,
Paula Degen
Designer:
Miho
Redding, CT
Photographers:
Various
Publisher:
Eastern Acorn Press
Typographer:
Southern New England
Typographers, Inc.
Printer:
John D. Lucas Printing
Co.
Produced By:
Publishing Center for
Cultural Resources
Paper:
Vintage Gloss #80
Binder:
John D. Lucas Printing
Co.

The early part of the glides were practically soaring, our speed over ground being from one to two feet per second, often for distances of 25 to 75 feet. We took a number of measurements of the relative wind by running along by side of machine with the anemometer. . . . Many of these flights were at heights from 40 to 60 feet, by far the highest gliding we have ever done. We made 3 pictures.
[Orville Wright's Diary D, October 21, 1903]

Wright State University

This 1903 photograph of a glide on the 1902 machine is one of the pictures mentioned in Orville's diary for October 21. The camp buildings are visible in the distance.

The illustration shows one of these very slow glides at a time when the machine was practically at a standstill. The failure to advance more rapidly caused the photographer some trouble in aiming, as you will perceive. In looking at this picture you will readily understand that the excitement of gliding experiments does not entirely cease with the breaking up of camp. In the photographic darkroom at home we pass moments of as thrilling interest as any in the field, when the image begins to appear on the plate and it is yet an open question whether we have a picture of a flying machine, or merely a patch of open sky. [Wilbur Wright lecture to Western Society of Engineers, September 18, 1901]

Library of Congress

MOUNTAINS OF THE MIDDLE KINGDOM

Exploring the High Peaks of China and Tibet

GALEN ROWELL

Sierra Club Books, San Francisco
IN ASSOCIATION WITH THE AMERICAN ALPINE CLUB

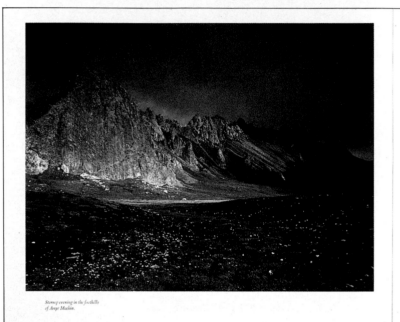

Stormy evening in the foothills of Anye Machin.

Contents

Book Title:
Mountains of the Middle Kingdom
Author:
Galen Rowell
Editor:
James Robertson
Designers:
James and Carolyn Robertson
Photographer:
Galen Rowell
Publisher:
Sierra Club Books
Typographer:
MacKenzie-Harris Corp.
Printer:
Dai Nippon Printing Co., Ltd.
Production Manager:
Eileen Max
Paper:
Satin Kinfuji
Binder:
Dai Nippon Printing Co., Ltd.
Jacket Designer:
James and Carolyn Robertson
Photographer:
Galen Rowell

well as every other one in Tibet. The lamas themselves said that one hundred million ounces of gold had been "given" by the people to construct the Potala.

Although we were far more able to pay than the poor Tibetan nomads, peasants, and traders, I felt a clear sense of being ripped off. Such an emotion had been absent in past situations where I had respected religious restrictions imposed by Moslems, American Indians, and those born of us in Tibet as transplants, the Sherpas of Nepal. But my experience here was no different than that of Father della Penna, an eighteenth-century missionary who had written of the lamas, "They are greedy of money . . . arrogant and proud." They are inclined to vindictiveness," or of the first British journalist into Lhasa, Percival Landon, who reported in the *London Times* at the turn of the century, "No priestly caste in the history of religion has ever preyed upon . . . its flock with the systematic brigandage of the lamas."

Today's tourists, coming passively to look, were enchanted by the monks' quaintness and were typically unaware that their avarice was as unchanged as their appearance. Because the Chinese had outlawed the religious training of youth before the 1959 rebellion, there has been little opportunity for progressive change in Lamaistic Buddhism. Even though I was able to admire the edifices of the faith, my own conclusion was that it is doomed by its own contradictions.

The Dalai Lama, no longer the naïve teenager who fled Lhasa in 1951, has become one of the world's most astute political observers, well aware of the sad reality that no country in the modern world, whether subjugated or totally free, has ever successfully reverted to a past society, much less a theocracy. He and his representatives have simply declared that he will only return to an independent Tibet.

The challenge of the Dalai Lama is not to bring back the old religion to Tibet, but, now that there is a rising generation of lamas, to change it so that it can withstand the tests of these times, not those of the past.

Apart from the lamas, I have no doubts that the Tibetan people will regain their dignity. I remember especially one ten-year-old boy I met on the street outside Tashilhunpo. In one hand he held a worn school book and in the other a makeshift leash attached to a wiggly puppy. We walked to-

gether for an hour, sharing smiles, a few words of mutual language, and curiosity that knew no bounds. In his gentle, unaffected character were the roots of the best tradition, and I saw, once again, the contented dogs on the sidewalks of Lhasa, the joyous crowds that we had at first thought were phony, and the majesty of devotion in the Jokhang Temple.

At moments like this Tibetan living seemed as pastoral as that of the yaks I saw grazing in the fields under mountain and cloud. But the yaks, too, were far more involved in the world around them than they appeared. Their butter lights the lamps of monasteries, their wool carpet floors, blankets beds, tents homes, clothes bodies; their milk and cheese nourish children, their skins raft people across great rivers, sole tender feet, their dung warms homes, cooks their own meat.

When the explorer P. K. Kozloff returned to Russia in 1911, he began the narrative of his adventures with a comparison of two incompatible races he had met in Central Asia, the Chinese Mongols and the Tibetans. The desert Chinese were as much People of the Camel (for which Kozloff developed quite an affinity), as the Tibetans were People of the Yak. He learned never to mix these two cultures.

In the mountains and high tablelands of Tibet, coat robes as different in their manners and customs from the Chinese Mongols as their horse and obstinate yaks are from camels. On the word "took took" and a gentle pulling of the lead rope, the camel lies down to be loaded. The bull yak is always looking for an opportunity to gore his neighbor. Some of them will lie down to be loaded, but others plunge about, and having broken away from their attendants, never rest until they have thrown their loads.

On the eve of our departure from Lhasa, I set off into the fields while the group went to dinner. On a hunch I chased a weak rainbow I had seen hovering just above the horizon. The end of a rainbow is set by one's own perspective, and I peeped along a dirt path to move toward where I wanted it. Forces beyond my control came to my aid to lengthen and brighten it against a black sky. A hole opened in the clouds, setting sunbeams on one spot, the Potala Palace. The rainbow rose magically from the golden rooftops of this summer of Buddhism as if some power in the palace were its source.

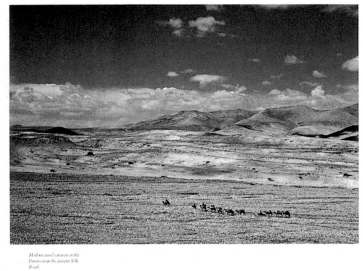

Modern camel caravan in the Pamirs near the ancient Silk Road.

2

76

Chapter 1: The Father of Adventure Travel

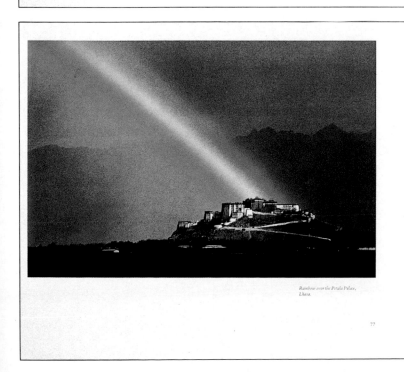

Rainbow over the Potala Palace, Lhasa.

HE WAS EIGHTEEN THAT SUMMER, crossing the Pamir steppes in a caravan. His father and uncle were traders on their second journey to China, traveling through a no-man's-land between Muscovy and Imperial China. The youth had no concept of being an explorer. Indeed, their strings of camels plodded along a monotonous track. He had been on the trail for the better part of two years, a considerable portion of his formative years. Brief flurries of camp activity punctuated the monotony of constant travel as he passed into manhood on the back of a camel.

The youth kept a journal with detailed notes on his travels. The pastures that he knew in Europe were artificial sports cleared of rock and scrub. Here they spread for miles, flat as lakes, green as spring leaves, and no less natural. Such valleys had given the surrounding mountains their name. He wrote, "This plain, whose name is Pamir, extends fully twelve days' journey. In all these twelve days there is no habitation or shelter, but travelers must take their provisions with them. . . . Because of the height and cold . . . fire is not so bright here nor of the same colour as elsewhere, and food does not cook well."

When the caravan passed beneath a mountain wreathed with a dozen glaciers, the youth wrote, "This is said to be

the highest place in the world . . . a plain between two mountains with a lake from which flows a very fine river." Mustagh Ata, called the Father of Ice Mountains, rose from a landscape grand beyond human sense of scale. Here, sand dunes began two miles above the sea and climbed thousands of feet toward and the heavens, still not touching the eternal snows of the peaks. The youth described "the best pasturage in the world, "with grass so lush "that a lean beast will fatten to your heart's content in ten days." Here, "wild game of every sort abounds. There are great quantities of wild sheep of huge size. Their horns grow to as much as six palms in length."

As long as the youth could remember, his life had been tenuous. When he was six, his father had left for China to trade jewels, hoping to return a rich man. Years passed with no word; then his mother died. Even greater uncertainty came into his life at fifteen, when his father returned with an unquenchable sense of mission. China's ruler, the "Great Khan," wanted a hundred learned emissaries of Christianity to come to his kingdom "at the ends of the earth in an easternortheasterly direction." The Great Khan also wanted proof of the power of the faith in the form of oil from a lamp of eternal flame on Christ's tomb in Jerusalem. The youth was

77

3

The tall dark plume of ash, steam, and gas boiling up from the shattered cone of Mount St. Helens stood tall on the horizon as the high-flying U-2 spy plane arrived on the scene from California. The single-seat observation plane, dispatched from the National Aeronautics and Space Administration's Ames Research Center, was gathering samples of gas and dust in the stratosphere, measuring what the volcano was injecting into the earth's atmospheric circulation system.

The U-2, of course, is famous as the once secret spy plane that was shot down in 1956 over the Soviet Union with pilot Gary Powers at the controls. For the Mount St. Helens work, however, it and several other exotic craft had been fitted with seven experiments designed by scientists involved in NASA's Aerosol Climatic Effects (ACE) program at Ames. Their goal was to measure what aerosols, of what size and what chemistry, were being carried high into the stratosphere above the volcano.

But the experiments carried aboard the U-2 were only a small part of the work done in the air and on the ground to study the volcanic eruption. Indeed, the Mount St. Helens eruption was turning out to be the most thoroughly studied, best-documented volcanic event in history. Squads of scientists—using helicopters, airplanes, four-wheel-drive vehicles and long-range observing instruments—descended on southwestern Washington to set up shop and learn what they could about the mountain and its activities.

Seismologists, for example, were able to record a whole series of underground events that started with small earthquakes, developed into earthquake swarms, and then became harmonic tremors as magma moved into the mountain. Even as the mountain's seismic activity was accelerating, teams of field geologists were surrounding it with an array of new and sensitive seismometers. Thus, within months, as the eruptions continued, a team of seismologists at the University of Washington, in Seattle, became able to predict eruptions—even to within a few hours.

At the same time, other scientists were setting up infrared instruments around the steaming volcanic cone, taking readings on the mountain's changing heat patterns. These observations, however, did not prove to be as useful for making predictions. But

Right:
Computer-enhanced thermal infrared image—or thermograph—of Mount St. Helens just a day before the massive eruption of May 18, 1980. In the crater area, to the right, can be seen two thermal anomalies corresponding to the craters that formed during eruptive activity in March. Also visible are scattered hot spots throughout what was the dangerous bulge area. (Oregon Army National Guard image)

Below:
Computer-enhanced thermal infrared image taken at 5:52 A.M. on May 18, the day of the huge, cataclysmic eruption. The patterns of thermal activity appear to be the same as those seen in earlier thermographs, with no major new activity evident. Nonetheless, the massive eruption occurred only 2.6 hours later. (Oregon Army National Guard image. Digital enhancement by Geography Department, Oregon State University)

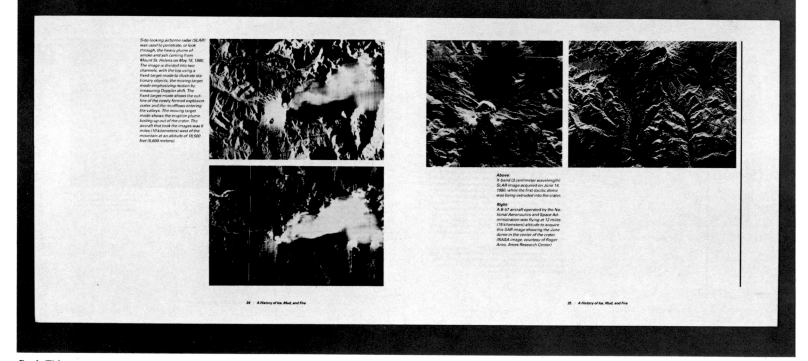

Side-looking airborne radar (SLAR) was used to penetrate, or look through, the heavy plume of smoke and ash coming from Mount St. Helens on May 18, 1980. The image is divided into two channels, with the top using a fixed-target mode to illustrate stationary objects, the moving target mode emphasizing motion by measuring Doppler shift. The fixed-target mode shows the outline of the newly formed explosion crater and the mudflows entering the valleys. The moving target mode shows the eruption plume boiling up out of the crater. The aircraft that took the images was 6 miles (10 kilometers) west of the mountain at an altitude of 18,500 feet (5,600 meters).

Above:
X-band (3 centimeter wavelength) SLAR image acquired on June 14, 1980, while the first dacitic dome was being extruded into the crater.

Right:
A B-57 aircraft operated by the National Aeronautics and Space Administration was flying at 12 miles (19 kilometers) altitude to acquire this SAR image showing the June dome in the center of the crater. (NASA image, courtesy of Roger Arno, Ames Research Center)

Book Title:
Earthfire
Authors:
Charles Rosenfeld
Robert Cooke
Editor:
Richard Ross
Designer:
Diane Jaroch
Cambridge, MA
Photographers:
Charles Rosenfeld
and others
Publisher:
The MIT Press
Typographer:
Graphic Composition
Printer:
Halliday Lithograph Co.,
Mark Burton, Inc.
Production Manager:
Dick Woelflein
Paper:
LOE Gloss #70
Binder:
Halliday Lithograph Co.
Jacket Designer:
Diane Jaroch
Photographer:
Charles Rosenfeld

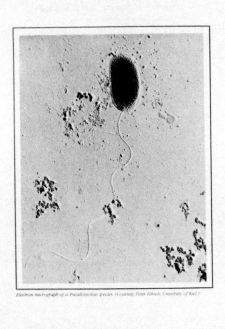

Electron micrograph of a Pseudomonas species. (Courtesy Peter Hirsch, University of Kiel.)

Background to the study of microbiology

SECTION ONE

chapter 1
Introduction to microbiology

chapter 2
Microbiological methods: pure culture and microscopic techniques

chapter 3
Introduction to biochemistry

Clinical microbiology: identification of disease-producing microorganisms and determination of antibiotic susceptibility

554
Clinical microbiology: identification of disease-producing microorganisms and determination of antibiotic susceptibility

Clinical microbiology and immunology laboratories are involved in determining the causes of disease and assisting the physician in selecting the appropriate treatment methods. A major task of a clinical laboratory is to determine whether a given disease condition is caused by a microbial infection, with the objective of documenting the presence or absence of infectious agents in samples collected from an ailing individual. If a disease is of microbial origin, the clinical laboratory has the responsibility of **identifying the causative microorganism (etiologic agent).** Further, the clinical laboratory is responsible for **assessing the effectiveness of antimicrobial agents** that may be selected for treatment of the infection. The clin-

ical microbiology laboratory applies the full scope of our basic understanding of microorganisms, the immune response, and the relationships between host and pathogen with regard to the disease process. Diagnostic methods include various types of microscopic observation, isolation, and culture methods for the identification of pathogenic microorganisms. Clinical identification schemes employ a variety of morphological, physiological, and biochemical features to provide accurate and timely identification of a variety of human pathogens. Immunological (in vivo) and serological (in vitro) antigen-antibody reactions are also employed for the detection and identification of various etiologic agents.

Indicators that diseases are of microbial etiology

The characteristics of the immune response system provide the basis for determining whether a disease is of probable microbial etiology. In most cases a microbial infection elicits an inflammatory response, characterized by fever, pain, swelling, and redness. Although an inflammatory response does not necessarily reflect an infectious disease, an elevated body temperature (fever) is often used as presumptive evidence of a microbial infection. The physician observing a patient with a red sore throat, and who is also running a fever, assumes that the symptoms are the result of a microbial infection. In many such cases, when the pre-

sumptive evidence strongly indicates pharyngitis (infection of the pharynx), treatment is administered without rigorous clinical diagnosis and confirmation of the cause.

Differential blood counts

In other cases, where the identification of a microbial infection is not clear-cut, additional presumptive evidence of an infectious process can be obtained by performing a differential blood count in which the relative concentrations of dif-

Plate 5
Various differential and selective media are used for the isolation of pathogenic microorganisms. The characteristic appearance of a pathogen on such media aids the clinical microbiologist in determining the causative organism. (A) Salmonella typhimurium on xylose-lysine desoxycholate agar (XLD), the black color of the colonies indicates hydrogen sulfide production. (B) Vibrio cholerae on TCBS agar, the yellow color indicates acid production. (C) Salmonella enteritidis on Hektoen agar, the black colonies indicate hydrogen sulfide production, the lack of yellow color around the colonies indicates that acid is not produced. (D) Klebsiella pneumoniae on MacConkey agar showing characteristic pink colonies.

Book Title:
Microbiology,
Fundamentals and
Applications
Author:
Ronald M. Atlas
Editors:
Gregory Payne
Robert Hunter
Art Director:
Andrew P. Zutis
Designer:
Ben Kann
New York, NY
Illustrator:
Vantage Art. Inc.
Publisher:
Macmillan Publishing Co.
Typographer:
Waldman Graphics, Inc.
Printer:
R.R. Donnelley & Sons
Co.
Production Manager:
Dubose McLane
Paper:
New Era Matte #45
Binder:
R.R. Donnelley & Sons
Co.
Jacket Designer:
Ben Kann

Book Title:
The American Weigh
Author:
Ruth K. Meyer
Editor:
Ruth Meyer
Art Director:
Chuck Byrne
Designers:
Chuck Byrne
Michael Overton
Karen Reed
Cincinnati. OH
Photographers:
Vince Leo
Kerry Schuss
Publisher:
The Taft Museum
Typographer:
Cobb Typesetting
Printer:
The Hennegan Co.
Paper:
Quintessence Gloss Cover
#100
Vintage Gloss Text #100

Watling 200

66½" x 13½"
Date of Manufacture: production started 1941
Watling Scale Co., Chicago

The advertisement further asserted that, "It is a proven psychological fact that the average person does not regard the penny as being very valuable. The average person will not hesitate to practically "throw away" a few pennies in any manner that a passing whim may dictate." In addition to this profligate attitude, the penny scale patron was also thought to be motivated by excess coinage in their pockets which was attributed to the new sales taxes. Because of the sales taxes, people were constantly receiving pennies with their change and more were being put into circulation as sales taxes were enacted in more and more states.

41

Peerless Artistocrat Deluxe

69" x 14½"
Patent: Mechanism Patent #1,638,524,
filed 9/23/21 & issued 8/9/27
Peerless Weighing Machine Co., Detroit

opportunity to watch their weight without visiting a doctor's office. Moreover, from their infancy these penny scales featured a mirror enabling the customer to check his or her appearance as well. Shortly, two types of scales were developed: the dial-type which showed the customer (and any onlooker) his correct weight, and the ticket-type which automatically printed the weight on a card, insuring privacy and offering the opportunity to convey an additional message. Character analysis and horoscopic predictions were clearly of interest to the weight-conscious patron; other bonuses were movie star portraits and advertising pitches.

25

Level

Calipers

Handsaw

Wood clamp

Book Title:
Tools
Author:
Ken Robbins
Editor:
Norma Jean Sawicki
Art Director:
Kathleen Westray
Designers:
Ken Robbins
Kathleen Westray
New York, NY
Photographer:
Ken Robbins
Publisher:
Four Winds Press
Typographer:
Southern New England
Typographic Service, Inc.
Printer:
Rae Publishing Co.
Production Manager:
Doris Barrett
Paper:
Glatco Matte #70
Binder:
A. Horowitz & Son
Jacket Designers:
Ken Robbins
Kathleen Westray
Jacket Photographer:
Ken Robbins

Book Title:
Scott Joplin & the Music
of Ragtime
Editor:
Glenn Goluska
Designer:
Glenn Goluska
Toronto. CAN
Publisher:
imprimerie dromadaire
Typographer:
Glenn Goluska
Printer:
Glenn Goluska
Paper:
Mohawk Letterpress Text
Binder:
Anne Goluska
Jacket Designer:
Glenn Goluska

Ragtime is absolutely characteristic of its inventors – from nowhere but the United States could such music have sprung ... Nor can there be any doubt about its vigour, brimming over with life ... Here for those with ears to hear are the seeds from which a national art may ultimately spring.

Rag time's days are numbered. We are sorry to think that anyone should imagine that ragtime was of the least musical importance. It was a popular wave in the wrong direction.

The London Times, 1900
Metronome Magazine, 1901

'Rag time' is a term applied to the peculiar, broken, rhythmic features of the popular 'coon song.' It has a powerfully stimulating effect, setting the nerves and muscles tingling with excitement. Its esthetic element is the same as that in the monotonous, recurring rhythmic chant of barbarous races. Unfortunately, the words to which it is allied are usually decidedly vulgar, so that its present great favor is somewhat to be deplored.

'Rag-time' is essentially a simple syncopation. The faculty for it must be acquired, much like a taste for caviar ... Another of its peculiarities is that its best exponents are generally execrable musicians.

Etude Magazine, 1898

Book Title:
William Morris:
The Ideal Book
Author:
William Morris
Editor:
William J. McClung
Art Director:
Steve Renick
Berkeley, CA
Designer:
William S. Peterson
Publisher:
The University of
California Press
Typographer:
Cottage Press
Cambridge University
Press
Printer:
Malloy Lithographing Co.
Production Coordinator:
Ellen Herman
Paper:
S.D. Warren Old Style
Wove #70
Binder:
John H. Dekker & Sons
Case Designer:
Steve Renick

tro faceuano grande infift

che erano gente dipregio.

oldo. Tucti questi faccend

er lalunga mosseno esiore

aggiote sforzo italmanier

techati &fossi inpiu luog

otessi ne uscire ne étrare.I

alle man fra lemura della

sifaceuano apistoia: Papa

decto nelpontificato p il

3 Leonardus Brunus Aretinus, *Historia Florentina* (Venice: Jacobus Rubeus, 1476), fol. H6ᵛ; a photographic enlargement of a portion of the page, made by Emery Walker for Morris. This was Morris's chief model for the Golden type. *Courtesy of the St. Bride Printing Library.*

4 From a scrapbook compiled by Sydney Cockerell (British Library, shelf-mark C.102.h.18). The two panels above show Morris's early attempts to design the Golden type, based on the Jenson–Rubeus model. The instructions by Morris for the modification of the *h* are addressed to Edward P. Prince, who engraved all of the Kelmscott Press types. *Courtesy of the British Library.*

Woodcuts of
Gothic Books
in 1500, decidedly leans towards the French in style, rather than the native manner deduced from the earlier block-books.

France began both printing and book illustration somewhat late, most of its important illustrated works belonging to a period between the years 1485 and 1520; but she grasped the art of book decoration with a firmness and completeness very characteristic of French genius; and, also, she carried on the Gothic manner later than any other nation. For decorative qualities, nothing can excel the French books, and many of the picture-cuts, besides their decorative merits, have an additional interest in the romantic quality which they introduce: they all look as if they might be illustrations to the *Morte D'Arthur* or *Tristram.*

In Italy, from about 1480 onward, book illustrations became common, going hand-in-hand with the degradation of printing, as I said before. The two great schools in Italy are those of Florence and Venice. I think it must be said that, on the whole, the former city bore away the bell from Venice, in spite of the famous Aldine *Polyphilus,* the cuts in which, by the way, are very unequal. There are a good many book illustrations published in Italy, I should mention, like those to Ulric Han's *Meditations of Turrecremata,* which are purely German in style; which is only to be expected from the fact of the early printers in Italy being mostly Germans.

I am sorry to have to say it, but England cannot be said to have a school of Gothic book illustration; the cuts in our early printed books are, at the best, French or Flemish blocks pretty well copied; at the worst, they are very badly copied. This lamentable fact is curious, considered along with what is also a fact: that in the thirteenth and fourteenth centuries the English were, on the whole, the best book decorators.

I have a few more words to say yet on the practical lessons to be derived from the study of these works of art; but before I say them, I will show you, by your leave, the slides taken from examples of these woodcuts. Only I must tell you first, what doubtless many of you know, that these old blocks were not produced by the graver on the end section of a piece of fine-grained wood (box now invariably), but by the knife on the plank section of pear-tree or similar wood – a much more difficult feat when the cuts were fine, as, *e.g.,* in Lützelburger's marvellous cuts of the *Dance of Death.*

[*Mr. Morris then showed a series of lantern slides, which he described as follows: –*]

30

13 *La Mer des Histoires* (Paris: Pierre Le Rouge for Vincent Commin, 1488–89), 1, fol. A1ʳ. Size of original: 371 × 254 mm. Morris owned a copy of this book.

Book Title:
Renard the Fox
Author:
Patricia Terry
Editor:
Deborah Kops
Art Director:
Ann Twombly
Designer:
David Ford
Illustrators:
Various
Publisher:
Northeastern University
Press
Typographer:
Eastern Typesetting Co.
Printer:
The Murray Printing Co.
Production Manager:
Ann Twombly
Paper:
Glatfelter Writer's Offset
#60
Binder:
The Murray Printing Co.
Jacket Designer:
David Ford
Jacket Illustrator:
Unknown

Renard the Fox

Translated from the Old French
by Patricia Terry

1983 Northeastern University Press / Boston

Book Title:
I Mean, You Know
Author:
Warren Lehrer
Art Director:
Warren Lehrer
Designer:
Warren Lehrer
Bayside, NY
Illustrator:
Warren Lehrer
Letterer:
Jan Baker
Publisher:
Ear-Say/
Visual Studies Workshop
Typographer:
Warren Lehrer
Printer:
Visual Studies Workshop
Production Manager:
Joan Lyons
Paper:
Mohawk Superfine
Binder:
Riverside Bindery
Jacket Designer:
Warren Lehrer
Jacket Illustrator:
Warren Lehrer

BRANCH Va

Renard and Ysengrin the Wolf

(continued)

Then, as if drunk right out of his mind,·
He kicked her. "Do you think I'm blind,
You vile, stinking, shameless whore—
260 You got what you were asking for!
I saw Renard as he straddled your tail
To cuckold me, and he did not fail!
Now will you say you're innocent?"
Hearing his angry words, Hersent
In her fury nearly lost her head,
But she replied with the truth instead:
"My lord, there's no doubt that I've been shamed,
But I've also been unjustly blamed.
Hear me out and you'll realize
270 That Renard took me by surprise
Against my will. But what's done is done.
It will do no good to anyone
If we just stay here quarreling,
Let's bring our grievance to the king!
That is what Noble's court is for—
Whatever might be cause for war,
Disputes and claims get a hearing there,
And the lion's judgment will be fair.
If we go to him and state our case
280 He will put an end to our disgrace—
You'll meet Renard on the jousting field."·
Ysengrin's anger had to yield

64

Branch Va [RENARD THE FOX

When Hersent explained how she was caught.
"What a fool I was," he said, "to have thought
As I did! But now I've seen the light;
What you advise is surely right.
Renard will pay dearly for his sport
If I can bring him to Noble's court."
 They saw no reason to delay,
290 And stopped for nothing all the way
To King Noble's court where Ysengrin
Was sure of the vengeance he would win
If he could bring his foe to trial:
Renard the Red, despite his guile,
Would find that it was not a joke.
Lord Ysengrin, after all, spoke
Several languages; he presided
As marshal where the king resided.·
Now they had reached the very place
300 Where they hoped the king would hear their case.

65

angelica continues
she has the floor
from high
upon her ladder

that they had buried
my mother's wicked
sinful cousin
on top of my grandma
so
she called
all the family together
and she told em they got to get him up from there

so
i had to be the first one
to open my mouth
i'm always gett'n myself in trouble
i mean they think
that come judgement day when the first trumpet is blown

and all of the dead in christ is supposed to rise up
out of their graves
my grandma
couldn't get up
unless they first wake up james
who was the wicked one
so i said
well ma
you know
when grandma died
and the preacher
was preachin the sermon
you know
he said
the spirit of the lord
had come into the room
where grandma was
and took her up to heaven
now
she's up there
in a righteous place
why she want to come back down here for?
and then
go back down into the ground!
into the earth!
and then
rise on up again!
you know

BALL

"Coccyx, thoracic, lumbar, pelvic, sacrum, ischial tuberosities" may sound chilling but together they translate into the award winning Ball Collection, designed and engineered to meet a dynamic situation—

sitting."

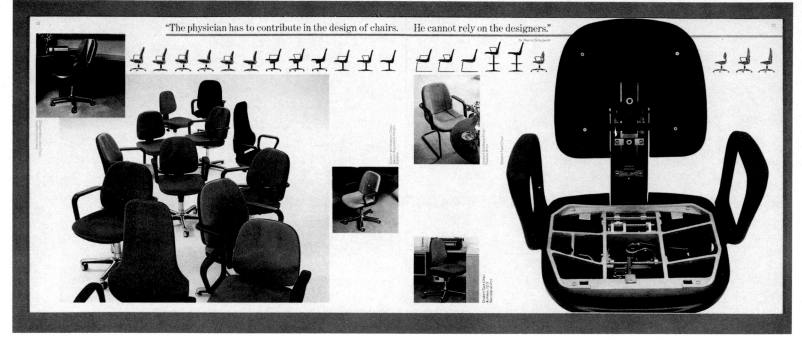

"The physician has to contribute in the design of chairs. He cannot rely on the designers."

Book Title:
Sunar '83
Author:
Christine Rae
Editor:
Christine Rae
Art Director:
Bill Bonnell
Designer:
Bill Bonnell
New York, NY
Photographers:
Various
Publisher:
SunarHauserman
Typographer:
Typogram
Printer:
Dai Nippon Printing Co.,
Ltd.
Paper:
Dai Nippon Printing Co.,
Ltd.
Binder:
Dai Nippon Printing Co.,
Ltd.

QUINTESSENCE
THE QUALITY OF HAVING *IT*

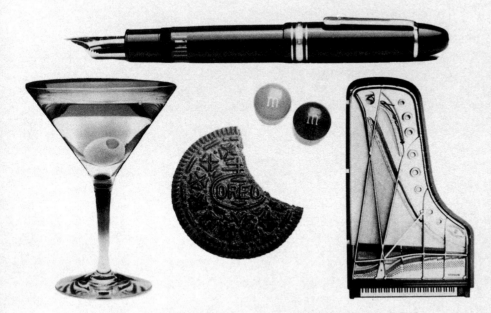

BY BETTY CORNFELD AND OWEN EDWARDS
DESIGN BY JOHN C. JAY

Book Title:
Quintessence: The Quali
of Having It
Authors:
Betty Cornfeld,
Owen Edwards
Editor:
Pamela Thomas
Art Director:
James K. Davis
Designer:
John C. Jay
New York, NY
Photographer:
Dan Kozan
Publisher:
Crown Publishers, Inc.
Typographer:
Adroit Graphic
Composition, Inc.
Printer:
Kingsport Press
Production Manager:
Teresa Nicholas
Paper:
S.D. Warren's Flokote
Binder:
Kingsport Press
Jacket Designer:
John C. Jay
Jacket Photographers:
Dan Kozan,
David Langley

Camel Cigarettes

Being a smoker used to mean never having to say you were sorry. Smoking was not only *done* but it was done with real style. Nobody ever pretended it was good for you, but to smoke with grace and elegance was a sign of a virtue that counted for more than mere clean living. In fact, smoking a real cigarette gave any man, woman, and the occasional red-faced, gasping adolescent several chances daily to exhibit, quite literally, grace under fire. If you could fill your lungs with the sort of substance that could kill a 200-pound fireman and at the same time tap off an ash with a gesture befitting a Balinese dancer, you had

come a long way, baby, toward joining the inestimably grown-up.

In those days of forthright smoking, cigarettes didn't apologize, either. They didn't hide their elemental natures under names like Merit, True, Vantage, even (for God's sake) Satin. There were giants in the ashtray then: Pall Malls, Chesterfields, Lucky Strikes (stunning in green and gold). Best of all there were—and still are—Camels, the

powerful, pungent, basic smokes that are America's answer to such classic weeds as Balkan Sobranies and Galoises. Since they were first introduced by R.J. Reynolds in 1913, Camels have been the true smoker's cigarette. Untainted by menthol, undistorted by needless extra centimeters, Camels have entered the age of interchangeable cigarettes and boutique smoking with their integrity intact. And so has the Camel pack, a wonderful pocket-sized evocation of the exotic Middle East whose design closely resembles—except for the placement of the palm trees and the pyramid—an 1820 etching by a French artist named de Sèvres. At its best, smoking ought to imply worldliness and at least the possibility of romance; the Camel pack does the job without so much as an inhale. And the unfiltered cigarette lets you do the things a smoker ought to—from tamping down the loose shreds of tobacco (deftly, six times, on a thumbnail) to discreetly picking that one errant bit off the tip of the tongue. Camel, we light up your leaf.

CLASS GASTROPODA
Snails

There are many kinds of land snails (Figs. 26-5 and 26-6). The imported European snail (*Helix*) is a typical one. The well-developed head has two pairs of retractile, sensory tentacles and a pair of light-sensitive eyes on the hollow, longer tentacles. A muscular foot is attached to the head and is supplied with mucous glands to assist in locomotion. The internal organs (visceral mass) form a hump surrounded by a mantle, which secretes the external, coiled shell. A muscle can pull the body within the shell.

The digestive system consists of (1) a mouth, (2) a pharynx with a radula of chitinous teeth for rasping green vegetation, (3) an esophagus, (4) a thin-walled crop, (5) a stomach, (6) a long, coiled intestine, and (7) an anus, located in the margin of the mantle at the edge of the shell. A pair of salivary glands pours their secretions into the pharynx to assist in the digestive process. A large liver, high up in the spiral shell, pours its secretions into the stomach. Since *Helix* is a land snail, it has a membranous lung, well supplied with blood vessels (veins) to aerate the blood. Air is drawn into and forced out of the lungs through the respiratory pore, which is located in the

margin of the mantle at the edge of the shell. The circulatory system consists of one heart (one auricle and one ventricle), arteries to carry blood to various organs, and veins to return blood. The excretory system consists of a kidney (nephridium) to secrete wastes that are carried by a tubular ureter to the mantle cavity.

The nervous system consists of a concentration of ganglia (cerebral, buccal, pedal, and visceral) that encircle the pharyngeal region and nerves leading to various organs. Sensory organs include light-sensitive eyes, olfactory organs on the tentacles, chemical and tactile (touch) organs on the head and foot, and a pair of statocysts (Gr. *statos*, stationary; *kystis*, sac) near the pedal ganglia for equilibrium.

Helix is monecious, but cross-fertilization is com-

FIGURE 26-5 Snail (*Helix pomatia*). The roof of the pulmonary sac is cut and turned to the right, the pericardium and visceral sac are opened, and the internal organs (viscera) are somewhat separated. The finger gland is also called the mucous gland.

FIGURE 26-6 A, Freshwater snail (*Lymnaea*); **B,** land snail (*Humboldtiana*). Bodies are expanded from the shell. (From Potter, G.E.: Textbook of zoology, ed. 2, St. Louis, The C.V. Mosby Co.)

Book Title:
General Biology
Author:
George B. Noland
Editor:
Diane L. Bowen
Art Director:
Kay Michael Kramer
Designer:
Diane M. Beasley
St. Louis, MO
Publisher:
The C. V. Mosby Co.
Typographer:
Typographic Sales, Inc.
Printer:
Von Hoffmann Press, Inc.
Production Manager:
Jerry Wood
Paper:
New Era Matte #45
Binder:
Von Hoffman Press
Jacket Designer:
Diane M. Beasley
Jacket Photographer:
Rick Vanderpool; The
Ware St. Design Group

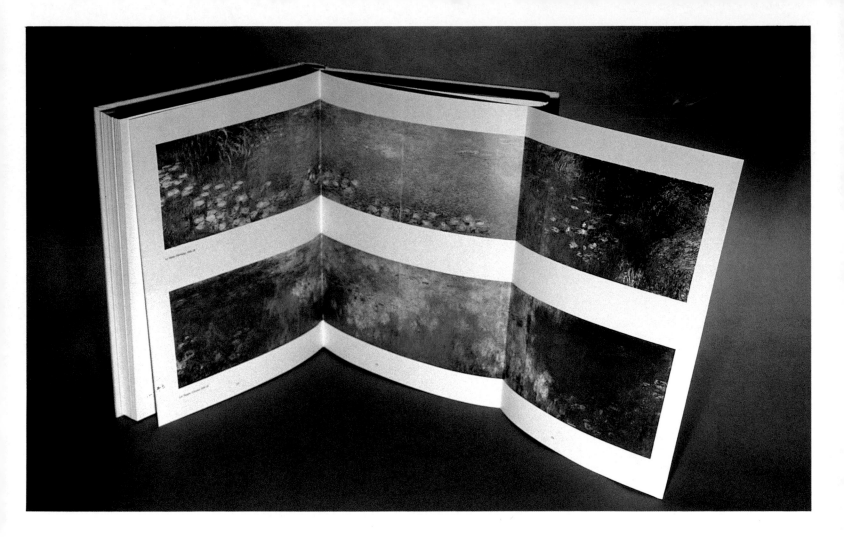

Le Pont Routier, Argenteuil
(The Bridge at Argenteuil), 1874

*The two paintings opposite, and one of the bar
bor at night, were painted from Monet's hotel
window in Le Havre in 1872. Impression, Soleil
Levant was one of the twelve works—seven
were pastel sketches—that Monet contributed to
the first exhibition of the group later to be
known as the Impressionists. It was because of a
facetious reference to this painting by the critic
Louis Leroy that the name Impressionist gained
currency. Years later, looking back on that first
independent exhibition, Monet told Maurice
Guillemot:*
Landscape is nothing but an impression, and
an instantaneous one, hence this label that was
given us, by the way because of me. I had sent
a thing done in Le Havre, from my window,
sun in the mist and a few masts of boats stick-
ing up in the foreground....They asked me for
a title for the catalogue, it couldn't really be
taken for a view of Le Havre, and I said, 'Put
Impression.' From that came Impressionism,
and the jokes blossomed....As for me, I gained
as much success as I could have wished, which
means I was energetically hooted at by all the
critics of the time.

If an assemblage of trees, mountains, water, and houses such as we call a landscape

paintings survive from the decade preceding Monet's arrival at Argenteuil. For
the six years he was there, there are listed two hundred and sixty. The
Impressionist language had given him a power over appearances, over all
appearances, as though he had found in it a wide-open channel through which
the commanding current of his eye could flow with total freedom. One can well
imagine how for a short while the "objectivity" of Impressionist vision must
have appeared to writers like Zola the crowning phase of the Realist project—
a vision without parti pris, competent, for the first time in painting, to survey
human life in its context, the world of man as a continuous extended
phenomenon. It was of course an illusion, like any theory of objectivity in art.
But the Argenteuil years remind us of Zola's ambition. Two kinds of subject
claimed Monet's attention there: the world outside, and the world of his
family—Argenteuil, on the fringe between the metropolis and the unchanging
countryside, the river with its yachts and bridges, its factories and tree-lined
towpaths; and the enclosed garden or nearby meadows as the habitat of
Camille and Jean. Modernity impinges on Argenteuil. Camille's world is
Cythera.

Once Monet had given up trying to make his name with large figure com-
positions, people played a less and less important part in his pictures. He gave
himself over to landscape and to the light of open air.

What did—or could—a landscape without figures, and painted in a spirit of
objectivity, mean? The question had been in the air for some time. Baudelaire
had voiced it in his review of the Salon of 1859:

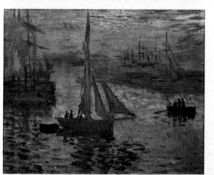

above: Impression, Soleil Levant (Impression, Sunrise), 1873

below: Soleil Levant, Marine (Sunrise, Seascape) 1873

Book Title:
Monet
Authors:
Robert Gordon,
Andrew Forge
Editor:
Robert Morton
Art Director:
Samuel N. Antupit
Designer:
Tina Davis Snyder
New York, NY
Artist:
Claude Monet
Publisher:
Harry N. Abrams, Inc.
Typographer:
Concept Typographic
Services, Inc.
Printer:
Nissha Printing Co., Ltd.
Production Manager:
Shun'ichi Yammamoto
Paper:
Fukiage Matte Coated:
157 GM2
Binder:
Taikansha
Jacket Designer:
Tina Davis Snyder

Book Title:
American Design Ethic
Author:
Arthur J. Pulos
Editor:
Paul Bethge
Designer:
Diane Jaroch
Cambridge. MA
Photographers:
Various
Publisher:
The MIT Press
Typographer:
Village Typographers
Printer:
Halliday Lithograph Co.
Production Manager:
Dick Woelflein
Paper:
LOE Dull #70
Binder:
Halliday Lithograph Co.
Jacket Designer:
Diane Jaroch
Photographers:
Various

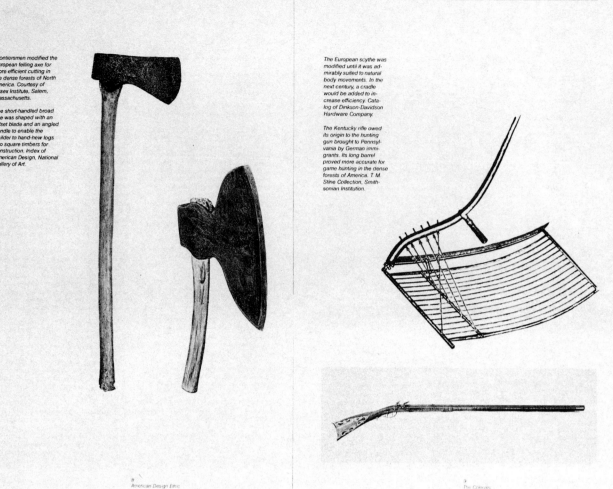

Frontiersmen modified the European felling axe for more efficient cutting in the dense forests of North America. Courtesy of Essex Institute, Salem, Massachusetts.

The short-handled broad axe was shaped with an offset blade and an angled handle to enable the builder to hand-hew logs into square timbers for construction. Index of American Design, National Gallery of Art.

The European scythe was modified until it was admirably suited to natural body movements. In the next century, a cradle would be added to increase efficiency. Catalog of Denkson-Davidson Hardware Company.

The Kentucky rifle owed its origin to the hunting gun brought to Pennsylvania by German immigrants. Its long barrel proved more accurate for game hunting in the dense forests of America. T. M. Stine Collection, Smithsonian Institution.

8
American Design Ethic

9
The Colonies

modern European craftsmen were stressing "functionalist design," defined as design determined by the process of manufacture and end function. "The results," Avery wrote, "are often severe and uncompromising, but in their very insistence they gain their point. People numbed by seeing nothing but conventional patterns, used to superfluous and stupid ornamentation, can perhaps be roused from this apathy only by the strong medicine of German and Scandinavian expression." (153, 263) Richards wrote: "It is the Germans who carried this idea farthest. With characteristic zeal, they are concentrating upon the effort to produce 'type forms' in which both the limitations and capabilities of the machine are recognized and which can be produced with the greatest speed and economy." (195, 609)

A year later, the Metropolitan staged the twelfth American industrial art exhibition in the series that had begun in 1917. The show had now broadened its scope to include what some now called the art-less" industries (major and minor manufactured appliances). Its primary purpose was stated as intending to trace the effect of the 11th exhibition of 1929, whose interiors and furnishings had been custom-designed by architects. Of course, the practice of designing for manufacture was already well established outside the sphere of influence of museums. Nevertheless, acting in their self-anointed role of preachers of taste, museums had demonstrated their power to canonize an aesthetic movement or a style. Over the years since the exhibitions began, the sacred relics of tradition had been converted to Art Moderne, lost to the purgatory of modernistic, and then elevated to modern, and now R. F. Bach proposed that the new religion of design should be baptized as *contemporary*. Hence the exhibition was given the new title of Contemporary American Industrial Art. Henry Dreyfuss concurred: ". . . good modern design does not have to be 'modernistic'. ('Modernistic' is rightly used to describe the odd-looking objects thrown together to look extreme and outlandish, while the word modern or 'contemporary' denotes the spirit of today interpreted in good taste.)" (126, 192)

Still, museums were as reluctant then as they are today to recognize mass-manufactured products on their own terms against their own environments. It was believed that to be evaluated properly such products had to be viewed "without the insistence and limitation of salesroom and counter, without the interference of captious customers, without reliance upon advertising and selling talk." (154, 226)

The secular world, however, saw the exhibition in a different light. *Business Week* magazine found it a sharp contrast to what it called the "gaudy" 1929 exhibit, and welcomed the attention to products "designed by Americans, made by repetitive processes or machines" away from the "exhuberance and easy money" of the past. (119, 22) And a *New York Times* editorial recognized that the exhibition held "encouraging promise to those who, while cherishing the past, watch for new combinations of usefulness and beauty." (190)

Whereas the industrial arts had been promoted in the 1920s as a means of achieving status by way of manufactured luxuries, industrial design was more concerned in the 1930s with making common necessities attractive to the general public. The Great Depression of 1929–1935 may have provided the catalyst Americans needed in order to recognize that there was beauty and a natural elegance to be found in vernacular products. It became evident that domestic appliances and business and industrial machines could be sold if they were endowed with good proportions, fresh colors, and modern detailing. Then in 1932, during the brief period when prices were stabilized under the National Recovery Act, manufacturers recognized that, quality and price being equal, a product's appearance became paramount in attracting the buying consumer. New models of old products as well as completely new products provided the stimulus that helped the economy turn upward again. In this respect, Norman Bel Geddes may have been uniquely instrumental in stimulating public aspirations for a better future. His book *Horizons* proposed a future of hope and progress with design as the great liberator, and his bold prophecies in a 1932

The symbol displayed by companies cooperating with the short-lived National Recovery Administration. Author's collection.

issue of *Ladies' Home Journal* reflected the optimism and vision of the twentieth-century entrepreneurs. He foresaw a time when, among other things, a new fuel of vastly improved power but infinitesimal bulk would replace gasoline, synthetic materials and curtain walls would dominate buildings, photoelectric cells would open doors, and the garage would move in to face the street and become part of the house. He was convinced that artists would be "thinking in terms of the industrial problems of their age," and that utilitarian objects would be "as beautiful as what we call today 'works of art.'" (140, 3)

In 1933, with the country still in economic trouble, the Century of Progress Exposition opened in Chicago. It was a neon, krypton, and xenon celebration, with lineal decorative lighting provided when tubes containing these rare gases were energized. For the first time industrial designers were provided with the unique opportunity to meet the challenges of design for the larger man-made environment. Norman Bel Geddes, who had served since 1928 as a consultant on lighting to the Architectural Commission for the Fair, had developed, with his associates, a series of innovative theater and restaurant concepts — including the first proposal for a revolving restaurant perched on a high tower, a feature that has become almost mandatory for high-rise hotels and television towers. Although Bel Geddes's imaginative suggestions ended up as casualties of the Depression (perhaps because of the architects' reluctance to accept suggestions from a nonarchitect), they broke dramatic new ground by suggesting that theatrical settings and the real world could be joined in an exciting human experience. For many visitors the Century of Progress Exposition offered a dream world where one could escape the austerity of a troubled time by living for a few hours in the future.

Other designers whose recommendations contributed to the fair included Joseph Urban, who provided a palette of harmonious colors for the buildings; John Vassos, who designed the unique and now classic Perey turnstiles; and Wolfgang Hoffman, Jean Reinecke, Gilbert Rohde, Eugene

346
American Design Ethic

347
The Design Decade

Book Title:
A Field Guide to Stars
and Planets
Authors:
Donald H. Menzel
Jay M. Pasachoff
Editors:
Henry Foster
Barbara Stratton
Designer:
Copenhaver Cumpston
Publisher:
Houghton Mifflin Co.
Typographer:
York Graphic Services
Printer:
Halliday Lithograph Co.
Production Coordinator:
Brenda Lewis
Paper:
Glatfelter Old Forge
Enamel #70
Binder:
Halliday Lithograph Co.
Jacket Designer:
Robert Anthony
Photographer:
Royal Observatory.
Edinburgh

ATLAS CHART 1. Bubble Nebula, Tycho's Supernova
The Milky Way in Cassiopeia, with its rich fields of clouds, gas and dust, and star clusters, is an interesting area to scan with low-power telescopes or binoculars. Several open clusters are easy to find because they lie close to bright stars. NGC 457 is an especially bright open cluster in the same field of view as φ (phi) Cas, which lies southwest of δ (delta) Cas in the W of Cassiopeia. Even a small telescope gives a good view of the stars in this cluster; more stars are visible with telescopes of higher power. Close by is the open cluster NGC 436. Since binoculars or telescopes with small apertures show only a few stars here, NGC 436 is more suitable for viewing with larger telescopes. M103 (NGC 581) is a fan-shaped, 7th-magnitude cluster (C.Pl. 29) located northeast of δ (delta) Cas.

About 5° northwest of β (beta) Cas, near the border of Cepheus, is M52 (NGC 7654), a rich, 7th-magnitude open cluster. Close to M52 is the Bubble Nebula, NGC 7635, which has a high total brightness even though it is spread over so much sky that its average surface brightness is low. Southwest of β (beta) Cas, about halfway between ρ (rho) and σ (sigma) Cas, is the open cluster NGC 7789. Its diameter is about the same as the moon's. You can detect this cluster with binoculars, and telescopes resolve many of its 1,000 stars.

Northeast of β (beta) Cas is κ (kappa) Cas, with the two open clusters NGC 133 and NGC 146 nearby. NGC 146 has about 50 stars within a 6 arc min diameter; this cluster should be viewed with high power because of the richness of the Milky Way in this part of the sky.

Tycho's Supernova of 1572 appeared slightly to the northwest of NGC 146, growing so bright that it was visible to the naked eye for about six months. Since the appearance of a new star showed that the sky changed, contrary to the Ptolemaic theory, this object was important for the acceptance of Copernicus' heliocentric theory. The remnant of the supernova is now only faintly visible with large telescopes, appearing as thin filaments that form an incomplete ring 8 arc minutes across. Radio telescopes, however, detect strong signals.

Fig. 43. The Bubble Nebula (NGC 7635) in Cassiopeia. (Lick Observatory photo)

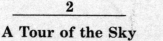

constellations that are visible from the southern hemisphere as well as the ones that can be seen from the northern hemisphere. However, since most users of this guide are at midnorthern latitudes, much of the following discussion is designed for them.

The region of the sky near Polaris, the North Star, is visible from midnorthern latitudes all through the year. In this region you can easily see the Big Dipper, the asterism that makes up part of the constellation Ursa Major, the Big Bear. In the autumn evening sky, the bowl of the Big Dipper appears right-side-up, while in the evening sky in the spring, the bowl appears upside-down. Figure 6 shows the Big Bear, including the Big Dipper, from the celestial atlas Johannes Hevelius published in 1690.

On the front side of the bowl of the Dipper, the Pointers point to Polaris, which lies at the end of the handle of the Little Dipper. To find Polaris, follow a line that extends north from the Pointers for about 30°. Thirty degrees is ⅓ of the distance between the horizon and the zenith. Extend your arm upward from horizontal ⅓ of the way toward the zenith to get an idea of 30°. (Also, 30° is about

2

A Tour of the Sky

The sun dominates the daytime sky. Sunlight scatters throughout the atmosphere, making the sky blue. This blue sky is brighter than the stars behind it, so we cannot usually see the stars during the daytime. When the sky is clear enough, the moon can often be seen in the daytime, especially if you know where to look. Chapter 8 discusses the phases of the moon and where to find the moon in the sky.

Shortly before sunset or just after sunrise, the sky becomes dark enough for us to see the brightest planets and stars. Venus is the brightest of these objects and is sometimes bright enough to cast noticeable shadows. If you see an exceedingly bright object in the west at or after sunset — the "evening star" — it is usually Venus. If you see an exceedingly bright object in the east before or at sunrise — the "morning star" — it is also usually Venus. A second bright object in the sky, usually even closer to the sun, may be Mercury.

Jupiter, Mars, and Saturn can also be prominent in the sky, and can be quite far from the sun, so planets visible late at night are from this trio. Mars' reddish tinge is subtle, yet not hard to notice even with the naked eye. Saturn's rings are noticeable with a small telescope but are not visible to the naked eye. Jupiter's moons, belts, and Great Red Spot also require a small telescope to be seen. To tell at a glance which planets are visible in the sky on your night of observation, you can use one of the Graphic Timetables in Chapter 9. The characteristics that will help you distinguish the planets from the bright stars nearby are described in Chapter 1.

Beyond the Solar System

As the sky darkens, the brightest stars become visible. In a city, only a few dozen stars may become visible because the sky remains very bright even at night. But far from the haze of pollution and the competing glimmer of city lights, about 3000 stars may be visible to the naked eye. An equal number of stars are hidden beyond the horizon and most can be viewed by waiting through the night or for a different time of year. The rest of the stars become visible only to observers closer to the equator or in the hemisphere opposite to that from which you are observing. The Atlas Charts and descriptions in Chapter 7 show the entire sky — the stars and

Fig. 6. Ursa Major, the Big Bear, from the star atlas of Hevelius (1690). The handle of the Big Dipper is in the Bear's tail, and the bowl is in its back. The constellation is drawn backwards from the way it appears in the sky because Hevelius drew the celestial sphere as it would appear on a star globe seen from the outside.

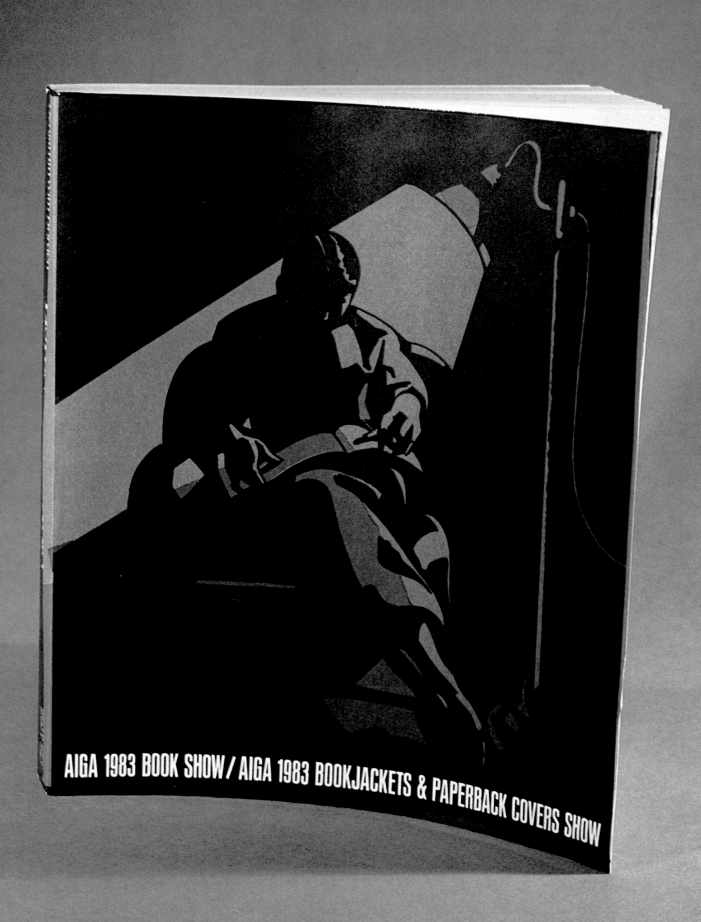

AIGA 1983 BOOK SHOW / AIGA 1983 BOOKJACKETS & PAPERBACK COVERS SHOW

This inaugural show celebrates individuality,
rather than any significant directions or trends.
If a consensus emerged during the judging, it
is that the bookjacket is an enigma.

Chairman
Milton Glaser
President
Milton Glaser, Inc.

Jury
Paul Bacon
Designer
Paul Bacon Studio

Cheryl Lewin
Designer
Cheryl Lewin Design

Wendell Minor
Designer
Wendell Minor Design

J.C. Suarès
Designer

One cannot always judge a good book by its cover—which is why dust jackets and paperback covers are considered separately from interiors. Logic and fairness are best served by this policy, because more often than not, the two forms are worked on by different designers—sometimes with discordant styles. Regardless, the question of how and where to celebrate jackets and covers has always been an issue for debate. Traditionally, they have been included in the Cover Show, along with other visual selling tools for records, magazines, etc. This year, the book cover secessionists prevailed, and created a separate category with its own judging panel—under the Book Show umbrella, where it naturally belongs.

Although the new policy has not resulted in substantially increased submissions, the number included in the show this year did grow considerably—from 12 previously to 45. Having more pieces included affords us the opportunity to view the form as an entity. As it turns out, this inaugural show celebrates individuality rather than any significant directions or trends.

The selection process was as difficult as the approaches to the form are varied. The qualitative range is so broad that no single criterion appeared to govern the process. Although at times during the judging, an enigmatic question was raised—Does it sell or does it further the cause of graphic design? —choices were made according to variegated personal responses. As a whole, the jury was well rounded, including those naturally predisposed toward the classical, as well as proponents of experimentation. All in all, the judges were catholic in their tastes—both subtly elegant and tumultuously exuberant approaches are represented. However, as one jury member stated: "A lot of good covers were passed over simply because they were not *innovative*."

That heavy weight of innovation, though, was only one measure on the scale, for as juror Wendell Minor pointed out: "We often voted positively on something that was typographically flawed, simply because it was too evocative or compelling to overlook." The purism of the past was decidedly eschewed, as evidenced by the comparatively large number of dissonant designs accepted, in which striking illustrations or compelling photographs transcended obvious design

mistakes, or where apparently awkward, if not gawdy, type executions were arrestingly effective.

While the more unorthodox covers herein may derive from New Wave or post modernist aesthetics, neither approach is overwhelmingly represented, nor does any other school emerge. Of those selected, no single individual is setting a universal standard. Technologically, there are no inventions. There are some striking wraparounds included, such as "The Rolling Stones"; there also appears to be a preference for matte or matte laminated jacket and cover stocks, when the marketing people allow them to be used. While this was the year of the novelty book, there were no novelties selected.

Invariably, there was prejudice against the mass-market paperback, made clear by the absence of all but one example. "And in that case we bent over backwards," says Minor, "since it was the most tasteful, if not surprising, use of the too-pervasive blind embossing process." While exclusion of this publishing mainstay limits the scope of the survey, it is commonly felt that, while a lone cover may be an exception, the nature of mass-market publishing forces overdesign. No doubt, in contrast, the handsome *Aventura* series is celebrated because of the designer's ability to deal intelligently with a mass market format. Also absent are examples of the big commercial novels, where the large type and small image are the keys. Perhaps the formula is too predictable, or possibly jacket designs for the so-called "intellectual novels" have been more surprising in recent years.

If a consensus emerged during the judging of this show, it is that the bookjacket is an enigma. In spite of this, certain questions are left unanswered: When and why are covers successful? Are the sales a primary concern or is the publisher's *image* most important? While some publishers eschew the hardsell, others rely on it, and designers must solve both problems. In order to truly survey the year's best, both aspects must be considered. With this in mind, Minor offers a rule of thumb: "If the overall assemblage of graphics and concept makes you want to pick up the book, then the package is a success. Isn't that what *this* form of graphic design is all about?"

Paperback Cover:
Before I Get Old
Art Director:
Andy Carpenter
Designer:
I.G.C. Graphics
New York, NY
Illustrator:
Izumi Inoue
Publisher:
St. Martin's Press
Letterer:
Izumi Inoue
Printer:
The Longacre Press

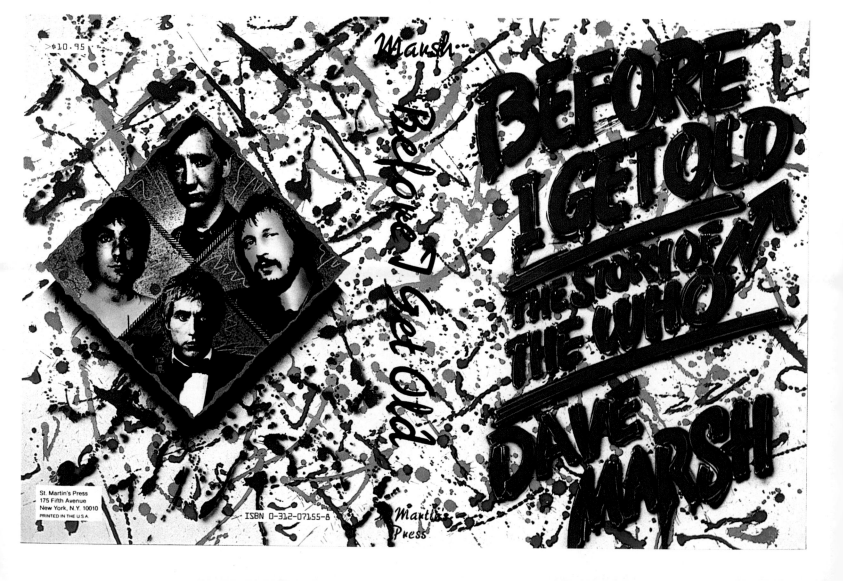

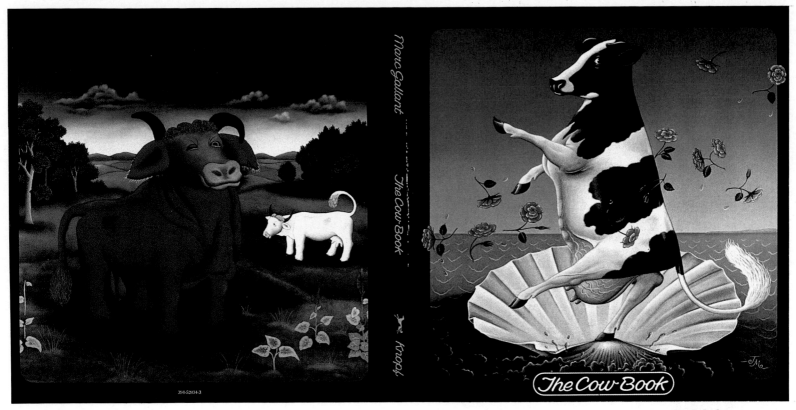

Book Jacket:
The Cow Book
Art Director:
Marc Gallant
Designer:
Marc Gallant
New York, NY
Illustrators:
James Marsh
Ivan Generalie
Letterer:
Marc Gallant
Publisher:
Alfred A. Knopf, Inc.
Printer:
Arnoldo Mondadori
Editore

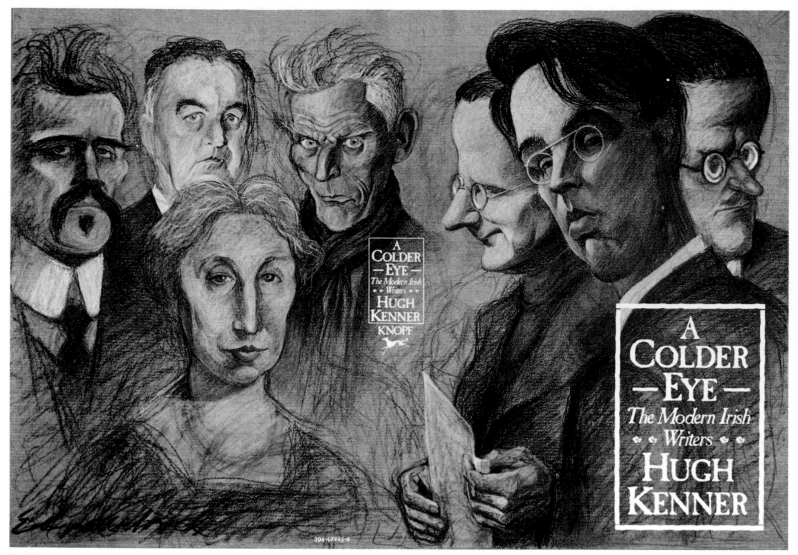

Book Jacket:
A Colder Eye
Art Director:
Lidia Ferrara
Designer:
Carin Goldberg
New York, NY
Illustrator:
Edward Sorel
Publisher:
Alfred A. Knopf, Inc.
Typographer:
Haber Typographers
Printer:
Philips Offset Co., Inc.

Book Jacket:
Annie Leibovitz
Art Director:
Louise Fili
Designer:
Louise Fili
New York. NY
Photographer:
Annie Leibovitz
Publisher:
Pantheon Books
Typographer:
Haber Typographers
Printer:
Dai Nippon Printing Co..
Ltd.

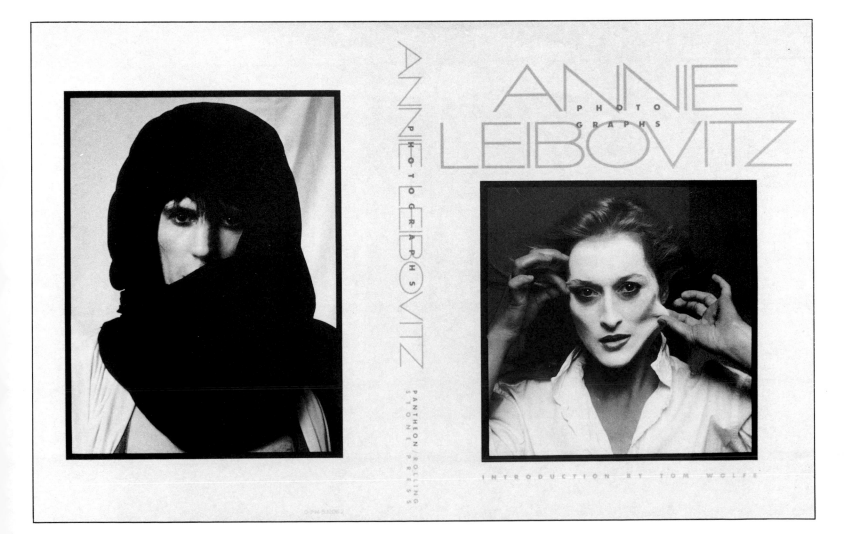

Book Jacket :
Black Coconuts.
Brown Magic
Art Director:
Jack Ribik
New York. NY
Illustrator and Letterer:
Irving Freeman
Publisher:
Doubleday & Co.. Inc.
The Dial Press
Printer:
Doubleday & Co.. Inc.

Book Jacket:
From Bonsai to Levis
Art Director:
Jackie Merri Meyer
Designers:
Yasuo Kubota,
Carol Ann Bender
New York, NY
Publisher:
Macmillan Publishing Co.
Typographer:
Cardinal Type Services,
Inc.
Printer:
Philips Offset Co., Inc.

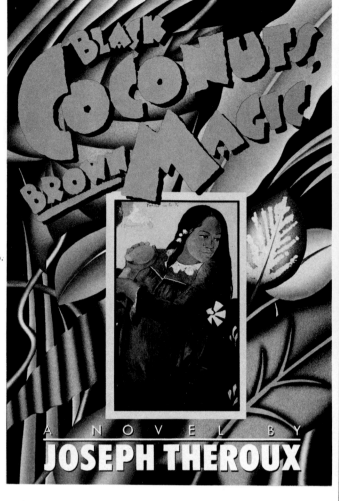

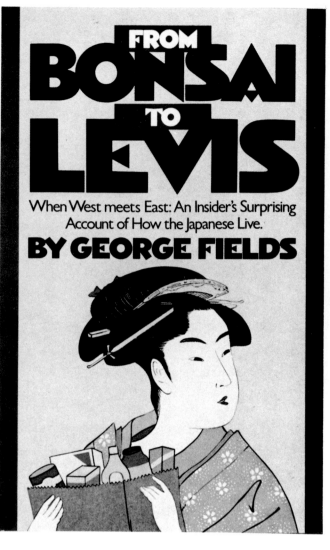

Paperback Cover:
The WPA Guide to
New York City
Art Director:
Louise Fili
Designer:
Louise Fili
New York, NY
Illustrator:
John Martinez
Publisher:
Pantheon Books
Typographer:
Haber Typographers
Printer:
The Longacre Press. Inc.

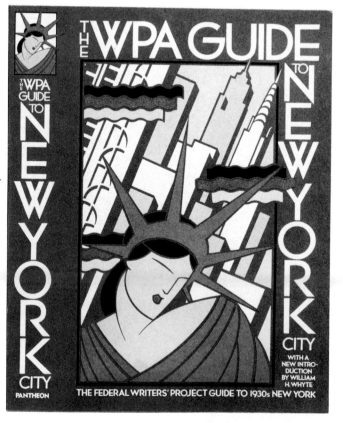

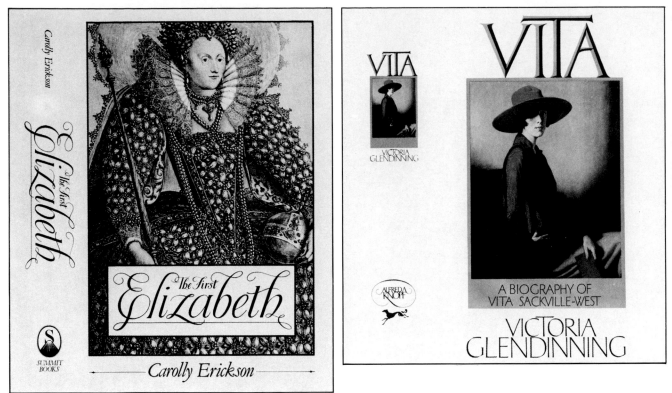

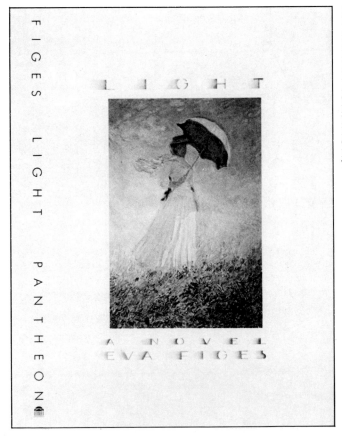

Book Jacket:
The First Elizabeth
Art Director:
Frank Metz
Designer:
Fred Marcellino
New York. NY
Publisher:
Summit Books/
Simon and Schuster

Book Jacket:
Vita
Art Director:
Lidia Ferrara
New York. NY
Designer:
Gun Larson
Artist:
William Strang
Letterer:
Gun Larson
Publisher:
Alfred A. Knopf. Inc.
Printer:
Coral Color

Book Jacket:
Light
Art Director:
Louise Fili
Designer:
Louise Fili
New York. NY
Artist:
Claude Monet
Publisher:
Pantheon Books
Letterer:
Craig de Camps
Printer:
The Longacre Press. Inc.

Paperback Cover:
Catch a Fire
Art Director:
Robert Reed
Designer:
Robert Reed
Illustrator:
Dan Maffia
Englewood, NJ
Publisher:
Holt Rinehart & Winston

Book Jacket:
Arcadio
Art Director:
Gael Towey Dillon
Designer:
Bascove
New York, NY
Illustrator:
Bascove
Publisher:
Clarkson N. Potter, Inc.,
Publishers
Printer:
Lehigh Press, Inc.

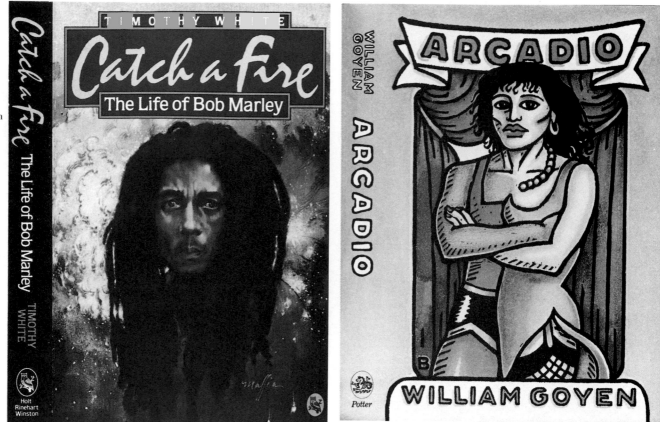

Book Jacket:
Yousuf Karsh:
A Fifty-Year
Retrospective
Designer:
Carl Zahn
Boston, MA
Photographer:
Yousuf Karsh
Letterer:
Carl Zahn
Publisher:
New York Graphic Society
Typographers:
Carl Zahn
Typographic House
Printer:
Imprimerie Jean Genoud

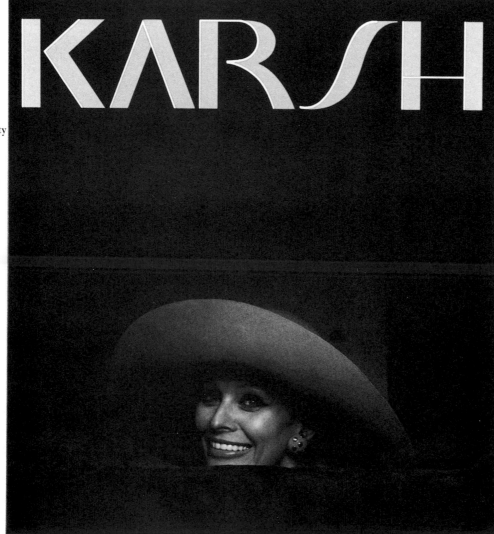

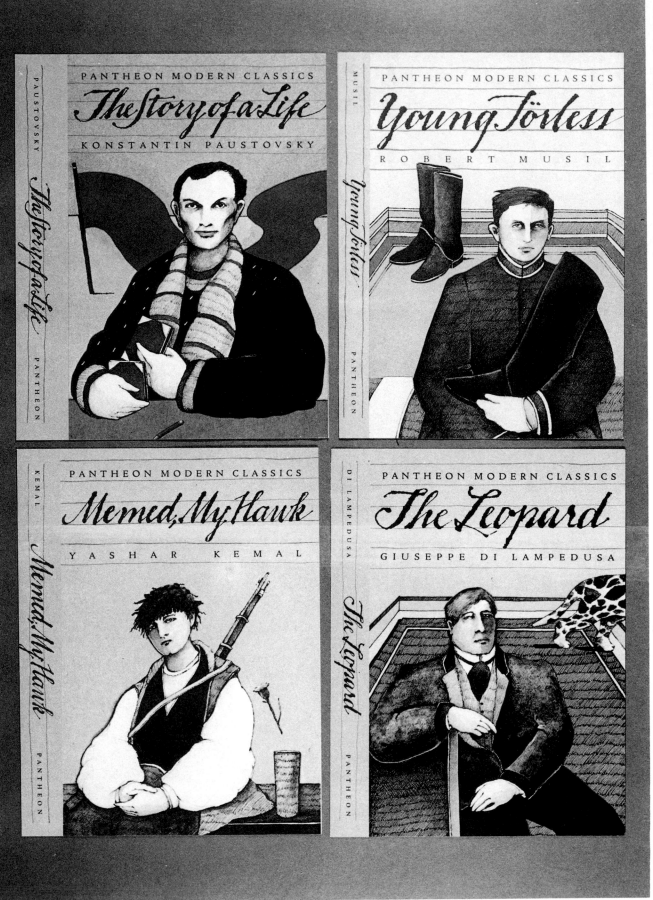

Paperback Cover:
The Pantheon Modern
Classic Series:
Memed. My Hawk.
Young Torless.
The Story of a Life.
The Leopard
Art Director:
Louise Fili
Designer:
Louise Fili
New York. NY
Illustrator:
Dagmar Frinta
Letterer:
Louise Fili
Publisher:
Pantheon Books
Typographer:
Haber Typographers
Printer:
The Longacre Press. Inc.

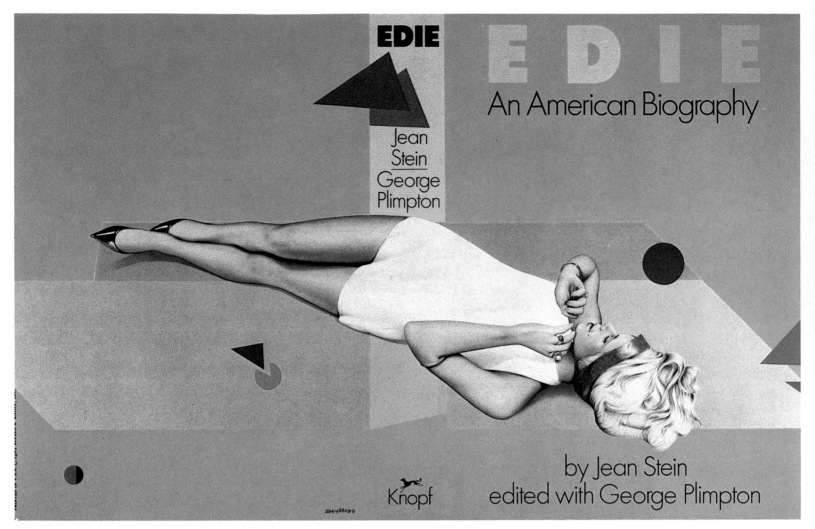

Book Jacket:
Edie
Art Director:
Lidia Ferrara
Designer:
Guy Fery
New York, NY
Illustrator:
Guy Fery
Publisher:
Alfred A. Knopf, Inc.
Typographer:
TypoGraphic Innovations,
Inc.
Printer:
Coral Color

Book Jacket:
USSR: The Corrupt
Society
Art Director:
Frank Metz
Designer:
George Corsillo
New York, NY
Publisher:
Simon and Schuster

USSR: THE CORRUPT SOCIETY
KONSTANTIN SIMIS

"Konstantin Simis has written an utterly fascinating book about a side of Soviet life that we have never glimpsed before. He has given us an irresistible gallery of Russian rogues and scoundrels, and a vivid portrait of the Soviet bureaucracy at work. I recommend his book without reservation."
— Robert G. Kaiser, author of
Russia: The People and the Power

"[This] is a remarkably revealing and graphic account of the underside of Soviet life. The cases he cites offer a look at the way things work in the USSR that others have only been able to hint at. For those who assess the nature and spirit of Soviet life today, this book will be of invaluable help."
— Peter Osnos
London Bureau Chief of
The Washington Post

0882-1450

0-671-25003-5

USSR: THE CORRUPT SOCIETY

THE SECRET WORLD OF SOVIET CAPITALISM

KONSTANTIN SIMIS

Paperback Cover:
Souls on Fire
Art Director:
Frank Metz
Designer:
Fred Marcellino
New York, NY
Illustrator:
Fred Marcellino
Publisher:
Summit Books/
Simon and Schuster

Paperback Cover:
The Random House Book
of Twentieth Century
French Poetry
Art Director:
Judith Loeser
Designer:
Daniel Pelavin
New York, NY
Letterer:
Daniel Pelavin
Publisher:
Vintage Books
Typographer:
TypoGraphic Innovations,
Inc.

Book Jacket:
Turtle Beach
Art Director:
Frank Metz
Designer:
Fred Marcellino
New York, NY
Illustrator:
Fred Marcellino
Publisher:
Simon and Schuster
Printer:
The Lehigh Press

Book Jacket:
When Things of the
Spirit Come First...
Art Director:
Louise Fili
Designer:
Louise Fili
New York, NY
Letterer:
Craig de Camps
Publisher:
Pantheon Books
Printer:
The Longacre Press, Inc.

MAGNETIC FIELD(S)

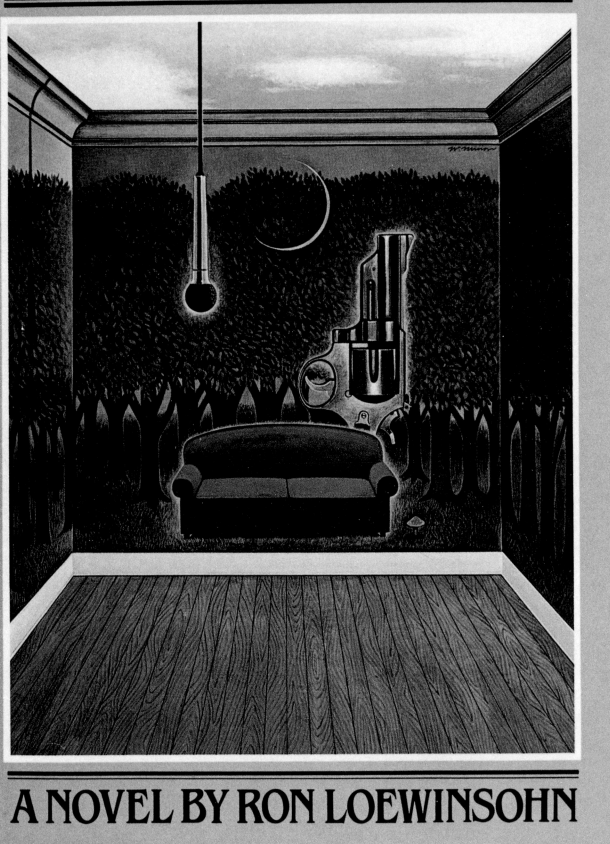

A NOVEL BY RON LOEWINSOHN

Book Jacket:
Magnetic Fields
Art Director:
Lidia Ferrara
Designer:
Wendell Minor
New York, NY
Illustrator:
Wendell Minor
Publisher:
Alfred A. Knopf, Inc.

Book Jacket:
Maigret in Court
Art Director:
Rubin Pfeffer
Designer:
Wendell Minor
New York, NY
Illustrator:
Wendell Minor
Publisher:
Harcourt Brace
Jovanovich
Typographer:
Scarlett Letters, Inc.
Printer:
The Longacre Press

SIMENON
MAIGRET IN COURT

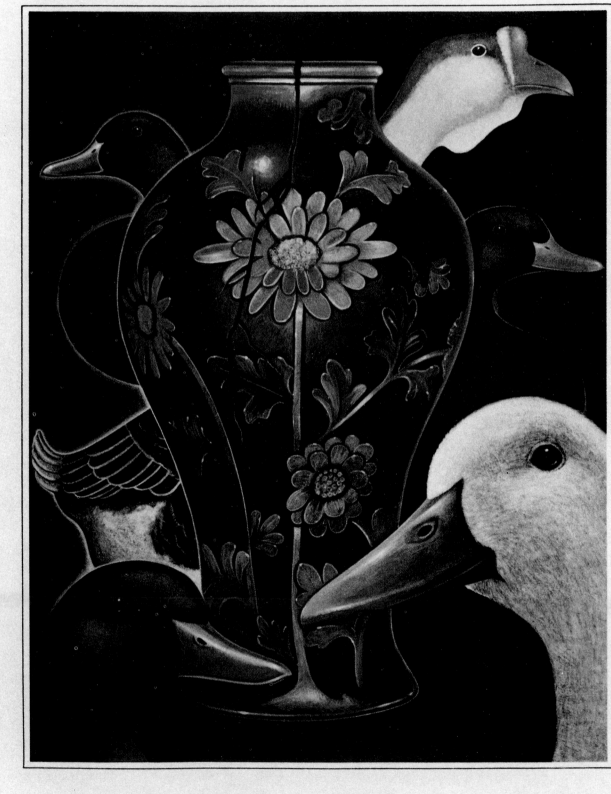

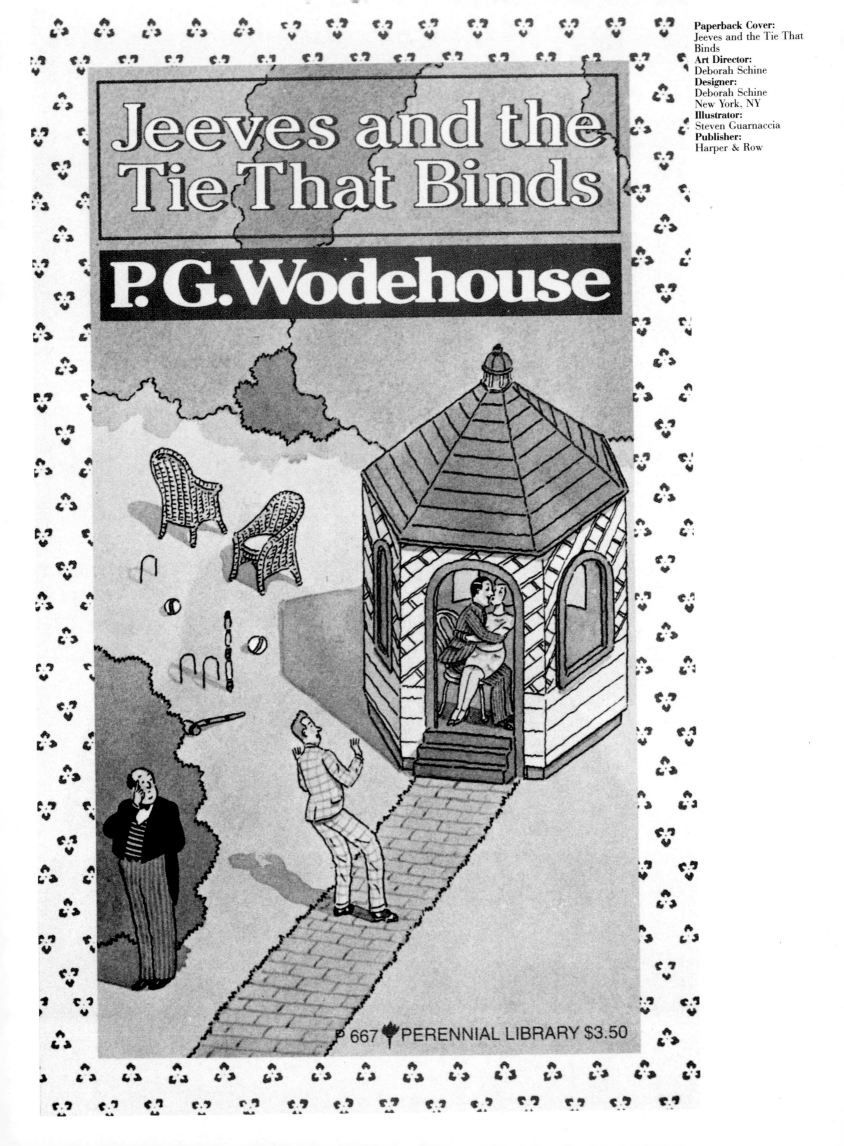

Jeeves and the
Tie That Binds

P.G.Wodehouse

P 667 PERENNIAL LIBRARY $3.50

Paperback Cover:
Jeeves and the Tie That
Binds
Art Director:
Deborah Schine
Designer:
Deborah Schine
New York, NY
Illustrator:
Steven Guarnaccia
Publisher:
Harper & Row

JOHN YOUNT

TOOTS
IN
SOLITUDE

A NOVEL

ST. MARTIN'S
MAREK

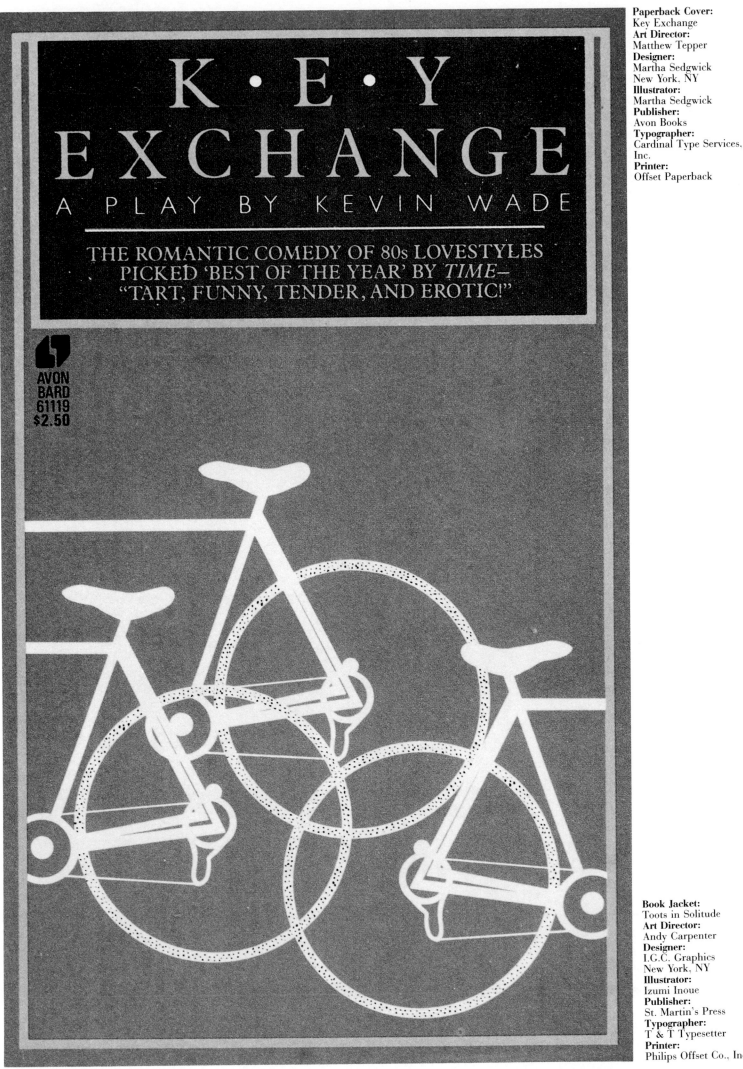

K·E·Y
EXCHANGE
A PLAY BY KEVIN WADE

THE ROMANTIC COMEDY OF 80s LOVESTYLES
PICKED 'BEST OF THE YEAR' BY *TIME*—
"TART, FUNNY, TENDER, AND EROTIC!"

AVON
BARD
61119
$2.50

Paperback Cover:
Key Exchange
Art Director:
Matthew Tepper
Designer:
Martha Sedgwick
New York, NY
Illustrator:
Martha Sedgwick
Publisher:
Avon Books
Typographer:
Cardinal Type Services,
Inc.
Printer:
Offset Paperback

Book Jacket:
Toots in Solitude
Art Director:
Andy Carpenter
Designer:
I.G.C. Graphics
New York, NY
Illustrator:
Izumi Inoue
Publisher:
St. Martin's Press
Typographer:
T & T Typesetter
Printer:
Philips Offset Co., Inc.

Book Jacket:
Natural Causes
Art Director:
Cristina Skowski
Designer:
Michael Schwab
San Francisco, CA
Illustrator:
Michael Schwab
Publisher:
Congdon & Weed, Inc.
Typographer:
Repro Type

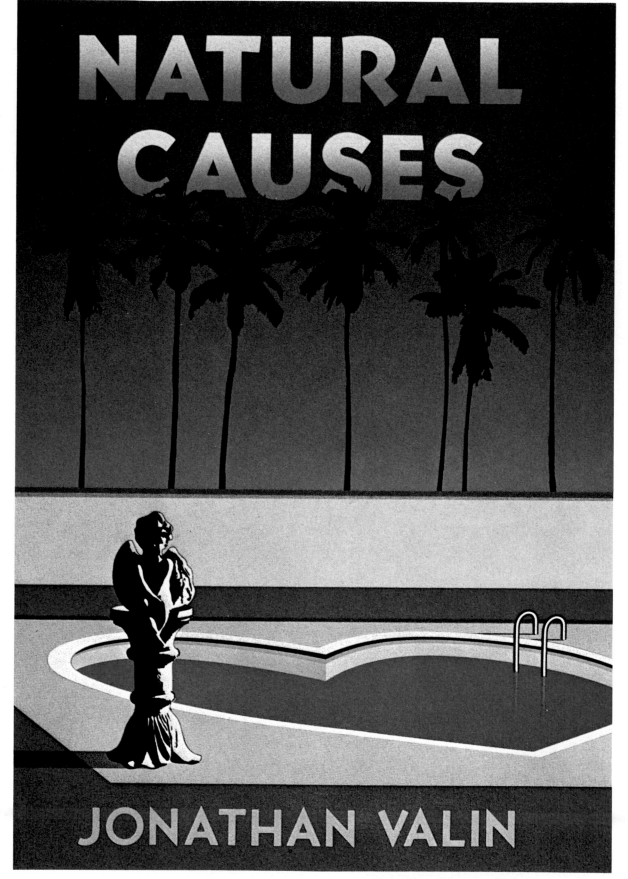

Book Jacket:
Photographing for
Publication
Art Director:
Hoi Ling Chu
Designer:
Hoi Ling Chu
New York, NY
Photographer:
Peggy Barnett
Publisher:
R. R. Bowker Co.
Produced by:
Mark Iocolano
October Press, Inc.
Typographer:
Haber Typographers
Printer:
Sanders Printing Corp.

Norman Sanders
Photographing for Publication

Bowker

Norman Sanders Photographing for Publication

How to Create and Evaluate
Photographs for Better Reproduction:
A Guide for Photographers, Editors,
and Graphic Arts Professionals.

Book Jacket:
The Ticket Out
Art Director:
Rubin Pfeffer
Designer:
Paul Gamarello
Eyetooth Design,
New York, NY
Photographer:
Diana Michener
Publisher:
Harcourt Brace
Jovanovich
Typographer:
Haber Typographers
Printer:
The Longacre Press

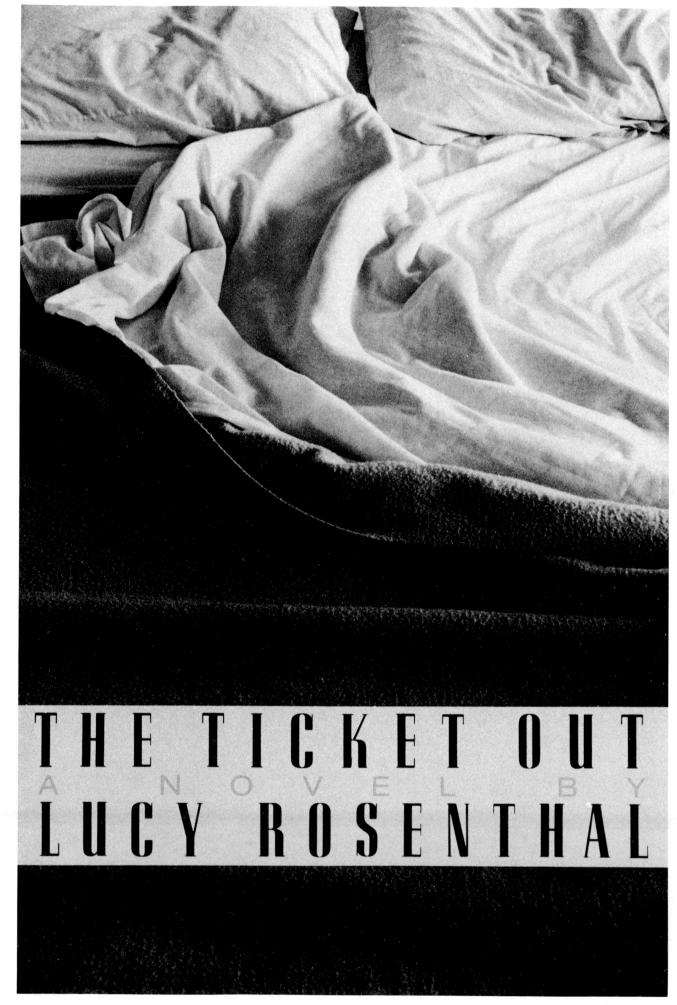

0-515-06717-2/$2.75 **J A JOVE BOOK**

"MARVELOUSLY TOLD, WITH PASSION & SKILL!"
—Los Angeles Times

THE BLOCKBUSTER NEW THRILLER
Selected by the Literary Guild and Doubleday Book Club

Paperback Cover:
A Stab in the Dark
Art Director:
Frank Kozelek
Mike Stromberg
Designer:
Mike Stromberg
New York, NY
Photographer:
Mort Engel
Publisher:
Berkley Publishing Co
Typographer:
Cardinal Type Services,
Inc.
Printer:
Offset Paperback

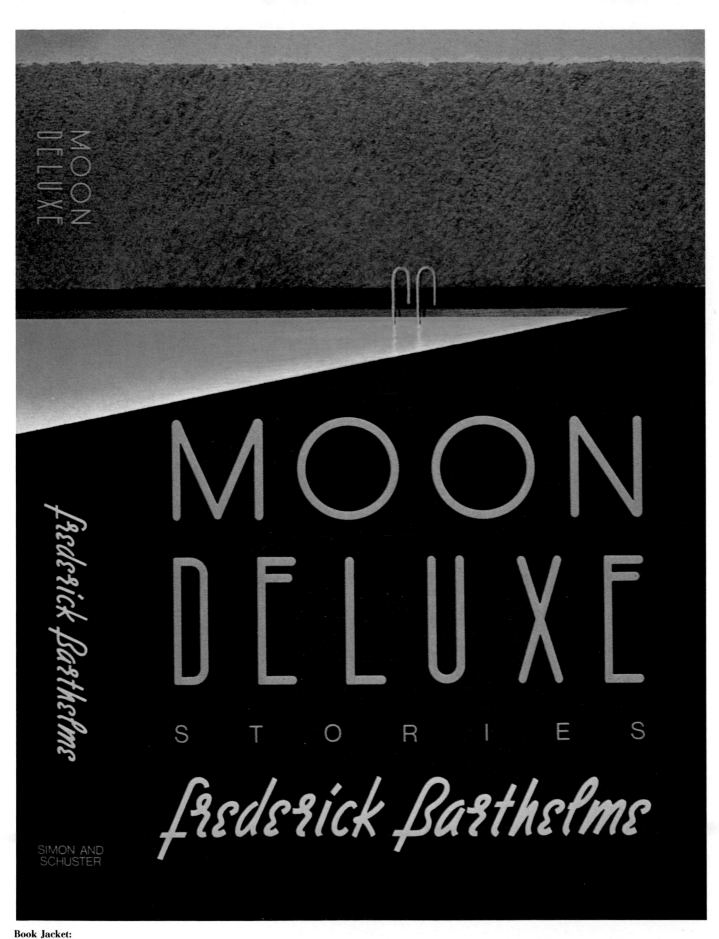

Book Jacket:
Moon Deluxe
Art Director:
Frank Metz
Designer:
Fred Marcellino
New York, NY
Illustrator:
Fred Marcellino
Publisher:
Simon and Schuster
Printer:
The Longacre Press. Inc.

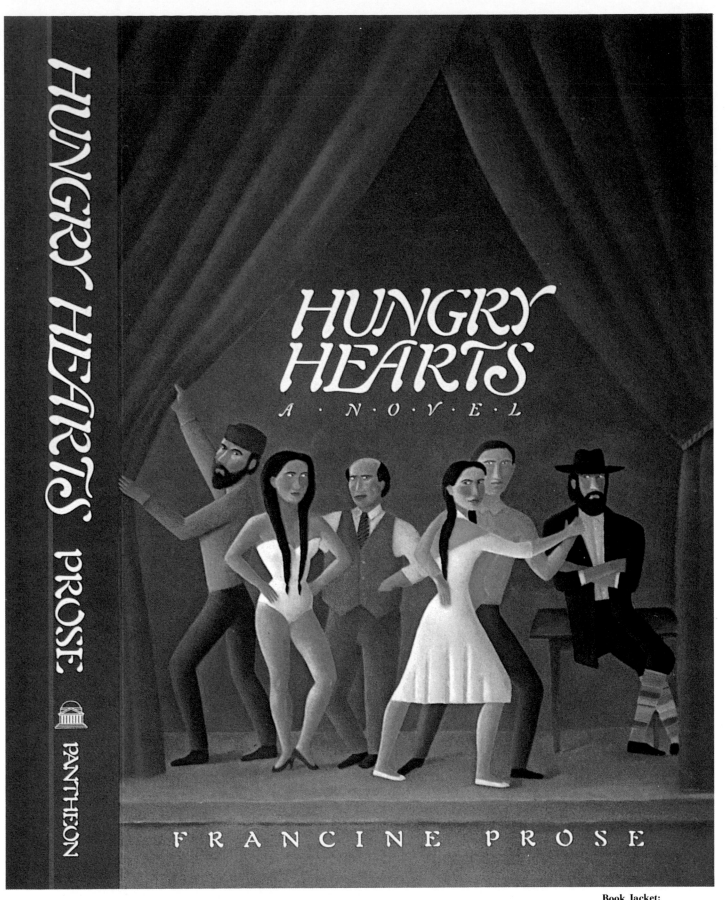

Book Jacket:
Hungry Hearts
Art Director:
Louise Fili
Designer:
Louise Fili
New York, NY
Illustrator:
Susan Walp
Publisher:
Pantheon Books
Typographer:
Photo-Lettering
Printer:
The Longacre Press, Inc.

Book Jacket:
Dinner at the Homesick
Restaurant
Art Director:
Lidia Ferrara
Designer:
Fred Marcellino
New York, NY
Illustrator:
Fred Marcellino
Publisher:
Alfred A. Knopf, Inc.
Typographer:
Haber Typographers
Printer:
Coral Color

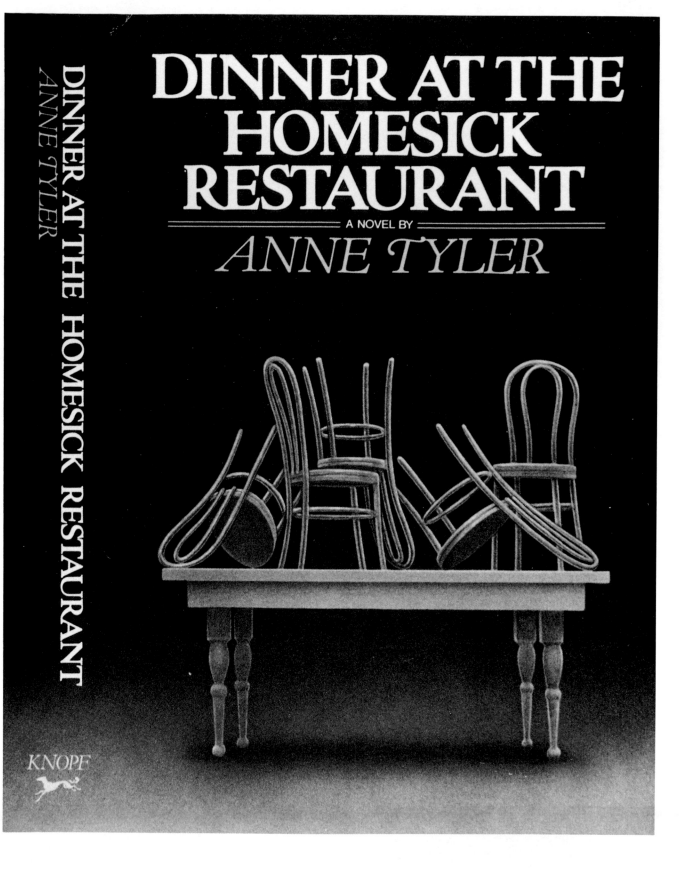

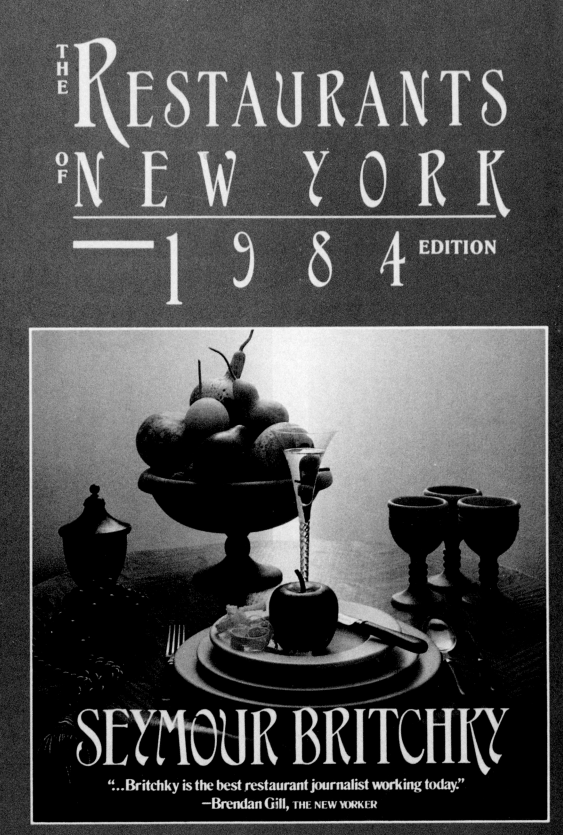

THE RESTAURANTS OF NEW YORK —1984 EDITION

THE RESTAURANTS OF NEW YORK —1984 EDITION

SEYMOUR BRITCHKY

Simon and Schuster

SEYMOUR BRITCHKY

"...Britchky is the best restaurant journalist working today."
—Brendan Gill, THE NEW YORKER

Paperback Cover:
The Restaurants of New York. 1984 Edition
Art Director:
Frank Metz
Designer:
Paula Scher
New York, NY
Photographer:
Alan Ginsburg
Publisher:
Simon and Schuster
Printer:
The Lehigh Press

Book Jacket:
Free Agents
Art Director:
Joseph Montebello
Designer:
Steven Guarnaccia
New York, NY
Illustrator:
Steven Guarnaccia
Publisher:
Harper & Row
Letterer:
Steven Guarnaccia

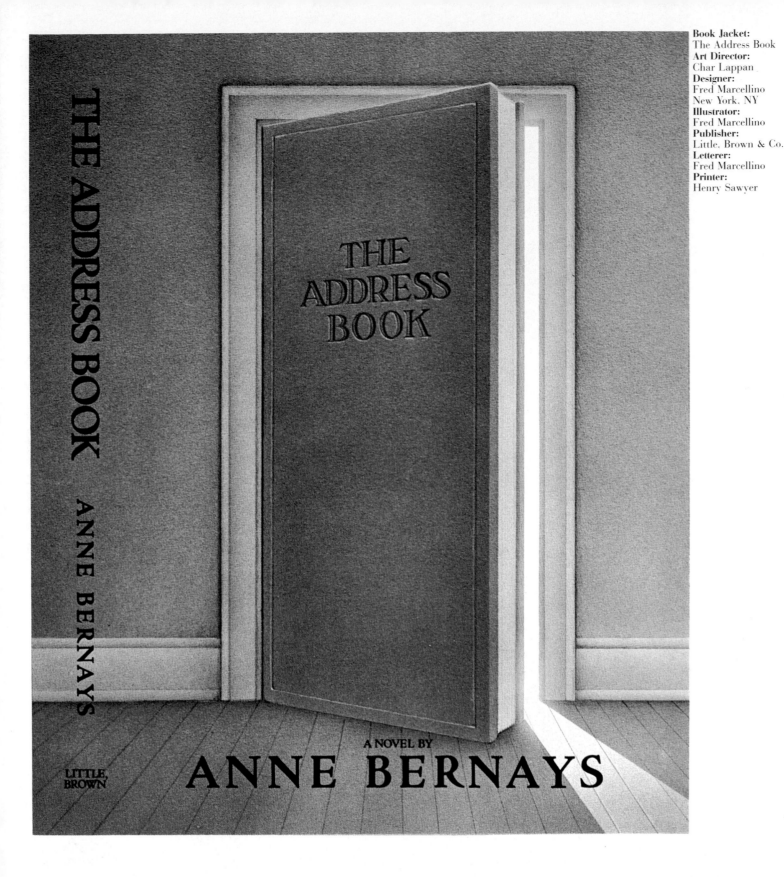

Book Jacket:
The Address Book
Art Director:
Char Lappan
Designer:
Fred Marcellino
New York. NY
Illustrator:
Fred Marcellino
Publisher:
Little. Brown & Co.
Letterer:
Fred Marcellino
Printer:
Henry Sawyer

Book Jacket:
Rockwell Kent
Art Director:
R.D. Scudellari
Designer:
R.D. Scudellari
New York, NY
Illustrator:
Rockwell Kent
Publisher:
Alfred A. Knopf, Inc.
Typographer:
TypoGraphic Innovations,
Inc.
Printer:
Coral Color

Paperback Cover:
The Moonstone
Art Director:
Jim Plumeri
Designer:
Robert Katz
New York, NY
Artist:
Casper David Friedrich
Publisher:
New American Library
Typographer:
All-American
Photolettering
Printer:
Stevenson Photocolor

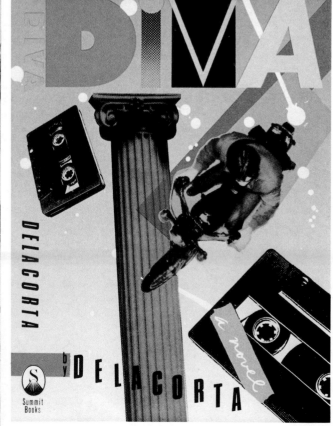

Paperback Cover:
Sources
Art Director:
Steven Hoffman
Designers:
Steven Hoffman,
Sarah Jewler
New York, NY
Photographer:
James Wojcik
Publisher:
Performing Arts Journal
Publications

Book Jacket:
Diva
Art Director:
Frank Metz
Designer:
George Corsillo
New York, NY
Photographers:
George Corsillo
Globe Photos
Publisher:
Summit Books/
Simon and Schuster
Printer:
The Longacre Press, Inc.

**Paperback Covers and
Slipcase:**
Abraham Lincoln:
The Prairie & The War
Years
Art Director:
Rubin Pfeffer
Designer:
Paul Gamarello
Eyetooth Design.
New York, NY
Publisher:
Harcourt Brace
Jovanovich
Typographer:
Haber Typographers
Printer:
The Longacre Press

Paperback Cover:
Aké
Art Director:
Judy Loeser
Designer:
Keith Sheridan
New York, NY
Illustrator:
Wendy Hole
Publisher:
Aventura/Random House
Typographer:
Haber Typographers
Printer:
The Longacre Press, Inc.

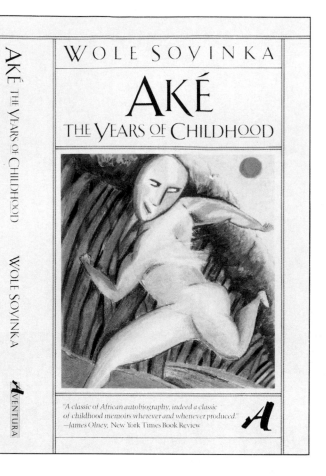

Paperback Cover:
Correction
Art Director:
Judy Loeser
Designer:
Keith Sheridan
New York, NY
Illustrator:
Marshall Arisman
Publisher:
Aventura/Random House
Typographer:
Haber Typographers
Printer:
The Longacre Press, Inc.

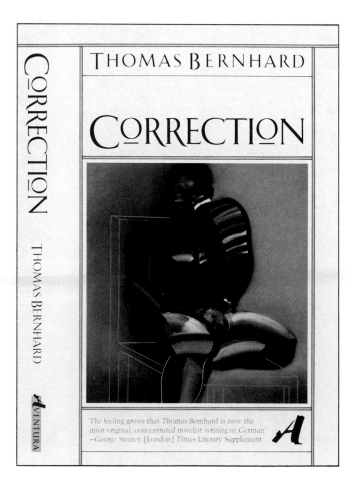

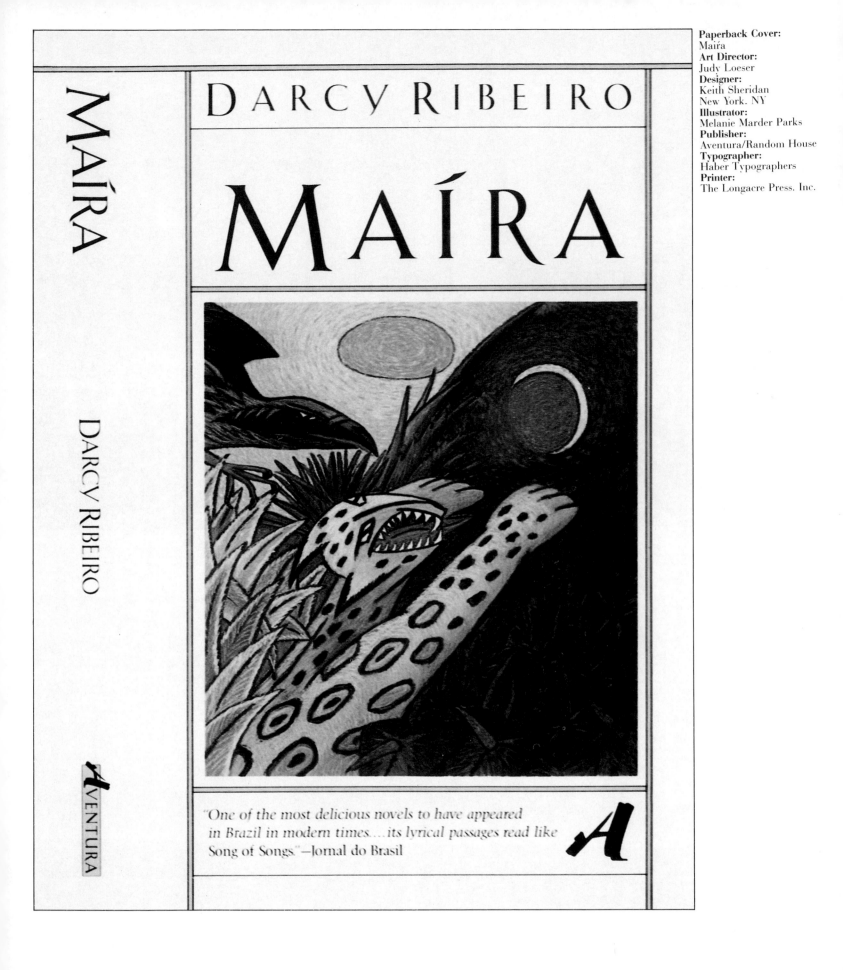

DARCY RIBEIRO

MAÍRA

DARCY RIBEIRO

MAÍRA

"One of the most delicious novels to have appeared
in Brazil in modern times....its lyrical passages read like
Song of Songs." —Jornal do Brasil

AVENTURA

Paperback Cover:
Maíra
Art Director:
Judy Loeser
Designer:
Keith Sheridan
New York. NY
Illustrator:
Melanie Marder Parks
Publisher:
Aventura/Random House
Typographer:
Haber Typographers
Printer:
The Longacre Press. Inc.

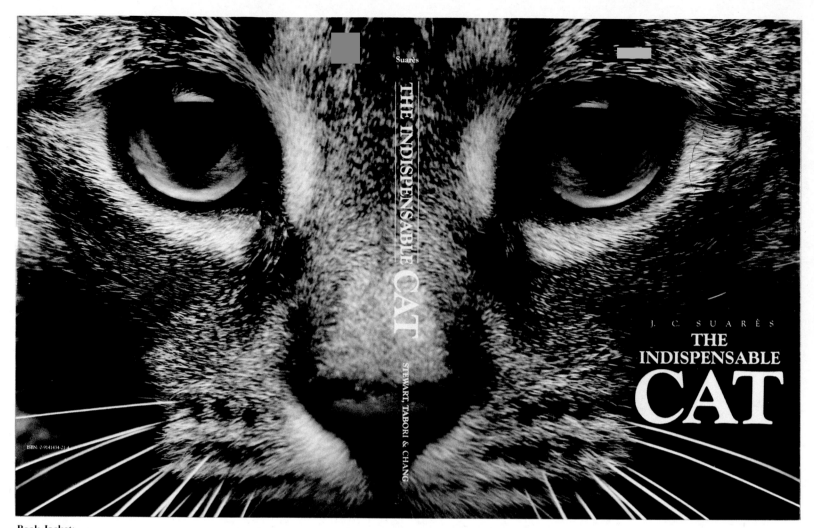

J. C. SUARÈS
**THE
INDISPENSABLE
CAT**

THE INDISPENSABLE CAT

STEWART, TABORI & CHANG

Suarès

ISBN: 0-941434-21-4

Book Jacket:
The Indispensable Cat
Art Director:
Nai Chang
Designer:
J.C. Suarès
New York, NY
Illustrators:
Various
Publisher:
Stewart, Tabori & Chang
Publishers, Inc.
Typographer:
U.S. Lithograph, Inc.
Printer:
Amilcare Pizzi, s.p.a.

Book Jacket:
The Rolling Stones
Art Director:
Mary Shanahan
Designer:
Mary Shanahan
New York, NY
Photographer:
Hiro
Publisher:
Rolling Stone Press
Doubleday & Co., Inc.

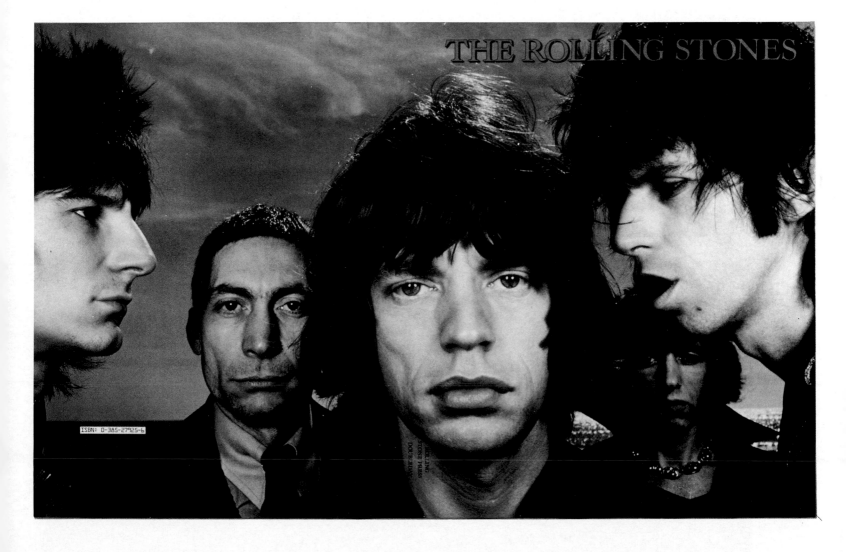

Call for Entry:
Communication Graphics
Designer:
Jack Summerford
Photographer:
Jim Myers
Typographer:
Southwestern Typographics
Printer:
Heritage Press
Paper:
Mead Paper

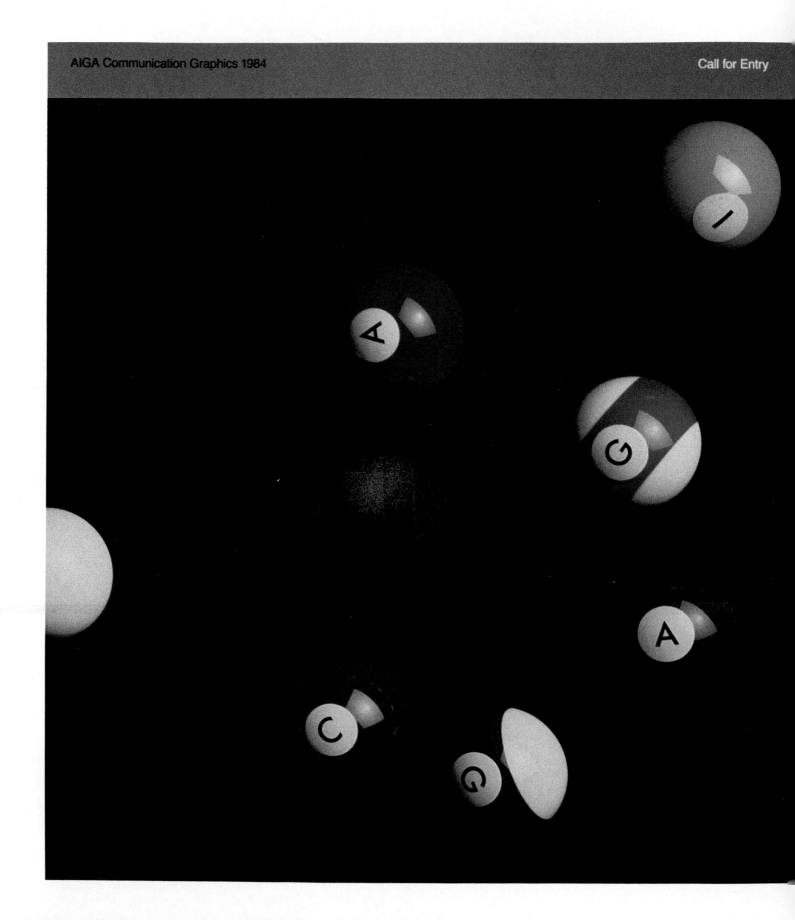

AIGA Communication Graphics 1984

Call for Entry

Communication Graphics

The true value of Communication Graphics is that it shows uncategorically that graphic design is a confluence of diverse forms and styles, which fulfills the ultimate goal: to communicate with intelligence, wit and surprise.

Chairman's Statement	Eligibility	Procedure	Entry and Hanging/ Publication Fees	Deadline	The Jury
takes strength to resist riting such obvious copy … might be expected with …e given visual. The use of …ch terms as "snookered," "ight ball," or "mis-cue" … a temptation. …he fact is, The American …stitute of Graphic Arts …ommunication Graphics …ow needs no hype or …ever announcement. …his show stands as one of …e best and most defini- …ve graphic design shows … the world. …hether it be brochures, …nnouncements, let- …rheads, annual reports, …gos or other material …eeting the eligibility re- …uirements, the standards …e the highest, the honor …e greatest. But you …n't need to be told that. … take your best shot… …couldn't resist. …ck Summerford	Brochures, leaflets, an- nouncements, folders, invitations, booklets, labels, letterheads, pro- grams, annual reports, house organs, calendars, sales promotion materials, print advertising, cata- logues, posters, mailing cards, instructional man- uals, logos, corporate graphics, menus, environ- mental graphics, signage, and any other commer- cially printed matter that is not for sale to the gen- eral public and has been printed in excess of 500 impressions in the United States or Canada between January 1, 1983 through December 31, 1983. For posters larger than 50" and environmental graph- ics and vehicle signage, please send 35mm color slides. Books, magazines, bookjackets, newspapers, record albums, controlled circulation magazines, and packages that are for sale are not eligible, as they are included in other AIGA exhibits.	Please send unmounted proofs or tearsheets. En- tries cannot be returned. The judging process con- sists of voting by each juror anonymously and is based on individual judg- ment alone. Upon accep- tance by the jury, each entrant will be asked to submit two additional copies of the accepted piece(s) for exhibition backup and for the travel- ling exhibition. In addi- tion, the Curator of The Popular & Applied Arts Division of the Library of Congress will make a se- lection from the accepted entries for inclusion in their archives. If your work is selected, you will *not* be required to provide photographs or slides for the AIGA Annual, travelling show or archives. The AIGA will be photographing all ac- cepted piece(s) in order to ensure consistency of pho- tographic style and quality, and thus relieve acceptees of this obliga- tion. The entrant acknowl- edges the right of the AIGA to use this material in *AIGA Graphic Design USA:5*, as well as other publications reporting on the exhibition or AIGA ac- tivities. The AIGA Cer- tificate of Excellence will be awarded to those who have participated in the creation of the selected en- tries. There is no best-of- show award.	The entry fee for AIGA members is $10 per piece and $15 for nonmembers. If a piece is accepted for the exhibition, there will be a hanging/publication fee of $45 per piece for members and $65 for non- members. In addition, there will be a photogra- phy fee of $20. Entries must be accompanied by a check payable to AIGA Communication Graphics. Brokerage and customs fees on Canadian entries must be prepaid and Cana- dian entry checks must be payable in U.S. dollars. If wish to be informed of the judges' decision, please en- close your check in a self- addressed, stamped, un- sealed #10 envelope. Please note the AIGA membership application. A completed application with separate check for membership accompany- ing submitted materials al- lows you to take advantage of lower members fees.	All entries must be received by February 6, 1984. Ad- dress entries to: Com- munication Graphics, The American Institute of Graphic Arts, 1059 Third Avenue, New York, NY 10021.	Jann Church *Jann Church Partners, Inc. Newport Beach, California* John Massey *John Massey, Inc. Chicago, Illinois* B. Martin Pedersen *Jonson, Pedersen, Hinrichs & Shakery, Inc. New York, New York* Tyler Smith *Tyler Smith Art Direction Providence, Rhode Island* Jack Summerford *Summerford Design, Inc. Dallas, Texas* **The Committee** Jack Summerford *Chairman* David R. Brown *AIGA President* Caroline Hightower *AIGA Executive Director*

Chairman
Jack Summerford
President
Summerford Design, Inc.

Jury
Jann Church
Principal
Jann Church Partners, Inc.

John Massey
Principal
John Massey, Inc.

B. Martin Pedersen
Principal
Jonson, Pedersen, Hinrichs
& Shakery, Inc.

Tyler Smith
Principal
Tyler Smith Art Direction

That this section is called *Communication Graphics* is an anomaly, since the function of all graphic design—including those areas already surveyed in this Annual—is to *communicate*. The problem here is a curious inability to accurately say in two words what designers must accomplish, as a matter of course, through the marriage of words and images, and what this show proves they do so well: communicate messages, information and ideas.

Specifically, *Communication Graphics* is a miscellany of uncategorized, serendipitous, and often high-budgeted, graphic design, such as annual reports, posters, catalogues, menus, calendars, self-promotion and personal ephemera—the best of which are clever and beautiful. Some have been produced for a client under tremendous time pressures, yet qualitatively transcend the constraints; others are produced in freer environments, in which boundaries and limits are self-imposed. The scope of this show and the formidable number of excellent entries might cause the judges to run amuck—like children in a candy store with so many goodies to choose from. However, if past juries have flexed their critical muscles, accepting only the *creme de la creme*, this year's panel was even more selective.

"I feel very good about the results of this judging," says Chairman Jack Summerford. "We've distilled the best work by many excellent designers across the country. Furthermore, after seeing all the entries, I'm assured that there is a very high level of design being practiced in the United States, one that has risen over previous years. I can honestly say that what is selected for this CG Show stands out in relation to a generally high standard."

The current show was pared down considerably from previous years—only 138 pieces as opposed to 250 last year—reflecting two significant currents: a clear-cut rejection of Post-Modernist and New Wave conventions, and a substantially decreased annual report selection (only 8 were chosen out of about 200 submitted). The reason for the latter, according to the jury members, is due to the consistently high level of annual report design over the past five years, in which consistency is the norm. This year, the high gloss look, so prevalent in the form, is commonplace, and therefore overlooked in favor of more classical approaches; quiet typography and subtle

illustration are now virtues. As for the apparent backlash against Post-Modernist design, Summerford suggests: "The reason is simple. It was exciting when new, and most of us enjoyed playing with it because it was so different. However, the process has become a formula—an easy way out for some designers. Now style alone rather than substance predominates, and, moreover, it has become irrelevant to the real problems of design. Either consciously or unconsciously, the choices made by this jury indicate that designers are returning to basics."

If the return to basics is the key to this CG show, then utilitarianism is right behind the front door. The jury eschewed *unnecessary design*—whereby function and purpose took a backseat to overly stylized work. "The single calibrating measurement we used as a group was: Does a particular piece represent the workaday world or is it conjured from a dream?" says Summerford. Among the dreams referred to are the lavish jobs done for free, whereby a designer makes the suppliers pay the proverbial pound of flesh by overdesigning and overpricing a work. Also excluded are those examples of personal ephemera which have no greater purpose than to be beautiful. This year, birth and wedding announcements, Christmas cards, and similarly personal materials were intensely scrutinized; only the most serendipitous and witty were recognized as successful designs. "We all love the opportunity to create anything we want," continues Summerford, "but often those pieces are not the best indication of what goes on in the profession."

Extravagance *was*, however, celebrated when the solution was an appropriate response to the problem. The leather-bound catalogue, for instance, was just right—it reeked of class—and an aluminum covered portfolio also answered its problem with flair. Self-promotional portfolios, in general, were well done. And, as a genre, posters and art catalogues generally fared well. Letterheads were less in evidence than in previous years. And as is always the case in CG shows, those one-of-a-kind solutions to odd projects, such as "The Skyline High School Class of 73 Reunion" souvenir book, were recognized—in this particular case, because the designer succeeded in conceptually making a silk purse out of a weird idea.

Although it is hard to draw any substantial conclusions from this eclectic presentation, the true value of *Communication Graphics* is that it shows uncategorically that graphic design is a confluence of diverse forms and styles, which fulfills the ultimate goal: to communicate with intelligence, wit and surprise.

Poster:
Catch the Vision
Art Director:
McRay Magleby
Designer:
McRay Magleby
Artist:
McRay Magleby
Design Firm:
Brigham Young
University
Graphic
Communications
Provo, UT
Publisher:
Brigham Young
University
Printer:
Robert G. Carawan

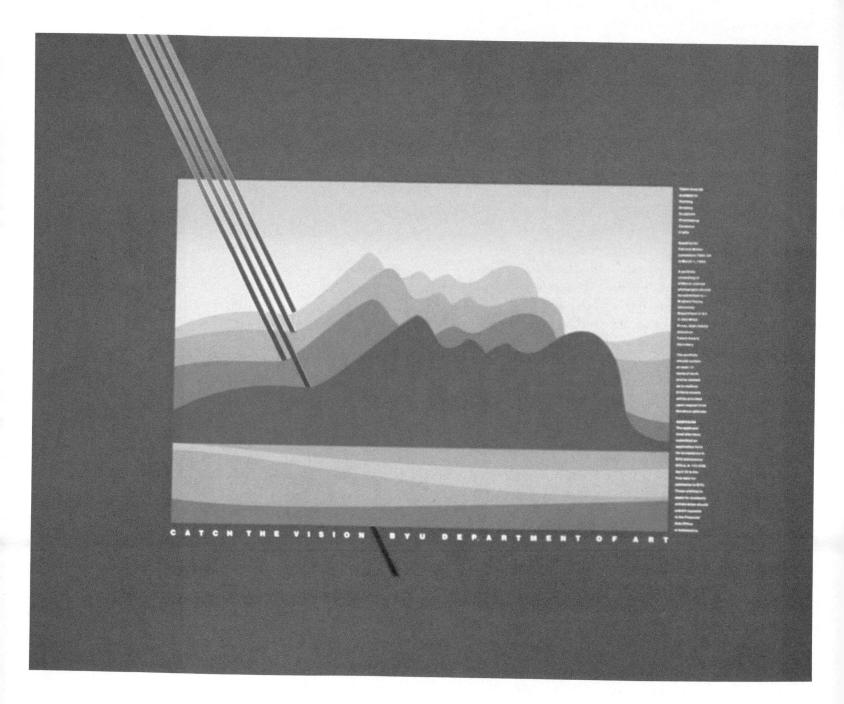

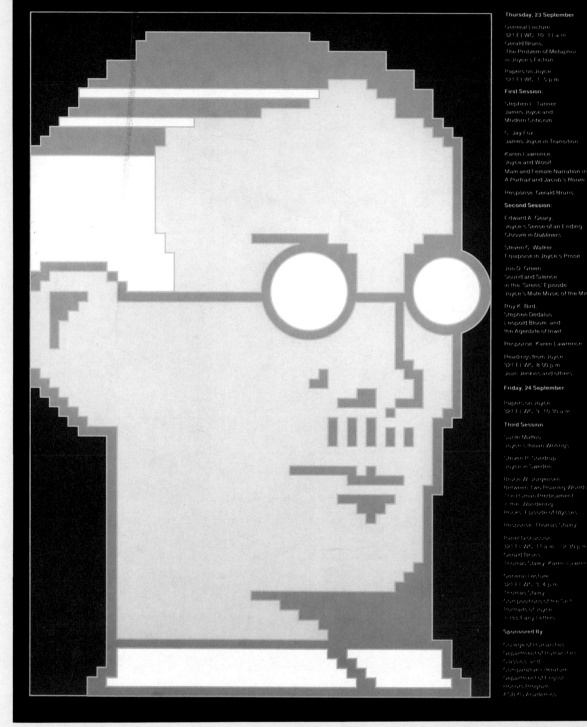

JAMES JOYCE SYMPOSIUM

Thursday, 23 September

General Lecture
321 ELWC, 10–11 a.m.
Gerald Bruns,
The Problem of Metaphor
in Joyce's Fiction

Papers on Joyce
321 ELWC, 1–5 p.m.

First Session:

Stephen L. Tanner,
James Joyce and
Modern Criticism

C. Jay Fox,
James Joyce in Transition

Karen Lawrence,
Joyce and Woolf:
Male and Female Narration in
A Portrait and Jacob's Room

Response: Gerald Bruns

Second Session:

Edward A. Geary,
Joyce's Sense of an Ending:
Closure in Dubliners

Steven C. Walker,
Equipoise in Joyce's Prose

Jon D. Green,
Sound and Silence
in the 'Sirens' Episode:
Joyce's Mute Music of the Mind

Roy K. Bird,
Stephen Dedalus,
Leopold Bloom, and
the Agenbite of Inwit

Response: Karen Lawrence

Readings from Joyce
321 ELWC, 8:00 p.m.
Jean Jenkins and others

Friday, 24 September

Papers on Joyce
321 ELWC, 9–10:30 a.m.

Third Session

Carole Mattern,
Joyce's Italian Writings

Steven P. Sondrup,
Joyce in Sweden

Bruce W. Jorgensen,
Between Two Roaring Worlds:
The Human Predicament
in the 'Wandering
Rocks' Episode of Ulysses

Response: Thomas Staley

Panel Discussion
321 ELWC, 11 a.m.–12:30 p.m.
Gerald Bruns,
Thomas Staley, Karen Lawrence

General Lecture
321 ELWC, 3–4 p.m.
Thomas Staley,
Compositions of the Self:
Portraits of Joyce
in his Early Letters

Sponsored By

College of Humanities
Department of Humanities,
Classics, and
Comparative Literature
Department of English
Honors Program
ASBYU Academics

Poster:
James Joyce
Symposium
Art Director:
McRay Magleby
Designer:
McRay Magleby
Artist:
McRay Magleby
Design Firm:
Brigham Young
University
Graphic
Communications
Provo, UT
Publisher:
Brigham Young
University
Printer:
Robert G. Carawan

Poster:
Sew up your
registration. . . .
Art Director:
McRay Magleby
Designer:
McRay Magleby
Artist:
McRay Magleby
Design Firm:
Brigham Young
University
Graphic
Communications
Provo, UT
Publisher:
Brigham Young
University
Printer:
Robert G. Carawan

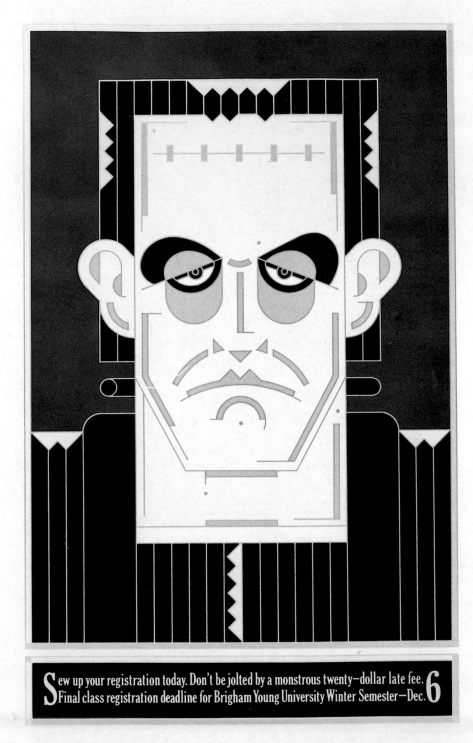

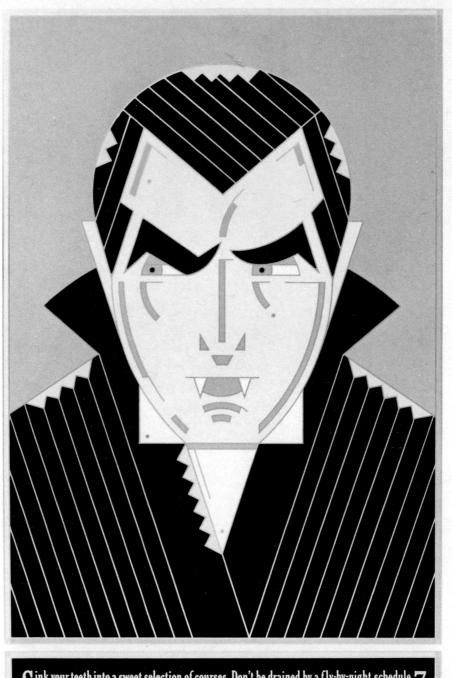

Poster:
Sink your Teeth. . . .
Art Director:
McRay Magleby
Designer:
McRay Magleby
Artist:
McRay Magleby
Design Firm:
Brigham Young
University
Graphic
Communications
Provo, UT
Publisher:
Brigham Young
University
Printer:
Robert G. Carawan

Sink your teeth into a sweet selection of courses. Don't be drained by a fly-by-night schedule. First-priority registration deadline for Brigham Young University Winter Semester—Nov. 7

*E*arly Greek astronomers were puzzled by the irregular motions of the planets. (The word **planet** comes from the Greek word for wanderer.) Claudius Ptolemaeus, better known as Ptolemy, proposed an answer for these unusual planetary movements. This Greco-Egyptian astronomer, who studied in the spacious library and museum at Alexandria in about A.D. 140, refined a complex geometric system of epicycles and deferents (first developed by Hipparchus) to explain and calculate the motions of the moon and planets around a stationary earth. Ptolemy's complex system of epicycles, recorded and passed down in his famous **Almagest**, withstood its critics and remained virtually unchallenged for more than 1,000 years.

*F*inally, the Ptolemaic system was successfully challenged and modified by Polish astronomer Nicolaus Copernicus (1473-1543). Often referred to as the father of modern astronomy, Copernicus audaciously and heretically—in the eyes of the clerics—moved the earth from the center of the celestial system, replacing it with the sun. Ironically, Copernicus was led to adopt the idea of a sun-centered universe as a result of having been commissioned by the Pope to revise the calendar. The most significant and intriguing consequence of Copernicus' thinking, however, was the implication that the earth moves swiftly through the heavens. The 18th-century machine shown here is based on the Copernican system.

Brochure:
Astronomy
Art Director:
McRay Magleby
Designer:
McRay Magleby
Artist:
McRay Magleby
Design Firm:
Brigham Young
University
Graphic
Communications
Provo, UT
Publisher:
Brigham Young
University
Printer:
Robert G. Carawan

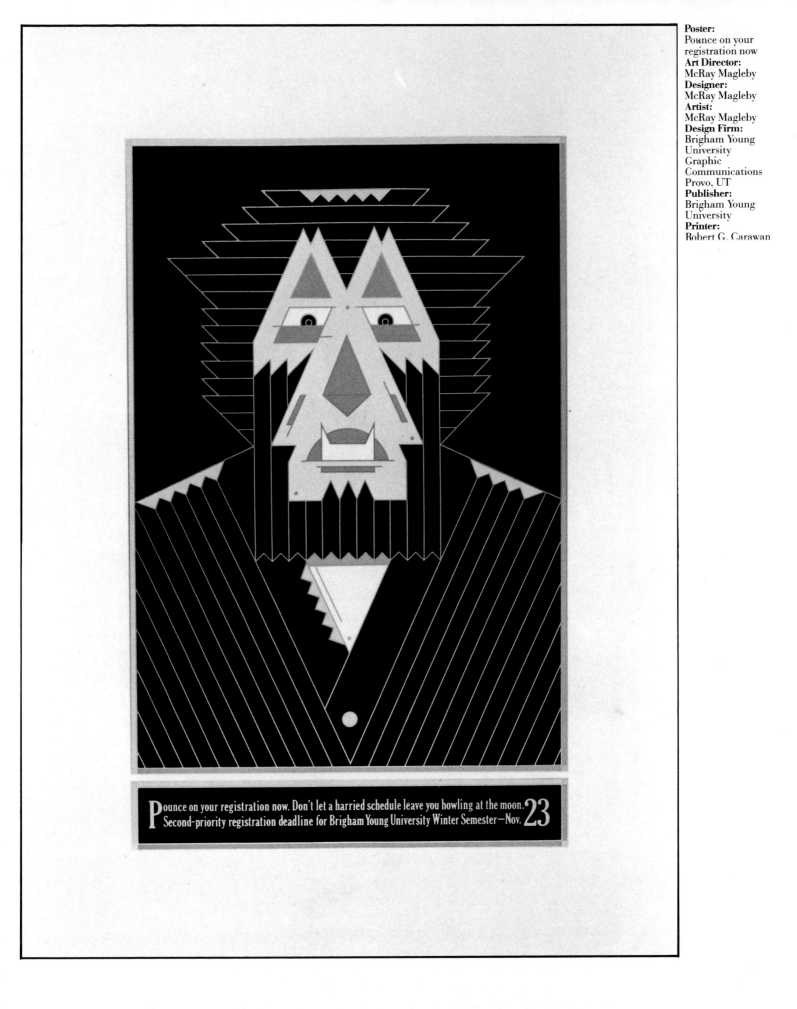

Poster:
Pounce on your
registration now
Art Director:
McRay Magleby
Designer:
McRay Magleby
Artist:
McRay Magleby
Design Firm:
Brigham Young
University
Graphic
Communications
Provo, UT
Publisher:
Brigham Young
University
Printer:
Robert G. Carawan

Poster:
Dallas Museum of Art
Art Director:
Woody Pirtle
Designer:
Woody Pirtle
Artist:
Claes Oldenburg
Design Firm:
Pirtle Design
Dallas, TX
Publisher:
Dallas Museum of Art
Typographer:
Southwestern
Typographics, Inc.
Printer:
Brodnax Printing

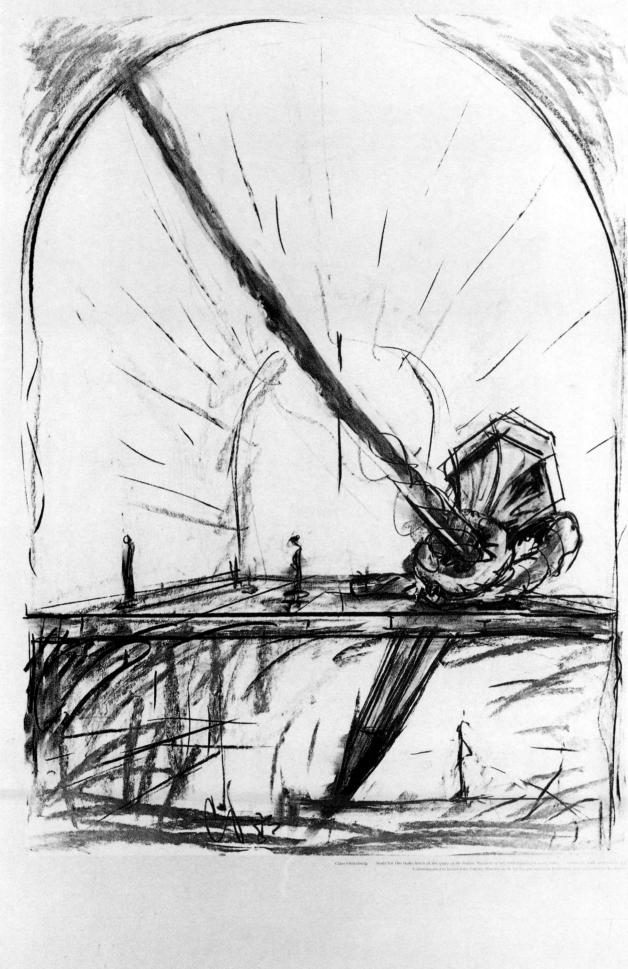

DALLAS MUSEUM OF ART

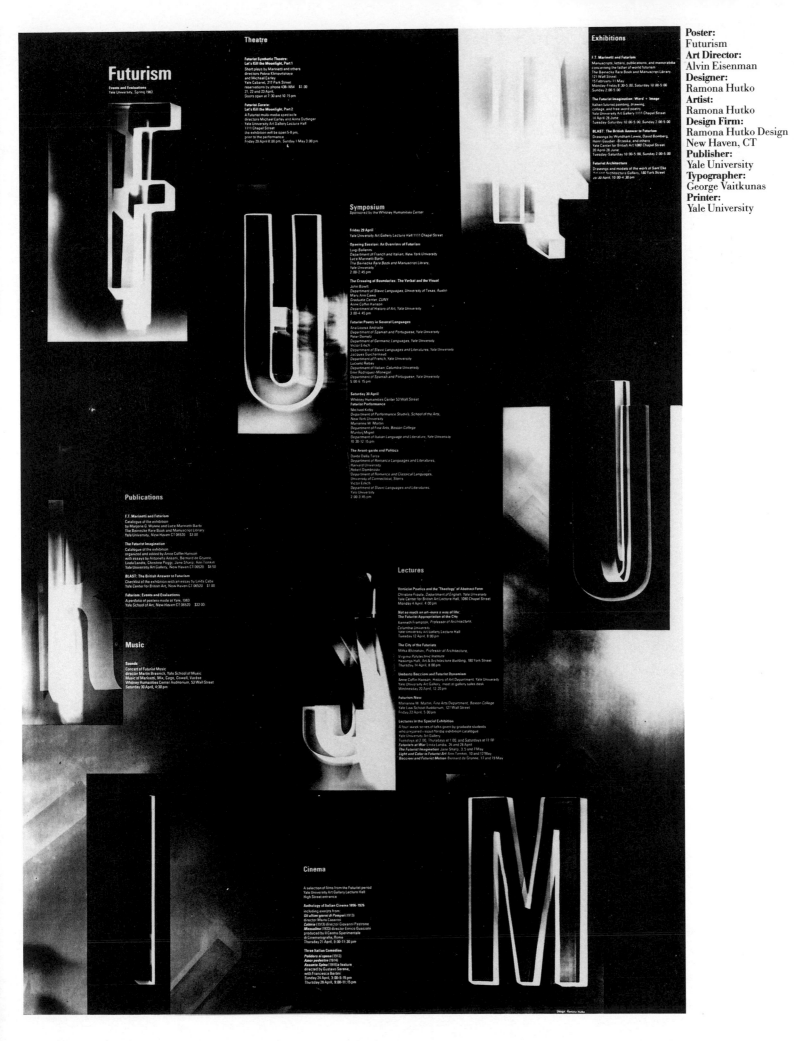

Poster:
Futurism
Art Director:
Alvin Eisenman
Designer:
Ramona Hutko
Artist:
Ramona Hutko
Design Firm:
Ramona Hutko Design
New Haven, CT
Publisher:
Yale University
Typographer:
George Vaitkunas
Printer:
Yale University

Ingres

Poster:
Ingres
Art Director:
Julius Friedman
Designer:
Julius Friedman
Artist:
Ingres
Design Firm:
Images
Louisville, KY
Publisher:
J. B. Speed Art Museum
Typographer:
Adpro
Printer:
Pinaire Lithographing

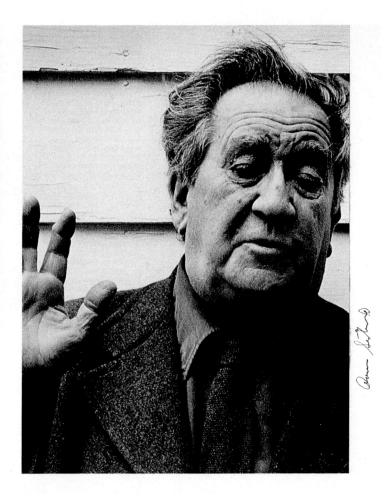

Promotional Brochure:
Herring Design
Quarterly #10
Art Director:
Jerry Herring
Designer:
Jerry Herring
Photographer:
Charles Schorre
Design Firm:
Herring Design
Houston, TX
Publisher:
Herring Design
Typographer:
Professional
Typographers
Printer:
Wetmore & Co.

Aaron Siskind, Ivan Chermayeff

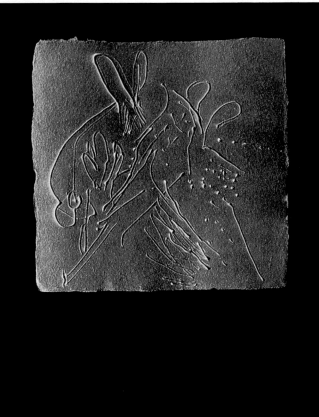

‹ Inside front cover:
"Place Where the Rabbit Was"
(8" x 8" on paper)

Booklet:
Drawings & Notes II
Art Director:
Charles Schorre
Designers:
Charles Schorre,
Jerry Herring
Artist:
Charles Schorre
Design Firm:
Herring Design
Houston, TX
Publisher:
Seashore Press
Typographer:
Professional
Typographers, Inc.
Printer:
Wetmore & Co.

Year Book:
Portfolio 1983
Art Directors:
Dara Emers,
Allison Muench,
Eric A. Pike
Designers:
Dara Emers,
Allison Muench,
Eric A. Pike
Photographers:
Clay Gordon,
Richard Pandiscio
Publisher:
Rhode Island School
of Design
Providence, RI
Typographer:
Typographic House
Printer:
Arlington Lithographers

Poster:
Mead Papers Top Sixty
Art Director:
Ken White
Designer:
Ken White
Photographer:
G. Robert Nease
Design Firm:
Ken White Design
Office, Inc.
Los Angeles, CA
Publisher:
Mead Paper
Typographer:
Aldus Type Studio, Ltd.
Printer:
Scott & Scott, Inc.

Poster:
Dallas Museum of
Fine Art
Sculpture Garden
Art Director:
Rex Peteet
Designers:
Rex Peteet, Ken Shafer
Artist:
Rex Peteet
Design Firm:
Sibley/Peteet Design, Inc.
Dallas, TX
Publisher:
Dallas Museum of
Fine Art
Typographer:
Southwestern
Typographics
Printer:
Harp Press

Poster:
John Massey
Art Director:
John Massey
Designer:
John Massey
Artist:
John Massey
Design Firm:
John Massey, Inc.
Chicago, IL
Publisher:
University of Tennessee
Typographer:
Ryder Types
Printer:
Accurate Silk Screen Co.

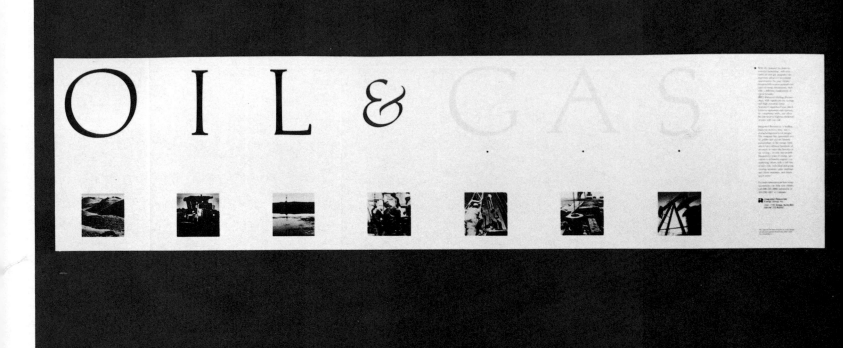

Promotional Folder:
Oil and Gas
Art Director:
Elinor Pettit
Designer:
Mark Hamilton Hanger
Photographer:
Steve Collecter
Design Firm:
Interface
Communications
Englewood, CO
Client:
Integrated Resources
Energy Group
Typographer:
Cynthia Covall
Printer:
Communigraphics

DALLAS ZOO

Logo:
Dallas Zoo
Art Director:
Dick Mitchell
Designer:
Dick Mitchell
Artist:
Dick Mitchell
Design Firm:
Richards, Sullivan,
Brock & Assoc.
Dallas, TX
Client:
Dallas Zoo
Typographer:
JCS

Untitled, 1979
pencil and acrylic on
primed canvas
9' x 13'
Courtesy of the artist

Exhibition Catalogue:
Gene Davis
Art Director:
John Muller
Designers:
John Muller,
Debbie Wright
Artist:
Gene Davis
Design Firm:
John Muller & Co.
Kansas City, MO
Client:
University of Missouri
Kansas City; Gallery of
Art
Typographer:
Lopez Graphics
Printer:
Ashcraft, Inc.

Stationery:
Arthur Meyerson
Art Directors:
Woody Pirtle,
Mike Schroeder
Designer:
Mike Schroeder
Photographer:
Arthur Meyerson
Design Firm:
Pirtle Design
Dallas, TX
Client:
Arthur Meyerson
Photography
Typographer:
Southwestern
Typographics, Inc.
Printer:
Allcraft Printing

Poster:
The Germans:
The Composers
Art Director:
Jay Loucks
Designer:
C. Randall Sherman
Artist:
John Collier
Design Firm:
Loucks Atelier, Inc.
Houston, TX
Publisher:
Palmer Paper Co.
Typographer:
ProType
Printer:
Printing Resources, Inc.

THE COMPOSERS

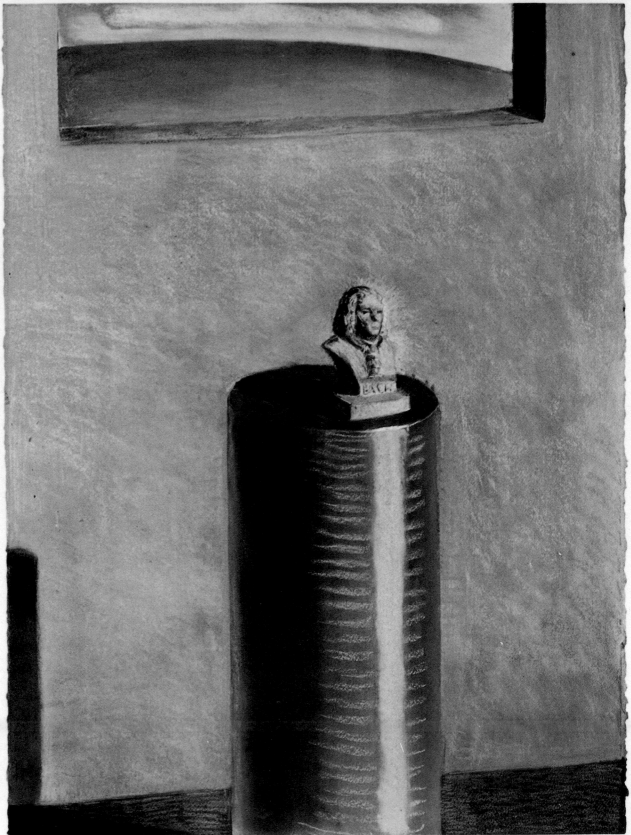

There is a magnificent line of German composers, and German-influenced composers, that begins with Johann Sebastian Bach and stretches forward through Beethoven and Mozart to the mercurial Richard Wagner. It was Bach, the consummate professional musician, who revolutionized music for his era—and centuries to come—by refusing to follow the latest local musical trends and, instead, configured his refinements and investigations into the potential of Baroque music. Born the son of a town musician, who gave Bach much of his early training in musical instruments and the primary elements of composition, Bach was a fast and productive study who was soon holding down a prized appointment as the choirmaster of a church in Lüneburg, Germany. He composed cantatas, and a variety of scores for ensembles and solo instruments. In no time at all, Bach was upsetting the church hierarchy with the radical flourishes and strange harmonies he used when accompanying the church choir on the organ. However, Bach was already so highly respected in Europe at the time, that the church would not consider dismissing him. Bach's work included writing classic books on the organ and keyboard instruments (the Well-Tempered Clavier, the Inventions, and the Little Organ Books). And composing and performing across the continent where he was regarded a keyboard superstar. Bach also found time to father 20 children by two wives, three of his sons, Karl, Wilhelm, and Johann went on to

become famous and productive composers and performers on their own. Bach's special gift—in addition to his exceptional knowledge of the organ and other keyboard instruments—was in his ability to mix various musical styles and to employ, gracefully and articulately, every resource available in the musical vocabulary. His precision at writing intricate counterpoints was legendary, but equally startling was his ability to write the musical equivalent of a concept or a verbalization. Almost three hundred years after Bach's birth, his music is still a powerful force, for outlining the musical trends of the 18th century and translating exquisitely when played by modern instruments like the electronic synthesizer. It was Bach's ability to transcend the technical aspects of musical composition, and to express feeling in his music, that make him so interesting to the artist. As all artists are aware, the key to communication is to transfer feelings and emotions from the artist, through a medium, to the viewer or listener. In all cases, the concept is to make the medium an enhancer of the emotion or feeling being expressed. And, when dealing in subtleties, the ability of the medium to capture nuance and detail, and to faithfully reproduce meaning, becomes paramount. Phoenix Imperial is paper capable of expressing your feelings, emotions, and intentions. It has been designed, engineered, and fabricated to serve one purpose: to provide the finest medium for print reproduction available today.

LEWIS STEIN

SKY PAINTINGS 1979-80

October 3–22, 1983. You are cordially invited to the opening on Monday, October 3, 5:00–7:00 pm.
Guest Curator: David Whitney. Visual Arts Museum, 209 East 23 Street, N.Y.C. 10010, 212-679-7350.
Hours: Monday–Thursday, 12:00–9:00 pm. Friday, 11:00 am–4:30 pm. Saturday, 9:00 am–4:00 pm.

VISUAL ARTS MUSEUM

Poster Invitation:
Lewis Stein:
Sky Painting
1979-1980
Art Director:
Bill Kobasz
Designer:
Bill Kobasz
Artist:
Lewis Stein
Design Firm:
School of Visual
Arts Press, Ltd.
New York, NY
Publisher:
School of Visual Arts
Typographer:
Scarlett Letters
Printer:
School of Visual
Arts Press, Ltd.

Calendar:
Zanders 1984 Calendar
Art Director:
Milton Glaser
Designer:
Milton Glaser
Artist:
Milton Glaser
Design Firm:
Milton Glaser, Inc.
New York, NY
Publisher:
Zanders Feinpapiere,
A.G.

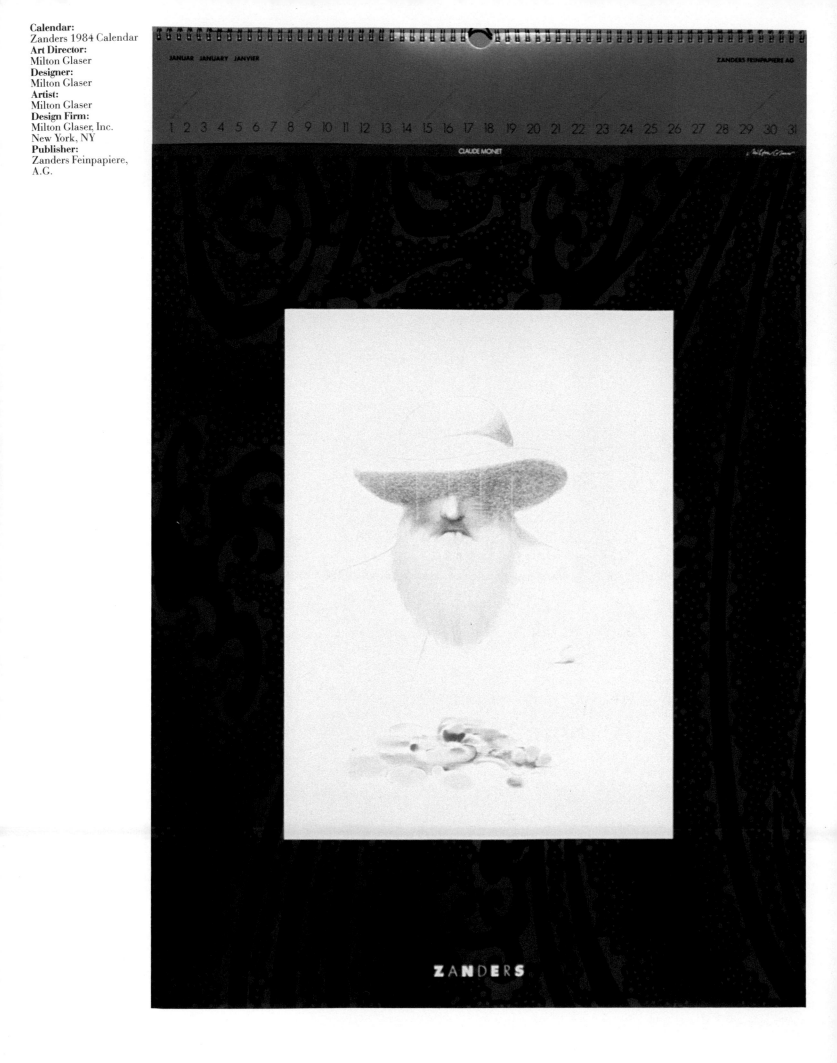

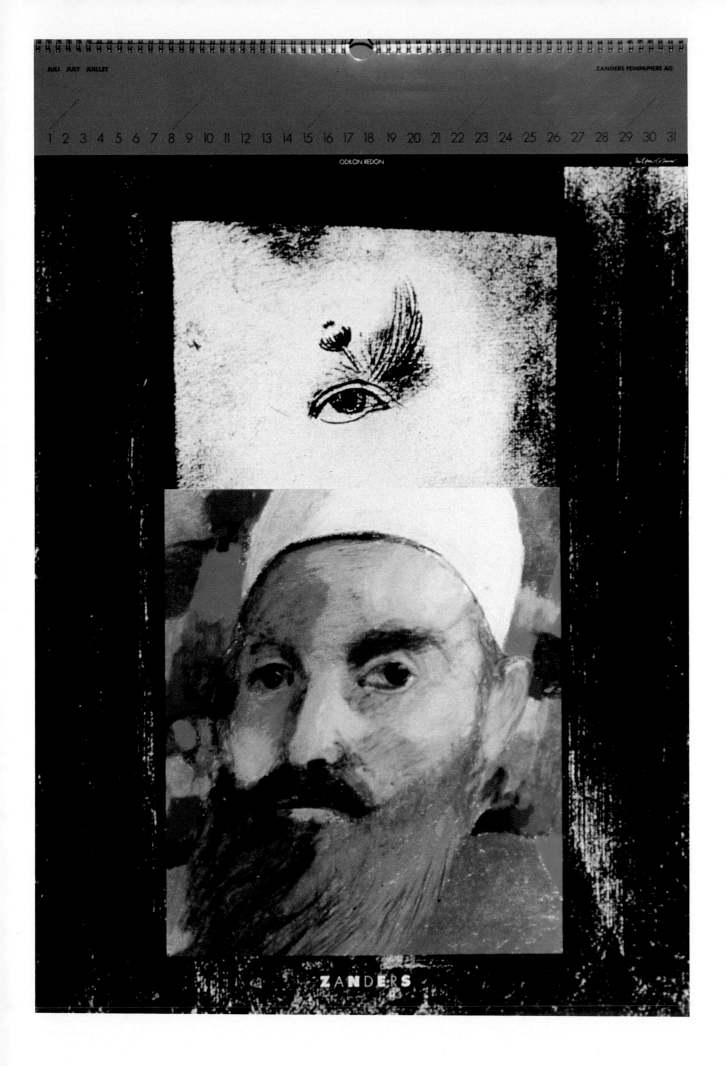

ZANDERS

Promotional Folio:
Simpson Letterform
Art Director:
James Cross
Designer:
Steve Martin
Design Firm:
Cross Assoc.
Los Angeles, CA
Client:
Simpson Paper Co.
Typographer:
Central Typesetting
Printer:
Welsh Graphics

SIMPSON

TORINO

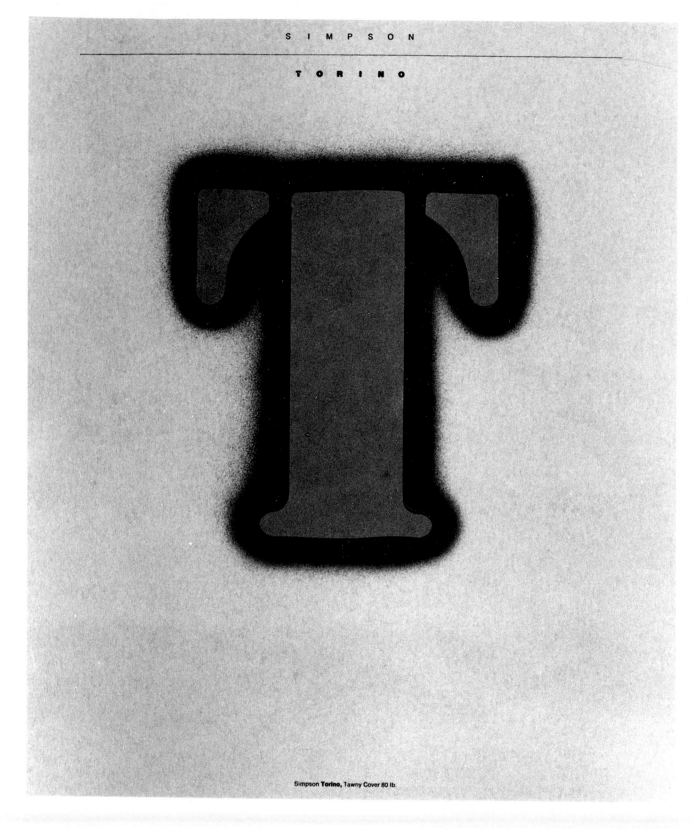

Simpson **Torino,** Tawny Cover 80 lb.

Simpson **Teton**, Gray Cover 80 lb.

Poster:
Connections
Art Director:
Jim Cross
Designer:
John Massey
Artist:
John Massey
Design Firm:
John Massey, Inc.
Chicago, IL
Client:
Simpson Paper Co.
Printer:
Rohner Printing Co.

It's a Picnic with Champion All Purpose Litho.

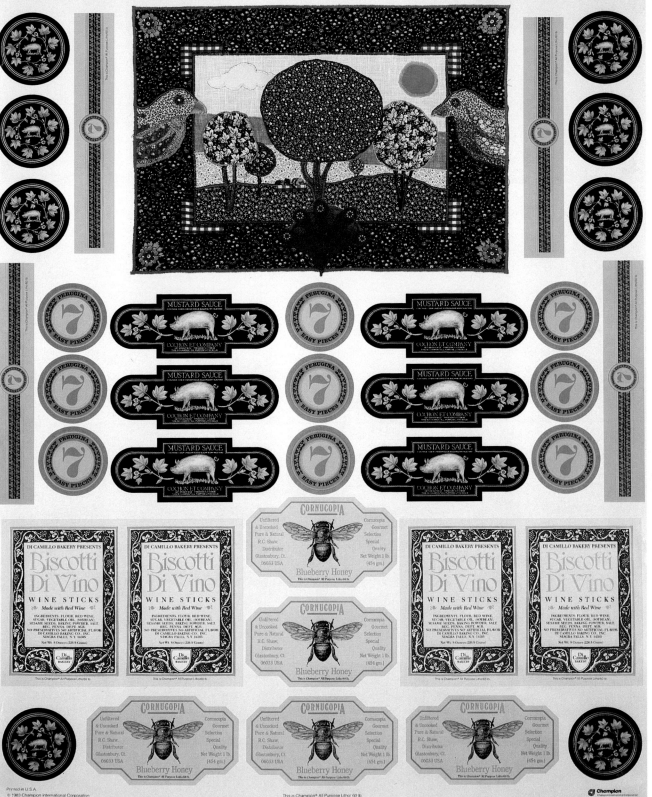

Poster:
It's a Picnic. . .
Art Director:
Peter Good
Designer:
Peter Good
Artists:
Janet Good,
Peter Good
Design Firm:
Peter Good Graphic
Design
Chester, CT
Client:
Champion International
Typographer:
Eastern Typesetting Co.
Printer:
G. S. Litho

Slipcased Booklet:
Dallas Symphony
Orchestra
Art Directors:
D.C. Stipp,
Brent Croxton
Designers:
D.C. Stipp,
Brent Croxton
Photographers:
Various
Design Firms:
Richards, Sullivan,
Brock & Assoc./
The Richards Group
Dallas, TX
Publisher:
Dallas Symphony
Orchestra
Typographer:
Chiles & Chiles
Printer:
Williamson Printing Co.

Humphrey Browning MacDougall, Inc.

request the pleasure of your company

at an evening of cocktails, dinner, dancing,

and entertainments in celebration of

Parker Brothers' One Hundredth Anniversary and

H.B.M.'s attainment of one hundred million in billings

on Thursday, the sixth of October

from six o'clock to midnight

Hasty Pudding Club, Ten Holyoke Street

Cambridge, Massachusetts

R. S. V. P.

Black Tie

M

○ *will* ○ *will not attend*

○ *will* ○ *will not require parking*

Please respond by September the Twentieth

Invitation:
Parker Brothers 100th
Anniversary
Art Directors:
David Lopes,
Cheryl Heller
Designer:
David Lopes
Artist:
Michael Orzech
Design Firm:
HBM Design Group
Boston, MA
Publisher:
HBM/Creamer
Client:
Parker Brothers
Typographer:
Typographic House
Printer:
Daniels

UNIFORMITY

to mean the same old thing. Uniform
results repeat themselves time after t
ing corn; reliable when you're repro

SURFACE

is more than
meets the eye. Beneath the
smooth surface of a billiard
ball are unseen elements of
strength, solidity, and bal-
ance. Beneath the smooth
surface of S. D. Warren
Cameo Dull are all the
elements needed to rack
up superb printed results.

HOLDOUT

is a protective screen keeping out un-
wanted elements. To maintain the sharpness
and intensity of your printed impres-
sion, we suggest the outstanding ink hold-
out qualities of S. D. Warren Cameo Dull.

Magazine Ads:
Holdout, Surface,
Uniformity
Art Director:
Cheryl Heller
Designer:
Cheryl Heller
Photographers:
Ron Scott, Harald Sund,
Bruno Joachim, Shigeta
Assoc.
Design Firm:
HBM Design Group
Boston, MA
Client:
S.D. Warren Paper Co.
Typographer:
Typographic House
Printer:
National Bickford
Foremost

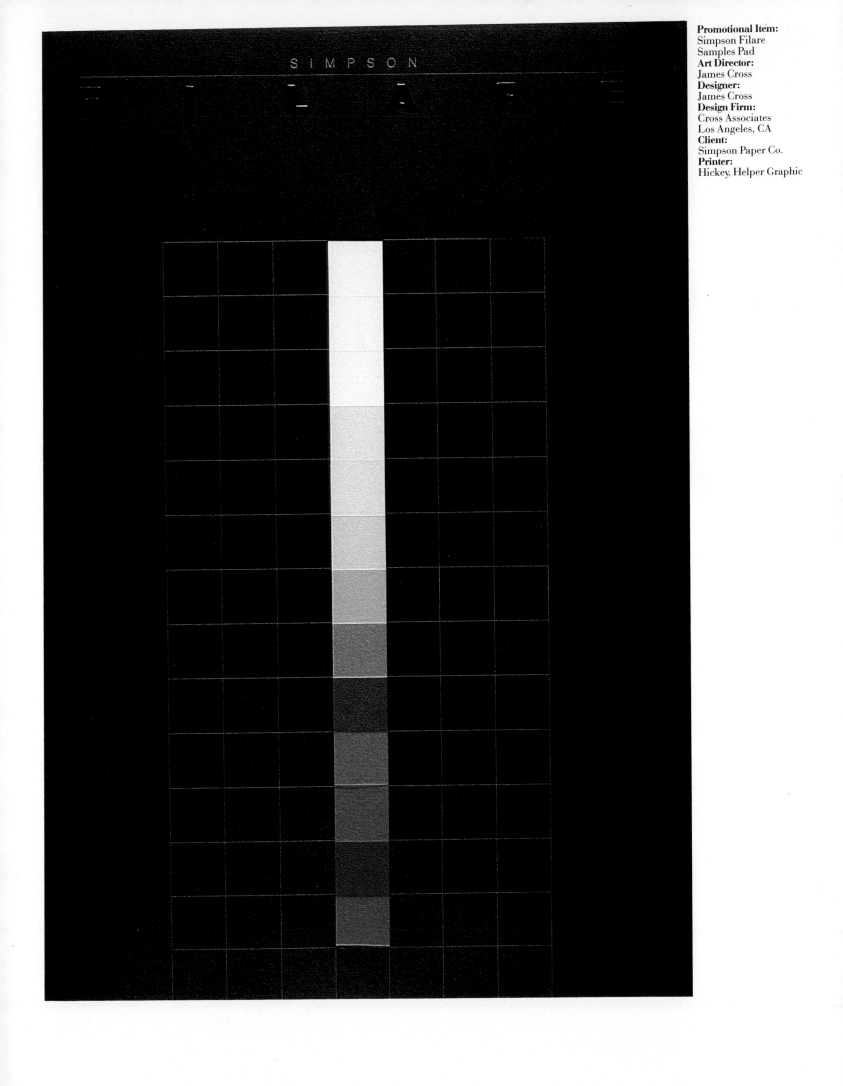

Promotional Item:
Simpson Filare
Samples Pad
Art Director:
James Cross
Designer:
James Cross
Design Firm:
Cross Associates
Los Angeles, CA
Client:
Simpson Paper Co.
Printer:
Hickey, Helper Graphic

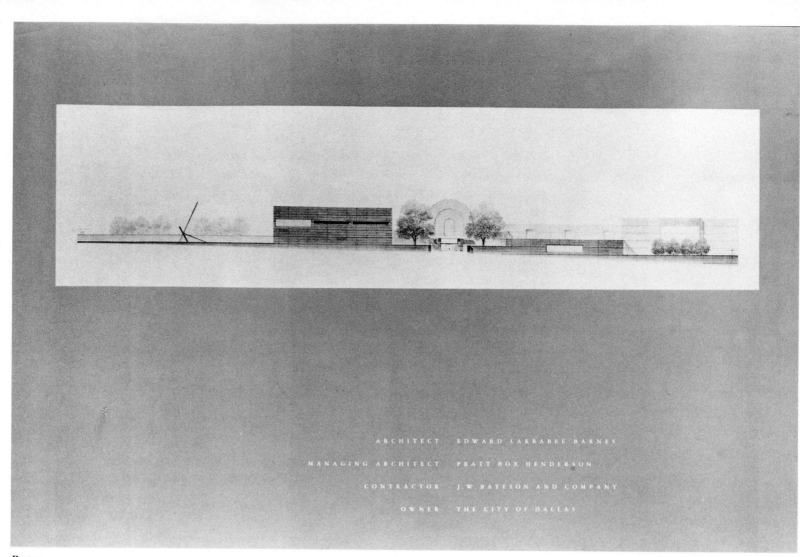

ARCHITECT EDWARD LARRABEE BARNES

MANAGING ARCHITECT PRATT BOX HENDERSON

CONTRACTOR J. W. BATESON AND COMPANY

OWNER THE CITY OF DALLAS

Poster:
Dallas Museum of Art
Art Director:
Woody Pirtle
Designer:
Woody Pirtle
Design Firm:
Pirtle Design
Dallas, TX
Publisher:
Dallas Museum of Art
Typographer:
Southwestern
Typographics, Inc.
Printer:
Brodnax Printing

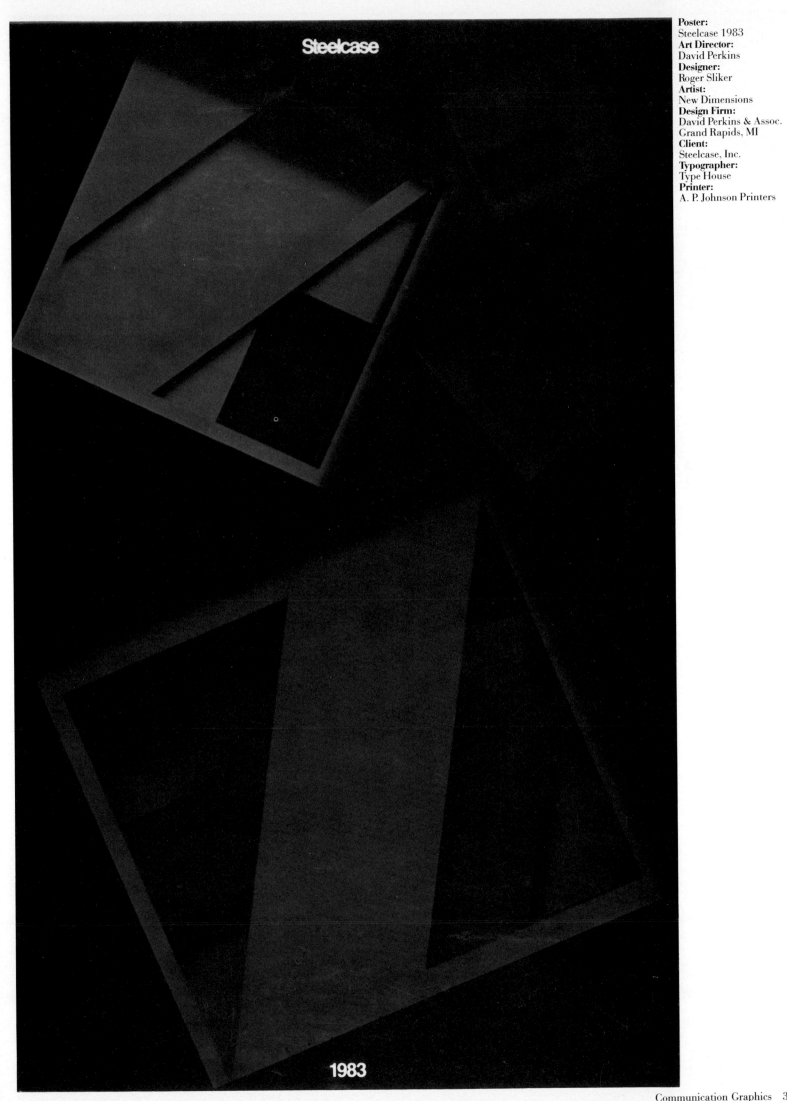

Poster:
Steelcase 1983
Art Director:
David Perkins
Designer:
Roger Sliker
Artist:
New Dimensions
Design Firm:
David Perkins & Assoc.
Grand Rapids, MI
Client:
Steelcase, Inc.
Typographer:
Type House
Printer:
A. P. Johnson Printers

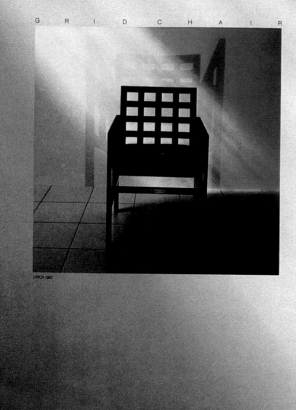

G R I D C H A I R

CIRCA 1982

In the tradition of ancient Egypt, Momoyama Japan and Renaissance Italy. Interpreted by architects Charles Rennie Mackintosh, Josef Hoffmann and Luis Barragan. Ward Bennett redefines the form. The Grid Chair,™ a small scale pull-up for dining, conference or executive suites. Handcrafted of kiln dried solid ash in a variety of finishes. With upholstered seat. Brickel Associates Inc., 515 Madison Ave., New York, New York 10022, 212 MU 8-2233.

Magazine Ad:
The Grid Chair
Art Director:
Michael Donovan
Designer:
Jane Zash
Photographer:
Amos T. S. Chan
Design Firm:
Donovan and Green
New York, NY
Client:
Brickel Assoc., Inc.
Typographer:
Concept Typographers

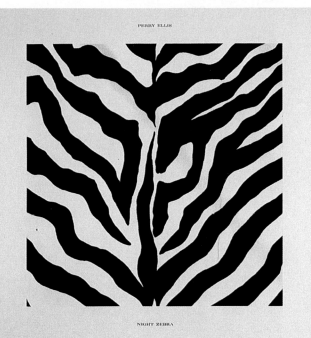

PERRY ELLIS

NIGHT ZEBRA

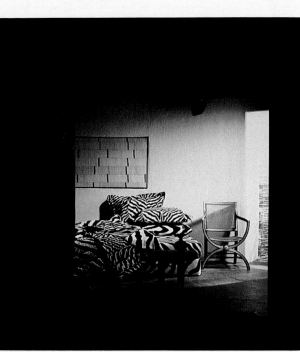

MARTEX

WALL STREET

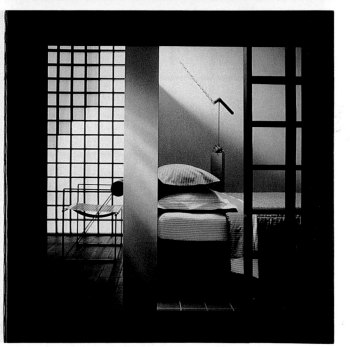

Promotional Catalogue:
Martex: 4 Collections
Art Director:
James Sebastian
Designers:
James Sebastian,
Michael McGinn
Jim Hinchee
Photographer:
Bruce Wolf
Design Firm:
Designframe, Inc.
New York, NY
Client:
Martex/West Point
Pepperell
Typographer:
Pastore DePamphilis
Rampone
Printer:
Crafton Graphic Co.,
Inc.

Poster:
Goodwill Opens Doors
Art Director:
Alan Lidji
Designer:
Alan Lidji
Photographer:
Laynie Lidji
Design Firm:
Cunningham & Walsh
Dallas, TX
Client:
Goodwill Industries
Typographer:
JCS
Printer:
The Jarvis Press

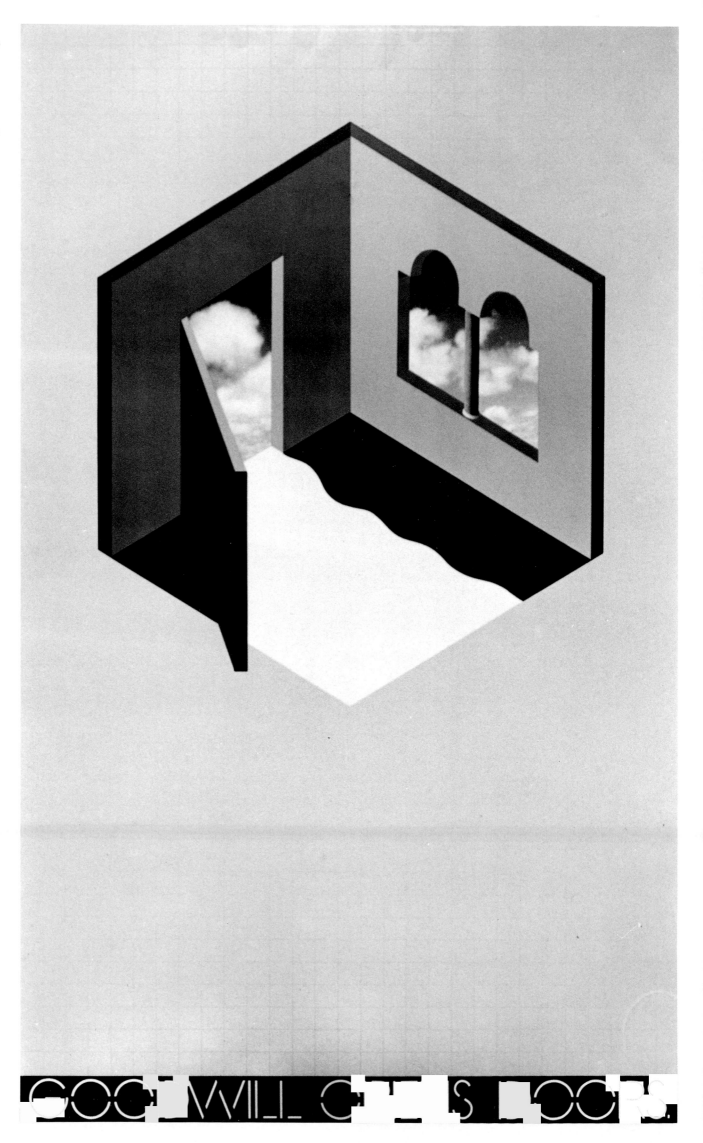

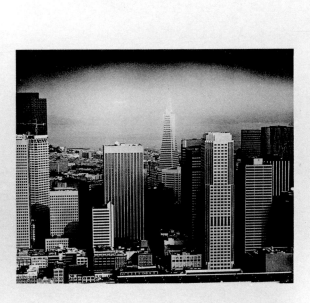

Brochure:
Barker Interests Ltd.
Art Director:
Jerry Herring
Designer:
Jerry Herring
Photographers:
Steve Brady, Richard
Payne, John Blaustein
Design Firm:
Herring Design
Houston, TX
Client:
Barker Interests Ltd.
Typographer:
Professional
Typographers, Inc.
Printer:
Grover Printing

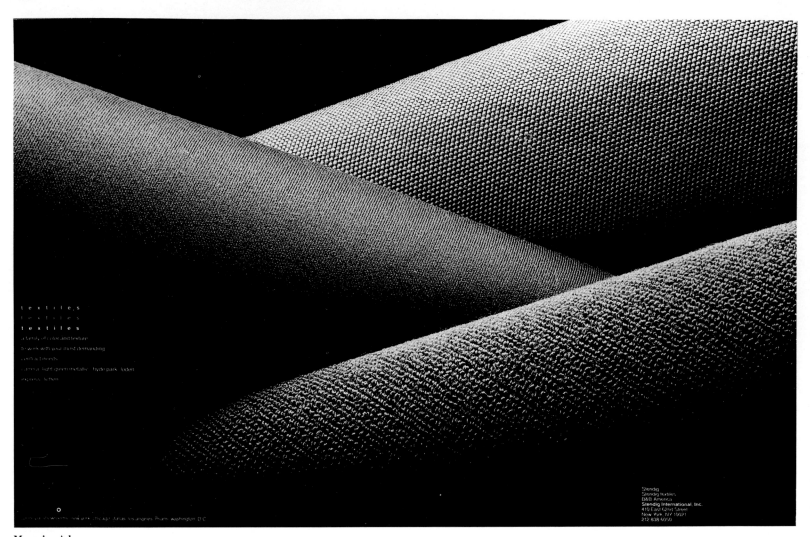

Magazine Ad:
Textiles—a family of
colors. . . .
Art Director:
Bridget DeSocio
Designer:
Bridget DeSocio
New York, NY
Photographer:
Bill White
Publisher:
Stendig International
Typographer:
Nassau Typographers
Printer:
Sterling Roman Press

324

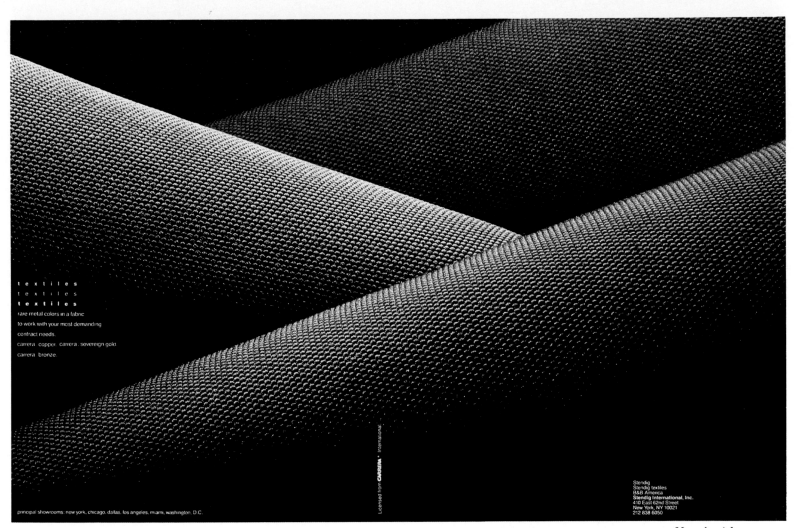

textiles
t e x t i l e s
textiles
rare metal colors in a fabric
to work with your most demanding
contract needs.
carrera. copper. carrera. sovereign gold.
carrera. bronze.

principal showrooms: new york, chicago, dallas, los angeles, miami, washington, D.C.

Licensed from **CARRERA** International.

Stendig
Stendig textiles
B&B America
Stendig International, Inc.
410 East 62nd Street
New York, NY 10021
212 838 6050

Magazine Ad:
Textiles—rare metal
colors. . . .
Art Director:
Bridget DeSocio
Designer:
Bridget DeSocio
New York, NY
Photographer:
Bill White
Publisher:
Stendig International
Typographer:
Nassau Typographers
Printer:
Sterling Roman Press

Booklet:
The Atrium
Art Director:
Jann Church
Designers:
Jann Church,
Lea Pascoe
Photographer:
O.E. Photographers
Design Firm:
Jann Church Partners,
Marketing &
Advertising Design
Newport Beach, CA
Client:
The French & McKenna
Co.
Typographer:
Andresen Typographics
Printer:
I.P.D. Printing &
Distributing, Inc.

THE
ATRIUM

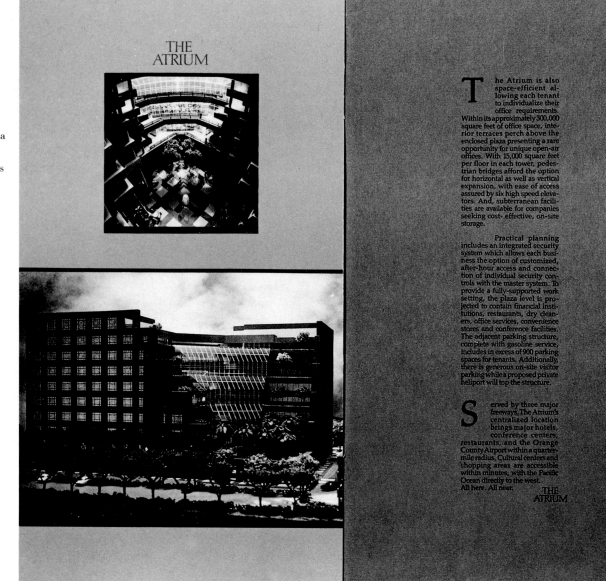

The Atrium is also space-efficient allowing each tenant to individualize their office requirements. Within its approximately 300,000 square feet of office space, interior terraces perch above the enclosed plaza presenting a rare opportunity for unique open-air offices. With 15,000 square feet per floor in each tower, pedestrian bridges afford the option for horizontal as well as vertical expansion, with ease of access assured by six high speed elevators. And, subterranean facilities are available for companies seeking cost-effective, on-site storage.

Practical planning includes an integrated security system which allows each business the option of customized, after-hour access and connection of individual security controls with the master system. To provide a fully-supported work setting, the plaza level is projected to contain financial institutions, restaurants, dry cleaners, office services, convenience stores and conference facilities. The adjacent parking structure, complete with gasoline service, includes in excess of 900 parking spaces for tenants. Additionally, there is generous on-site visitor parking while a proposed private heliport will top the structure.

Served by three major freeways, The Atrium's centralized location brings major hotels, conference centers, restaurants, and the Orange County Airport within a quarter-mile radius. Cultural centers and shopping areas are accessible within minutes, with the Pacific Ocean directly to the west. All here. All near.
THE
ATRIUM

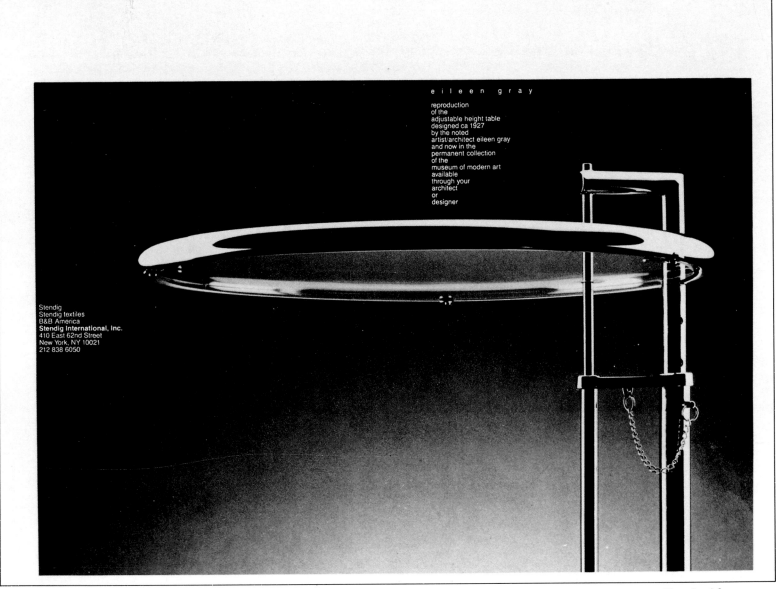

eileen gray

reproduction
of the
adjustable height table
designed ca 1927
by the noted
artist/architect eileen gray
and now in the
permanent collection
of the
museum of modern art
available
through your
architect
or
designer

Stendig
Stendig textiles
B&B America
Stendig International, Inc.
410 East 62nd Street
New York, NY 10021
212 838 6050

Magazine Ad:
Eileen Gray
Art Director:
Bridget DeSocio
Designer:
Bridget DeSocio
New York, NY
Photographer:
Bill White
Publisher:
Stendig International
Typographer:
Nassau Typographers
Printer:
Sterling Roman Press

Poster:
The Germans: Das
Bauhaus
Art Directors:
Jay Loucks,
C. Randall Sherman
Designer:
C. Randall Sherman
Photographer:
Joe Baraban
Design Firm:
Loucks Atelier, Inc.
Houston, TX
Publisher:
Palmer Paper Co.
Typographer:
ProType
Printer:
Printing Resources, Inc

Poster:
HBF-Hickory Business
Furniture
The New
Tradition
Art Director:
Michael Vanderbyl
Designer:
Michael Vanderbyl
Artist:
Michael Vanderbyl
Design Firm:
Vanderbyl Design
San Francisco, CA
Publisher:
Hickory Business
Furniture

DAS BAUHAUS

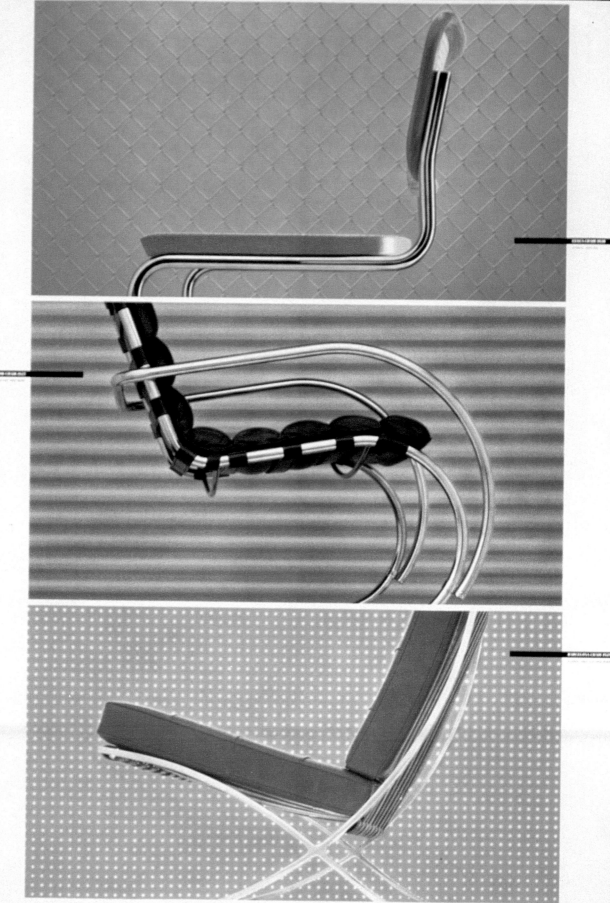

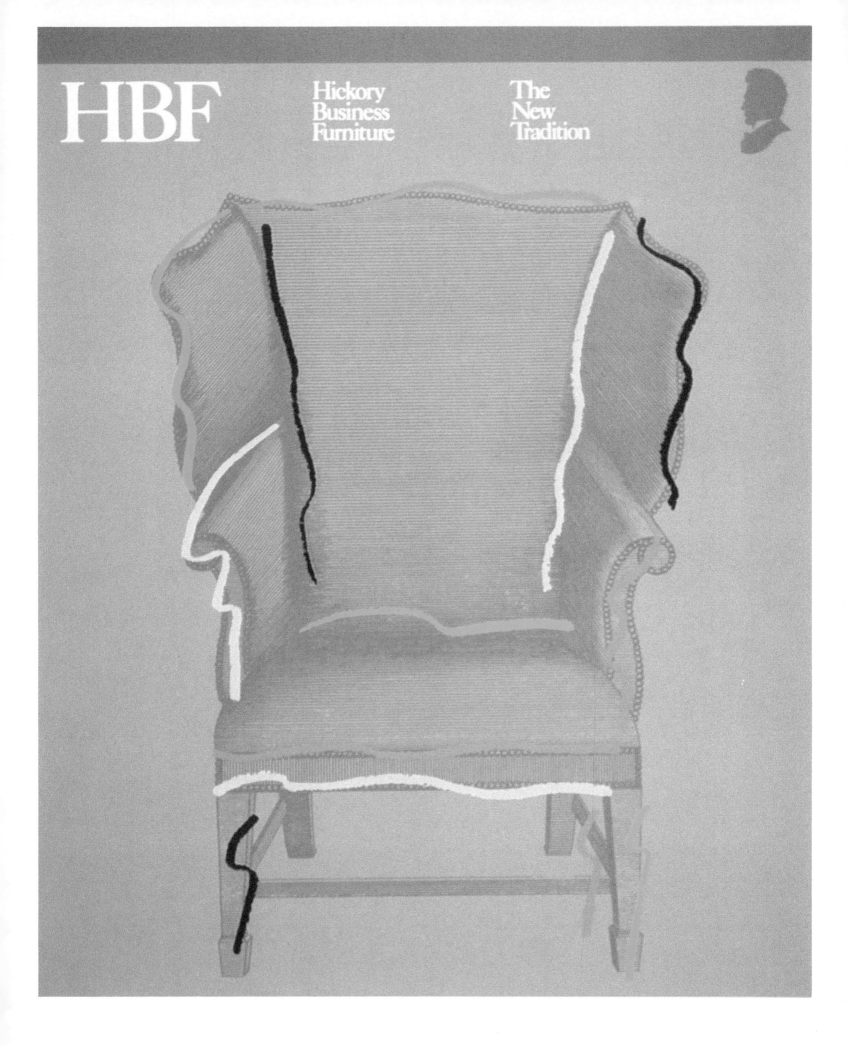

HBF

Hickory
Business
Furniture

The
New
Tradition

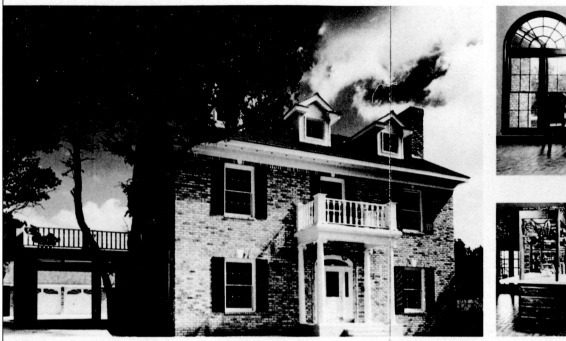

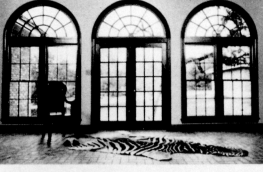

IN A SCHOLL HOME, YOU'LL BE SHOWN WHAT TALENT AND PATIENCE CAN DO. NO DETAIL, NO MATTER HOW MINUTE, HAS BEEN CONSIDERED TRIVIAL ENOUGH TO IGNORE OR TOO TROUBLESOME TO PERFECT. BECAUSE EVERY SQUARE INCH OF EVERY SCHOLL HOME HAS FELT THE TRAINED TOUCH OF A SKILLED CRAFTSMAN.

THAT TOUCH IS UNMISTAKABLE, CONFIDENT, INCOMPARABLE. IT IS THE SIGNATURE OF SCHOLL.

Brochure:
Jacobian Revival
Fredericksburg Stone
Classic Georgian
Designer:
Janis Koy
Photographer:
Bob Maxham
Design Firm:
Koy Design, Inc.
San Antonio, TX
Client:
Michael A. Scholl
Enterprises
Typographer:
Protype of San Antonio
Printer:
Superb Litho, Inc.

Brochure:
Learning in the Light
Art Director:
McRay Magleby
Designer:
Bryan Peterson
Photographers:
John Snyder, Jerry Bybee
Design Firm:
Brigham Young
University
Graphic
Communications
Provo, UT
Publisher:
Brigham Young
University
Typographer:
Brigham Young
University
Printing Service
Printer:
Brigham Young
University
Printing Service

Although headquarters of the LDS Church
Educational System are in Salt Lake
City—adjacent to historic Temple Square—its
reach is worldwide. Enrollment in Church secular
schools, seminaries and institutes, and institutions
of higher learning now exceeds 370,000 in 68
countries and territories. Nearly 19,000 full- and
part-time faculty are involved.

Booklet:
June 16, 1982
New York, New York
Art Director:
Chris Hill
Designers:
Chris Hill, Joe Rattan
Photographer:
Chris Hill
Design Firm:
Hill/A Graphic Design
Group
Houston, TX
Publisher:
Chris Hill
Typographer:
Professional
Typographers, Inc.
Printer:
Superb Litho, Inc.

ADOLPHUS HOTEL 1915 · Robert Bender

HYATT REGENCY 1978 · Phil Hollenbeck

Poster:
Cities
Art Director:
Michael Vanderbyl
Designer:
Michael Vanderbyl
Artist:
Michael Vanderbyl
Design Firm:
Vanderbyl Design
San Francisco, CA
Typographer:
Headliners/Identicolor
Printer:
Pischoff Signage Co.

3:36 P.M.

3:49 P.M.

C I T I E S

CITIES:
Urban Lessons for San Francisco

The Galleria Design Center
101 Henry Adams (formerly Kansas) Street
Tuesdays and one Thursday at 7:30 pm
September 21, 28, October 12, 19, November 4, 16, 1982

"What makes certain cities great? is the question addressed by four scholars and two architects speaking in the fourth annual lecture series sponsored by the American Institute of Architects, San Francisco Chapter and the San Francisco Museum of Modern Art. No-host bar from 5:30-7:30 pm; no-host light supper and dessert by Bon Appetit beginning at 6:00.

Series Tickets:
Advanced subscriptions are available only to members of the AIA and the Museum through August 16, 1982, at $30 per series ticket. Please make checks payable to AIA/SF and enclose a self-addressed and stamped envelope. Payment should be sent to Cities Lecture Series, American Institute of Architects, San Francisco Chapter, 790 Market Street, San Francisco, Ca. 94102. Series tickets will be made available to the general public on August 16.

Individual lecture tickets (general public $7, SFMMA and AIA members $6; students and seniors $4) available at the door only with space permitting. Seating for all ticket holders is on a first-come first-serve basis.

Tuesday, September 21: Professor Reyner Banham,
"Tale of Three Cities London, Los Angeles, San Francisco." Author of The New Brutalism, 1971, and Megastructures, 1976. Professor of the History of Art at the University of California, Santa Cruz. "I make no apology for it. The splendours and miseries of Los Angeles, the graces and grotesqueries, appear to me as

Tuesday, September 28: Professor Heinrich Klotz,
"Knitting and Fitting the Cities-Berlin and Frankfurt." Author of Conversations with Architects. Director of the Deutsche Architekturmuseum, Frankfurt, and professor at the Philipps Universität, Marburg. Also, a member of the Jury of the Berlin Architecture Competition, 1982. "American architecture today is represented in a pluralism of styles, by many voices speaking simultaneously ... After World War II, as the influence of the International Style began to break down, architecture became increasingly independent of European prototypes." John W. Cook and Heinrich Klotz, Conversations with Architects, 1973.

Tuesday, October 12: Moshe Safdie, architect,
"Context." Speaking on Habitat and Jerusalem. Designed Habitat for Expo 67 in Montreal. Professor of Architecture and Urban Design, Harvard University, and author of Beyond Habitat, 1970. "The wonderful thing about living in Habitat during Expo 67 was that it was exactly the way I envisioned it to be – a community, almost rural in nature, in the city."

Tuesday, October 19: James Wines, architect,
"Identity and Density-Personalized Image within the Context of High Rise Architecture." Founder of SITE, Inc., a collaborative of artists and architects.

unrepeatable as they are unprecedented. I share neither the optimism of those who see Los Angeles as the prototype of all future cities, nor the gloom of those who see it as the harbinger of universal urban doom."

Tuesday, October 26: Professor Spiro Kostof,
Designer of BEST Products showrooms. SITE's statement of purpose: Architecture as Art rather than Design: "Architecture as art is a means for responding to social, psychological, and environmental influences for monitoring sub-conscious rituals and impulses of a cultural context. Architecture as art implies a new iconographic role for buildings derived from an acknowledgment that the idea of a structure generates as an extension of its own internal functions are neither as valid, nor as interesting as those it absorbs from the outside."

Thursday, November 4: Professor Spiro Kostof,
"The Esthetics of Demolition – an Historical Look at Urban Renewal." Author of The Third Rome, 1973; Caves of God: The Monastic Environment of Byzantine Cappadocia, 1972. Professor of the History of Architecture, University of California, Berkeley. "PREAMBLE: Rape ... The third such ... Betrayal of historic patrimony. For many who know and love Rome, what has happened to it in the last one hundred years can only be characterized in such terms. After the Goths and the Vandals, after the mercenaries of Charles V in 1527, the fateful city succumbed one final time to a spectacular ravaging. It came at the hands of its own people-politicians, landowners, speculators ..."

Tuesday, November 16: Bernard Rudofsky, author,
"The Well-Tempered Cityscape: a Plea for Urban Urbanity." Has written many books including Architecture without Architects, 1964; Streets for People, 1969; The Unfashionable Human Body, 1974; and The Prodigious Builders, 1977. "The American city has always been the repository of the inhabitants' collective lack of know-how and no other facet of national life illustrates the shortage of instinct, imagination, and grace as does the urban environment. Nevertheless, many Americans regard ugly cities as an asset, for they produce that tough streak in man that makes him eminently fit to survive in an atmosphere of ruthless competition."

Brochure:
Napa Valley Corporate
Park
Art Director:
Michael Vanderbyl
Designer:
Michael Vanderbyl
Photographer:
Monica Lee
Design Firm:
Vanderbyl Design
San Francisco, CA
Client:
Bedford Properties
Typographer:
Community Press
Printer:
James H. Barry

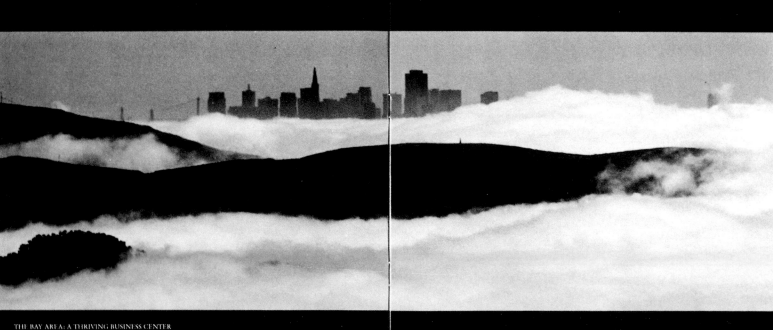

THE BAY AREA: A THRIVING BUSINESS CENTER

The San Francisco Bay Area, a land of great natural beauty, mild climate, and cultural and recreational diversity, has a well-deserved reputation as one of the most appealing spots on earth.

In addition to unexcelled amenities, the Bay Area also possesses a healthy mix of industrial and non-industrial enterprises and a thriving economic climate that has attracted corporations of both national and international renown. From shipping to manufacturing, retail to financial, real estate to agriculture, Bay Area industries continue to enjoy dynamic growth in a state whose population is expected to jump from 24 to almost 32 million by the year 2020 (an average annual increase of 1.4 percent from 1980 onwards).

Close to the Bay Area's urban centers is one of California's treasured landmarks, Napa Valley, site of the country's premier vineyards and the 246-acre Napa Valley Corporate Park.

Pecanland Mall will bring together, just as the Ouachita Valley does, historic and contemporary facets of the area. Because we believe that a center should reflect the community's spirit, the local architectural firm of ARCHITECTURE + was chosen to create a design that captures both the heritage and the dynamic pace of the area. In the finest tradition, Pecanland Mall will be gracious. And, in keeping with the community's progressive spirit, it will be the finest shopping experience ever enjoyed in this region. Pecanland Mall will provide – in the most contemporary terms – a cool, comfortable environment: a fitting legacy from the site's sprawling shady pecan trees for which the center is named.

Brochure:
Pecanland Mall
Art Director:
Don Sibley
Designer:
Don Sibley
Photographers:
Gary McCoy, Bill Summer
Design Firm:
Sibley/Peteet Design, Inc.
Dallas, TX
Client:
Paul Broadhead & Assoc.
Typographer:
Southwestern Typographics, Inc.
Printer:
Williamson Printing Co.

Brochure:
Rosewood Properties
Art Director:
Dennis Benoit
Designer:
Dennis Benoit
Photographer:
Bill Crump
Design Firm:
Ben-Wah Design, Inc.
Dallas, TX
Client:
Rosewood Properties
Typographer:
Southwestern
Typographics, Inc.
Printer:
PM Press

Rosewood Properties is active in land acquisition for our own commercial developments as well as for long term investment.

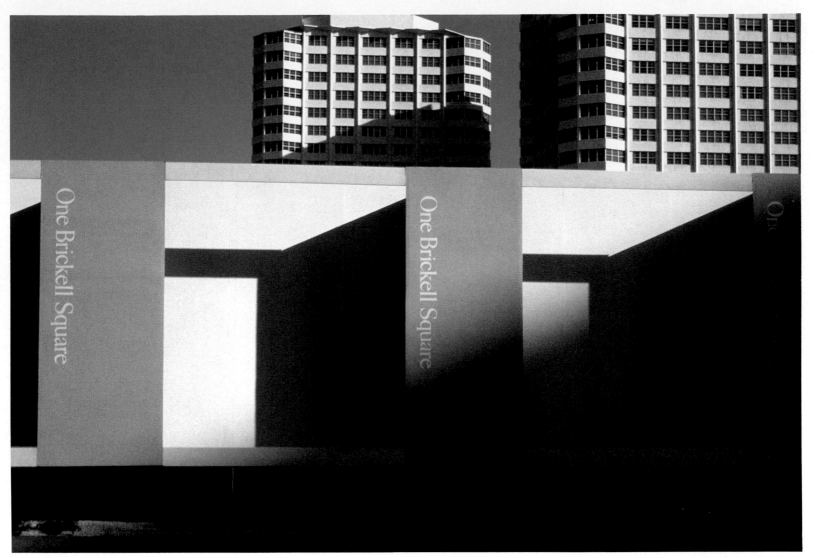

**Environmental
Graphics:**
Construction Fence
Art Director:
Tom Geismar
Designer:
Tom Geismar
Design Firm:
Chermayeff & Geismar
Assoc.
New York, NY
Client:
Tishman-Speyer
Properties
Fabricator:
George Hyman
Construction Co.

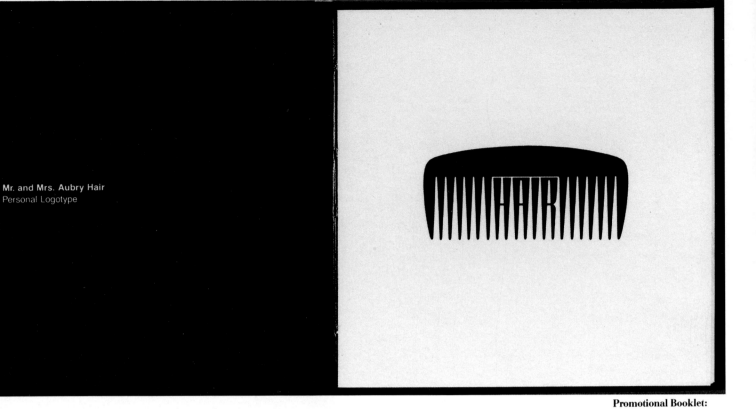

Mr. and Mrs. Aubry Hair
Personal Logotype

Promotional Booklet:
Pirtle Design Logos
Art Director:
Woody Pirtle
Designer:
Woody Pirtle
Artist:
Pirtle Design
Design Firm:
Pirtle Design
Dallas, TX
Publisher:
Pirtle Design
Typographer:
Southwestern
Typographics, Inc.
Printer:
Williamson Printing Co.

Promotional Item:
Yellow Pad Paperweight
Art Director:
Tibor Kalman
Designer:
Tibor Kalman
Design Firm:
M & Co.
New York, NY
Publisher:
M. & Co.

Brochure:
HMBW Interior
Architecture
Art Director:
Jack Summerford
Designer:
Jack Summerford
Photographer:
James F. Wilson
Design Firm:
Summerford
Design, Inc.
Dallas, TX
Client:
Haldeman Miller
Bregman Hamann
Typographer:
Southwestern
Typographics, Inc.
Printer:
Heritage Press

Bedrock Development Corporation
Corporate Headquarters

IBM Customer Demonstration Area
and Usability Test Lab

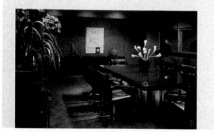

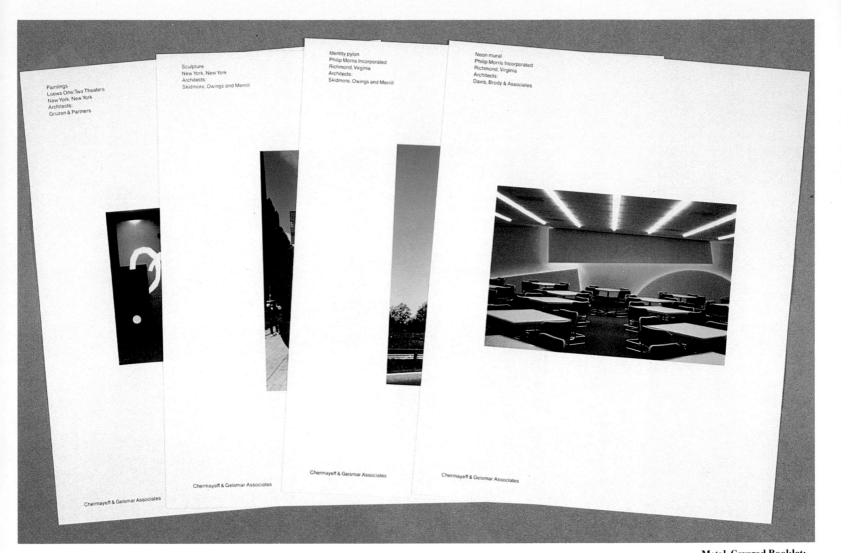

Paintings
Loews One/Two Theaters
New York, New York
Architects:
Gruzen & Partners

Sculpture
New York, New York
Architects:
Skidmore, Owings and Merrill

Identity pylon
Philip Morris Incorporated
Richmond, Virginia
Architects:
Skidmore, Owings and Merrill

Neon mural
Philip Morris Incorporated
Richmond, Virginia
Architects:
Davis, Brody & Associates

Chermayeff & Geismar Associates

Chermayeff & Geismar Associates

Chermayeff & Geismar Associates

Chermayeff & Geismar Associates

Metal-Covered Booklet:
Art in Architecture
Art Director:
Chermayeff & Geismar
Assoc.
Designer:
Chermayeff & Geismar
Assoc.
Artists/Photographers:
Various
Design Firm:
Chermayeff & Geismar
Assoc.
New York, NY
Publisher:
Chermayeff & Geismar
Assoc.
Typographer:
Print & Design
Printer:
Saunders
Manufacturing

Promotional Folio:
Simpson Photography
Art Director:
James Cross
Designer:
Steve Martin
Photographers:
Various
Design Firm:
Cross Assoc.
Los Angeles, CA
Client:
Simpson Paper Co.
Typographer:
Central Typesetting
Printer:
George Rice & Sons

C O R S I C A N

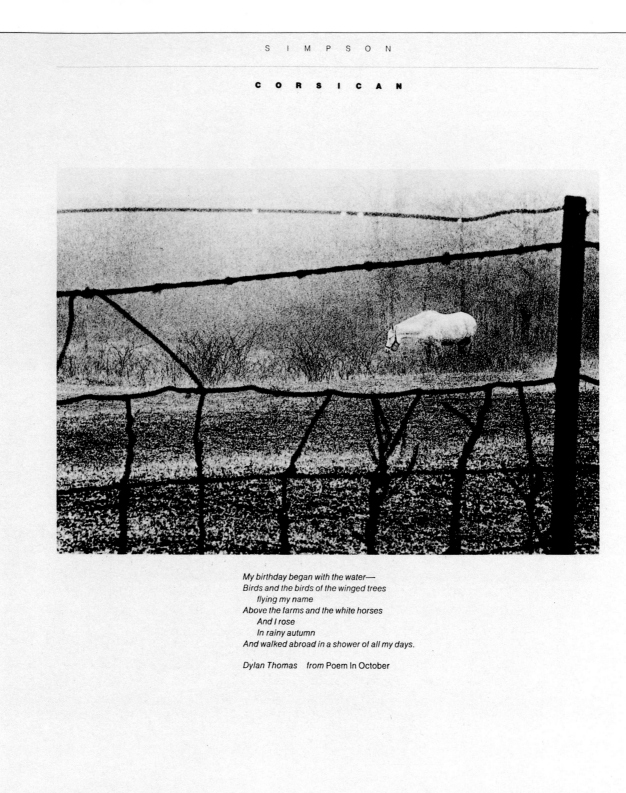

My birthday began with the water—
Birds and the birds of the winged trees
 flying my name
Above the farms and the white horses
 And I rose
 In rainy autumn
And walked abroad in a shower of all my days.

Dylan Thomas from Poem In October

Simpson **Corsican**, White Text 80 lb.

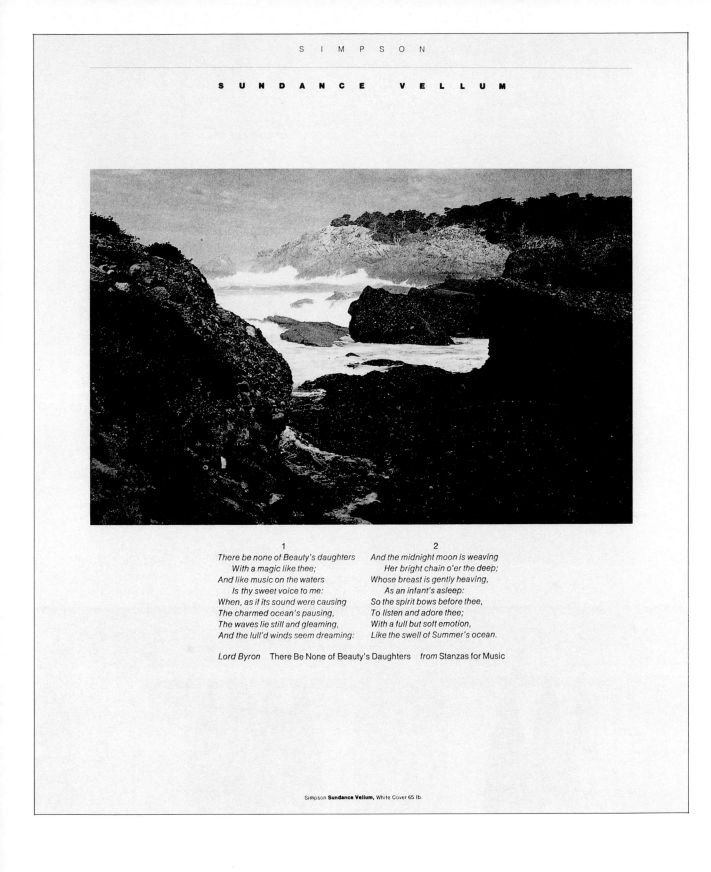

1

There be none of Beauty's daughters
 With a magic like thee;
And like music on the waters
 Is thy sweet voice to me:
When, as if its sound were causing
The charmed ocean's pausing,
The waves lie still and gleaming,
And the lull'd winds seem dreaming:

2

And the midnight moon is weaving
 Her bright chain o'er the deep;
Whose breast is gently heaving,
 As an infant's asleep:
So the spirit bows before thee,
To listen and adore thee;
With a full but soft emotion,
Like the swell of Summer's ocean.

Lord Byron There Be None of Beauty's Daughters *from* Stanzas for Music

Simpson **Sundance Vellum,** White Cover 65 lb.

Promotional Catalogue:
Perry Ellis/Martex
Art Director:
James Sebastian
Designers:
James Sebastian,
Michael McGinn,
Jim Hinchee
Photographer:
Bruce Wolf
Design Firm:
Designframe, Inc.
New York, NY
Client:
Martex/West Point
Pepperell
Typographer:
M. J. Baumwell
Printer:
Crafton Graphic Co., Inc.

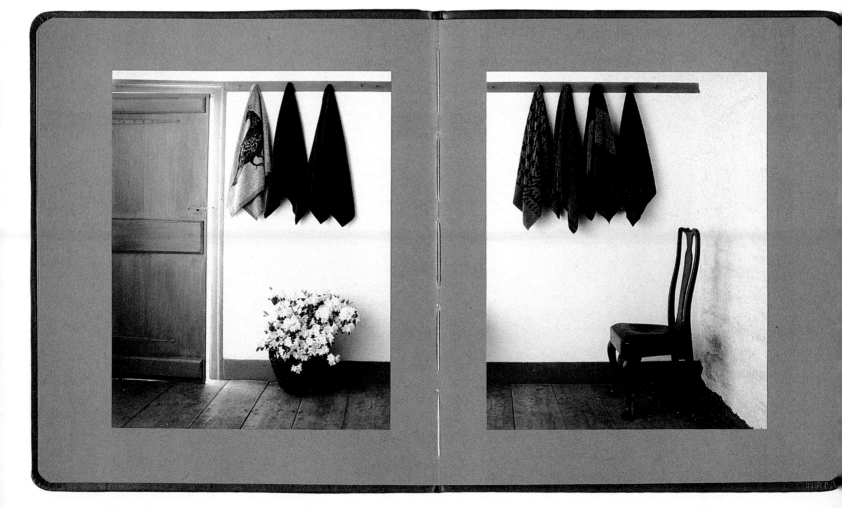

C
H
A
P
T
E
R

Instructional Manual:
MAD Computer:
MS-DOS
Reference Guide
Art Directors:
Mark Anderson,
Steve Tolleson
Designer:
Steve Tolleson
Design Firms:
Mark Anderson Design
Steve Tolleson Design
San Francisco, CA
Client:
MAD Computer, Inc.
Typographer:
Frank's Type
Printer:
The National Press

Newsletter:
The Stendig Statement
#2
Art Director:
Bridget DeSocio
Designer:
Bridget DeSocio
New York, NY
Photographer:
Henry Wolf
Publisher:
Stendig International
Typographer:
Nassau Typographers
Printer:
Sterling Roman Press

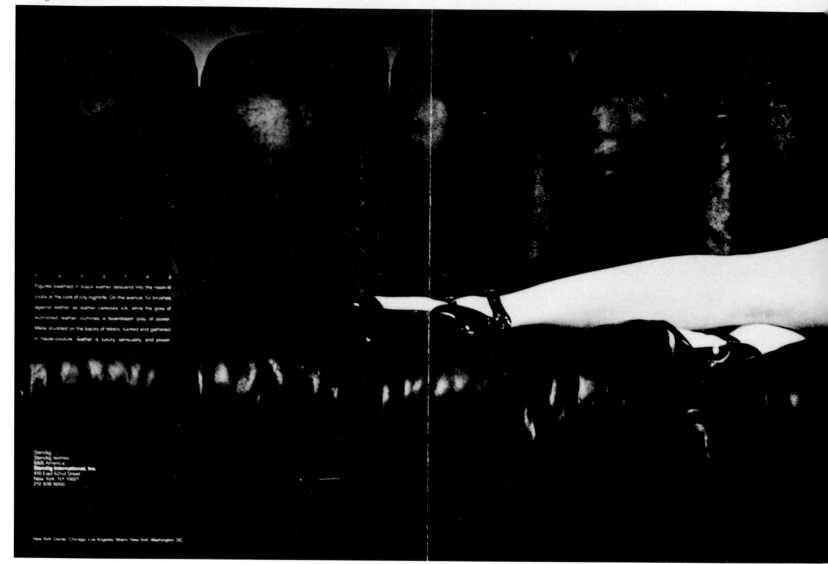

346

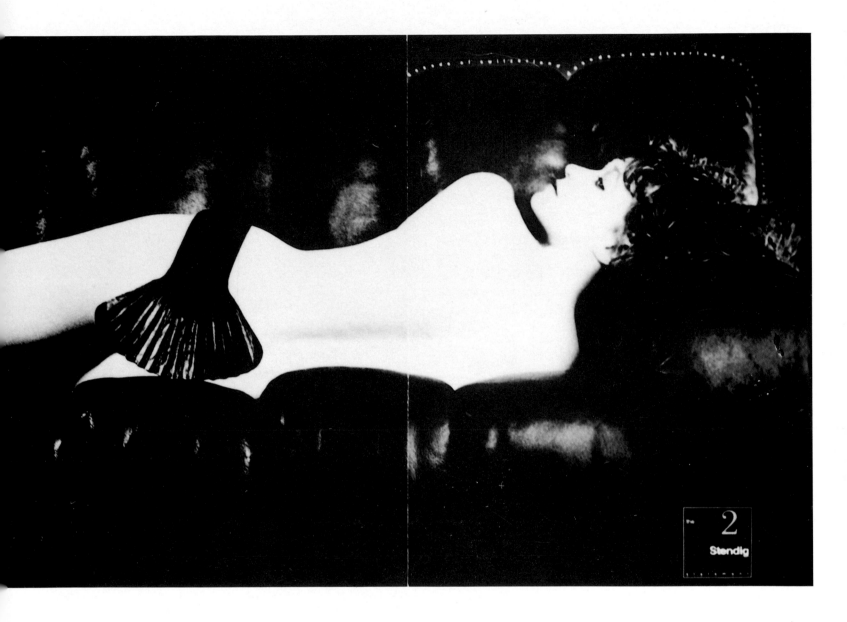

Brochure:
City Post Oak Traffic
Improvement Plan
Art Director:
Chris Hill
Designers:
Chris Hill,
Joe Rattan
Artist:
Regan Dunnick
Design Firm:
Hill/A Graphic Design
Group
Houston, TX
Client:
Gerald D. Hines Interests
Typographer:
Professional
Typographers, Inc.
Printer:
Grover Printing Co.

City Post Oak

Traffic Improvement Plan

February

S M T W T F S
 1 2 3 4
5 6 7 8 9 10 11
12 13 14 15 16 17 18
19 20 21 22 23 24 25
26 27 28 29

12 Lincoln's Birthday

14 St. Valentine's Day

20 Washington's Birthday

We have provided design services to National Gypsum Company for about five years. This cover and spread are from their recent annual report, which focuses on the ever-increasing problems relative to providing affordable housing to the American people.

National Gypsum Company

Annual Report 1982

Where
will our
children
live?

"The trend is toward apartment-size houses on tiny lots, but I'm a dedicated suburbanite. I like having a house and yard and space of my own. It's a reflection of my own preferences, but I hope this will be an option for my children."

Calendar:
Pirtle Design Calendar
Art Director:
Woody Pirtle
Designer:
Woody Pirtle,
Kenny Garrison
Artists/Photographers:
Various
Design Firm:
Pirtle Design
Dallas, TX
Publisher:
Pirtle Design
Typographer:
Southwestern
Typographics, Inc.
Printer:
Heritage Press

Photographic Monthly:
Photo Metro
Art Director:
Henry Brimmer
Designer:
Henry Brimmer
Design Assistants:
Therese Randall,
Adelaida Mejia
Photographers:
Various
Design Firm:
Henry Brimmer Design
San Francisco, CA
Publisher:
Photo Metro
Typographer:
Metro Type
Printer:
Crain Press

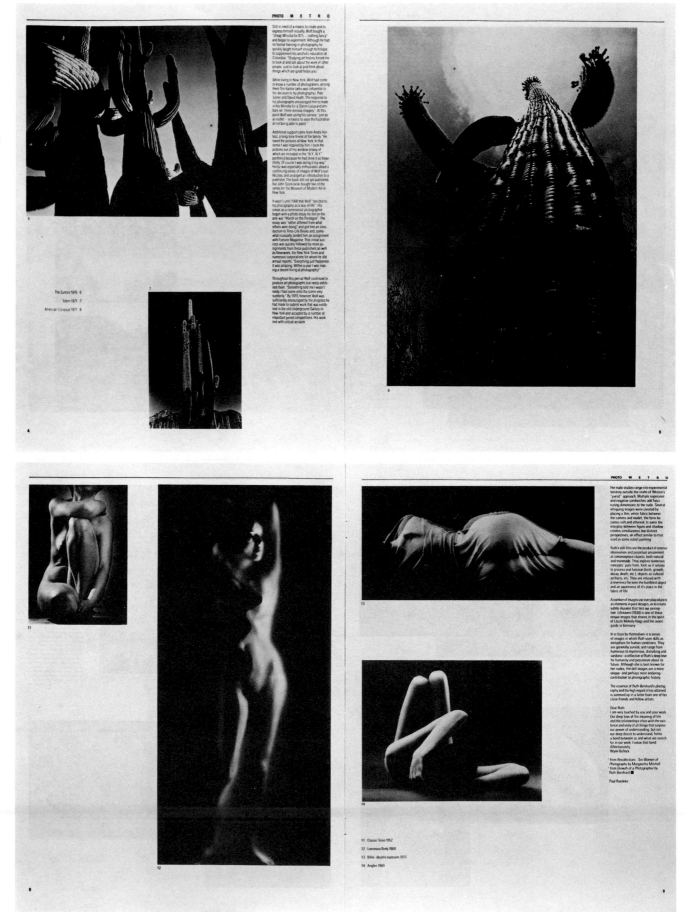

The Suitors 1978 6

Totem 1971 7

American Colossus 1971 8

11 Classic Torso 1952

12 Luminous Body 1969

13 Billie - double exposure 1973

14 Angles 1969

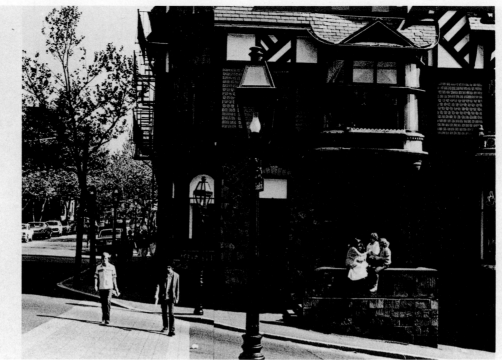

Contents

Catalogue:
Rhode Island School of
Design 1983–84
Art Director:
Joseph Gilbert
Designer:
Joseph Gilbert
Cover Photographer:
Gary Gilbert
Design Firm:
Gilbert Assoc.
Providence, RI
Client:
Rhode Island School of
Design
Typographer:
Gilbert Assoc.
Printer:
Acme Printing Co.

The design process can be divided into three phases. The conceptual phase deals with ideas. In the second phase, ideas are translated into visual forms, so our clients can see exactly how the end result will look. The third phase is production – preparing a design for printing, ensuring that the printed piece retains the integrity of the original design, and supervising all the tasks that must be coordinated for timely completion of a quality job. ☐ Gunn Associates stresses the importance of good production skills. Without these, the entire creative process is jeopardized. Mechanical art must be prepared so printers can follow detailed instructions. Photographs and photo separations must be carefully evaluated to ensure quality reproduction. On-press supervision is needed to make certain that a printed piece matches all the design specifications. ☐ Our strong emphasis on production improves our ability to maintain tight schedules. It gives us greater control over the quality of a printed piece. Because we treat design and production as an integrated process, we can make the fullest use of modern printing technology to create innovative visual effects and to achieve cost-saving efficiencies.

Brochure:
Gunn Associates
in Perspective
Art Director:
David Lizotte
Designer:
David Lizotte
Photographers:
Various
Design Firm:
Gunn Associates
Boston, MA
Publisher:
Gunn Associates
Typographer:
Typographic House
Printer:
Nimrod Press

Magazine Ad:
Bermuda
Art Director:
Tyler Smith
Designer:
Tyler Smith
Photographer:
Graeme Outerbridge
Design Firm:
Tyler Smith
Providence, RI
Client:
National Bickford
Foremost
Typographer:
Typesetting Service

Graeme Outerbridge

Bermuda.

There are times when words are superfluous, objects too limiting, and do you really need a palm tree to conjur up Paradise?

What you want is the essence of the place—which is not a thing at all, but a feeling.

And in the simple play of light and color and form, you might just find an image that speaks volumes to the soul.

■ National Bickford Foremost has one of the finest fully integrated color printing operations in the country.

Everything from separations to printing.

To capture the art of color.

National Bickford Foremost
Huntington Industrial Park, Providence, Rhode Island 02907 Telephone: (401) 944-2700

Poster:
We put a little heart
in everything we do . . .
Art Director:
Jann Church
Designers:
Jann Church,
Lea Pascoe
Artist:
Lea Pascoe
Design Firm:
Jann Church Partners,
Marketing & Advertising
Design
Newport Beach, CA
Publisher:
Jann Church Partners
Typographer:
Andresen Typographics
Printer:
I.P.D. Printing &
Distributing, Inc.

DON CRUM & COMPANY

Greeting Card:
Christmas 1983—
Don Crum & Co.
Art Director:
Don Crum
Designer:
Tom Hair
Design Firm:
Don Crum & Co.
Dallas. TX
Publisher:
Don Crum & Co.
Typographer:
Southwestern
Typographics. Inc.
Printer:
Monarch Press

Greeting Card:
Christmas Card
Art Director:
Michael Patrick Cronan
Designer:
Michael Patrick Cronan
Artist:
Michael Patrick Cronan
Design Firm:
Michael Patrick Cronan,
Inc.
San Francisco, CA
Publisher:
Michael Patrick Cronan,
Inc.
Typographer:
Display Lettering
and Copy
Printer:
Creative Arts
Printing Co.

district to go from grades K through 12 and never pick up a paintbrush, musical instrument, or write a poem or see a play.) The program developed with a series of small interconnecting projects to bring art to elders, teens, small children, and high school students as well. The central concept has been to train teachers through an excellent series of teacher training workshops and teaching materials—because most teachers receive no training whatsoever on how to use visual arts in the basic curriculum. Program coordinator Karen Shellhammer developed a series of modular teaching units to instruct teachers in ways of using readily available art materials to stimulate students to use art in their regular schoolwork, as well as setting up a series of after-school programs for students who were more seriously interested in art. The results have been extraordinarily successful, as can be seen in some of the delightful paintings produced by the children who have been exposed to this program in their classes. We are happy to see that corporate and other private sources are participating more and more in the funding of this excellent project, so our support can diminish and we can move to other programs.

San Jose Community Opera Theatre has presented its production of "Mary Moons" to thousands of South Bay school children.

We have experimented with other approaches and projects, far too numerous to detail here. The main lesson learned from the arts education programs both we and other foundations have supported is that steadiness of support and a certain degree of longevity is more important than a great deal of money—an encouraging fact for a small foundation. Every one of the successes we have experienced has involved three or four years of funding at the least. We believe that smaller amounts of funding expended over a larger number of years can produce the best results for these programs for children in the schools or on an after-school basis.

In the current funding climate, arts programming in California schools is imperiled by other pressing needs. Thus, the main responsibility for bringing an appreciation of various art forms to students lies increasingly with performing companies, museums and local organizations geared to present events to students in the performing and visual arts. We are working with such grantees and new applicants to explore curriculum development for arts in the schools. If teachers who know little about the arts are given the responsibility of teaching them, the one great help in their effort is a series of good and useful curriculum materials which can be provided, with appropriate technical assistance, from national organizations such as Opera America, or local organizations such as Youth in Arts, a Marin County presenting group which brings a wide variety of arts programming into the schools at all levels.

We believe that the arts are a vital part of American life and some exposure to them to be part of the birthright of every American child, and we welcome the submission of proposals that seek innovative solutions for some of the problems we have noted here. We share with most philanthropic institutions a concern for balancing social and cultural welfare, but if the cultural loses out to the social, we may enjoy great material prosperity, but be surrounded by greyness with little desire to question, see, or experience life in a new way nor to create anything purely aesthetic, reflective or pleasure-giving. This possibility is probably not great, given the profundity and longevity of the aesthetic impulse in man, but we are not willing to sit back and run the risk.

Annual Report:
The L.J. Skaggs and
Mary C. Skaggs Founda-
tion Annual Report 1982
Art Director:
Michael Vanderbyl
Designer:
Michael Vanderbyl
Design Firm:
Vanderbyl Design
San Francisco, CA
Client:
Skaggs Foundation
Typographer:
Community Press
Printer:
Lithography by Design

Lonn Beaudry

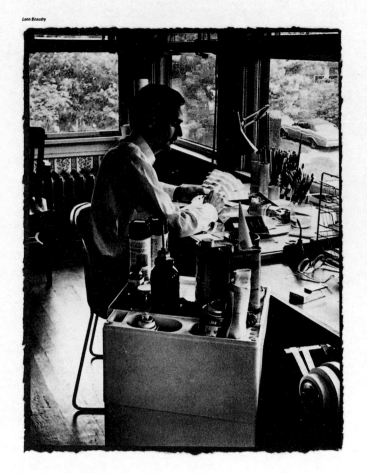

Roger L. Funk
Barry Crone
Ronald B. Kemnitzer
Jack P. Lew
Judith A. Moldenhauer
Stephen Sidelinger

Design Faculty

Roger L. Funk, Chairman, Professor. Involvement in the design profession and the teaching of design for over 25 years have given him a breadth of experience which serves as a valuable resource for students in the Department of Design. He is also an experienced photographer and a seasoned academic administrator with more than a decade of administrative work coupled with his regular teaching assignments. He is a member of the Industrial Designers Society of America and has been an active member in the Society for Photographic Education. He has served on several state level art, architecture and design commissions as well as municipal councils and boards dealing with the arts and environmental issues and is currently serving on the Ethics Advisory Council of IDSA. As a staff designer at the General Electric Company he was involved in the design of more than 25 products which reached the marketplace and holds three patents for work he accomplished at General Electric. This teacher administrator is active in a design consulting office in the firm belief that maintaining close contact with and a working understanding of the profession is a company to sound teaching.

University of Illinois, BFA. Syracuse University, MO.

Lonn Beaudry, Assistant Professor, is a graphic and environmental designer. Prior to joining the Art Institute faculty in 1978, he was a senior designer for Herman and Lees Associates, Cambridge, Massachusetts. His work includes identity programs and graphic standards manuals for the U.S. Department of Housing and Urban Development and His Highness the Aga Khan. His work is published in Graphic Design international and contained in two traveling exhibitions: — Design in Michigan and the New York Type Directors show. He is currently a partner in the graphics consulting firm Design Machine.

Layton School of Art and Design. Cranbrook Academy of Art. BFA, MFA.

Barry Crone, Assistant Professor, is a product, package and furniture designer. Prior to joining the Art Institute faculty in 1980, he was a furniture designer for Fixtures Manufacturing Corporation in Kansas City. Previous experience included five years as a senior designer with Philips Electronics in Australia, Netherlands and Italy. He traveled extensively throughout Europe and Southeast Asia before moving to the United States in 1976. One of his designs, a range of land use mobile radio telephones, was awarded "Australian Design Award" 1977. Currently he is doing freelance design work through his own consulting firm.

Royal Melbourne Institute of Technology (Australia). Associateship Diploma of Art in Industrial Design. Graduate studies in Industrial Design and Sociology.

Ronald B. Kemnitzer, Associate Professor, is a product designer who has served in the capacity of staff designer and consultant to a number of major corporations, including Sunbeam Appliance Company and Black & Decker Manufacturing Company. In addition to his current teaching involvement, he is a principal in the design consulting firm of Midwest Design, Inc. He is also the owner of Designs for Learning, Inc., which produces play and learning materials for handicapped children. He has been awarded seven patents for his work and has received national and international awards for outstanding design. He is a member of the Industrial Designers Society of America and served on its Board of Directors and as Chairman of the Education Committee.

University of Cincinnati, BS. Northern Illinois University, MA.

Jack P. Lew, Associate Professor, is an illustrator who is equally active in the gallery scene. His freelance assignments have included advertising, magazine and album cover illustrations. While in New York, he was represented by Artists International, an agency based in New York and London. The numerous solo and group shows he has held have been in Dallas, Houston and Memphis galleries. Besides illustration, he has intensively taught drawing, anatomy and calligraphy.

Cleveland Institute of Art, BFA. Syracuse University, MFA.

Judith A. Moldenhauer, Assistant Professor, is a designer whose professional interests lie predominantly in the areas of graphic design and typography. She has worked as a designer and illustrator for the United States Forest Service and as a graphics coordinator for several universities and colleges, winning several awards for her work. Recently, she founded a private press, The Minimal Press, to produce limited editions of handprinted posters, cards and books.

University of Illinois, BFA. Stanford University, MA. University of Wisconsin, MFA.

Stephen Sidelinger, Associate Professor, is a designer and illustrator of handmade books. One of his books was selected Best of Show distinction in "80 Miles of Art," regional juried exhibition at the Nelson-Atkins Museum, 1976. His most recent work is a series of handmade books dealing with images evoked by imagist writing and poetry, music and early 20th century French writers. He took further study in bookbinding in New York City with Gerard Charriere. He has written a book entitled A Color Manual for Printout Hair, Inc. He is a member of the William Morris Society and has traveled throughout Pakistan and Europe and in Japan.

Syracuse University, BFA. Illinois Institute of Technology, MS.

Catalogue:
Kansas City Art Institute: A four-year college of art and design
Art Director:
John Muller
Designer:
John Muller
Photographer:
Various
Design Firm:
John Muller & Co.
Kansas City, MO
Client:
Kansas City Art Institute
Typographer:
Lopez Graphics
Printer:
Ashcraft, Inc.

Calendar:
April 1984
Art Director:
Gene Federico
Designer:
Gene Federico
Photographer:
Roberto Bresan
Design Firm:
Gene Federico
Poundridge, NY
Publisher:
P.M. Typography
Typographer:
P.M. Typography
Printer:
B & C Lithographers

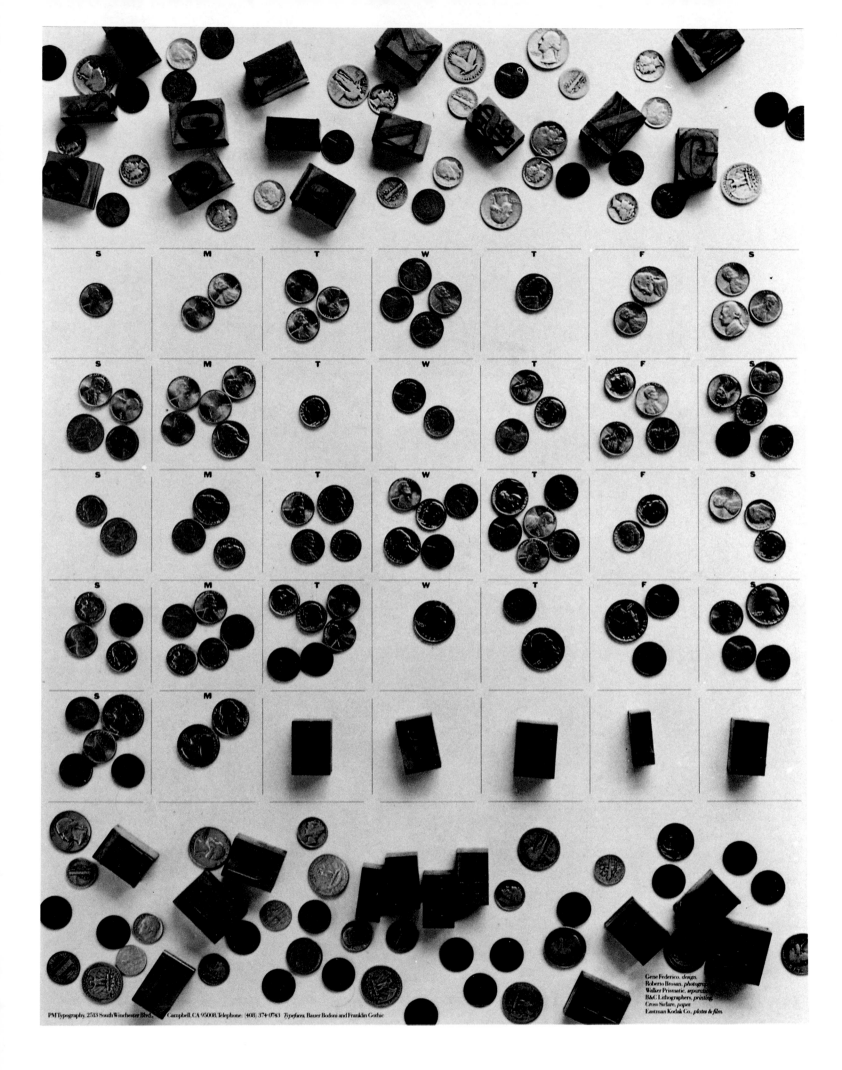

Gene Federico, design.
Roberto Brosan, photograph...
Walker Prismatic, separatio...
B&C Lithographers, printing...
Cross Siclare, paper.
Eastman Kodak Co., plates & film.

PM Typography, 2513 South Winchester Blvd., Campbell, CA 95008, Telephone: (408) 374-0743 Typefaces, Bauer Bodoni and Franklin Gothic.

Booklet:
Impressions of the
Holiday Season
Art Director:
Steve Gibbs
Designer:
Steve Gibbs
Artist:
Sibley/Peteet Design Inc.
Design Firm:
Sibley/Peteet Design, Inc.
Dallas, TX
Client:
Sibley/Peteet Design,
Inc.
Typographer:
Southwestern
Typographics Inc.
Printer:
Williamson Printing Co.

Greeting Card:
Happy Holidays
Art Directors:
C. Bernhardt, J. Fudyma
Designer:
J. Fudyma
Design Firm:
Bernhardt Fudyma
Design Group
New York, NY
Publisher:
Bernhardt Fudyma
Design Group
Printer:
Metropolitan Printing

BERNHARDT FUDYMA DESIGN GROUP

When Bob and Ruth Vogele acquire a work of art, it is because they intuitively respond to it. Unlike museum curators, they have no "responsibility" to art history, current trends, big names, or any other external pressures. They buy because they like something, and sometimes because they have become intrigued by an artist as well. Such are the joys of private collecting, joys which can be shared by us because of the Vogele's generous loan of work to this exhibition.

Walking through the collection as exhibited, one can see certain consistent concerns. One is an interest in geometry as a primary organizing principle in works of art. Another continuous element is subtly and beautifully textured surfaces. Many of the artists in the collection have a quirky individuality: they are idiosyncratic in style and content, especially in their free ranging choice and use of materials. An additional though less pressing bias is for work which raises "three-dimensional" issues: paintings which are not flat and sculpture which hangs on the wall. Overall, there is a lack of representational art which, according to Bob Vogele, leaves him little room for development of a two-way relationship with the art. The Vogeles enjoy knowing the artists whose work they collect, because the personal relationship increases their ability to share in the meaning of a work.

Bob and Ruth Vogele collect in order to have things around them which they love, to be able "to walk into a room full of friends," as Bob puts it. Since they have herewith given us access to their collection, they are effectively introducing us to what they value and how they see. No matter whether we are sophisticated art lovers or novice viewers, there is much pleasurable learning in putting ourselves behind their eyes for a while.

PHILIP YENAWINE

Steven Beyer's work deals, to some degree, with incongruity. Despite their simplicity of form, they make complex suggestions. For example, industrial materials, presumed the epitome of anonymity, can provoke emotional responses, so that a simple rectangular configuration of metal mesh can become a barrier, a cage, or a prison. It can also be simply a thing which creates patterns of light and dark as you walk by it. The untreated steel base can be an unyielding yet slowly decaying structure and at the same time an object whose mottled surface has both interesting texture and beautiful coloration. Beyer presents sculpture stripped of detail or unnecessary cosmetic coverings whose beauty and psychological interest come from the inherent strength and usefulness of the materials as well as from their lack of artifice and the manner in which they are used.

Exhibition Catalogue:
Selections from the
Collection of
Robert Vogele
Art Director:
Robert Vogele
Designers:
William Cagney,
Robert Vogele
Artists/Photographers:
Various
Design Firm:
Communication Design
Group, Inc.
Chicago, IL
Publisher:
Swen Parsons Gallery
Client:
Northern Illinois
University
Typographer:
Design Typographers,
Inc.
Printer:
Great Northern/Design
Printing

STEVEN BEYER

Work Illustrated:
"Sack Cloth, Ashes #2"
Welded Steel
1977
52" x 32" x 9"

Other Work in Exhibition:
"Four Member Family System"
Drypoint Diptych Etching
1979-80
47½" x 42½"

Birth Announcement:
Jackson Fred Myres
Art Director:
Danny Kamerath
Designer:
Danny Kamerath
Design Firm:
Jim Jacobs' Studio, Inc.
Dallas, TX
Client:
Sherry and Fred Myres
Typographer:
Typographics
Printer:
Spruiell Printing

THE HAY AGENCY, INC.

Debby Hay Werner
President

2121 San Jacinto Street
San Jacinto Tower Suite 800
Dallas, Texas 75201
214 922-0040

THE HAY AGENCY, INC.

2121 San Jacinto Street
San Jacinto Tower Suite 800
Dallas, Texas 75201

Stationery:
The Hay Agency
Art Director:
Marianne Tombaugh
Designer:
Marianne Tombaugh
Artist:
Marianne Tombaugh
Design Firm:
The Hay Agency, Inc.
Dallas, TX
Client:
The Hay Agency, Inc.
Typographer:
Jaggers Chiles Stovall,
Inc.
Printer:
The Printery, etc.

Poster:
State of the Art
Art Director:
R. Christine Hershey
Designer:
R. Christine Hershey
Photographer:
Rick Brian
Design Firm:
Hershey Dale & Assoc.
Los Angeles, CA
Publisher:
IABC/Los Angeles
Typographer:
Future Studio
Printer:
Chromatic

Vermillion

3515 Brown Suite 118 Dallas Texas 75219 214/521-9010

Stationery:
Vermillion
Art Director:
Mark Drury
Designer:
Mark Drury
Design Firm:
Eisenberg, Inc.
Dallas, TX
Client:
Cherri Oakley
Typographer:
Southwestern
Typographics, Inc.
Printer:
Spruiell & Co.

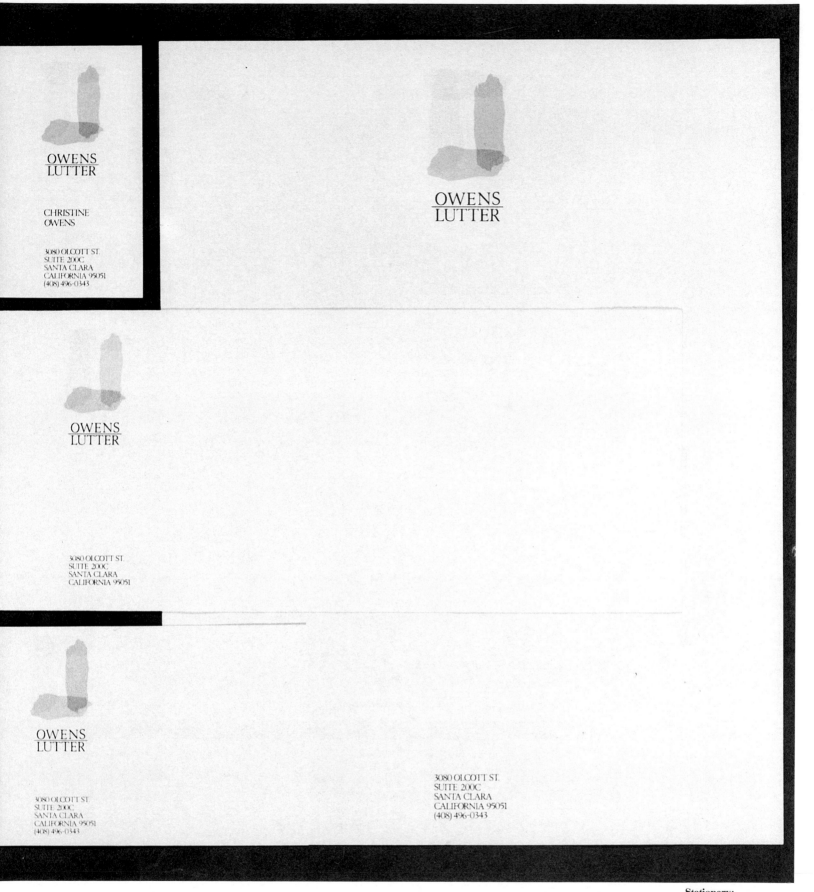

Stationery:
Owens/Lutter
Art Director:
Chris Owens
Designer:
Chris Owens
Artist:
Chris Owens
Design Firm:
Owens/Lutter
Santa Clara, CA
Publisher:
Owens/Lutter
Typographer:
Frank's Type
Printer:
Craftsman

Date Noriko Moore

Mr. John Smith
Title
Company Name
21 Bond Street Street Address
 City, State, Zip Code
New York, NY 10012

Tel 212 673-4965 Dear John,

 Noriko Moore letterheads have been designed for use with the
 particular typing format demonstrated here. All typing is flush
 left, with no indentations. Paragraphs are separated by a line
 space between them. Writer/typist, enclosure and copy information
 is typed as low as possible on the page, as indicated.

Noriko Moore

21 Bond Street Mr. John Smith
 Title
New York, NY 10012 Company Name
 Street Address
 City, State, Zip Code

Stationery:
Noriko Moore
Art Director:
Richard Moore
Designers:
Richard and Noriko
Moore
Design Firm:
Muir Cornelius Moore
New York, NY
Client:
Noriko Moore

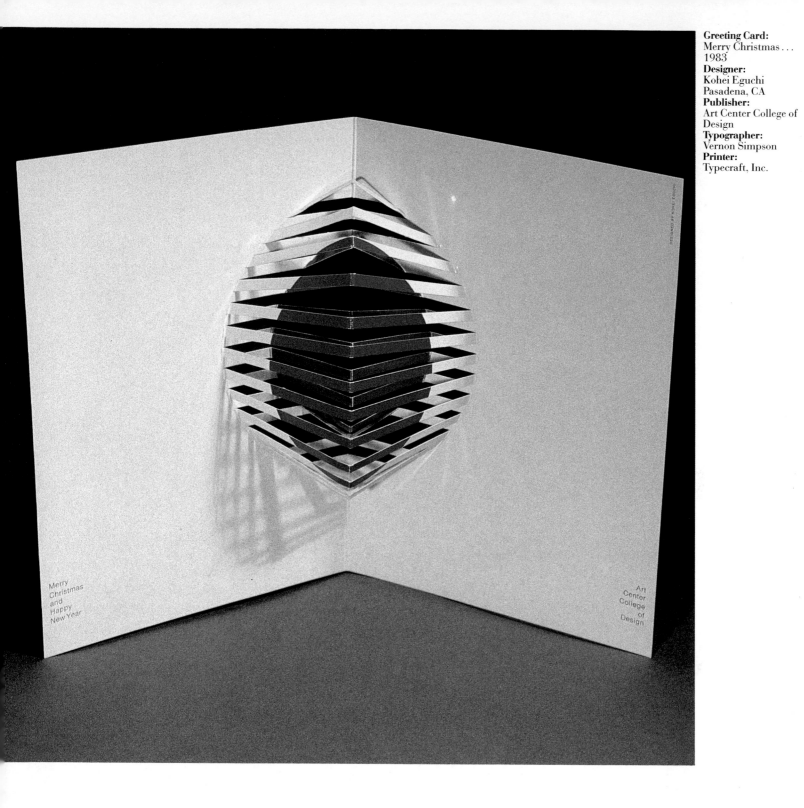

Merry
Christmas
and
Happy
New Year

Art
Center
College
of
Design

Greeting Card:
Merry Christmas . . .
1983
Designer:
Kohei Eguchi
Pasadena, CA
Publisher:
Art Center College of
Design
Typographer:
Vernon Simpson
Printer:
Typecraft, Inc.

Stationery:
Moran Colorgraphic
Art Director:
Malcolm Moran
Designer:
Malcolm Moran
Artist:
Malcolm Moran
Design Firm:
Moran Colorgraphic
New Orleans, LA
Client:
Malcolm Moran
Typographer:
Moran Typographic
Printer:
Moran Colorgraphic

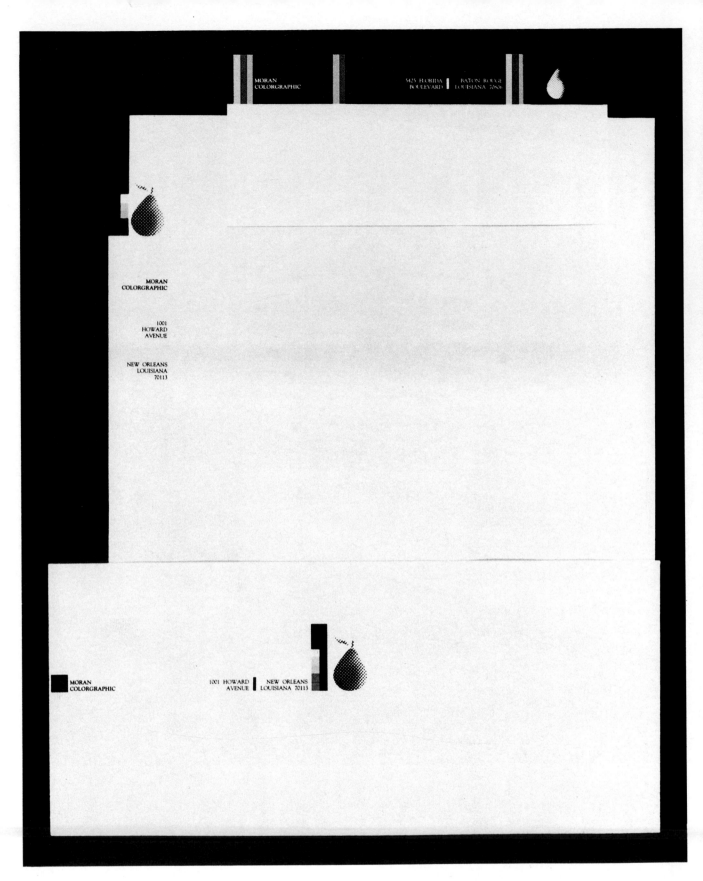

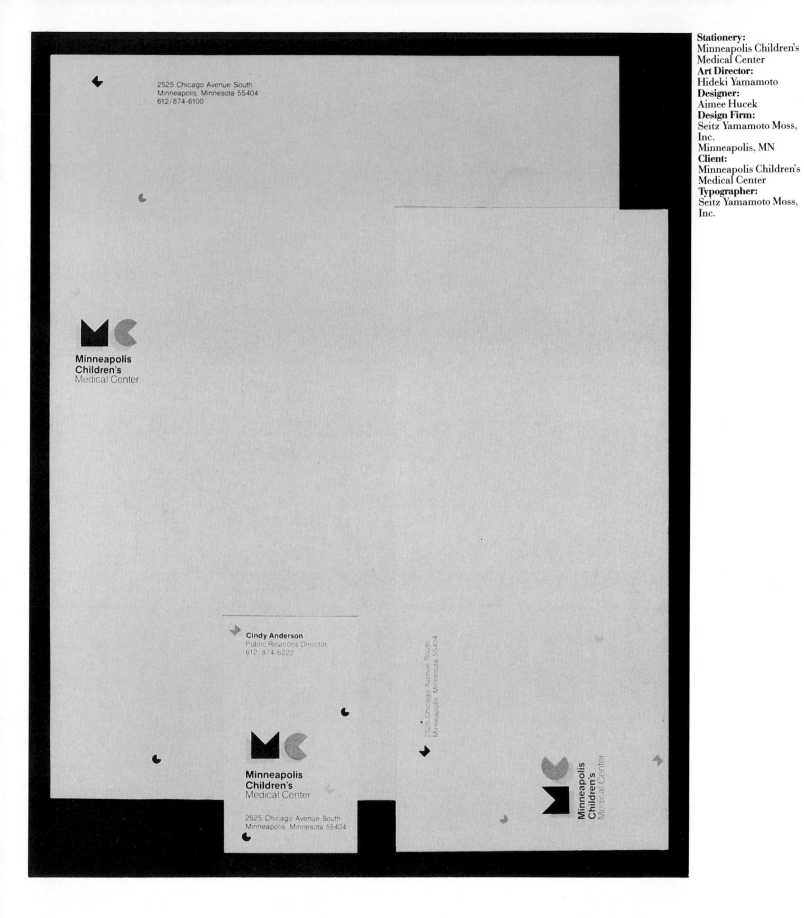

Stationery:
Minneapolis Children's
Medical Center
Art Director:
Hideki Yamamoto
Designer:
Aimee Hucek
Design Firm:
Seitz Yamamoto Moss,
Inc.
Minneapolis, MN
Client:
Minneapolis Children's
Medical Center
Typographer:
Seitz Yamamoto Moss,
Inc.

Stationery:
Southern California
Graphics
Art Director:
John Cleveland
Designer:
Michael Skjei
Design Firm:
John Cleveland, Inc.
Los Angeles, CA
Client:
Southern California
Graphics
Typographer:
Phototype House
Printer:
Southern California
Graphics

Southern
California
Graphics

8432
Steller
Drive

Culver City
California
90230

Telephone
213
559-3600

Stationery:
Janet Sanders & Assoc.
Art Director:
Joanne Tepper
Designer:
Joanne Tepper
Design Firm:
Tepper/Myers Graphic
Design
Venice, CA
Client:
Janet Sanders & Assoc.
Typographer:
CAPCO
Printer:
ADCO Graphics

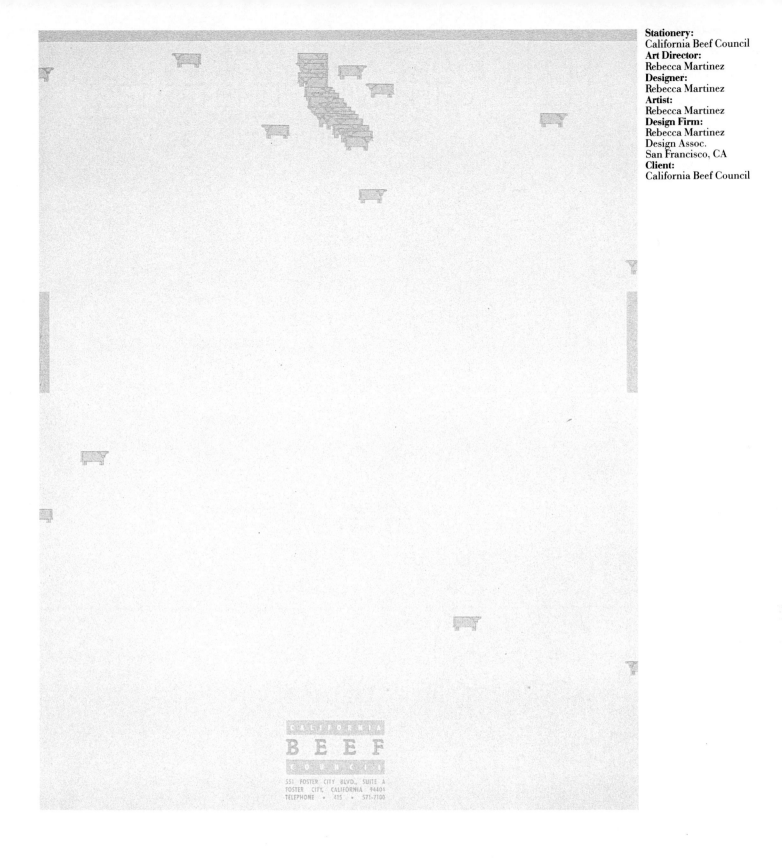

Stationery:
California Beef Council
Art Director:
Rebecca Martinez
Designer:
Rebecca Martinez
Artist:
Rebecca Martinez
Design Firm:
Rebecca Martinez
Design Assoc.
San Francisco, CA
Client:
California Beef Council

Promotional Brochures:
Malcolm Grear
Designers:
Publications, Identity,
Posters
Art Director:
Malcolm Grear
Designers
Designer:
Malcolm Grear
Designers
Artists/Photographers:
Malcolm Grear
Designers
Design Firm:
Malcolm Grear
Designers
Providence, RI
Publisher:
Malcolm Grear
Designers
Typographer:
Dumar Typesetting
Printer:
National Bickford
Foremost

MALCOLM GREAR DESIGNERS

Identity

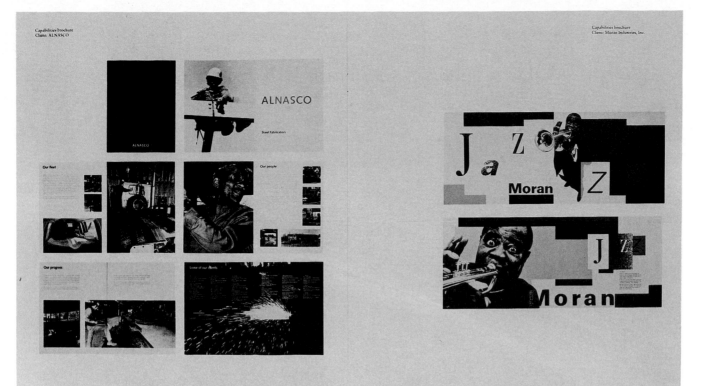

Capabilities brochure
Client: ALNASCO

Capabilities brochure
Client: Moran Industries, Inc.

MALCOLM GREAR DESIGNERS

Publications

MALCOLM GREAR DESIGNERS

Posters

▷
Poster:
Houston—A
Celebration of
Architecture
Art Director:
Woody Pirtle
Designers:
Alan Colvin,
Woody Pirtle
Photographers:
Joe Baraban,
Arthur Meyerson
Design Firm:
Pirtle Design
Dallas, TX
Publisher:
American Institute of
Architects
Typographer:
Southwestern
Typographics, Inc.
Printer:
Heritage Press

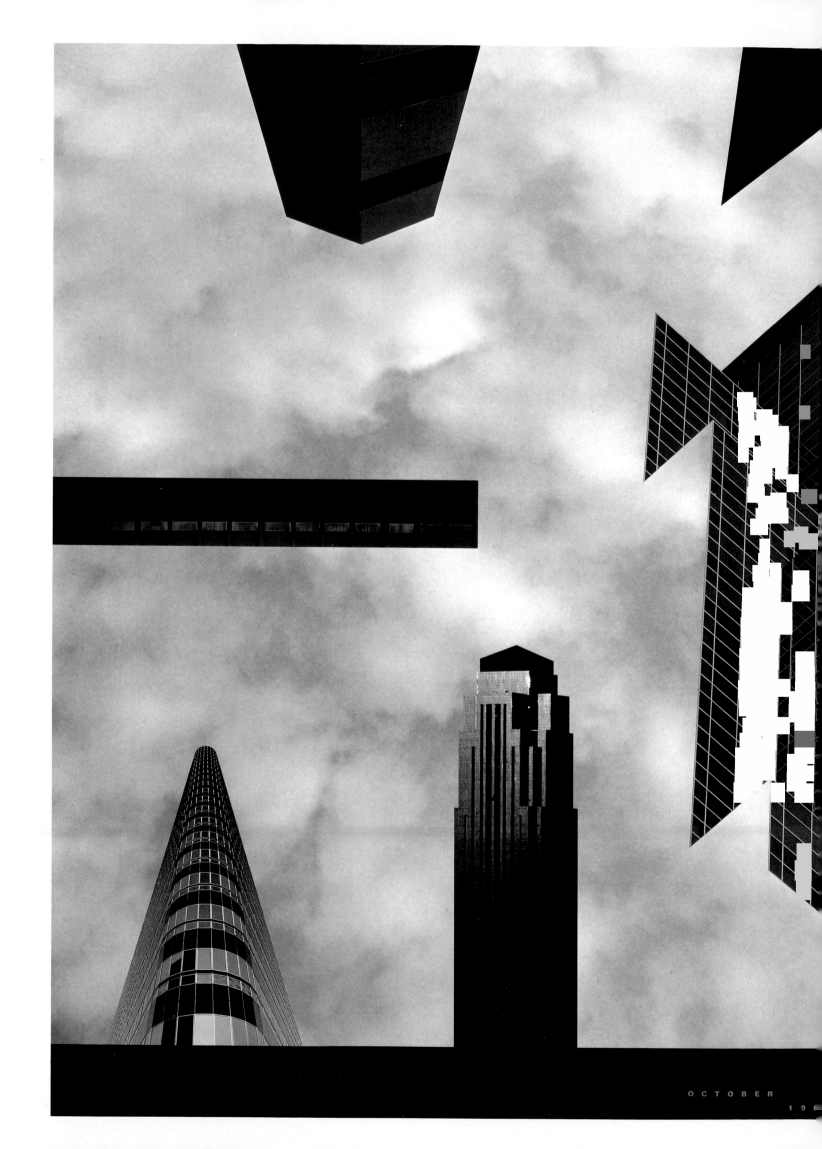

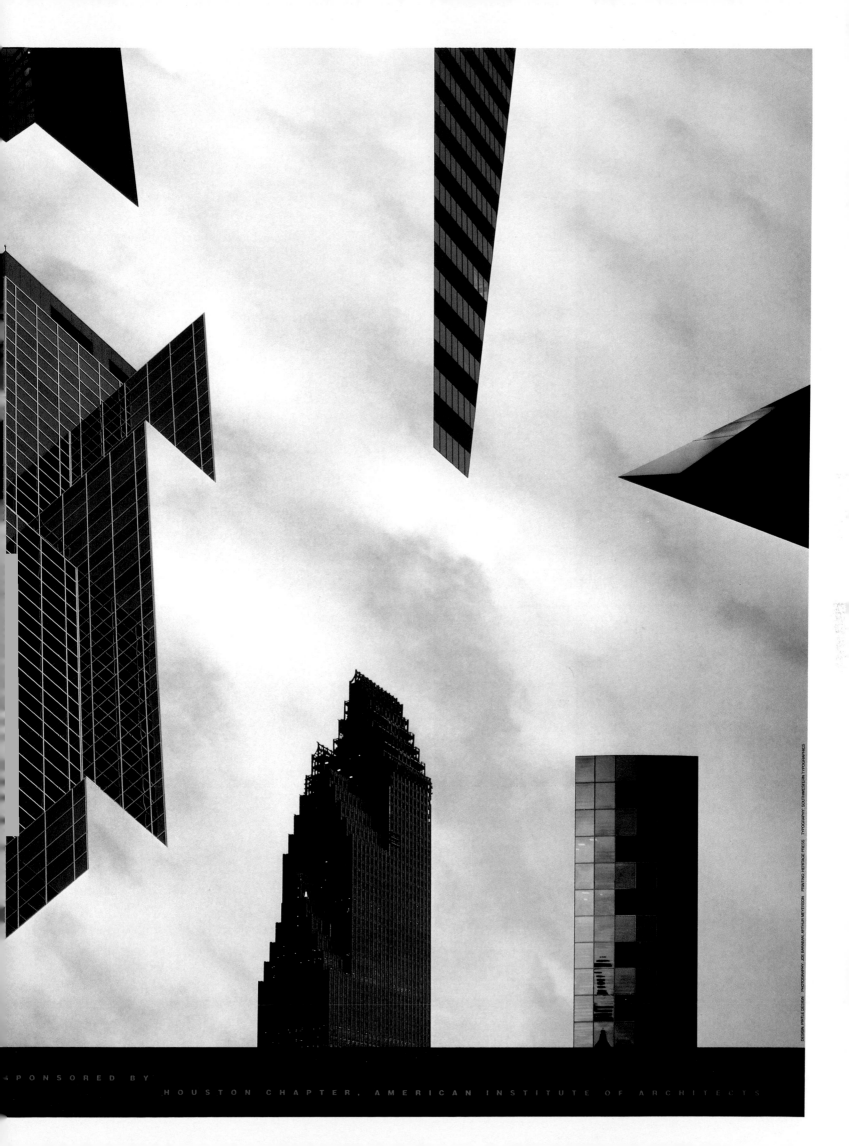

DESIGN: PENTZE DESIGN PHOTOGRAPHY: JOE AKERMAN, ARTHUR MEYERSON PRINTING: HERITAGE PRESS TYPOGRAPHY: SOUTHWESTERN TYPOGRAPHICS

SPONSORED BY

HOUSTON CHAPTER, AMERICAN INSTITUTE OF ARCHITECTS

Logo:
West Coast Artists
International Tennis
Tournament
Art Director:
Gordon Chun
Designer:
Gordon Chun
Artist:
Gordon Chun
Design Firm:
Gordon Chun Design
Berkeley, CA
Client:
The Oakland Museum

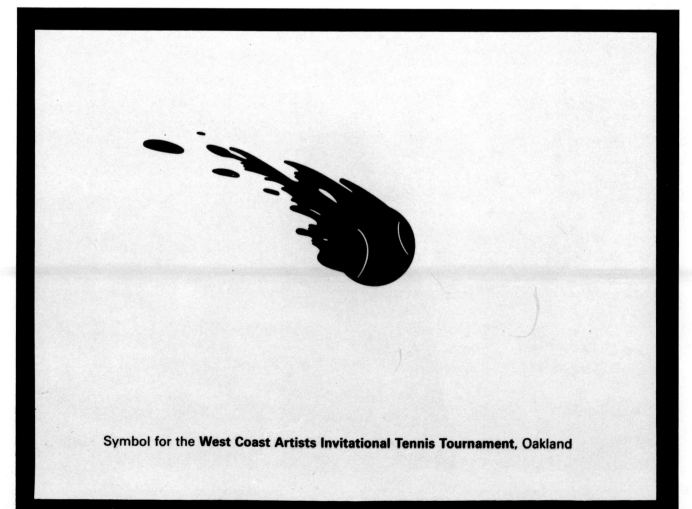

Symbol for the **West Coast Artists Invitational Tennis Tournament,** Oakland

1983 marks the
Tenth Anniversary
of Loucks Atelier
as a Houston design
establishment. We
want to thank our
clients, employees,
suppliers and friends
who have enabled
us to produce a
decade of design.

Announcement:
Loucks Atelier 10th
Anniversary
Art Directors:
Jay Loucks, Paul Huber
Designer:
Paul Huber
Design Firm:
Loucks Atelier, Inc.
Houston, TX
Publisher:
Loucks Atelier, Inc.
Typographer:
Professional
Typographers
Printer:
Heritage Press

Calendar Poster:
March-April 1983
Art Director:
Jack Summerford
Designer:
Jack Summerford
Photographer:
Gary McCoy
Design Firm:
Summerford Design, Inc.
Dallas, TX
Client:
Harvey Paper Co.
Typographer:
Southwestern
Typographics Inc.
Printer:
Brodnax Printing

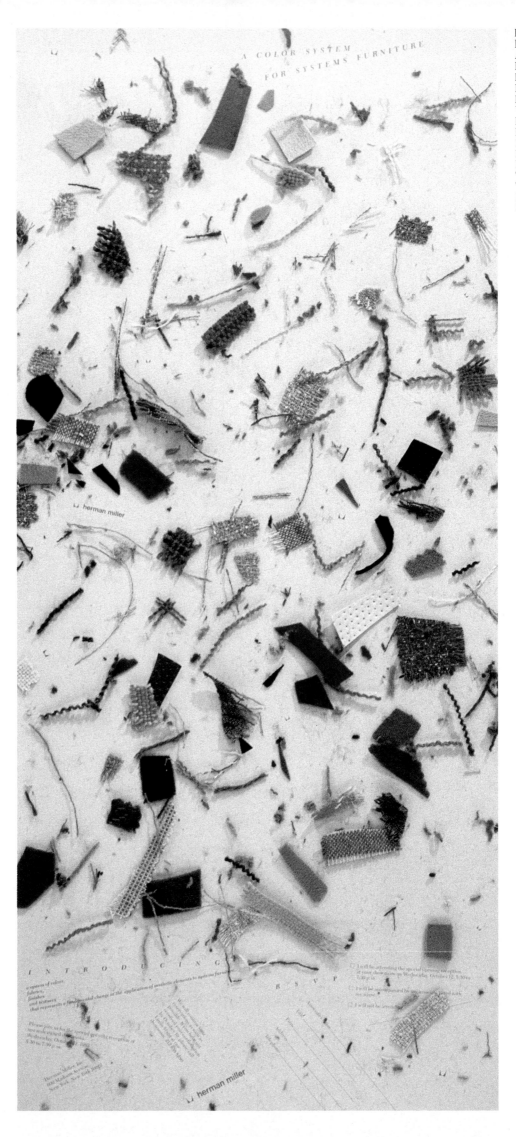

Invitation:
Designers Saturday
Art Director:
Barbara Loveland
Designer:
Barbara Loveland
Photographer:
William Sharpe
Design Firm:
Herman Miller, Inc.
Zeeland, MI
Publisher:
Herman Miller, Inc.
Typographer:
Typehouse, Inc.
Printer:
Burch Printer, Inc.

0,OOO

190, 200, 240, 280, 300, 318,
380, 450, 533, 911, 924, 928, 944

A Fortune of Wheels.

Clare Kittle, *President*
Business: Clare Adams Kittle, Inc.
3333 Elm St., Suite 202, Dallas, Texas
75226
653-1088
Home: 4101 Newton, Dallas, Texas 75219
522-2267

Bobby R. Knight, *President*
Business: The Knight Group
P.O. Box 800915, Dallas, Texas 75380
380-1817
Home: 4112 Brook Tree, Dallas, Texas
75248
733-0115

Tom Knott, *Senior Art Director/Design*
Business: The Bloom Agency
7701 Stemmons, P.O. Box 47906, Dallas,
Texas 75247
214-638-8100

Kath Koeppen, *Art Director*
Business: The Collateral Group
7701 Stemmons Fwy., Dallas, Texas 75247
638-8100
Home: 537 Harvest Hill St. Lewisville,
Texas 75067
436-0851

Ken Koester, *Art Director/Designer*
Business: Dennard Creative, Inc.
13601 Preston Rd., Suite 814 Carillon Tower
E., Dallas, Texas 75240
233-0430
Home: 7149 Pineberry, Dallas, Texas 75249
296-1535

Michael Landon, *Art Director*
Business: The Hay Agency
2121 San Jacinto Tower, Suite 800, Dallas,
Texas 75201
922-0040
Home: 2017 Pennington Dr., Arlington,
Texas 76014
467-6337

Bobby Larson, *Production Director*
Business: Cunningham & Walsh Dallas
4300 MacArthur Ave., Suite 209, Dallas,
Texas 75209
521-8700
Home: 414 Justice Dr., Cedar Hill, Texas
75104

Ms. Michal Lawrence
VP, Associate Creative Director
Business: The Bloom Agency
7701 Stemmons Fwy., Dallas, Texas 75247
638-8100
Home: 9127 Chapel Valley, Dallas, Texas
75220
358-0719

Marilyn Leaman, *President*
Business: Marilyn Leaman Productions
3425 Brockway Dr., Dallas, Texas 75234
241-4023
Home: 3425 Brockway, Dallas, Texas
75234
241-4023

Phyllis Lemke, *Art Director*
Business: Southwestern Life Insurance Co.
1807 Ross, Dallas, Texas 75221
655-5663
Home: 2428 Palo Alto, Arlington, Texas
76015
817-261-7107

Bruce Lescalleet, *Owner*
Business: Design Management
12700 Preston Rd. Suite 175, Dallas, Texas
75230
239-6280
Home: 1613 Belgrade Dr., Plano, Texas
75023
596-8050

Debbie Lewis, *Graphic Artist*
Business: Mart Advertising
515 Houston, Fort Worth, Texas 76102
817-870-9594
Home: 1102 N. Bell #102, Denton, Texas
76201
817-382-7324

Alan Lidji, *Creative Director*
Business: Cunningham & Walsh
4300 McArthur #209, Dallas, Texas 75209
521-8700
Home: 8601 Wingate, Dallas, Texas 75209
358-4858

Jo Marie Lilly, *Production Director*
Business: The Horchow Collection
4300 Alpha Road, Suite 200, Dallas, Texas
75234
385-2723
Home: 1817 W. Colorado, Dallas, Texas
75208
942-0581

Membership Directory:
Numbers
Art Director:
Jack Summerford
Designer:
Jack Summerford
Artist:
Jack Summerford
Design Firm:
Summerford Design,
Inc.
Dallas, TX
Publisher:
Dallas Society of Visual
Communications
Typographer:
Southwestern
Typographics, Inc.
Printer:
Padgett Printing

Invitation:
Skyline High School
The Class of 1973
Art Director:
Brian Boyd
Designer:
Brian Boyd
Photographer:
Unknown
Design Firm:
Richards, Sullivan,
Brock & Assoc./
The Richards Group
Dallas, TX
Client:
Skyline High School
Class of 1973 Reunion
Typographer:
Chiles & Chiles
Printer:
Williamson Printing Co.

Poster:
May the Joy and Hope of
this Holiday Season . . .
Art Director:
Scott Eggers
Designer:
Scott Eggers
Photographer:
Andy Post
Design Firm:
Richards, Sullivan,
Brock & Assoc./
The Richards Group
Dallas, TX
Client:
The Rouse Co.
Typographer:
Chiles & Chiles
Printer:
Brodnax Printing

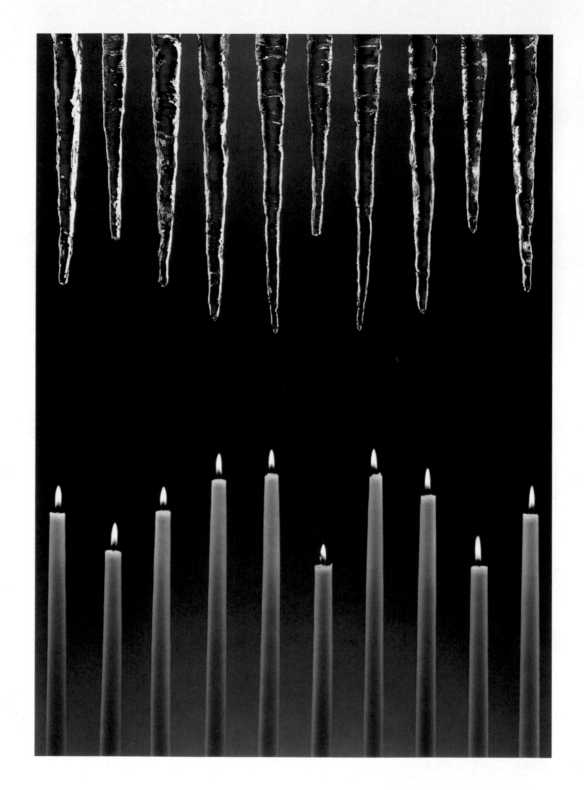

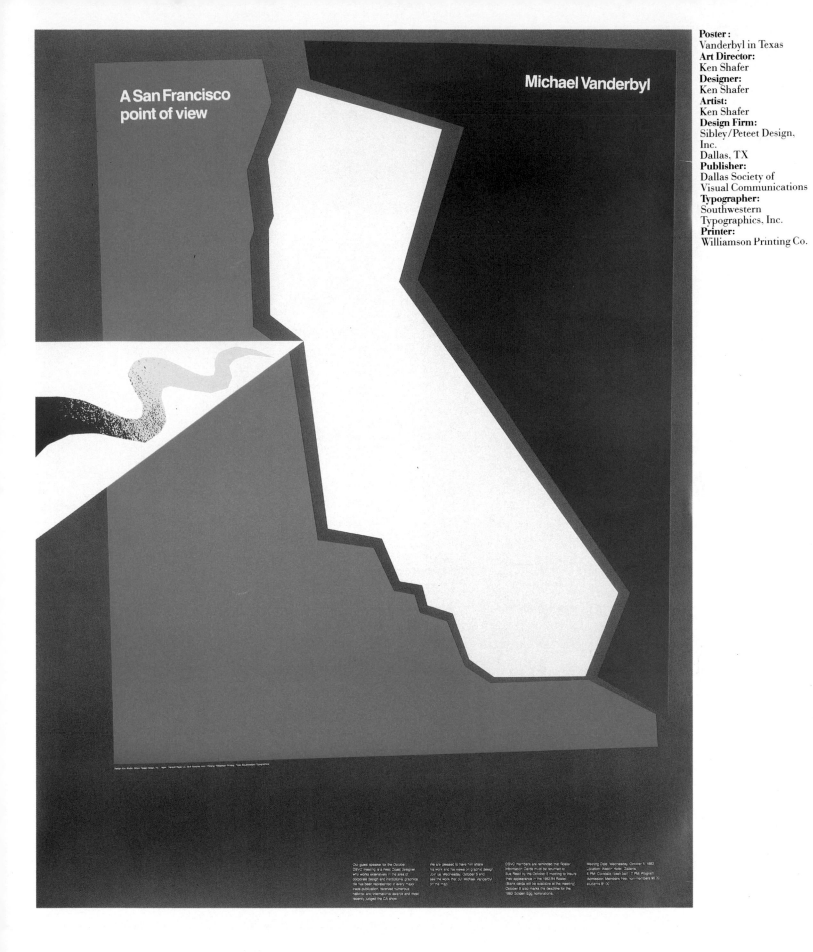

Poster:
Vanderbyl in Texas
Art Director:
Ken Shafer
Designer:
Ken Shafer
Artist:
Ken Shafer
Design Firm:
Sibley/Peteet Design,
Inc.
Dallas, TX
Publisher:
Dallas Society of
Visual Communications
Typographer:
Southwestern
Typographics, Inc.
Printer:
Williamson Printing Co.

Two roads diverged
in a yellow wood,
And sorry I
could not travel both
And be one traveler
long I stood
And I looked down one
as far as I could
To where it bent
in the undergrowth;

Promotional Booklet:
The Road Not Taken
Art Director:
Chris Hill
Designers:
Chris Hill, Joe Rattan
Photographer:
Gary Braasch
Design Firm:
Hill/A Graphic Design
Group
Houston, TX
Client:
Superb Litho, Inc.
Typographer:
Professional
Typographers, Inc.
Printer:
Superb Litho, Inc.

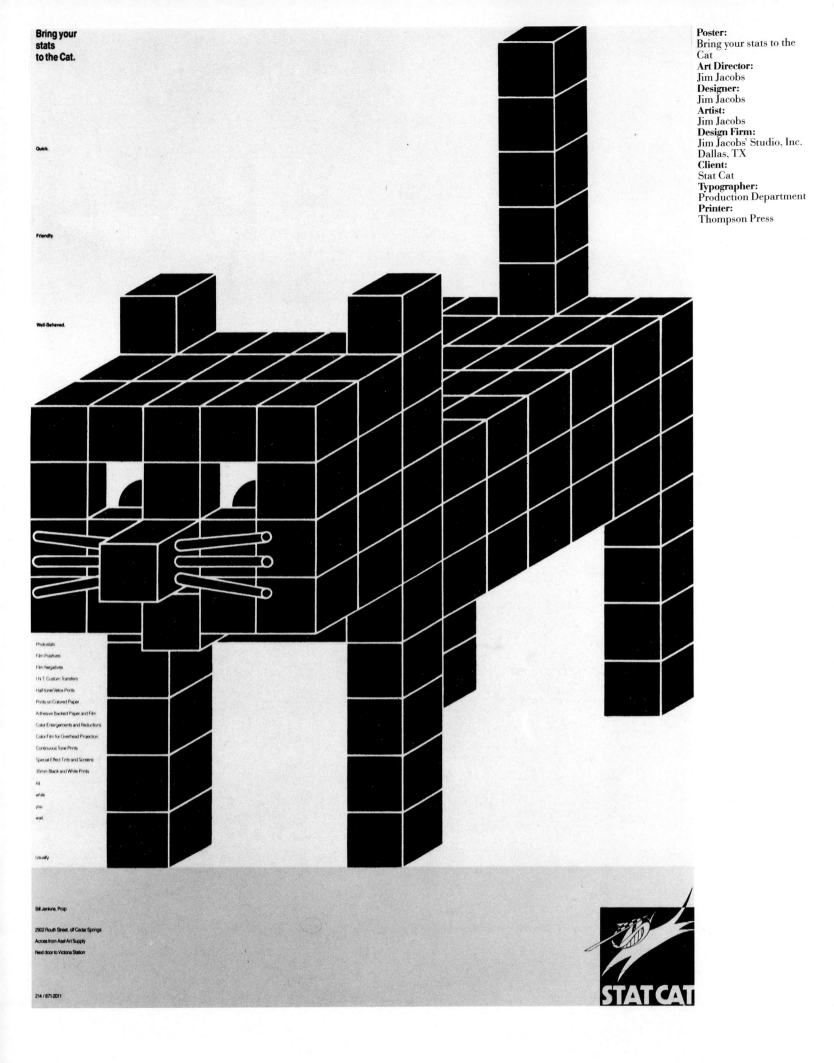

Bring your stats to the Cat.

Quick.

Friendly.

Well-Behaved.

Photostats
Film Positives
Film Negatives
I.N.T. Custom Transfers
Half tone/Velox Prints
Prints on Colored Paper
Adhesive Backed Paper and Film
Color Enlargements and Reductions
Color Film for Overhead Projection
Continuous Tone Prints
Special Effect Tints and Screens
35mm Black and White Prints
All
while
you
wait.

Usually.

Bill Jenkins, Prop.

2502 Routh Street, off Cedar Springs

Across from Asel Art Supply

Next door to Victoria Station

214/871-2011

STAT CAT

Poster:
Bring your stats to the Cat
Art Director:
Jim Jacobs
Designer:
Jim Jacobs
Artist:
Jim Jacobs
Design Firm:
Jim Jacobs' Studio, Inc.
Dallas, TX
Client:
Stat Cat
Typographer:
Production Department
Printer:
Thompson Press

WATER STREET OYSTER BAR

APPETIZERS

Zucchini Slices
Sliced zucchini coated with a seasoned batter and deep-fried. Served with Parmesan cheese. $3.25

Friday's Deep-Fried Broccoli Cheese Melt
Florets of fresh, tender broccoli encased in cheese, then batter dipped and deep-fried. Served with Parmesan cheese. $3.65

Friday's Onion Rings
Onion rings cut large, breaded with buttermilk batter and fried golden. Served with Parmesan cheese. $2.65

Thin Onion Rings
Red onions thinly sliced, breaded, and fried light and crisp. $2.65

Fried Clams
Tender clam strips buttermilk battered and lightly deep-fried. Served with wedge fries and homemade tartar sauce. $3.95

Fried Mozzarella
Strips of mozzarella coated with a seasoned breading and deep-fried until lightly crusty outside and soft and stringy inside. Served with homemade Italian meat sauce and Parmesan cheese. $3.25

Friday's Mushrooms
Fried fresh mushrooms, which are crispy outside, hot and juicy inside. Served with creamy horseradish sauce and Parmesan cheese. $2.95

Peel and Eat Shrimp
Spicy boiled shrimp served by the quarter pound with cocktail sauce. $3.95

Appetizer Potato Skins
(All served with sour cream and chives for dipping)

Loaded
Skins with a quarter pound of cheddar cheese and plenty of real crumbled bacon. $5.25

Spiced Chicken
Skins with spicy chicken and mushrooms and covered with a quarter pound of Jack cheese. $5.25

Combo
A combination of Spiced Chicken and Loaded skins. $5.25

Cheese Nachos
Mild cheddar cheese melted over crisp tortilla chips and topped with sliced jalapeños. $4.35

Bean and Cheese Nachos
Refried beans and mild cheddar cheese melted over crisp tortilla chips and topped with sliced jalapeños. $4.45

Menu:
T.G.I. Friday's To Go
Art Director:
Luis Acevedo
Designer:
Luis Acevedo
Artist:
Luis Acevedo
Design Firm:
Pirtle Design
Dallas, TX
Client:
T.G.I. Friday's, Inc.
Typographer:
Southwestern
Typographics, Inc.
Printer:
Allcraft Printing

Logo:
Water Street Oyster Bar
Designer:
Janis Koy
Design Firm:
Koy Design, Inc.
San Antonio, TX
Client:
Water Street Oyster Bar
Typographer:
ProType of San Antonio

OCTOBER

John DeGroot

1 Monday
2 Tuesday
3 Wednesday
4 Thursday
5 Friday
6 Saturday — Yom Kippur
7 Sunday
8 Monday — Columbus Day
9 Tuesday
10 Wednesday
11 Thursday
12 Friday
13 Saturday
14 Sunday
15 Monday

OCTOBER

Calendar:
1984
Art Director:
Michael Mabry
Designer:
Michael Mabry
Design Firm:
Michael Mabry Design
San Francisco, CA
Client:
Graphics, Etc.
Typographer:
petrographics
typeworld
Printer:
Overseas Printing Corp.

Promotional Item:
The Enveloping Herbs
Art Director:
Peter Good
Designer:
Peter Good
Artists:
Janet Good,
Peter Good
Design Firm:
Peter Good Graphic
Design
Chester, CT
Client:
Champion International
Typographer:
Eastern Typesetting Co.
Printers:
The Hennegan Co.,
Young & Kline,
Whiting & Clover,
Piqua

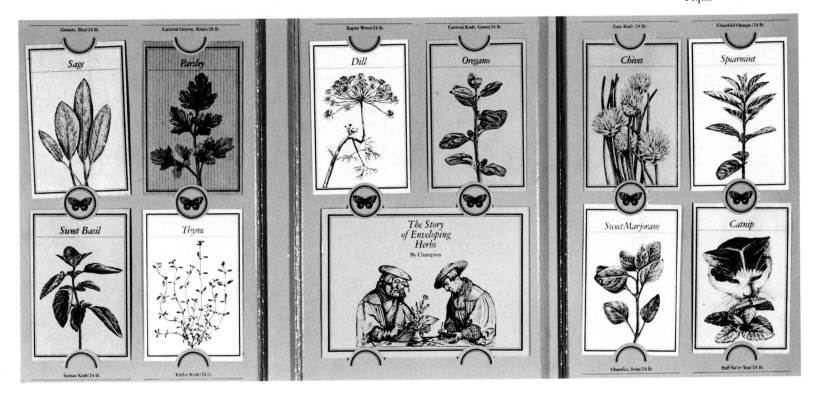

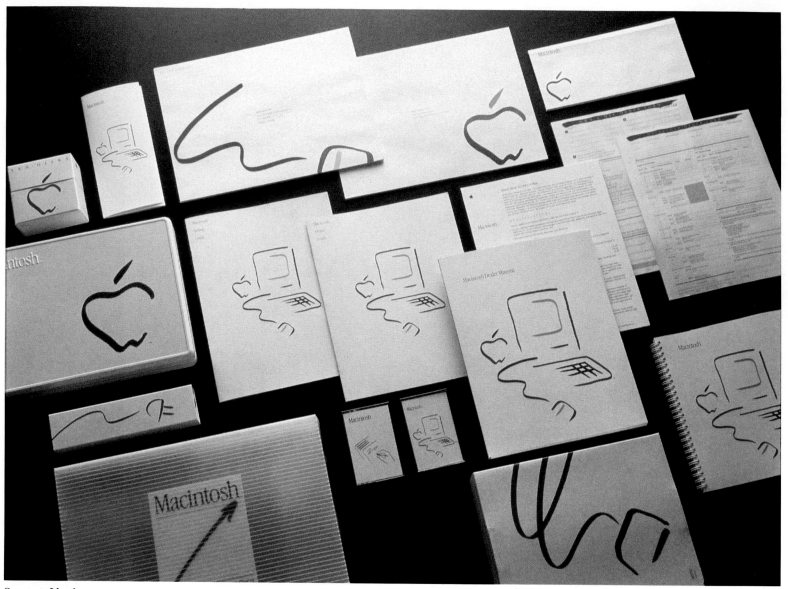

Corporate Identity:
Macintosh Program
Art Director:
Tom Hughes
Designers:
Tom Hughes,
Clement Mok,
Ellen Romano
Artists:
John Casado,
Clement Mok
Design Firm:
Apple Computer, Inc.
Cupertino, CA
Publisher:
Apple Computer/
Macintosh Div.
Typographer:
Vicki Takla

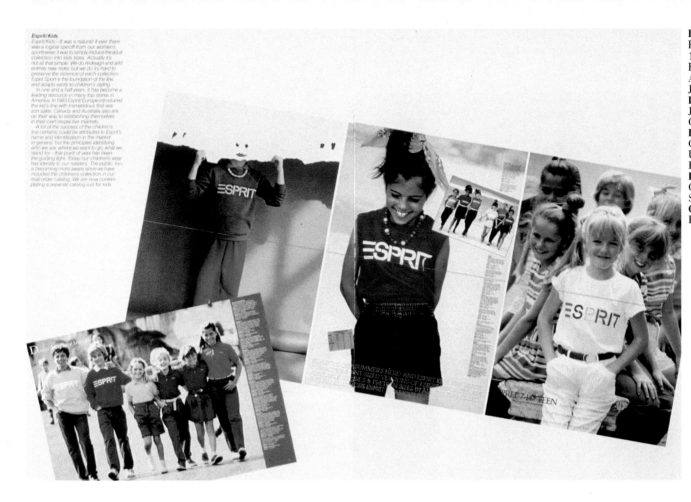

Esprit/Kids — It was a natural! If ever there was a logical spinoff from our women's sportswear it was to simply reduce the adult collection into kids sizes. Actually it's not all that simple. We do redesign and add entirely new styles, but we do try hard to preserve the essence of each collection. Esprit Sport is the foundation of the line, and adapts easily to children's styling.

In one and a half years, it has become a leading resource in many top stores in America. In 1983 Esprit Europe introduced the kid's line with tremendous first season sales. Canada and Australia also are on their way to establishing themselves in their own respective markets.

A lot of the success of the children's line certainly could be attributed to Esprit's name and identification in the market in general, but the principals identifying who we are, where we want to go, what we stand for — that point of view has been the guiding light. Today our children's wear has identity to our retailers. The public, too, is becoming more aware since we have included the children's collection in our mail order catalog. We are now contemplating a seperate catalog just for kids.

Brochure:
Esprit de Corp:
1979-1983
Formative Years
Art Director:
John Casado
Designer:
John Casado/Esprit
Graphic Design
Photographers:
Oliviero Toscani,
Uli Rose,
Roberto Carra
Design Firm:
Casado Design
San Francisco, CA
Client:
Esprit de Corp

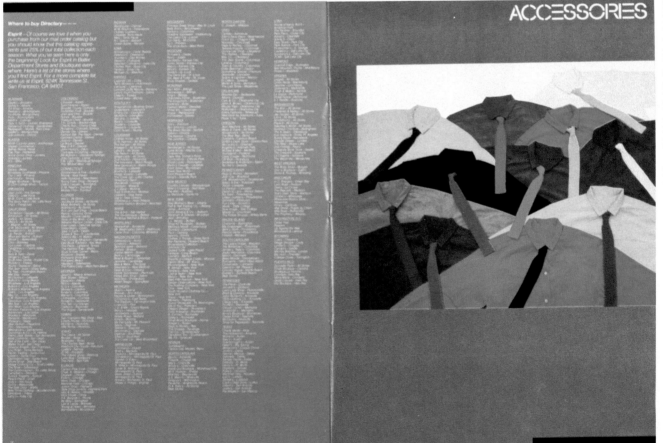

Catalogue:
Esprit Holiday '83
Mail Order Catalogue
Art Director:
John Casado
Designer:
John Casado
Esprit Graphic Design
Photographers:
Oliviero Toscani,
Uli Rose,
Roberto Carra
Design Firm:
Casado Design
San Francisco, CA
Client:
Esprit de Corp

Annual Report:
Peat Marwick
International
1983 Anual Report
Art Director:
Peter Harrison
Designer:
Susan Hochbaum
Photographer:
Neil Slavin
Design Firm:
Pentagram Design Ltd.
New York, NY
Client:
Peat Marwick
International
Typographer:
Peat Marwick
International
Printer:
Case-Hoyt Corp.

1

CHAIRMAN'S MESSAGE

Peat Marwick is dedicated to being the foremost professional accounting firm in the world through the achievement of the following goals:

> To provide our clients with professional services of the highest quality and with innovative approaches to meet their needs.

> To offer our employees opportunity for personal growth in an environment of professional excellence.

> To lead our profession so that it accepts its public responsibility while preserving its right to regulate itself.

> To fulfill our social responsibility through the commitment of our time, our talent, and our financial resources.

> To challenge our partners with a worldwide organization professionally vibrant, constantly growing, and continually profitable.

I am pleased to present the 1983 *Annual Review* of Peat Marwick International to our partners, staff, and friends around the world.

Details of developments during the fiscal year are set out in later sections of the review. Given the difficult economic conditions during the period in most of the territories in which Peat Marwick practices, I am happy to be able to report an increase in worldwide fee income from $1.15 billion in 1982 to $1.23 billion in 1983.

Just over a year ago, at the conclusion of the economic summit meeting at Versailles, the heads of state of the leading non-Communist industrial nations, as well as the representatives of the European communities, made the following declaration:

"Revitalisation and growth of the world economy will depend not only on our own effort but also to a large extent upon cooperation among our countries and with other countries in the exploitation of scientific and technological development. We have to exploit the immense opportunities presented by the new technologies, particularly for creating new employment. We need to remove barriers to, and to promote, the development of and trade in new technologies both in the public sector and in the private sector. Our countries will need to train men and women in the new technologies, and to create the economic, social, and cultural conditions which allow these technologies to develop and flourish."

The economic summit meeting set up a working group to consider the opportunities, problems, and challenges presented by technology, with special regard to economic growth and employment. The working group made its report in March of this year, and I would like to say a little about some of its conclusions in light of the experience of our practices around the world. Later in this review we describe some of the ways we have been able to serve clients involved in the new technologies, but I will comment here on their impact on economic growth and employment.

The working group noted that in the near term new technologies will be diffused throughout society largely by the mechanism of competitive enterprise. I am convinced of the truth of this observation. Innovation is driven by the desire to do things better, quicker, or more efficiently, or in ways impossible before. Science and innovation have transformed our world society in the last two hundred years. Now we look to the active development of such techniques as information technology, robotics, biotechnology, space exploration, and controlled thermonuclear fusion to create new industries to reinvigorate or replace some of the more mature industries and older skills.

One of the major problems in introducing the new technologies is a human reluctance to accept them. This is true of all our societies at all levels. There is discomfort and risk in change. We fear that the new technologies threaten our environment, our way of life, our livelihood. We need to confront the challenge of the new technologies to ensure that they work for us, not against us. The working group was right when it observed that "our nations should make better efforts to prepare their citizens for living and participating in a society of an increasingly technical nature," and that "the fate of our scientific and technological innovations is largely a function of the willingness of the public to accept them. More attention to the problem of public acceptance of new technologies

Annual Report:
Mercantile National
Bank At Dallas
Annual
Report 1982
Art Director:
Dick Mitchell
Designer:
Dick Mitchell
Design Firm:
Richards, Sullivan,
Brock & Associates
Dallas, TX
Client:
Mercantile National
Bank
Typographer:
Chiles & Chiles
Printer:
Padgett Printing

CONSOLIDATED STATEMENTS OF CHANGES IN FINANCIAL POSITION
(dollars in thousands)

	Year Ended December 31, 1982	1981
Funds were provided by:		
Operations:		
Net income	$ 51,690	$ 33,750
Items not using (providing) funds:		
Provision for possible loan losses	18,173	22,457
Depreciation and amortization	4,162	3,630
Deferred income tax benefit	(71)	(1,107)
Discount on sale of loans	—	5,682
Equity in operations of unconsolidated subsidiaries	(952)	(952)
Other—net	(83)	(24)
Funds provided by operations	72,919	63,436
Increases in:		
Deposits	604,706	526,230
Short-term debt	254,949	275,835
Decreases in:		
Cash and demand accounts	24,567	5,685
Investment securities	—	121,986
Trading account securities	—	4,078
Capital contributed by parent	—	15,000
Other—net	10,491	(653)
	$967,632	$1,011,597
Funds were used to:		
Pay cash dividends	$ 9,730	$ 10,100
Liquidate real property leasing activities	1,560	—
Increase:		
Time and Eurodollar deposits	255,294	61,548
Investment securities	20,961	—
Trading account securities	25,525	—
Federal funds sold and securities purchased under agreements to resell	73,730	49,777
Loans	574,167	844,188
Premises and equipment	4,071	7,277
Accrued interest receivable	1,394	37,507
Decrease:		
Long-term debt	1,200	1,200
	$967,632	$1,011,597

See accompanying notes to consolidated financial statements.

10

NOTES TO CONSOLIDATED FINANCIAL STATEMENTS AND SIGNIFICANT ACCOUNTING POLICIES
December 31, 1982 and 1981

Descriptions of the more significant accounting policies of Mercantile National Bank at Dallas and its subsidiaries are presented in *italics* in the notes to financial statements.

The accounting policies of Mercantile National Bank at Dallas and its subsidiaries conform to generally accepted accounting principles and to general accounting practices within the banking industry.

NOTE 1—GENERAL INFORMATION AND BASIS OF PRESENTATION
PARENT COMPANY Mercantile National Bank at Dallas (Bank) is a wholly-owned subsidiary of Mercantile Texas Corporation (Mercantile Texas). At December 31, 1982, the Bank could have paid approximately $61,960,000 in dividends to Mercantile Texas without obtaining prior regulatory approval.

CONSOLIDATION The consolidated financial statements include the accounts of the Bank and all wholly-owned subsidiaries except for Mercantile Realty Services Corporation. Investments in Mercantile Dallas Corporation (a 60%-owned small business investment company) and Mercantile Realty Services Corporation (a real estate investment advisory company) are recorded in other assets at equity.

All material intercompany balances and transactions have been eliminated in consolidation.

In 1982, the accounts of Mercantile Texas Capital Corporation (an equipment leasing company) and Mercantile Texas Credit Corporation (a commercial credit company) were consolidated for the first time, as contrasted to being accounted for on the equity basis of accounting, to more appropriately classify loans and interest income. The financial statements for 1981 were restated to reflect this change in reporting entity which had no effect on net income.

NOTE 2—SECURITIES
Investment securities are stated at cost adjusted for amortization of premium and accretion of discount. Gains or losses on the sale of investment securities are calculated using the cost of the securities based on specific identification and are shown separately in the consolidated statement of income. Provisions are made for losses resulting from permanent declines in the estimated maturity value of any investment security.

The book and market values of the Bank's investment securities at December 31, 1982 and 1981 were as follows (in thousands):

	1982 Book Value	1982 Market Value	1981 Book Value	1981 Market Value
United States Government	$ 71,316	$ 68,365	$ 39,245	$ 27,697
States and political subdivisions	289,471	246,827	300,679	213,139
Other	3,183	3,183	3,223	3,223
	$363,970	$318,375	$343,147	$244,059

At December 31, 1982 and 1981, investment securities carried at $261,446,000 and $251,103,000, respectively, were pledged to secure public and trust fund deposits and for other purposes required or permitted by law.

Trading account securities are stated at the lower of cost or market. Gains, losses and interest on trading account securities are considered to be a part of normal operations. Gains and losses are reported together in the consolidated statement of income as other revenue, and interest income is reported under revenue from earning assets.

Financial futures contracts utilized to hedge interest rate and/or market risks associated with asset/liability management represent future commitments and are not reflected in the consolidated balance sheet. Gains and losses from these financial futures contracts are accounted for in symmetry with the asset or liability being hedged. If an asset or liability being hedged continues to be held after the futures contract is closed out, the carrying value of the respective asset or liability being hedged is adjusted by the gain or loss resulting from the closed futures contract.

At December 31, 1982, the Bank had outstanding financial futures short positions, which were hedging trading account securities, valued at $19,999,000.

NOTE 3—LOANS
Loans are stated net of loan participations sold without recourse.

11

Coal & Minerals

Meridian Land & Mineral Company's revenues of $10 million were derived almost exclusively from taconite and coal-royalty payments. Royalties declined by 22 percent in 1982 as weakness in steel industry demand for taconite curtailed leaseholder operations. Operating expenses increased $5 million as the company expanded exploration and development programs for coal and other minerals located on BN properties. As a result, operating income declined to $335,000 in 1982 compared with $7 million in 1981. Meridian's business strategy focuses on the profitable development of its coal and mineral resources. Accordingly, 1982 activities included drilling and feasibility studies, land consolidations, and market evaluations of company-controlled coal, industrial minerals, and precious metals deposits. Coal remains Meridian's most promising long-term prospect, but weak demand and surplus capacity in the coal mining industry makes large-scale development of Meridian's deposits unlikely in the near future.

Land & Real Estate

The management of BN's diverse real-estate holdings is performed by two separate organizations. The sale and development of industrial properties is the responsibility of the Industrial Lands division of Burlington Northern Railroad Company. All other real-estate holdings—particularly those with significant commercial development potential—are managed by the Glacier Park Company. BN's real-estate subsidiary, Glacier Park Company also manages 1.2 million acres of grazing lands and 45,000 acres of cultivated farm lands. Combined revenues from real estate totaled $33 million in 1982, resulting in an operating income of $19 million. While most of this income resulted from land sales and leases, plans for development of high-potential commercial properties in Denver, Memphis, and Minneapolis were in progress at year-end, in addition to land consolidation and development efforts in other locations.

Annual Report:
Burlington Northern, Inc. 1982
Art Director:
John Van Dyke
Designer:
John Van Dyke
Design Firm:
Van Dyke Co.
Seattle, WA
Client:
Burlington Northern, Inc.
Typographer:
Paul O. Giesey
Printer:
Graphic Arts Center

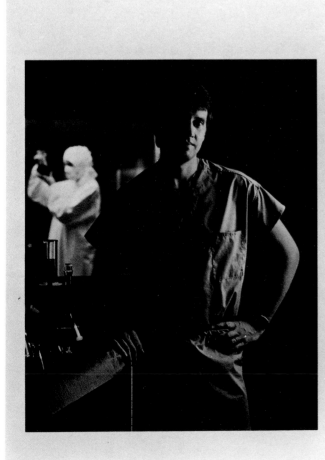

Pharmacist

Stanley Chamallas

What do you do at this research facility?

I'm manager of technical services and I'm helping standardize the Pharmix™ procedure and working with the quality control and assurance program.

How do your methods compare to a hospital pharmacy's?

I feel very good about the way Home Health Care compounds. We do things that no one else does. We test our people to be sure they have good aseptic technique, and improve that validation every month. We prove that our system is clean by doing sterility and pyrogen testing. We also test the air.

Our compounding rooms are class 100 and they are all Hepa-filtered. The Hepa-filters were initially developed for the NASA space program. They will remove 99.97% of any particles bigger than .3 microns, which is about 1/20 the size of a red blood cell. Any organism in the air or viable particle or piece of dust is taken out by the system. We test our system weekly with a device that samples the air, takes in a known quantity and impinges the air on a strip that will grow bacteria. We take the strip and grow it and calculate how many organisms we have per square foot, to make sure particles aren't getting through the filters.

So things stay pretty pure.

Annual Report:
Home Health Care of America, Inc.
1983 Annual Report
Art Director:
Jim Berte
Designer:
Jim Berte
Photographer:
Deborah Meyer
Design Firm:
Robert Miles Runyan & Assoc.
Playa del Rey, CA
Client:
Home Health Care of America, Inc.
Typographer:
Composition
Printer:
Lithographix

October		1984
1	Monday	
2	Tuesday	
3	Wednesday	
4	Thursday	
5	Friday	
6	Saturday	Yom Kippur
7	Sunday	
8	Monday	Columbus Day
9	Tuesday	
10	Wednesday	
11	Thursday	
12	Friday	
13	Saturday	
14	Sunday	
15	Monday	
16	Tuesday	
17	Wednesday	
18	Thursday	
19	Friday	
20	Saturday	
21	Sunday	
22	Monday	
23	Tuesday	
24	Wednesday	
25	Thursday	
26	Friday	
27	Saturday	
28	Sunday	
29	Monday	
30	Tuesday	
31	Wednesday	

Calendar:
1984
Art Directors:
Roger Cook,
Don Shanosky
Designers:
Roger Cook,
Don Shanosky
Photographers:
Melchior DiGiacomo,
L.A. Prosports
Design Firm:
Cook and Shanosky
Assoc.
Princeton, NJ
Publisher:
S .D. Scott Printing Co.
Typographer:
Optima Typesetting
Printer:
S. D. Scott Printing Co.

Promotional Magazine:
Close-Up, Vol. 14,
No. 2, Winter 1983
Art Director:
Katy Homans
Designer:
Katy Homans
Photographers:
Various
Design Firm:
Katy Homans
Cambridge, MA
Publisher:
Polaroid Corp.
Typographer:
Acme Printing Co.
Printer:
Acme Printing Co.

POLAROID **CLOSE-UP**

VOLUME 14 NUMBER 2 WINTER 1983

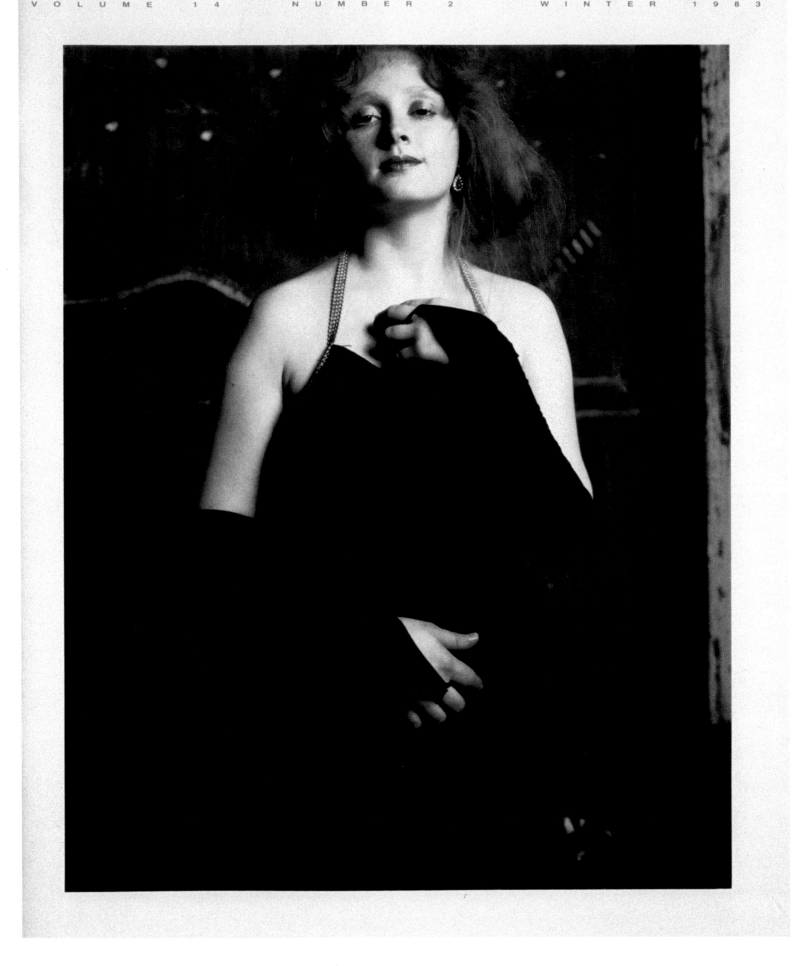

POLAROID **CLOSE-UP**

to more newsstands on Saturdays to accommodate the growing number of investment-oriented readers who prefer to have Barron's for weekend reading.

In January 1983, Barron's launched its first regional advertising edition. The section, which appears every other week in copies distributed in the 13 Western states, aims to attract advertisers who are interested in reaching a local and regional, rather than a national, audience.

Barron's advertising sales are expected to benefit from findings by the 1982 Simmons Study of Media and Markets, which advertisers use extensively in choosing publications for their advertising dollars. According to the Simmons study, Barron's readers have the highest incomes, highest educational levels and highest occupational rankings of any of the 108 magazines and newspapers included in the survey.

Early in 1983, Kathryn M. Welling, formerly assistant to the editor, was named managing editor of Barron's.

AMERICAN DEMOGRAPHICS

American Demographics,Inc., acquired in December 1981, increased circulation of its flagship publication by 12% in 1982 and launched a monthly newsletter aimed at multi-national companies. The company, based in Ithaca, New York, takes demographic statistics from a variety of sources and makes them interesting, understandable and directly applicable to business. Its major publication is American Demographics magazine, a monthly.

INTERNATIONAL

Dow Jones' overseas operations experienced robust growth in 1982 and, as the new year began, the company launched its newest international venture—The Wall Street Journal/Europe.

Headquartered in Brussels, printed in the Netherlands and distributed on day of publication in Continental Europe and the United Kingdom, The Wall Street Journal/Europe is tailored for the European business executive with international interests.

The Journal/Europe, which started operating with a circulation of 11,000 to 12,000, has its own staff of 27 reporters and editors covering European business and

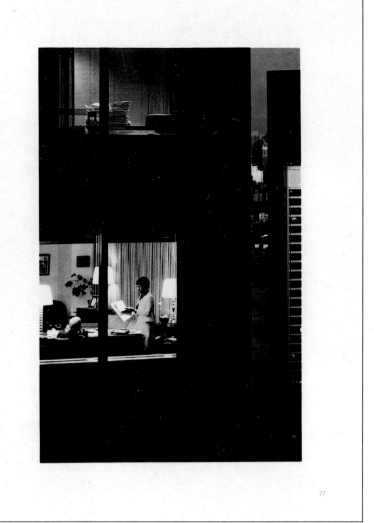

26 27

Annual Report:
Dow Jones Annual
Report 1982
Art Directors:
B. Martin Pedersen,
Adrian Pulfer
Designers:
B. Martin Pedersen,
Adrian Pulfer
Photographers:
Neil Selkirk,
Cheryl Rossum,
Robin Moyer
Design Firm:
Jonson Pedersen
Hinrichs & Shakery
San Francisco, CA
Client:
Dow Jones
Typographer:
Tri-Arts Press
Printer:
George Rice & Sons

IMPERIAL BANCORP ANNUAL REPORT 1982

Annual Report:
Imperial Bancorp
Annual Report 1982
Art Directors:
Clifford Yuguchi,
Stuart Araki
Designers:
Clifford Yuguchi,
Stuart Araki
Photographer:
Yuguchi & Krogstad
Design Firm:
Yuguchi & Krogstad,
Inc.
Los Angeles, CA
Client:
Imperial Bancorp
Typographer:
Central Type
Printer:
George Rice & Sons

Poster:
Blériot XI Monoplane
Art Director:
McRay Magleby
Designer:
McRay Magleby
Artist:
McRay Magleby
Design Firm:
Brigham Young
University
Graphic
Communications
Provo, UT
Publisher:
Brigham Young
University
Printer:
Robert G. Carawan

Poster:
Sopwith F.1 Camel
Art Director:
McRay Magleby
Designer:
McRay Magleby
Artist:
McRay Magleby
Design Firm:
Brigham Young
University
Graphic
Communications
Provo, UT
Publisher:
Brigham Young
University
Printer:
Robert G. Carawan

Poster:
Supermarine Spitfire
MK
Art Director:
McRay Magleby
Designer:
McRay Magleby
Artist:
McRay Magleby
Design Firm:
Brigham Young
University
Graphic
Communications
Provo, UT
Publisher
Brigham Young
University
Printer:
Robert G. Carawan

Poster:
Mitsubishi A6M3
Zero-Sen
Art Director:
McRay Magleby
Designer:
McRay Magleby
Artist:
McRay Magleby
Design Firm:
Brigham Young
University
Graphic
Communications
Provo, UT
Publisher:
Brigham Young
University
Printer:
Robert G. Carawan

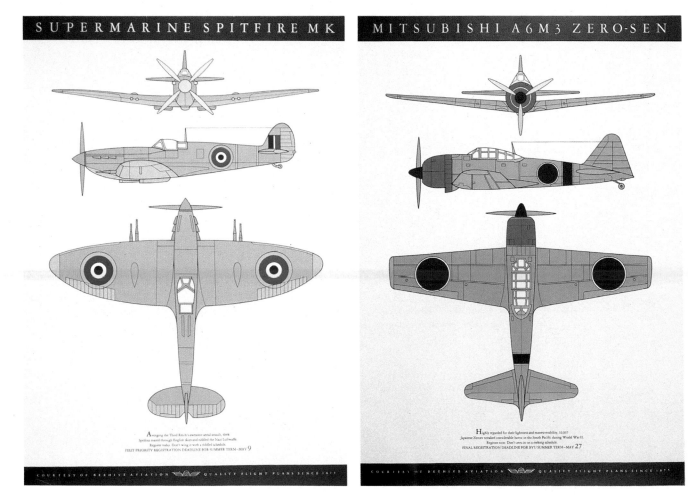

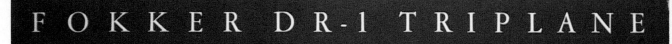

FOKKER DR-1 TRIPLANE

Poster:
Fokker DR-1 Triplane
Art Director:
McRay Magleby
Designer:
McRay Magleby
Artist:
McRay Magleby
Design Firm:
Brigham Young
University
Graphic
Communications
Provo, UT
Publisher:
Brigham Young
University
Printer:
Robert G. Carawan

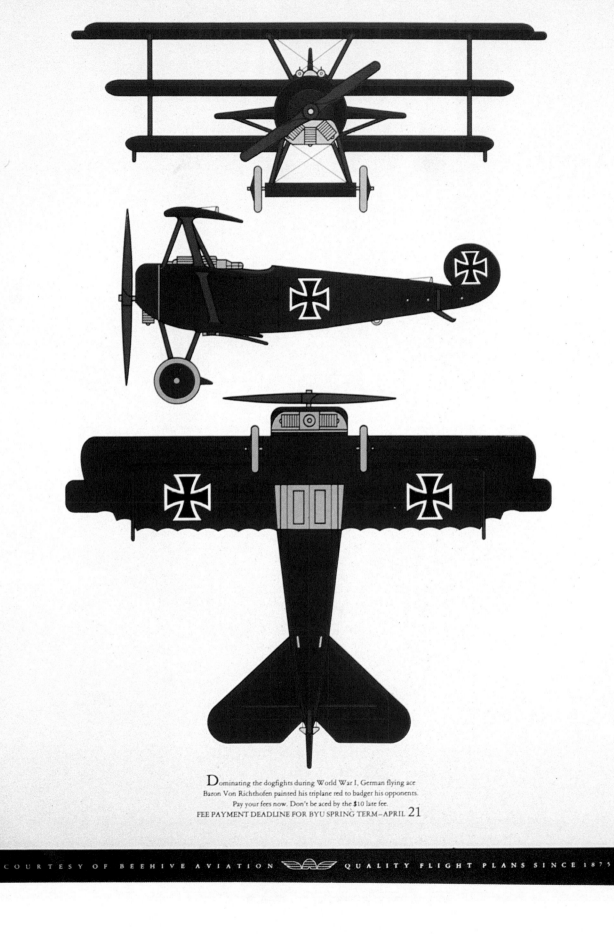

Dominating the dogfights during World War I, German flying ace
Baron Von Richthofen painted his triplane red to badger his opponents.
Pay your fees now. Don't be aced by the $10 late fee.
FEE PAYMENT DEADLINE FOR BYU SPRING TERM–APRIL 21

COURTESY OF BEEHIVE AVIATION — QUALITY FLIGHT PLANS SINCE 1875

What You Need
To Know Before
You Go

Holland America
Westours

Tickets
& Vouchers

**Travel Information
Packet:**
Holland America Travel
Documents
Art Director:
Keith Bright
Designers:
Gretchen Goldie,
Marc Herrington
Design Firm:
Bright & Assoc.
Los Angeles, CA
Client:
Westours, Inc.
Typographer:
Skilset Typographers
Printers:
George Rice & Sons,
Hibbert Col, Pioneer
Business Forms,
Cone-Neiden

Shopping Bag:
I. Magnin:
The Five Senses
of Christmas 1983
Art Director:
Art Shipman
Designer:
Brian Collentine
Artist:
Brian Collentine
Design Firm:
Brian Collentine
San Francisco, CA
Publisher:
I. Magnin
Printer:
Equitable Bag Co.

Slipcased Booklet:
Dallas Images
Art Director:
Don Sibley
Designer:
Don Sibley
Photographers:
Various
Design Firm:
Sibley/Peteet
Design, Inc.
Dallas, TX
Client:
Criswell Develop-
ment Co.
Typographer:
Southwestern
Typographics, Inc.
Printer:
Williamson Printing Co.

Dallas Museum Of Art 1983 · Les Walker

Fountain Place 1986 · Robert Harr

Magnolia Building 1922 · Robert Latorre

404

Poster:
Ponderosa Pine
Art Director:
McRay Magleby
Designer:
McRay Magleby
Artist:
McRay Magleby
Design Firm:
Brigham Young
University
Graphic
Communications
Provo UT
Publisher:
Brigham Young
University
Printer:
Robert G. Carawan

Announcement:
MAGIC Flip Book
Art Director:
Gerald I. Millet
Designer:
Jeff Boortz
Design Firm:
Lehman Millet, Inc.
Corning, NY
Client:
Corning Medical
Typographer:
Rochester Mono
Printer:
Flower City Printing

Annual Report:
Apple Computer, Inc.
Annual Report 1983
Art Director:
John Casado
Designer:
John Casado
Photographers:
Will Mosgrove,
Cheryl Rossum
Design Firm:
Casado Design
San Francisco, CA
Client:
Apple Computer, Inc.
Typographer:
Display Lettering
& Copy
Printer:
Gardner/Fulmer

Computer. We have no intention of tampering with it. Rather, we want to nourish this environment by improving the responsibility that people have at Apple to get things done on time, improve the quality of communication between groups and upgrade the processes through which our divisions interact. This is happening right now and we are gratified by the early results.

High-volume, low-cost manufacturing is central to our own long-term profitability. It is also an issue of national significance. So strongly do we feel about the need for state-of-the-art, automated assembly processes that we have designed and constructed a custom facility near our headquarters for production of a major new product. With this plant, a 160,000-square foot facility located in Fremont, California, we expect to be able to annually produce units valued at approximately $1 billion. This facility is one of the most highly-automated of its kind in our industry.

In our view, too many American industries were not only late to recognize the integral role of manufacturing technology in the delivery of affordable, quality products, but they remain slow to react to the progress made by their Japanese counterparts. Japan's preeminence today in industries once the reserve of American enterprise can be traced to the emergence of Japanese manufacturing technology. Watches, calculators, televisions, stereos, motorcycles and automobiles are dominated by Japanese companies today because those companies can build products of higher quality and lower cost than we can in America. At Apple, we think we have approximately three to four years to become one of the world's lowest cost, highest quality manufacturers or suffer the fate of those American companies who have succumbed to competitive pressure from Japanese rivals.

There is little doubt that Japan will, inevitably, have a major presence in personal computers, perhaps in as little as two years. But the industry can and should remain an American one. Apple believes one of the best ways of assuring this is to have a manufacturing capability as advanced and innovative as the products we manufacture.

There is no question that the next several quarters will be a time of testing for Apple. It will be characterized by intense competition and rapidly changing circumstances. There will be further turbulence in the industry, more shaking out, more consolidation. Consumers, retailers and third party software developers will be watching the industry from their respective vantages, sorting out the significance of each new development and reacting accordingly.

Apple Computer moves into this period as a financially sound, technologically superior, focused organization making a steady and deliberate transition to a more disciplined, multi-product, multi-market, multi-billion-dollar company. We enjoy a unique advantage in our industry because of our technological superiority. Our products have a competitive edge because they are software appliances to a much greater degree than anything else available. This means they are the simplest to learn,

Apple's newest manufacturing facility—featuring the world's most advanced automated assembly technology—will produce a new Apple computer every 27 seconds. The state-of-the-art manufacturing equipment and techniques allow exacting quality of high-volume, low-cost manufacturing, which is essential to long-term profitability and market strength. (Refer to text lines 7-15.)

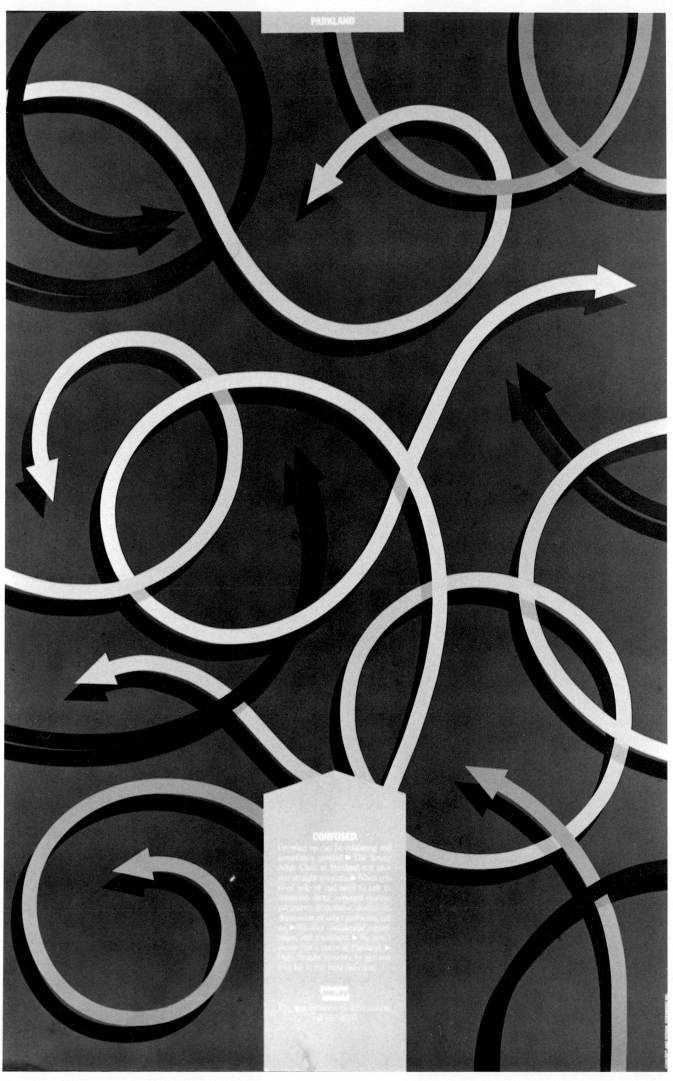

Poster:
Confused
Art Director:
Phil Waugh
Designer:
Phil Waugh
Design Firm:
Eisenberg, Inc.
Dallas, TX
Publisher:
Parkland Memorial
Hospital

Brochure:
Management Compen-
sation: The Carrot is
Mightier than the Stick
Art Director:
Paul Busman
Designer:
Paul Busman
Photographers:
Various
Design Firm:
Burson-Marsteller
Chicago, IL
Client:
Rollins Burdick
Hunter Management
Compensation Group

*A carrot
by any other name
would smell
as sweet.*

long-standing Rollins Burdick Hunter tradition of providing quality services and counsel, now aimed at protection of the human, as well as the physical assets of an individual company.

This brochure describes the variety of services that the Management Compensation Group, through your Rollins Burdick Hunter representative, can offer in this highly specialized field. We also review some critical issues every company should consider before taking action in this important area. We look forward to bringing our combined resources to bear on one of your most critical concerns—cost-effectively keeping the best possible management team in place and motivated for success in the years ahead.

*C*ompensation of top and middle management is a significant and necessary business cost for every organization. The wide variation in executive needs and the broad range of costs-per-dollar-of-benefit make this a complex and important area of corporate concern.

There is no direct relation between benefits and costs. Rather, there are advantages both in tailoring benefits, as well as savings through cash flow and other means without changing benefits. Here are the details.

*D*ifferent Needs. For example, executive "A" has changed employers in mid-career and is starting again at the bottom of the length-of-service formula in his new company's qualified pension plan. This executive may want immediately vested supplementary income to compensate for shortened tenure. Executive "B" is an "up and comer" with a young family. What motivates this executive may be an interest-free loan or wealth accumulation plan to aid in financing problems. Executive "C" has no family or dependents, and seeks flexible investment opportunities for early retirement.

The above executives are different, and demand different benefit options. An appropriately structured

TEXAS/NEW YORK

THE 62ND ANNUAL SHOW
OF THE ART DIRECTORS
CLUB OF NEW YORK.
AN EXHIBITION OF THE
TOP ADVERTISING AND
DESIGN FOR 1982-83.
OCTOBER 12-19, 1983
OPENING RECEPTION
OCTOBER 12, 6-10 PM
TEXAS COMMERCE TOWER
600 TRAVIS STREET
60TH FLOOR SKYLOBBY
CASH BAR

SPONSORED BY OLIVET GROUP
GERALD D. HINES INTERESTS
HILL/A GRAPHIC DESIGN GROUP

Poster:
Texas/New York
Art Director:
Chris Hill
Designers:
Chris Hill,
Joe Rattan
Artist:
Regan Dunnick
Design Firm:
Hill, A Graphic
Design Group
Houston, TX
Publishers:
Hill Design
& Olivet Group
Typographer:
Professional
Typographers, Inc.
Printer:
Olivet Group

Plastic Shopping Bags:
The Pottery Barn
Art Director:
Marjorie Katz
Designers:
Marjorie Katz,
Carol Zimmerman
Photographer:
Reanne Giovanni
Design Firm:
Marjorie Katz
Design, Inc.
New York, NY
Client:
The Pottery Barn
Printers:
Pak 2000,
Regal

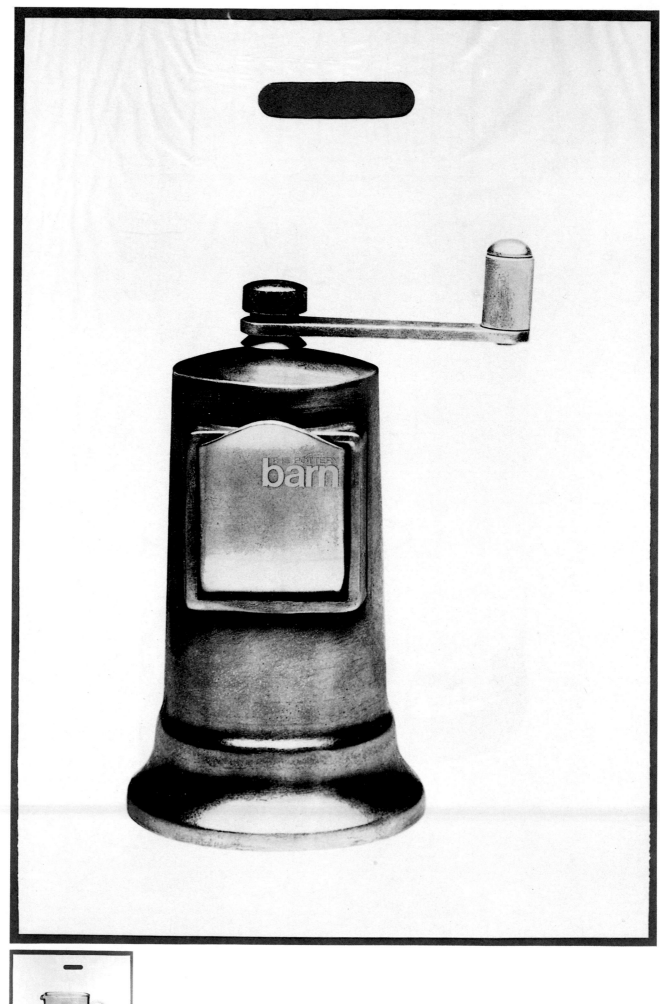

P2M·0682

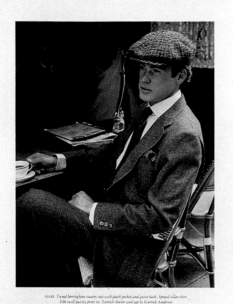

NINES. Tweed herringbone country suit with patch pockets and gusset back. Spread collar shirt.
Silk twill paisley print tie. Scottish cheviot wool cap by Garrick Anderson.

NINES. Double-breasted, side-vented wool Saxony suit.

Catalogue:
Louis, Fall-Winter 1983
Art Director:
Tyler Smith
Designer:
Tyler Smith
Photographers:
Aldo Fallai, Myron,
A. Jordan, J. Malignon
Design Firm
Tyler Smith Design
Providence, RI
Client:
Louis
Typographer:
Typesetting Service
Printer:
National Bickford
Foremost

Yet something that
also stands the
test of time.
Talk about having
the bugs ironed out!

Promotional Booklet:
Satisfaction
Art Director:
Craig Frazier
Designer:
Craig Frazier
Artist:
Craig Frazier
Design Firm:
Craig Frazier Design
San Francisco, CA
Client:
Forman Leibrock
Typographer:
Rapid Typographers
Printer:
Forman/Leibrock

The world of testing has been en-
hanced dramatically by the ability to
translate virtually any information into
appropriate digital formats. Logic
analyzers, spectrum analyzers, control-
lers, and calculators make use of this
medium effectively

1011010011 0

(estimated to be more than 10%) may
make purchase for infrequent use more
costly than rental. Besides avoiding
risks of obsolescence, renting elimi-
nates the need to carry or sell idle
equipment later on. Further, rentals
offer the alternative of "off-balance
sheet" financing.

There are other sound and specific rea-
sons our customers have for renting: to
meet short-term project needs, to avoid
costly down-time and to evaluate new
products. Moreover, sometimes the de-
sired item simply is not available from
the manufacturer due to lead times
that can be in excess of six months.
With respect to government projects,
the relative certainty of rental costs
can be helpful in bidding for and
obtaining such contracts and also
facilitates effective cost control
in their performance.

Service — An Important Standard
Providing the excellence of service re-
quired by our customers frequently
means acquiring new items in our basic
equipment lines early in their product
life because our customers often need
the most advanced equipment on short
notice. To meet this challenge, we
must stay in very close touch with the
market, monitoring both suppliers and
customers alike to track new prod-
uct developments and changing cus-
tomer requirements.

The quality of our service has been a
basic factor enabling Electro Rent to
grow and prosper. We stress rapid de-
livery and timely maintenance of our
equipment. Eleven equipment, calibra-
tion and service centers are operated
across the United States and Canada in
addition to six separate district sales
offices. These centers maintain
laboratories with standards directly
traceable to the National Bureau of
Standards, an important factor to our
customers since equipment must be
properly calibrated for optimum per-
formance. Reliability is a key to our
success, and all equipment is care-
fully inspected and calibrated by our
service personnel prior to delivery to
customers. This regular maintenance
facilitates equipment performance,
often at a lower cost than the cus-
tomer could otherwise obtain.

A New Life for Retired Equipment
The sale of used equipment is another
important and growing aspect of our
business. Through this ongoing process,
we continually keep our portfolio fresh
and current, and typically sell equip-
ment three or four years after its acqui-
sition at prices which have, on average,
been above the equipment's then book
value. These sales make an important
contribution to cash flow and have
been a key factor in maintaining a
rapidly growing equipment portfolio
without excessive borrowing. Used
equipment is checked for reliability,

refurbished if needed, and calibrated by
technicians at the Company's service
centers prior to sale. Because of our
strong sales and service capabilities
throughout the U.S. and Canada, we
can offer a warranty which in some in-
stances is equivalent to that of the
manufacturer.

Technology Without Obsolescence
Rapid advances in technology continue
to bring many new products to our
marketplace. Those new products con-
tinue to reflect increasing performance
capability in both scope of application
and data handling capacity. We believe
that this kind of rapid change makes
the service we provide an even more
essential element of any company's
equipment resource planning over the
next decade.

Annual Report:
Electro Rent
Corporation 1983
Annual Report
Art Director:
Robert Miles Runyan
& Assoc.
Designer:
Rik Besser
Artists:
Rik Besser
Paul Bice
Design Firm:
Robert Miles Runyan
& Assoc.
Playa del Rey, CA
Client:
Electro Rent Corp.
Typographer:
Composition
Printer:
Lithographix

Invitation:
The Last Hurrah, Dallas
Museum of Fine Arts
Fair Park 1936–1983
Art Director:
Woody Pirtle
Designer:
Woody Pirtle
Photographer:
Ken Shafer
Design Firm:
Pirtle Design
Dallas, TX
Client:
Dallas Museum
of Fine Arts
Typographer:
Southwestern
Typographics, Inc.
Printer:
Brodnax Printing

Promotional Booklet:
Trademarks
& Logotypes
Art Director:
Phil Waugh
Designers:
Arthur Eisenberg,
Phil Waugh
Design Firm:
Eisenberg, Inc.
Dallas, TX
Publisher:
Eisenberg, Inc.
Typographer:
Spruiell & Co.

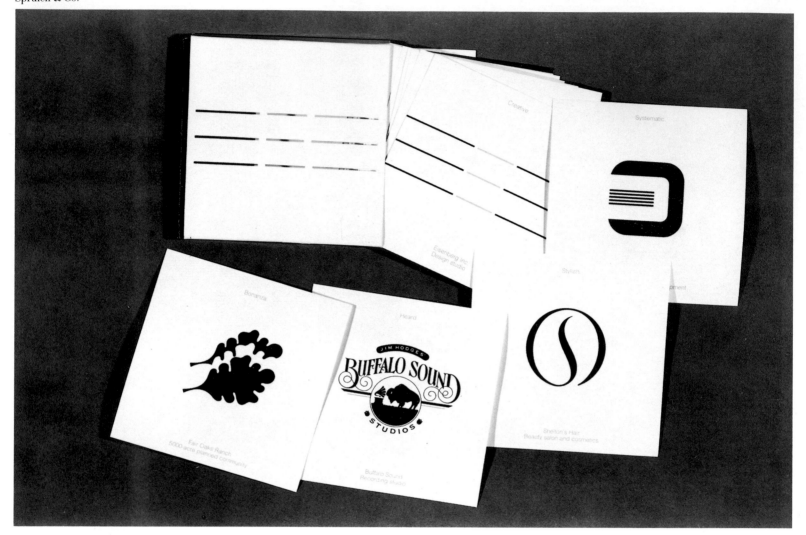

Texas Wine. The Next Big Thing From Texas.

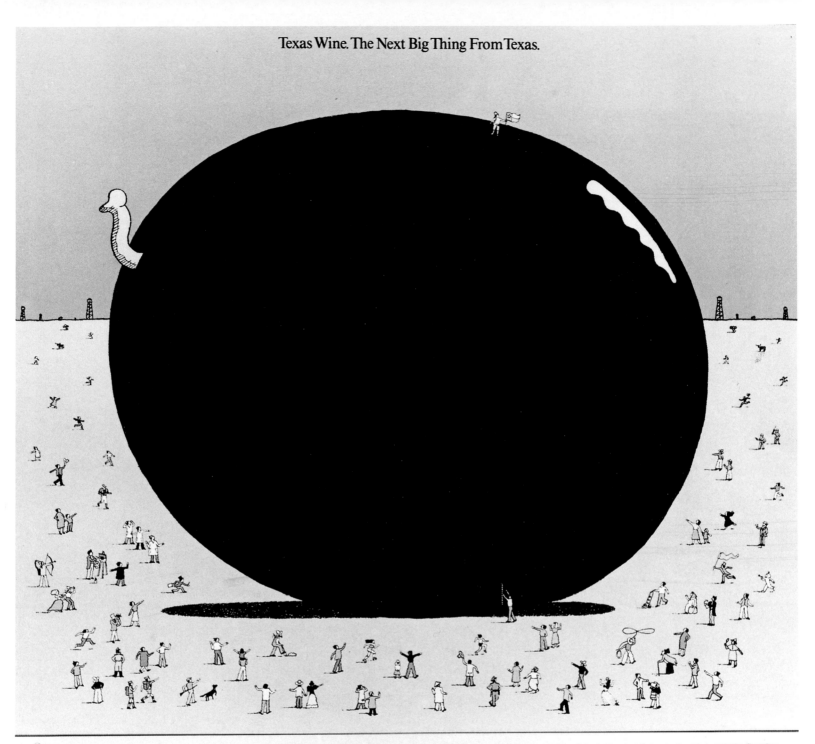

Something big and exciting is cropping up in Texas. Grapes. And as we all know, grapes make wine! From the Red River Valley to the Rio Grande Valley, from the Hill Country to the Llano Estacado, Texas is producing wine. Surprising, superb wine. From Chardonnays and Chenin Blancs to Cabernet Sauvignons and Pinot Noirs. A whole new industry is emerging. A whole new something for Texans to brag about – Texas wine! The next big thing from Texas. ● ● ●

Poster:
Texas Wine: The Next
Big Thing from Texas
Art Directors:
Bob Dennard,
Ken Koester
Designer:
Ken Koester
Artist:
Ken Koester
Design Firm:
Dennard Creative, Inc.
Dallas, TX
Publisher:
Texas Agriculture
Commission
Typographer:
Texas Agriculture
Commission
Printer:
Texas Agriculture
Commission

Poster:
T.G.I. Friday's
Summer '83
Art Director:
Woody Pirtle
Designer:
Woody Pirtle
Artist:
David Kampa
Design Firm:
Pirtle Design
Dallas, TX
Publisher:
T.G.I. Friday's, Inc.
Typographer:
Southwestern
Typographics, Inc.
Printer:
Allcraft Printing

Menu:
T.G.I. Friday's
Summer '83
Art Director:
Woody Pirtle
Designer:
Woody Pirtle
Artist:
David Kampa
Design Firm:
Pirtle Design
Dallas, TX
Client:
T.G.I. Friday's, Inc.
Typographer:
Southwestern
Typographics, Inc.
Printer:
Allcraft Printing

Index

Art Directors, Designers, Illustrators, Artists, Photographers, Authors, Editors, Copywriters and Production Managers

Design Firms and Agencies

Publishers and Clients

Typographers, Letterers and Calligraphers

Printers, Binders and Engravers